THE
MUSEUM
CALLED
CANADA

25 Rooms of Wonder

THE MUSEUM CALLED CANADA

25 Rooms of Wonder

Essays by
CHARLOTTE GRAY

Book concept and curation by
SARA ANGEL

Design by
DINNICK & HOWELLS

Cover and museum interior photography by
NANCY TONG

Created and produced by
OTHERWISE EDITIONS

for
RANDOM HOUSE CANADA

RANDOM HOUSE CANADA

For George, Alexander, Nicholas and Oliver, and my mother, Elizabeth Gray
– Charlotte Gray

For Michael
– Sara Angel

www.randomhouse.ca

National Library of Canada Cataloguing in Publication

Gray, Charlotte, 1948–
 The museum called Canada: 25 rooms of wonder / Charlotte Gray.

Includes bibliographical references and index.
ISBN 0-679-31220-X

1. Canada. 2. Canada – Pictorial works. I. Title.

FC21.G73 2004
971 C2004-901766-7

Printed and bound in China

10 9 8 7 6 5 4 3 2 1

Table of Contents
the Museum Called Canada *25 Rooms of Wonder*

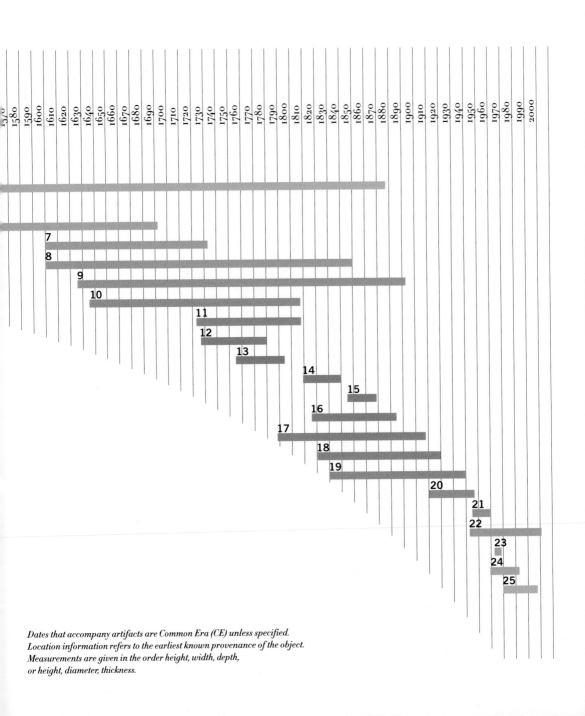

Dates that accompany artifacts are Common Era (CE) unless specified.
Location information refers to the earliest known provenance of the object.
Measurements are given in the order height, width, depth,
or height, diameter, thickness.

Chapter		Page

1 ENTRY HALL

2 FOSSIL FOYER

2.1 billion years ago to 65 million years ago

The oldest life form, the first land walker, a plant turned to glass, an Albertosaur

3 HALL OF ICE

80,000 years ago to 10,000 years ago

Some melted glacier, a prairie lion, some Paleoindian stone points

4 FIRST PEOPLES ROOM

3,500 years ago to 1878

A Tsimshian mask, a Cree meteorite, a Mi'kmaq cooking pot, an Inuit road sign

5 FIRST CONTACT COLLECTION

500 to 1300

A Viking cloak pin, the ghost of a nail, the "Bishop of Baffin Island"

6 WATER ROOM

1000 to 1693

A Basque harpoon, Cartier's account, Frobisher's peas, some Arctic ore

7 SALON DE LA NOUVELLE FRANCE

1603 to 1734

Champlain's foundations, an Iroquois war club, a seigneurial survey, the Great Peace

8 ATLANTIC PROMENADE

1600 to 1850

Canada's first newspaper, a marsh horseshoe, a Ferryland cross, a gentleman's waistcoat

9 TRAP ROOM

1627 to 1893

A beaver-felt hat, a spring trap, Prince of Wales Fort, an amerindian snowshoe

10 HALL OF MARTYRS

1636 to 1809

A cross of Lorraine, an iron-headed tomahawk, Brébeuf's skull

11 NORTH-WEST GALLERY

1723 to 1809

An Ojibwa belt, a Haida amulet, Vancouver's chronometer, Thompson's desk

12 GENERALS' COLLECTION

1727 to 1780

Wolfe's snuffbox, Montcalm's armour, West's famous painting

13 LOYALIST LODGE

1755 to 1794

A slave from Montreal, young Enoch's drum, Ben Franklin's letter, a patriotic powder horn

14 REBEL HALL

1810 to 1840

Brock's bloodstained uniform, Montreal money, a Patriote banner, maple leaves in stained glass

15 CONFEDERATION GALLERY

1845 to 1869

Fannie Parlee's quilt, John A's doodles, McGee's dead hand, Canada's Great Seal

16 WESTERN SALON

1817 to 1885

Lord Selkirk's treaty, a Métis sash, a Union Jack, Riel's putative coat

17 LOST & FOUND COLLECTION

1789 to 1909

An Inuit snowbeater, Sir John's rations, Admiral Peary's flag

18 SPACE & TIME ARCADE

1820 to 1920

Logan's odometer, Bell's contraption, Smith's final nail, Fleming's time zones, a flyer's goggles

19 THE MAPLE LEAF LOUNGE

1830 to 1939

Some three-pence beavers, Bertie's trowel, Tom Thompson's palette, Etta Platt's Stampede dress

20 WAR ROOM

1910 to 1948

A Ross rifle blueprint, a field service postcard, Private Brown's VC, Bethune in bed, a dummy paratrooper

21 BETTER LIVING ROOM

1945 to 1959

A plastic chair, a can of Pablum, the Rocket's jersey, an iron lung

22 GLOBAL VILLAGE SQUARE

1942 to 2001

A door to the UN, some keys to Glenn Gould, a McLuhan massage, Randy Bachman's suit, Warhol's Gretzky

23 CENTENNIAL PAVILION

1967

A Canada goose silver dollar, Snow's Walking Women, President de Gaulle's unclaimed gift

24 RIGHTS AUDITORIUM

1960 to 1982

Diefenbaker's Bill, a terrorist mailbag, Pham's suitcase, PET's Charter

25 EARTH & SKY ATRIUM

1970 to 1997

What's left of a right whale, Marc Garneau's experiment, a tree-hugger's bullhorn, Ballard's battery

ENTRY HALL

INTO A WORLD OF WONDERS
Charlotte Gray

Do you keep your own private museum? A handful of talismanic objects that
have quietly collected in a corner of your study, kitchen, or cottage? Objects that
are powerful reminders of past relationships and events? Objects that, when
you cradle them in your hand, are tangible evidence of a much larger story?

Catharine Parr Traill, the educated Englishwoman who immigrated to
Upper Canada in 1832, accumulated a precious collection of "things": bead-
work by the local Chippewa Indians; feathers from unfamiliar North
American birds; dried flowers, ferns, lichens, and grasses that she preserved
in a "herbarium." Her collection reflected her love of the natural world and
her increasing concern that species were being lost as settlers cleared the
wilderness. Private Edwin Pye from Saskatchewan, who sailed from Quebec
City in 1914 as a member of the First Expeditionary Force and watched a cloud
of poison gas drift over the battlefield at Ypres, had a similar urge to collect.
After the "Great War" ended in 1918, he returned to Canada and filled a scrap-
book with photos, letters, army tickets, wartime leaflets, and ration cards to
document an experience he could not forget. For both Traill and Pye, their pri-
vate museums were a way to hold on to something familiar amid the modern
maelstrom called "progress."

Things. There is so much history in *things*, and not only those that have a
personal relevance. Whether they are natural objects, such as pebbles or
bones, or artifacts such as teapots, maps, or feather bonnets, *things* allow us to
engage with history in a way that is far more immediate than the abstract con-
nection offered by the written word. An old plough or an archival photograph
triggers a tactile or visual response to the past. No matter how commonplace,
obsolete, or insignificant, an object can permit our empathy and imagination
to vault the gulf of time and recapture vanished experiences. When I pick up
old glass rolling pins or chipped 1950s Melaware bowls at a local flea market, I

am transported into the kitchens of other, earlier women. I can almost feel flour on my fingertips and smell the pie baking in the oven as I reflect on how different the owners' lives were from mine.

When Sara Angel invited me to become involved in *The Museum Called Canada*, I could not resist the lure of *things*. I also admired the way Sara planned to use the objects in her museum to tell a larger story. There are myriad pieces of our past here; they are objects and artifacts that have never been brought together before, and many have rarely been exhibited. But this museum has been carefully constructed: objects are displayed within an intellectual framework that brings out their larger meaning. It is not a "cabinet of curiosities" – the name given to the glass-fronted cases, stuffed indiscriminately with whales' teeth and minute carvings, which were so prized by the wealthy collectors of the eighteenth and nineteenth centuries. It is a virtual museum for the twenty-first century – a way of looking at Canada's vast sweep of history that no physical building could ever accommodate. When I wandered through the Trap Room, I understood the once-powerful grasp of the Hudson's Bay Company on our land. In the Global Village Square, I began to appreciate how each post-war generation has redefined for itself Canada's role in the world.

As in any good museum, artifacts are carefully juxtaposed in each of these rooms so that they illuminate each other. In the First Contact Collection, a Viking helmet and a Tuniit mask share the same display case, giving a physical reality to the first encounters between early Norse and the forerunners of the modern Inuit. In the Lost & Found Collection, two metal objects provide poignant evidence of Sir John Franklin's heroic, hopeless quest to find the North-West Passage: a dented tin of rations is displayed next to Franklin's badge as a Knight Commander of the Royal Hanoverian Guelphic Order. The Global Village Square vividly illustrates the ups and downs of Canada's post-war cultural emergence with a hit 45 rpm by Ottawa's own Paul Anka and a bunch of unreturned hotel keys collected by superstar pianist Glenn Gould while on tour in the 1950s.

Sara Angel and her team at Otherwise Editions have built this museum. They wrote the introductions that greet you at the entrance to each room. They selected both the artifacts on display and the "context images" evoking the world from which these objects came. They crafted the captions for each. And they decided to date each room by the objects it contained. They are the curators and the docents in *The Museum Called Canada*.

I had a different job. I was the visitor allowed to see, touch, feel. Sara showed me the artifacts she intended to put in each room, then I chose one that I wanted to engage in more detail. What lay behind my choices? Some artifacts illuminated people ignored by conventional written histories, such as the Cree wife of Peter Fidler, a Hudson's Bay Company surveyor, whose fourteen children's births are carefully registered on a torn page from one of her husband's notebooks. A handful, such as a First World War gas mask or a tear gas canister from the 2001 Summit of the Americas in Quebec City, grabbed me with their physical reality, prompting me to imagine their impact on the people who used them. Sometimes the subsequent lives of the artifacts themselves – what had happened to them over time – fascinated me. The story of Brébeuf's skull fits into this category – a story more Gothic than I could have imagined – as does the afterlife of General James Wolfe's copy of Gray's *Elegy in a Country Churchyard*. For each artifact, there were always more layers, more surprises as I dug deeper. In each case, the more I explored the object's story, the richer its appeal became.

But why don't you come inside yourself and discover the museum that is our land, our culture, our history, our country?

FOSSIL FOYER

2.1 billion years ago to 65 million years ago

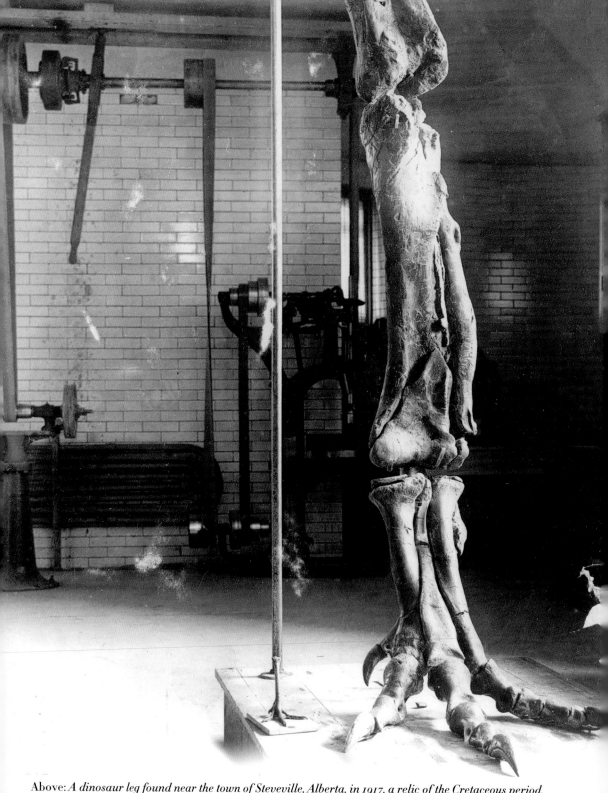

Above: *A dinosaur leg found near the town of Steveville, Alberta, in 1917, a relic of the Cretaceous period.*
Opposite: *Brachiopods like this one abounded in the earth's seas 500 million years ago.*

FOSSIL FOYER
2.1 billion years ago to 65 million years ago

The earliest history of Canada is written in stones – stones that include some of the oldest rocks ever found on the surface of the earth. The first chapter of this history begins about 4 billion years ago, when the molten crust of the young planet cooled into a layer of rock that separated into what modern geologists call tectonic plates. Over billions of years these plates – like pieces of a giant jigsaw puzzle – were always on the move, separating and colliding, but ultimately creating the North American continent, which pulled away from Europe for the last time about 45 million years ago. The first life forms, called cyanobacteria, arose in the waters of the ancient earth at least 3.5 billion years ago. Also known as blue-green algae, cyanobacteria were simple, single-celled, aquatic bacteria that manufactured their sustaining energy through photosynthesis, which produces oxygen as a by-product. Over hundreds of millions of years these microscopic beings gradually converted the earth's atmosphere into the oxygen-rich medium that allowed oxygen-dependent life to develop. The story of the earliest organisms that lived in what is now Canada can be read in the fossil record.

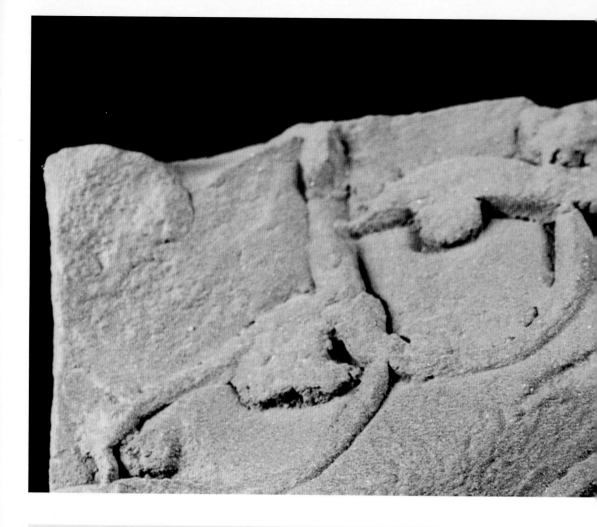

WORMLIKE CREATURE (*RHYSONETRON BYEI*), TRACE FOSSIL, APPROX. 2 BILLION YEARS OLD

Flack Lake, Ontario
rock
size unavailable

Here we see the slow path taken by what appears to be a wormlike creature, one of the earliest forms of multicellular animal life, as it tunnelled through undersea sediment. Fossils offer visible evidence of prehistoric plants or animals that have otherwise disappeared.

STROMATOLITES (SPECIES UNKNOWN), 2.1 BILLION YEARS OLD (OPPOSITE)

Sault Ste. Marie, Ontario
metamorphic limestone
15.2 x 20.3 x 8.9 cm

Stromatolites, the oldest known fossils, are actually the remains of reeflike colonies of cyanobacteria that thrived in the earth's ancient seas. The reefs were formed by the growth of these colonies (through a process called photosynthesis) and the addition of calcium carbonate – the same mineral that occurs in bones and teeth – as well as other sediments. Before the sediment deposits hardened, the bacteria grew through them and began to produce another layer of calcium carbonate and sediment on top.

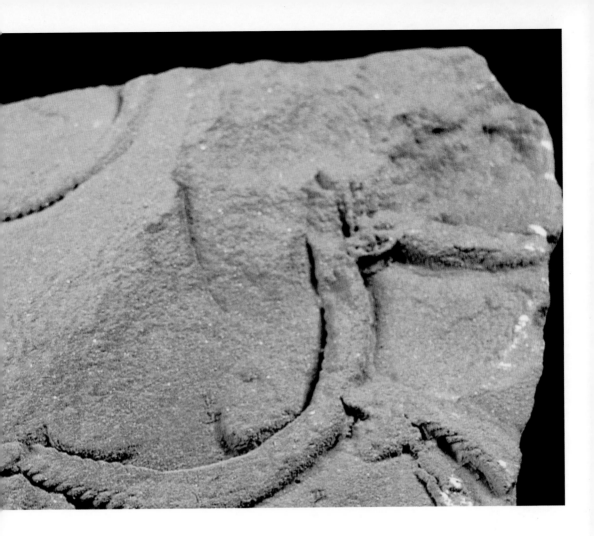

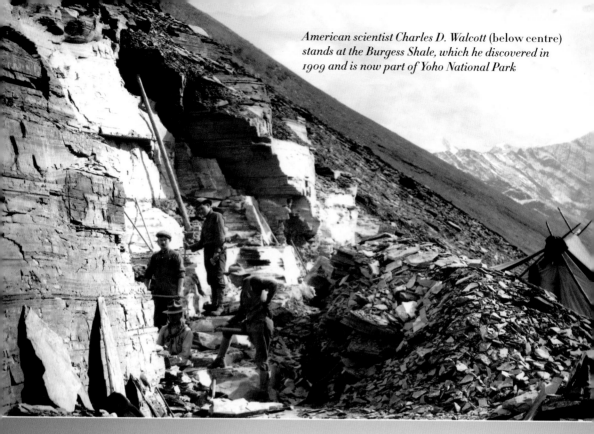

American scientist Charles D. Walcott (below centre) stands at the Burgess Shale, which he discovered in 1909 and is now part of Yoho National Park

About 545 million years ago the pace of evolution speeded up and complex life diversified dramatically, an event known as the Cambrian Explosion. Dramatic evidence of this event can be found in British Columbia's Burgess Shale, whose exposed layers of sedimentary rock, once the layers of mud deposited at the base of an ancient reef, offer a vast array of well-preserved soft-bodied fossils of early aquatic plants and animals. The causes of the explosion are unknown, but one theory argues that the rapid breaking apart of the continents suddenly created a host of new environments and myriad ecological niches waiting to be filled.

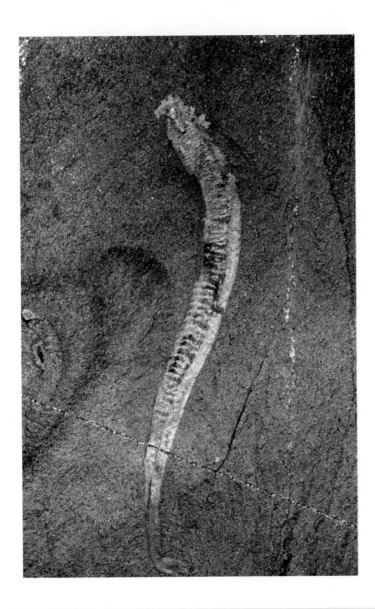

PRIMITIVE CHORDATE (*PIKAIA GRACILENS*), FOSSIL, 490–543 MILLION YEARS OLD

Burgess Shale, BC
shale
approx. 4.3 x 0.37 cm

Pikaia gracilens is the earliest member of the animal group to which humans belong – the chordates. This animal had gills (the human fetus has gill slits during its first weeks), a tail (we still have tailbones), and a cartilage-supported nerve rod running down its "back." It swam above the sea floor much like a modern eel, but with the additional aid of a tail fin. No one can say if this particular creature is a direct ancestor of human beings, but it resembles a living chordate commonly known as the lancet.

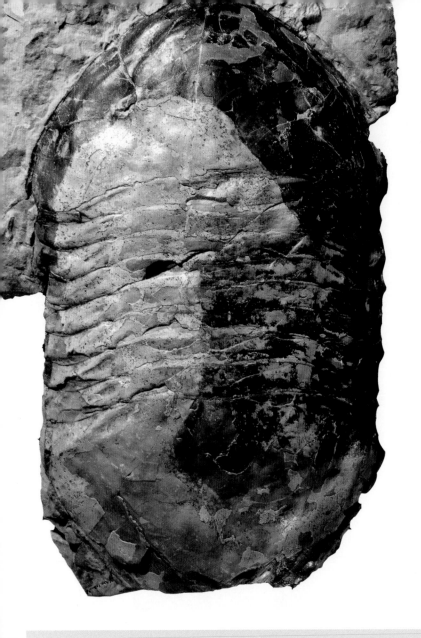

TRILOBITE (*ISOTELUS REX*), FOSSIL, APPROX. 445 MILLION YEARS OLD

near Churchill, Manitoba
sedimentary rock (dolostone)
and calcitic exoskeleton
approx. 70 x 40 cm

Before dinosaurs arrived on the prehistoric scene, trilobites were the dominant creatures. This fossil is about the size of a large serving tray – the largest trilobite ever discovered. It is at least seven times larger than the average such creature, which measured between 3 and 10 centimetres in length. Now extinct, this many-legged arthropod's closest living relative is the horseshoe crab, but it is part of the huge family of invertebrates that includes insects and spiders as well as crustaceans.

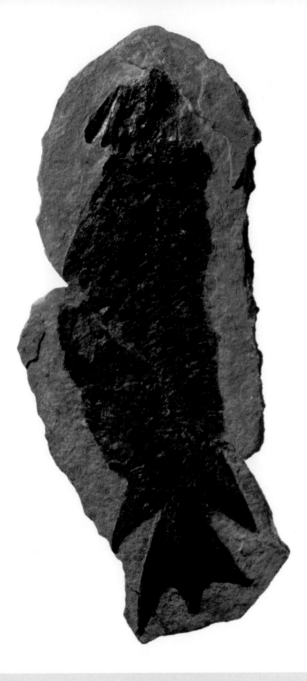

LOBE-FINNED FISH (*EUSTHENOPTERON FOORDI*), FOSSIL, APPROX. 365 MILLION YEARS OLD

Miguasha Provincial Park, Quebec
fossilized bone
fish, approx. 21.6 x 7.6 cm;
slab, approx. 24 x 12.7 cm

One of the most studied fossils in the world, this lobe-finned fish possessed lungs as well as gills, and limb-like fins. Fish like this were probably the ancestors of all four-footed land animals. Over millions of years its fins evolved into feet and its gills became less and less useful, until they no longer developed in adults.

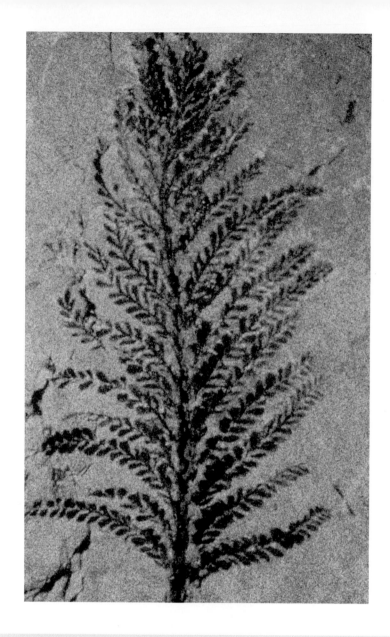

EARLY TREE (*ARCHAEOPTERIS HALLIANA*), FOSSIL, APPROX. 370 MILLION YEARS OLD

*Miguasha Provincial Park, Quebec
shale
approx. 30.5 cm x 20.3 cm*

The earliest land plants, which probably appeared during the late Ordovician period (about 440 million years ago), reproduced by means of single-celled spores, not seeds. Progymnosperms such as this one looked like modern conifers, with trunks more than 1 metre in diameter. Paleobotanists believe that the male and female spores these plants produced were the precursors of reproduction by means of seeds. Archaeopteris is often referred to as the "first modern tree."

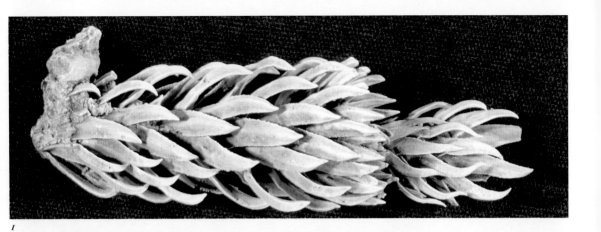

1

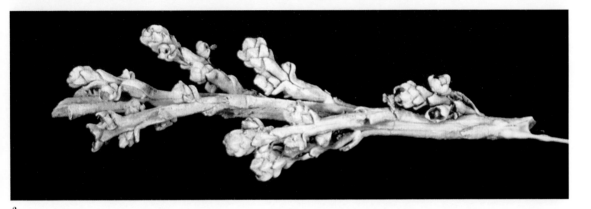

2

1 CONIFER (*CUNNINGHAMIA*-LIKE) BRANCH,
APPROX. 71 MILLION YEARS OLD

Drumheller, Alberta
ironstone and quartz
5 cm

2 *TAXODIUM* (SPECIES UNKNOWN) TWIG,
APPROX. 71 MILLION YEARS OLD

Drumheller, Alberta
ironstone and quartz
4 cm

Prehistoric reptiles lived in a world lush with plants. During fossilization, the organic material of these two ancient branches was replaced by amorphous quartz, which is the main mineral used in the formation of glass. They are so fragile that they would break at the slightest touch. Several other plant fossils found with them are the only known life forms to have been fossilized as "glass."

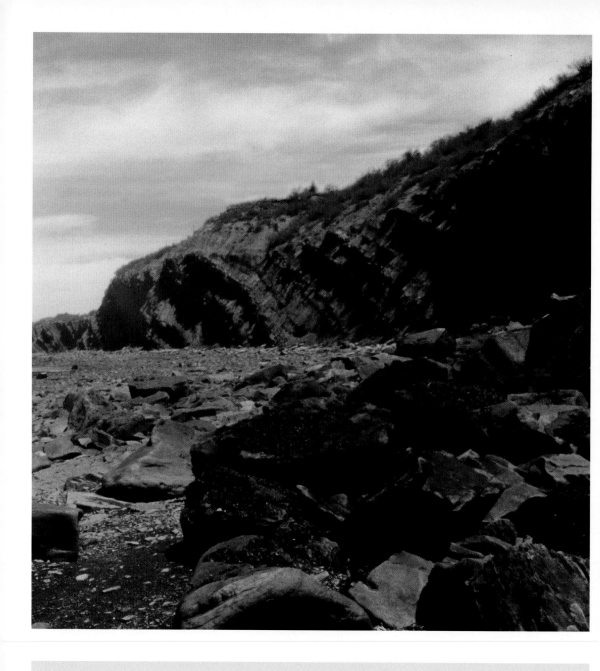

JOGGINS FOSSIL CLIFFS, 310–300 MILLION YEARS OLD

Joggins, NS
coal, siltstone, limestone,
and sandstone
approx. 23 x 10,000 x 2,500 m

The Joggins Fossil Cliffs offer a peek into life 286–350 million years ago, a time known as the Carboniferous period because of its abundant plant life and the vast coal deposits that resulted from them. These exposed cliffs on the Bay of Fundy have yielded fossils of the earliest animals that walked on land.

FIRST FOOTPRINTS
The Joggins Fossil Cliffs

I am walking on a beach of fossils, a rocky beach of many colours: brilliant orange, olive, taupe, many shades of grey, dark black. On my right, waves splash onto the shoreline as the sea advances up Chignecto Bay, at the head of the Bay of Fundy. I bend down to pick up a small grey stone with thin black lines scored into its surface – the imprint of a prehistoric leaf from a member of the genus *Cordaites*, a primitive conifer. Nearby, a large, flat, grey rock bears the print of two parallel tracks running 60 centimetres apart – evidence that a giant sowbug of the genus *Arthropleura* crawled along the floor of the steamy forest that covered this area of Nova Scotia 300 million years ago, during the Carboniferous period. I look up to the left at the cliff that towers above me, deeply scored by dramatic diagonal striations, layer on layer of prehistory eroded by the powerful Fundy tides – the Joggins Fossil Cliffs.

The cliffs' sandstone layers are among their richest, the source of spectacular lycopods, giant treelike ancestors of our club mosses. Joggins's lycopod stumps can measure up to 60 centimetres in diameter and close to 2 metres in height, and they have extensive root systems at their base. Equally impressive lycopods occur all over the world, but here they conceal even more significant fossils – evidence of the earliest animals ever to have walked on land.

These unique fossils were discovered in 1851, at a time when there was an explosion of interest in the fossil record and what it meant for the story of life on earth. Earnest experts in the new science of geology were busy chipping away at ancient rocks, arguing all the while whether their findings made nonsense of the biblical tale of God's creation. The standing fossil trees of Joggins had attracted geologists from the United States and Great Britain ever since they were first documented in 1829. An American visitor, Abraham Gesner, waxed lyrical about "the place where the delicate herbage of a former world is now transmuted into stone," and his description caught the eye of Britain's Sir

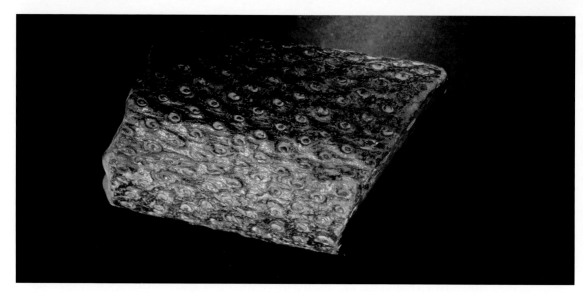

LYCOPOD TREE ROOT (*STIGMARIA FICOIDES*), 310–300 MILLION YEARS OLD

Joggins, NS
sandstone
approx. 20 x 30 cm

Today's club mosses, such as creeping cedar, are small evergreens that grow close to the ground, but during the Carboniferous period they grew as tall as modern trees. William Dawson found a fossil of the earliest reptile, *Hylonomus*, inside a fossilized trunk (actually a part of the root system of an ancient lycopod moss) similar to this one.

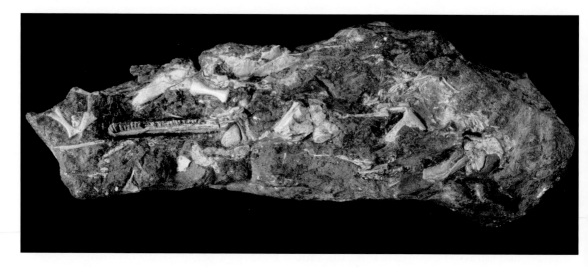

OLDEST KNOWN REPTILE (*HYLONOMUS LYELLI*), FOSSIL, 300–310 MILLION YEARS OLD

Joggins, NS
carbonaceous sediment
18.5 x 8.55 cm

One of the lizardlike fossils collected at Joggins by Charles Lyell and William Dawson in 1851. The short, stubby bones are leg bones, and the thin, curved slivers are ribs. *Hylonomus lyelli* looked very much like a modern lizard. It had a slender body and reached 20 centimetres in length, including the tail, and used its small, sharp teeth to feed on millipedes and insects.

Charles Lyell, author of *Principles of Geology* (1830–33), which had established the study of rocks as a science.

Lyell made his first fossil-hunting visit to the colony of Nova Scotia in 1842. "My dear Marianne," he wrote to his sister, "I went to see a forest of fossil coal-trees – the most wonderful phenomenon perhaps that I have seen." He returned nine years later, accompanied by a young assistant he had hired in Halifax, William Dawson, a Nova Scotian who had been studying in Edinburgh. (Dawson went on to become principal of McGill University and founder of the Royal Society of Canada.) The two men intended to make a detailed study of the fossilized trees. But close examination of the interior of the once-hollow stumps revealed something even more remarkable, the fossilized bones of two small vertebrate animals – an amphibian they named *Dendrerpeton* and an ancient reptile that Dawson later named *Hylonomus lyelli*, or "Lyell's wood mouse."

Both men understood instantly that the reptile fossils were something new and extraordinary. Dawson recalled Lyell, an arresting figure with mutton-chop whiskers and shiny black boots, ranting and gesticulating on the empty Nova Scotian beach. "I well remember," Dawson wrote, how "his thoughts ran rapidly over all the strange circumstance of the burial of the animal, its geological age, and its possible relations to reptiles and other animals, and he enlarged enthusiastically on these points, till, suddenly observing the astonishment of a man who accompanied us, he abruptly turned to me and whispered, 'This man will think us mad if I run on in this way.'"

Within weeks, Lyell and Dawson's discovery was an international sensation because of its bearing on the emotional debate between evolution and creation. In the early 1850s paleontologists had no accurate system of dating, but Lyell and Dawson could argue convincingly that the fossilized trees and the creatures within them predated the land formation of the Bay of Fundy area. If that were so, their discovery made nonsense of the story in Genesis that God created the land before the animals. Charles Darwin mentioned the Joggins Fossil Cliffs in his groundbreaking 1859 work, *On the Origin of Species*. In 1863 Dawson

published his own analysis of the find, entitled *Air-Breathers of the Coal Period.*

We now know that these tiny reptiles scurried along the ground of a tropical forest during the Carboniferous period, over 225 million years before dinosaurs frolicked on the Alberta Badlands in the later Cretaceous periods. Some of them found their way into the stumps of dead lycopod trees that had been killed during one of the regular floods in this area. The floods buried their bases in silt and smothered their roots. Later, their tops broke off and the interiors rotted away, leaving a hollow to catch small creatures. When the next flood came, the trapped tetrapods were drowned, then preserved in solidifying silt. In some cases the skeletons are complete; in others, they have been torn apart, perhaps by hungry later arrivals to the trunk. Fossilized droppings suggest that some of the animals may have survived within the stumps for some time. Up to seventeen skeletons have been found inside one lycopod tomb.

Other creatures are preserved inside the tree trunks too – tiny land snails and a small, articulated, wormlike creature. But it is the land-based vertebrates that still attract to Joggins paleontologists and geologists from all over the world, eager to read for themselves one of the earliest chapters in the story of life.

A scene from the Carboniferous period, shown on the frontispiece of Air-Breathers of the Coal Period *(1863) by J.W. Dawson*

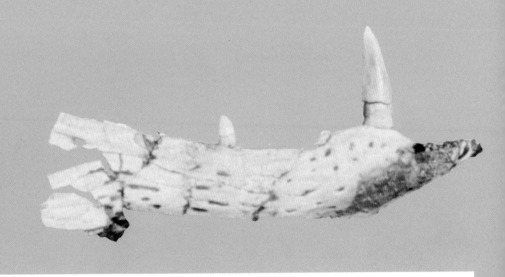

TRITHELODONT JAWBONE (SPECIES UNKNOWN), FOSSIL, APPROX. 205 MILLION YEARS OLD

Parrsboro, NS
permineralized bone
approx. 2.5 cm

About 200 million years ago, when dinosaurs were becoming the dominant land animals, this mammal-like reptile represented an important link in the chain of evolution from reptiles to mammals. The world's largest trove of *Trithelodont* bones has been found near Parrsboro, Nova Scotia, another spot along the Fundy shore where time and tides have exposed many layers of fossil-rich sedimentary rock.

From those first tiny lizardlike creatures discovered at Joggins, reptiles evolved into larger and larger species, including the dinosaurs, the largest creatures ever to live on land. The Age of Dinosaurs, which scientists call the Mesozoic era, lasted from roughly 245 to 65 million years ago, a time when land reptiles diversified into many other groups such as lizards, snakes, crocodiles, turtles, and a group known as "mammal-like reptiles." Dinosaurs that flourished in what is now Canada included *Tyrannosaurus, Triceratops,* and *Albertosaurus.*

Detail from an 1854 diagram by sculptor Benjamin Waterhouse of the full-size replicas of prehistoric creatures he was constructing at Sydenham Park near London

Chalk. *Wealden.* *Oolite.* (*Stonesfield Slate.*) *Lias.*

Pterodactyle. Iguanodons. Hylæosaurus. Megalosaurus. Taleosaurus. Plesiosa

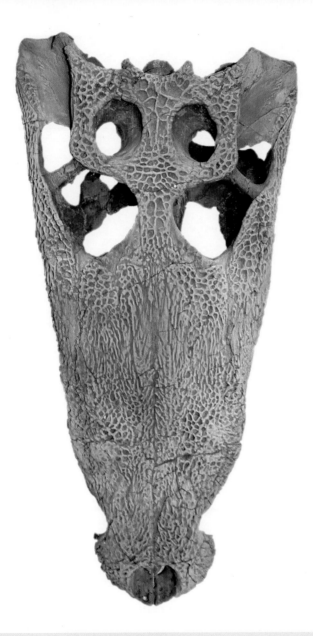

ALLIGATOR-LIKE SKULL (*LEIDYOSUCHUS CANADENSIS*), FOSSIL,
APPROX. 75 MILLION YEARS OLD

Dinosaur Provincial Park, Alberta
sandstone
36 x 20 cm

Crocodiles, alligators, and birds are the only survivors of the vast
and dominant group of animals known as *archosauria* (ruling rep-
tiles), whose most famous members were the dinosaurs. The group
included pterosaurs, plesiosaurs, and ichthyosaurs. This skull
belonged to an alligator-like reptile that lived in what is now
Alberta about 10 million years before the heyday of the giant
Tyrannosaurus rex.

PLESIOSAURUS (DOLICHORHYNCHOPS KIRKI), FOSSIL,
APPROX. 90 MILLION YEARS OLD

Treherne, Manitoba
shale
3.8 m

This fossil skeleton may look like a dinosaur, but it is a giant
marine reptile commonly called a plesiosaur, which ruled the
earth's ancient waters along with the mosasaur and the
ichthyosaur, or "fish-lizard." This plesiosaur swam in a vast sea
that once covered much of the interior of North America,
including large parts of Alberta, all of Saskatchewan, and most
of present-day Manitoba. There it likely preyed on fish and
squid-like belemnites, ammonites, and other invertebrates.

The dinosaurs, which dominated the biosphere for more than 150 million years, make the longevity of *Homo sapiens* look like an evolutionary footnote. Scientists classify dinosaurs into two main groups, "lizard-hipped" dinosaurs, whose pubic bones point frontwards, and "bird-hipped" dinosaurs, whose pubis faces the back. The latter group included plant-eaters like the "duck-billed" and armoured dinosaurs (including *Lambeosaurus* and *Triceratops*); the former included the fearsome carnivores (including *Albertosaurus* and *Tyrannosaurus*) and the other plant-eaters (including *Apatosaurus*, formerly known as *Brontosaurus*).

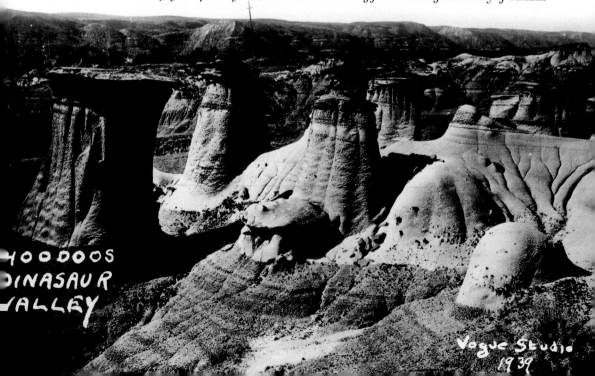

The hoodoos near Drumheller in the heart of Alberta's Badlands, where Canada's first dinosaur fossils were uncovered in 1884 by Joseph B. Tyrrell, while he was working for the Geological Survey of Canada

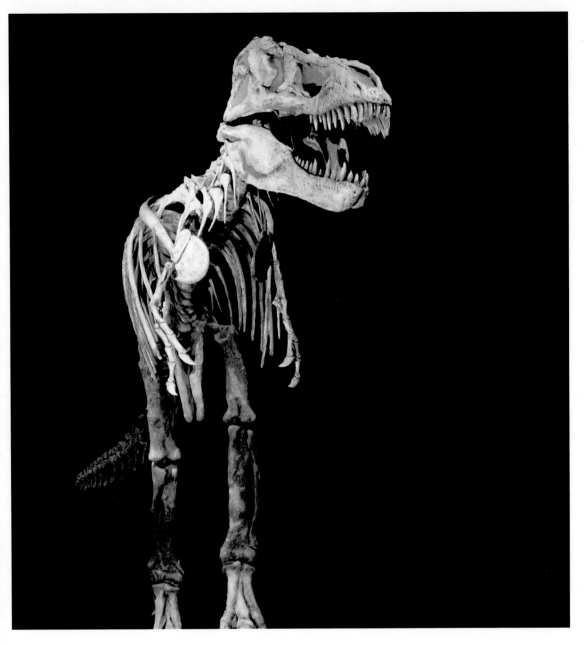

TYRANNOSAURUS (*TYRANNOSAURUS REX*), FOSSIL, APPROX. 65 MILLION YEARS OLD

Huxley, Alberta
sandstone
approx. 10.7 m

The name translates as "tyrant lizard king," and anyone who has stood next to the skeleton of a *Tyrannosaurus rex* will understand why this giant meat-eater still inspires so much awe. Its size (as tall as a giraffe) and its wicked-looking incisors make a terrifying impression. This example was discovered in the foothills of the Canadian Rockies. These "young" mountains, in geologic terms, are composed of sedimentary rock that was thrust upwards fewer than 65 million years ago, about the time the last of the dinosaurs were dying out.

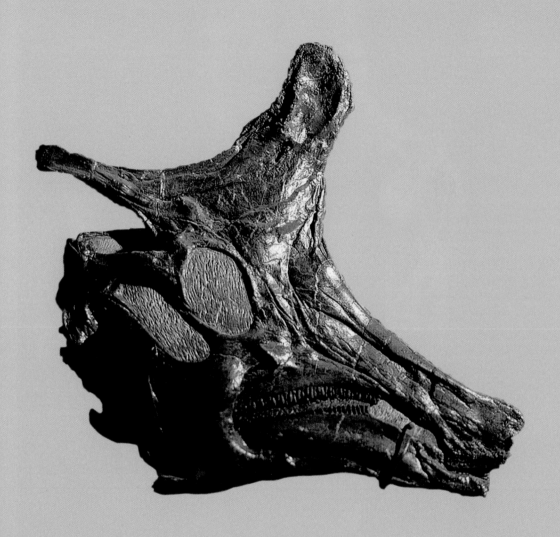

LAMBEOSAURUS (LAMBEOSAURUS LAMBEI) SKULL, FOSSIL, 72–75 MILLION YEARS OLD

Red Deer River region, Alberta
fossilized bone
approx. 70 x 76 cm

The *Lambeosaurus*, named after Lawrence Lambe, the father of Canadian vertebrate paleontology, is a species of duck-billed dinosaur, or hadrosaur. Some scientists think that its huge skull crest was connected to its nasal passage and used as a reverberating chamber in the production of sounds. The American dinosaur hunter Barnum Brown collected this skull during the 1910s.

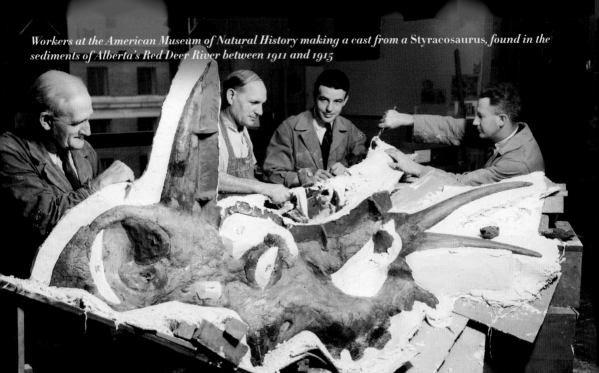

Workers at the American Museum of Natural History making a cast from a Styracosaurus, found in the sediments of Alberta's Red Deer River between 1911 and 1915

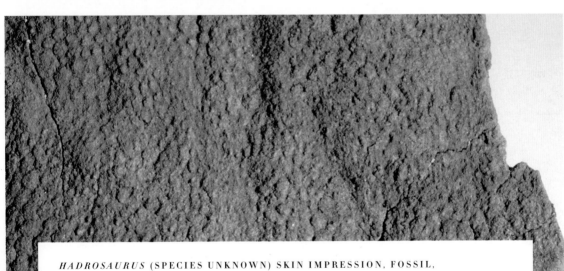

HADROSAURUS (SPECIES UNKNOWN) SKIN IMPRESSION, FOSSIL, APPROX. 70 MILLION YEARS OLD

Dinosaur Provincial Park, Alberta
sandstone
approx. 30 x 15 cm

Skin and other soft tissues are hardly ever fossilized, making this hadrosaur skinprint a rare glimpse of what this type of dinosaur actually looked like. We can only guess at the skin's original colour.

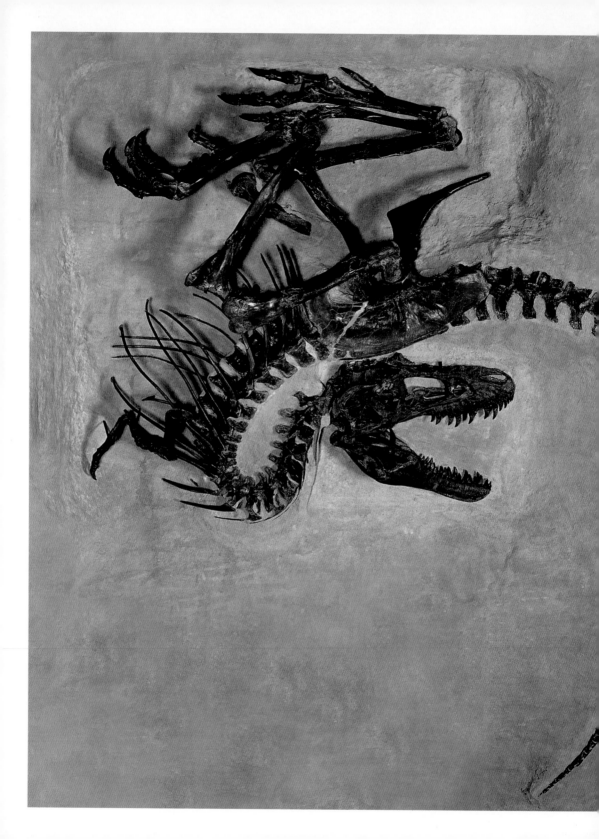

JUVENILE *ALBERTOSAURUS* (POSSIBLY *ALBERTOSAURUS LIBRATUS*), FOSSIL,
7 0 – 7 5 MILLION YEARS OLD

Dinosaur Provincial Park, Alberta
sandstone
5.1 m

This recently discovered juvenile *Albertosaurus* – a carnivore related
to *Tyrannosaurus rex* – rests with its long neck curved backwards in
what paleontologists call the death pose, a position caused by the
post-mortem contraction of the neck tendons. Complete skeletons
found in the same position they died in are extremely rare and highly
sought after.

For reasons still under debate, all the dinosaurs (except the birds) had disappeared by about 65 million years ago. Their extinction opened up all sorts of ecological space for other animals to occupy. The most successful at seizing this opportunity were the mammals, a group that first appeared about 220 million years ago, about the same time as the first flowering plants. As mammals took over all these vacant ecological niches, they diversified (though none grew as large as the largest dinosaur) and became more specialized. The Age of Mammals, which scientists call the Cenozoic era, had begun. It continues to this day.

BIRD (SPECIES UNKNOWN) FOOTPRINTS, FOSSIL, APPROX. 120 MILLION YEARS OLD

Peace River Canyon, BC
fine siltstone
footprint, approx. 8 cm (heel to central toe);
entire specimen, 180 x 120 cm

These footprints come from the Peace River Canyon trackway, the biologists' term for a series of imprints made by walking animals. This trackway is a priceless record of the earliest bird footprints ever found. Unlike other members of the dinosaur family, however, birds are still making footprints and have even adapted to life in cities. They are living links to our prehistoric past.

HALL OF ICE
80,000 years ago to 10,000 years ago

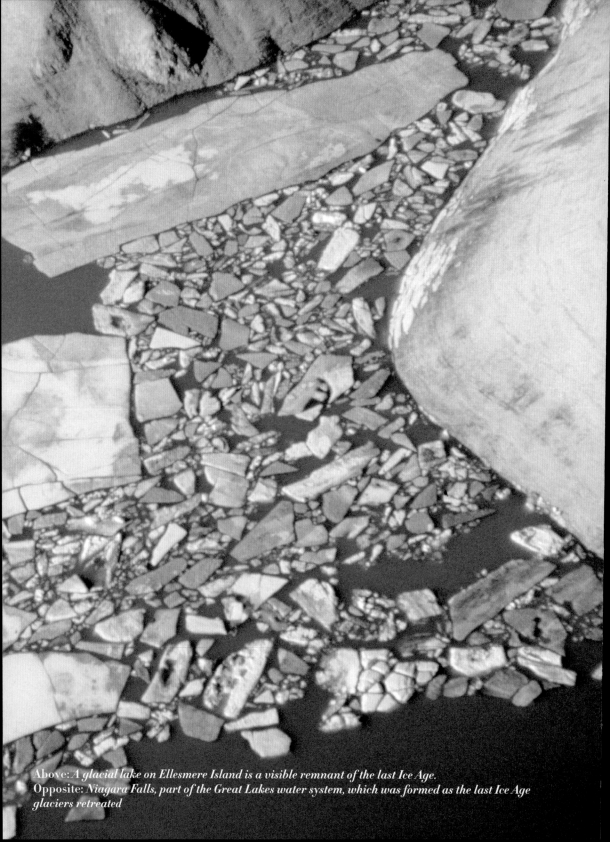

Above: *A glacial lake on Ellesmere Island is a visible remnant of the last Ice Age.*
Opposite: *Niagara Falls, part of the Great Lakes water system, which was formed as the last Ice Age glaciers retreated*

The last great ice cap – a vast and impenetrable ice sheet that covered most of the northern half of North America – formed about 30,000 years ago when a change in the earth's orbit caused the global climate to cool. The arrival of the ice marked the beginning of a time known to scientists as the Last Glacial Period and to the rest of us as the last Ice Age. For about 20,000 years this extensive layer of ice advanced and retreated, flowing like a slow-moving but massive body of water. The creeping ice scraped the earth's surface clean of younger rock, dropped layers of sediment as it moved, and often carried boulders several hundred kilometres from their place of origin. Torrents of glacial melt water formed many of the continent's valleys and water systems. The physical environment Canadians live in today remains a landscape shaped by ice.

FROZEN HISTORY
The Agassiz Ice Core and Other Glacial Secrets

Each of these plastic baggies, attached with wooden clothes pegs to a makeshift laundry line hung inside a tent, contains a sample of melted ice taken from the 100,000-year-old Agassiz Glacier on Ellesmere Island in the eastern Arctic. Some of this water is 3,500 years old. But what can it tell us about our prehistoric past? The contents of these innocent-looking bags can reveal fascinating information about contemporary climate change.

Take a look at a map of North America during the last Ice Age – the Pleistocene period, about 1.5 million to 10,000 years ago. Several times over this period a vast expanse of ice, split in two by the Rockies, stretched from the Atlantic Ocean to the Pacific and from the Arctic Islands to, roughly, the present Canada–U.S. border. Glaciers are our scientific link to that era. Apart from Greenland and Antarctica, twenty-first-century Canada contains the largest area of permanent ice in the world. The deepest levels of ice in the Agassiz Glacier, which is more than 200 metres thick, were once part of that glistening Ice Age shroud.

A glacier begins its life as an annual snowfall, not all of which melts. (The metre of snow that now falls on Agassiz each year rarely disappears completely in the Arctic summer.) Each subsequent snowfall adds weight that, over time, compresses the lower layers into ice crystals. And each layer of ice is unique. "Melted glacial ice is purer than distilled water," according to Dr. Fritz Koerner, a glaciologist with the Canadian federal government, "yet you can learn a lot from it." From an analysis of the ice slices they take, scientists can determine the temperatures at which the various layers in a glacier were formed, and these temperatures correlate to weather patterns in the year the snow fell. Analysis becomes more difficult as the ice layers get older and thinner.

Dr. Koerner is one of a handful of glaciologists – they tend to be bearded, intense, and extremely fit – who have been studying the Agassiz Glacier since the 1960s. Every spring, as the Arctic darkness lifts but before the snow becomes too

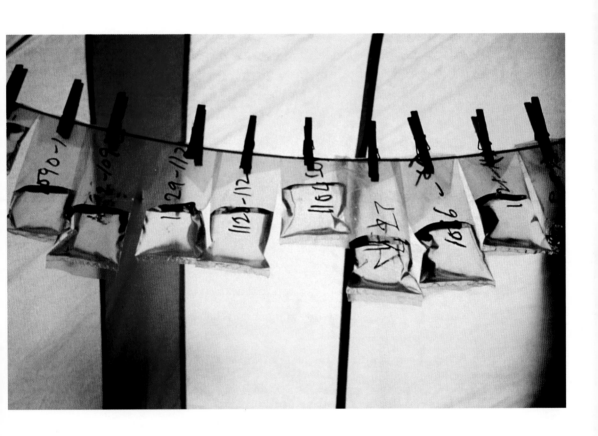

MELTED ICE SAMPLES, APPROX. 3,500 YEARS OLD

Ellesmere Island, Nunavut

The farther down you drill on an ice cap, the older the ice. These samples were taken in 1984 at a depth of 115 metres. Each bag represents a distinct ice layer (the number is keyed to information identifying the precise layer the sample came from). Ice caps, dome-shaped masses of glacier ice, are much larger than icefields. They spread outwards in all directions and cover as much as 50,000 square kilometres.

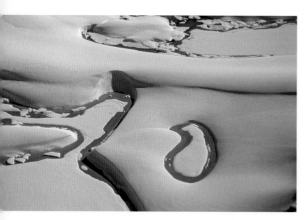

From the air, the Agassiz Ice Cap gives a glimpse of how most of Canada looked during the last Ice Age.

slushy to land a ski plane, he and his colleagues fly up to Ellesmere Island, pitch their tents, and drill deep into the glacier. They spend about six weeks removing cores of ice that are around 15 centimetres in diameter and as much as 200 metres long. Before it can melt, the core is sliced like a sausage into as many as 5,000 pieces, and each slice is carefully bagged and labelled to record its position on that core. To a glaciologist, the contents of those little bags read like a history book: the farther down the glacier the sample comes from, the older the ice.

Ice samples from the Agassiz and many other glaciers enable glaciologists to study long-term climate trends over thousands of years, providing an antidote to the sensationalism about melting polar ice caps that often erupts in debates about global warming. "The world warmed up quite fast at the end of the last Ice Age," Dr. Koerner observes. "Then it took about 10,000 years to cool off again, and it started warming up once more about 150 years ago. The next Ice Age will begin in about 5,000 to 10,000 years."

There have been significant fluctuations within this broader warming, cooling, warming pattern. Charts of Canadian weather over the last few millennia look like the graphs that track the Canadian dollar over the past couple of decades: there are dramatic peaks and troughs within long-term trends. About 9,000 years ago, temperatures were even warmer than they are today. Another warm period occurred in 800–1000 CE, when the early civilization of Iceland flourished, and the Vikings settled in Greenland. Temperatures were much cooler in the Little Ice Age, lasting from around 1700 to 1850. One reason why Sir John Franklin failed to find the North-West Passage was that his small wooden ships were battling some

of the coldest Arctic summers (and the thickest sea ice) of the previous seven centuries.

The core samples from the Agassiz Glacier hold other secrets too. A glacier is a museum of past atmospheres, because each layer of frozen snow contains minute traces of dust, pollen, and soluble pollutants, such as sulphur, that were in the air as the snow fell. Using special analysis techniques to

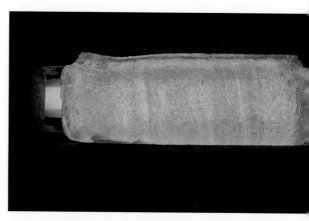

This ice core sample, 3,500 or more years old, was taken 115 metres into the Agassiz Ice Cap.

measure infinitesimal amounts of sulphuric acid in the water in those bags, glaciologists can deduce the approximate dates of volcanic eruptions. At Agassiz they've found evidence of Iceland's Laki volcanic eruption in 1783 and Indonesia's Krakatoa in 1883.

More recent ice layers show traces of radioactive fallout from the atomic bombs dropped on Hiroshima and Nagasaki in 1945 and from the nuclear tests of the 1950s. The ice that accumulated during the first half of the twentieth century confirms the sharp rise in the atmosphere of industrial pollutants from smoke-stack industries. In the glacial ice from Baffin Island, south of Ellesmere Island, the sulphates and nitrates start to surge in the early 1900s. In the Agassiz ice, however, the rapid increase doesn't occur until the 1940s. This evidence suggests to Dr. Koerner that the Baffin ice follows the chronology of North American industrialization, while the Ellesmere ice reflects the earlier industrialization of Britain, France, and Germany, whose industrial pollutants have blown over the North Pole via Russia.

These bags of glacier ice confirm that human behaviour affects the global climate. But Dr. Koerner takes the longer view: "The planet will simply continue on its own messy way until the onset of the next Ice Age."

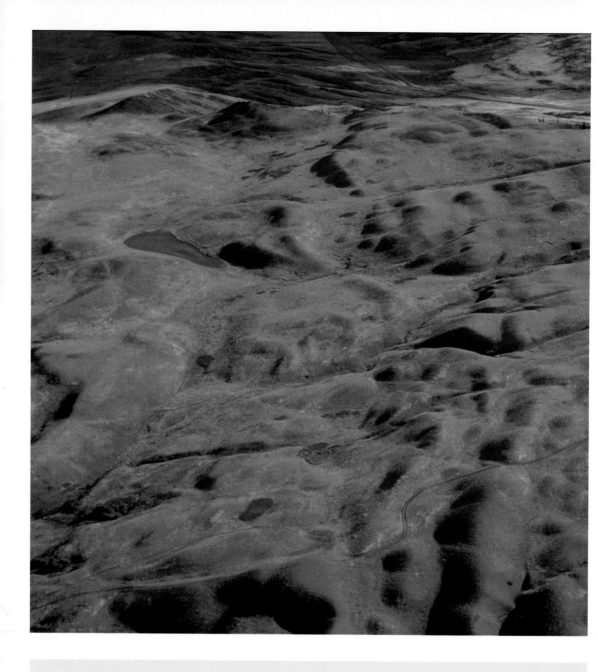

MORAINAL DEPOSITS, 10,000–12,000 YEARS OLD

Cypress Hills, Saskatchewan glacial till (clay, silt, sand, gravel, and boulders)

The undulating terrain of the Cypress Hills in southwestern Saskatchewan and southeastern Alberta comes from a series of 15,000-year-old morainal ridges, land formations composed of glacial till deposited when a glacier paused during its retreat. Once you train your eye, you can see Ice Age landmarks – moraines, eskers, drumlins, and erratics – all over Canada.

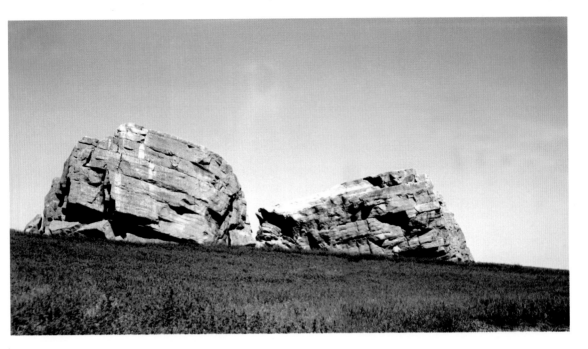

"BIG ROCK," DEPOSITED 10,000–12,000 YEARS AGO

Okotoks, Alberta
quartzite
approx. 9 x 40 x 18 m

This dramatic rock formation was once a single erratic, a massive boulder transported by ice to Okotoks from what is now Mount Edith Cavell in Jasper National Park, 480 kilometres northwest of its present location. If you look closely at the layers, you see they are composed of hardened layers of sand, silt, and small pebbles, evidence that this erratic is part of the same rock formation as Mount Edith Cavell – layers of sedimentary rock laid down more than 500 million years ago. The bigger of the two pieces is the largest known glacial erratic in the world and one of thousands of rocks in a 644 kilometre chain called the Foothills Erratic Train.

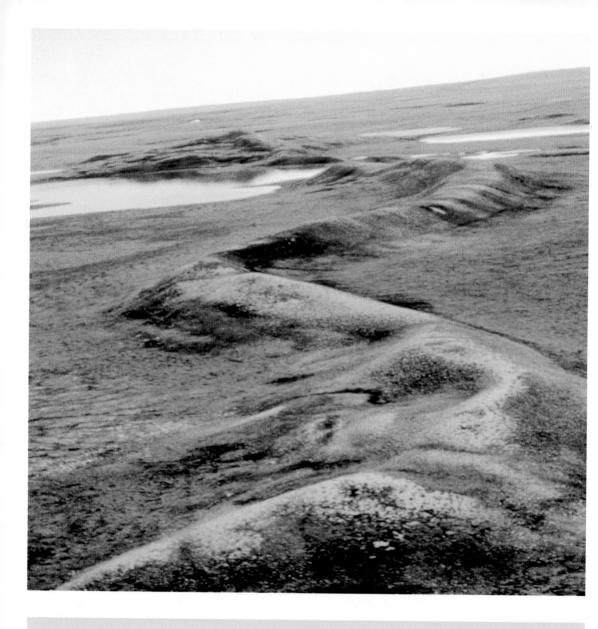

THELON ESKER, 10,000–12,000 YEARS OLD

Mackenzie, NWT
sand and gravel

As glaciers retreat, rivers of meltwater form on the surface and sometimes in tunnels beneath the ice. Once a glacier has disappeared, meltwater leaves behind coarse sediment in deposits called eskers. The Thelon esker runs for almost 800 kilometres and straddles the border between the Northwest Territories and Nunavut. It is the largest esker in Canada and one of the most dramatic remnants of the last Ice Age.

DRUMLIN, 10,000–12,000 YEARS OLD

Gaetz Head, NS
glacial till

Drumlins resemble eggs that have been sliced lengthwise and placed flat-side down. They are formed of glacial till from under a glacier, parallel to its direction of flow. These ellipsoidal hills measure up to 50 metres in height and several kilometres in length. Drumlins occur in every Canadian province and territory and are usually found in swarms, or large groups. Swarms consisting of several thousand drumlins can be seen in southern Ontario, the Thelon Plain of the Northwest Territories, Nunavut, and Nova Scotia.

Several of those animals that had survived the Pleistocene deep-freeze gathered in glacier-free areas of land, where many grew to enormous size. Now-extinct species including the mastodon, the giant beaver, the giant bear, and the giant moose thrived in wooded regions, while close relatives of animals that still live in Africa, including the camel, the lion, and the elephant, roamed the grasslands of North America. Paleozoologists and paleoecologists still speculate why these creatures grew so big and what caused them to disappear.

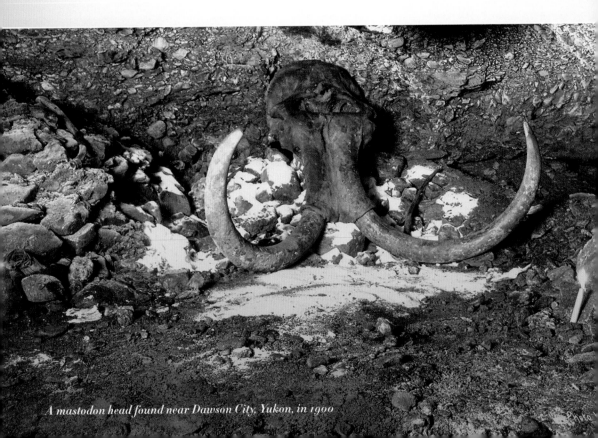

A mastodon head found near Dawson City, Yukon, in 1900

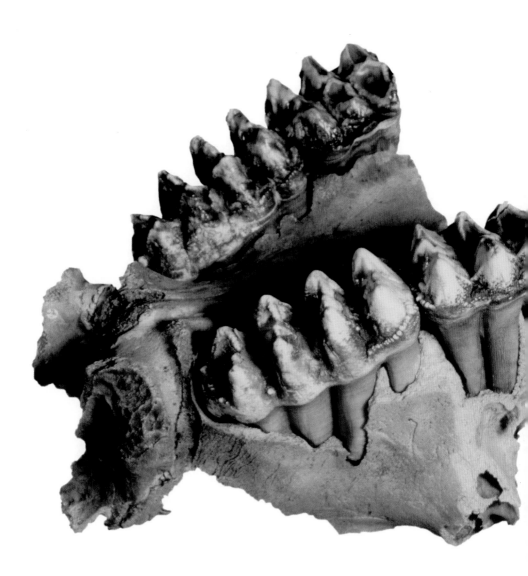

MASTODON (*MAMMUT AMERICANUM*) PALATE, FOSSIL, 70,000–80,000 YEARS OLD

East Milford, NS
partially fossilized
bone and teeth
16.5 x 30 x 30 cm

The East Milford mastodon, uncovered in 1991, is one of the most complete mastodon skeletons ever found in Nova Scotia. This palate contains four of the mastodon's massive molars – each with a cone-shaped cusp on an enamel-covered crown – ideal for chewing leaves and branches gathered by their trunks. Mastodons, which looked like long, squat elephants, died out about 9,000 years ago.

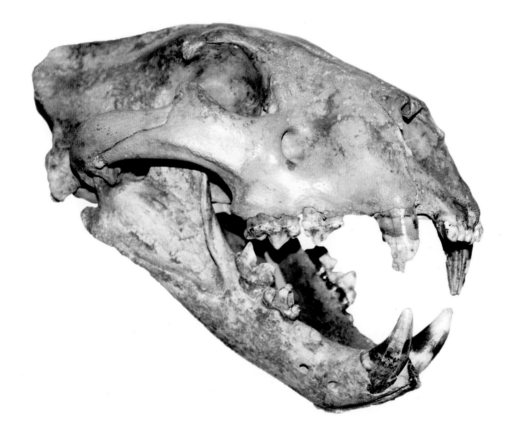

AMERICAN LION (*PANTHERA LEO ATROX*) SKULL, APPROX. 20,000–40,000 YEARS OLD

near Dawson City, Yukon
fossilized bone
size unavailable

The American lion, which roamed America's grasslands for about 50,000 years, was one of the largest flesh-eating land animals to live on this continent during the Ice Age. The lions ranged from Alaska and Yukon in the north as far south as Peru. They hunted bison and other herbivores but died out about 10,000 years ago, probably as a result of the disappearance of their plant-eating prey. They were roughly 25 percent larger than today's African lion. An adult American lion would have weighed as much as 235 kilograms, and a female as much as 175 kilograms.

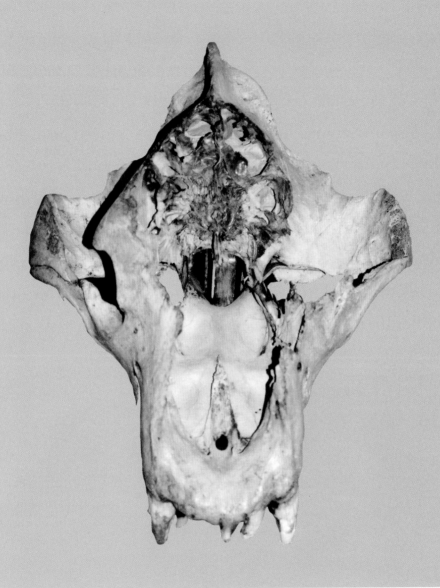

SHORT-FACED BEAR (*ARCTODUS SIMUS YUKONENSIS*) SKULL, APPROX. 26,000 YEARS OLD

Dawson City, Yukon
fossilized bone
57 x 36 x 24 cm

From about 70,000 to 10,000 years ago, the most powerful land predator in North America was the short-faced bear. This skull, the largest ever found, was discovered by a Yukon gold miner. It belonged to a species that once ranged the Ice Age grasslands stretching from Alaska to Mexico. A smaller, lighter relative flourished in the woodlands of Atlantic coastal areas. Mainly a flesh-eater, this bear likely preyed on bison, deer, and horses.

When did the first human beings arrive in North America? The evidence suggests it may have been as far back as 30,000 years ago, when the Pleistocene ice sheet still covered most of Canada. But even if they came as recently as 12,000 years ago, how did they get here? The conventional theory held that they crossed from Siberia across the Bering land bridge and then moved southward along ice-free corridors. But Canadian scientists have recently offered convincing evidence that no such corridors existed early enough to account for the human presence. Perhaps Canada's first inhabitants migrated northward from South and Central America. However they came, after their arrival, the Ice Age mammals began to disappear.

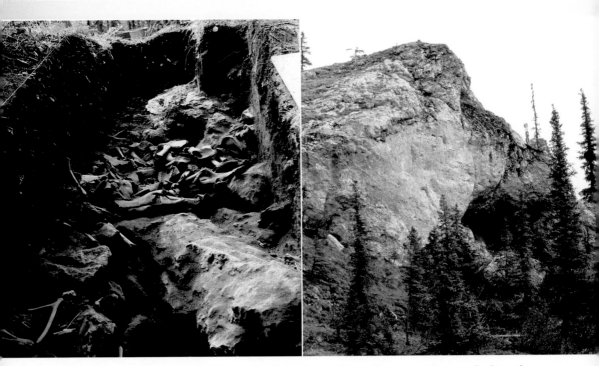

Above left: *A bone bed at the Bluefish Caves, discovered in 1978 on a limestone ridge overlooking the Upper Bluefish River in northern Yukon.* Above right: *These caves are the site of the oldest human artifacts found in Canada.*

MAMMOTH BONE CORE (LEFT) AND FLAKES (RIGHT), FOSSILS, 10,000–25,000 YEARS OLD

Bluefish Caves, Yukon
long bone
core, approx. 29 x 14 cm;
flakes, approx. 7–10 x 3–5 cm

These sharp-edged bone flakes were likely used by Ice Age hunters. If this is true, these tiny bone shards are some of the oldest evidence of the human presence in what is now Canada. Early human beings in Eurasia and in North America hunted the woolly mammoth for its meat and its thick layer of nourishing fat.

PALEOINDIAN STONE SPECIMENS, APPROX. 10,600 YEARS OLD

Debert, NS

1 PROJECTILE POINT OR KNIFE

chalcedony
7.3 x 2.7 cm

2 KNIFE OR PREFORM (UNFINISHED FLINT OBJECT)

chalcedony
14.5 x 7.6 cm

3 KNIFE OR PREFORM

brecciated chert
15.7 x 5.3 cm

4 PROJECTILE POINT

chalcedony
4.4 x 2.6 cm

5 PROJECTILE POINT

brecciated chert
10.9 x 3.5 cm

6 PROJECTILE POINT

chalcedony
5.5 x 2.7 cm

7 PROJECTILE POINT OR KNIFE

chalcedony
6.4 x 2.8 cm

8 GRAVING IMPLEMENT

chalcedony
2.4 x 2.1 cm

9 DRILL/KNIFE

brecciated chert
4.7 x 1.8 cm

Only through the patient and painstaking work of archaeologists, who have learned to read whole cultures in a few fragments of bone and stone, can we dimly imagine the world of Canada's earliest human inhabitants. They left no buildings, no monuments, no burial mounds. But traces of their distinctive stone tools have been found in many parts of Canada: projectile points that were fixed to the ends of weapons for hunting prey; and knives, preforms, drills, and graving implements used for shaping wood and working hides.

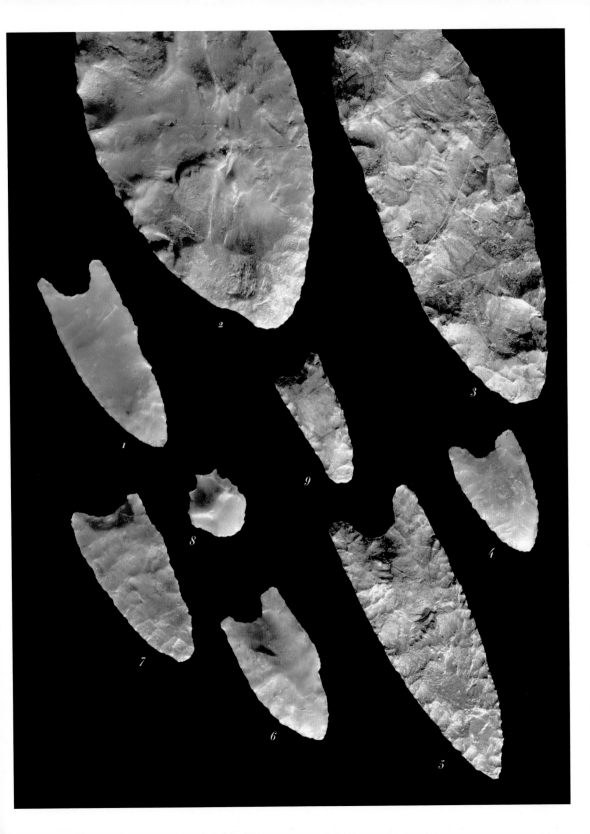

FIRST PEOPLES ROOM
3,500 years ago to 1878

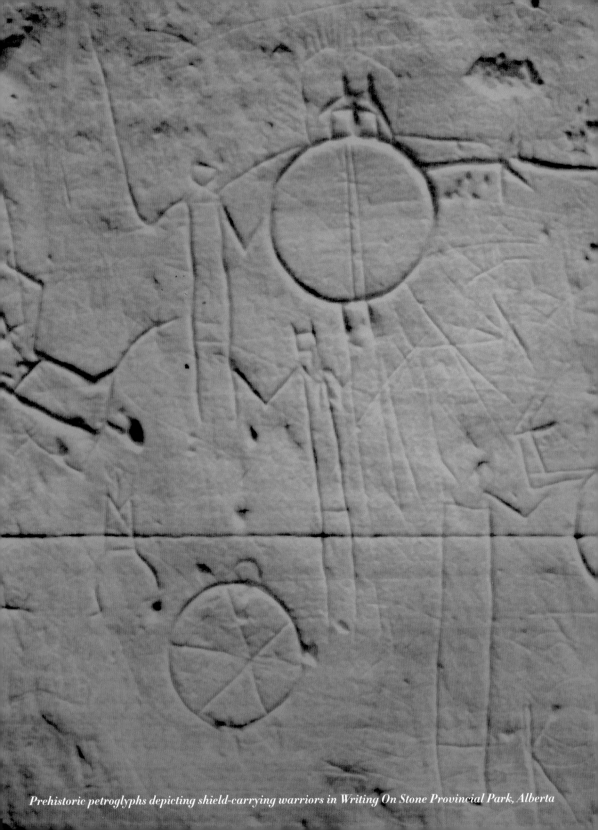

Prehistoric petroglyphs depicting shield-carrying warriors in Writing On Stone Provincial Park, Alberta

Archaeologists refer to the original North Americans as Paleoindians. As the ice sheets receded, these peoples populated the northern half of the continent and gradually separated into distinct cultural and linguistic groups shaped by the characteristics and challenges of the environments they lived in. West Coast peoples developed cultures intricately connected to the sea and its abundance. People of the plains were big-game hunters, just like their counterparts in the African savannahs. Inhabitants of the subarctic adapted to the annual migrations of the vast herds of caribou across the Barren Grounds. Eastern forest dwellers used lightweight birch-bark canoes to develop extensive trading systems, while those who lived in the fertile valley of the St. Lawrence became Canada's first farmers. Eastern coastal dwellers harvested the bounty of the local seas. Since Canada's first peoples left no written records and few pictorial ones, this room traces their history through objects they made before their first contact with Europeans.

Distinctive cultures emerged along the Pacific northwest coast and its interior plateau about 11,000 years ago. Subsequently they developed into one of the most linguistically diverse and artistically advanced First Nations groupings in what is now Canada. The plentiful resources of the sea, lakes, and rivers of the Pacific northwest coast allowed most of the people to live in permanent settlements. There they developed sophisticated social systems and evolved complex mythologies, which became the basis for their extraordinary works of art. Their descendants, including the Tlingit, the Haida, the Nootka, and the Kwakiutl, still live along Canada's Pacific coast.

Fraser Reach, near Butedale, on British Columbia's central coast

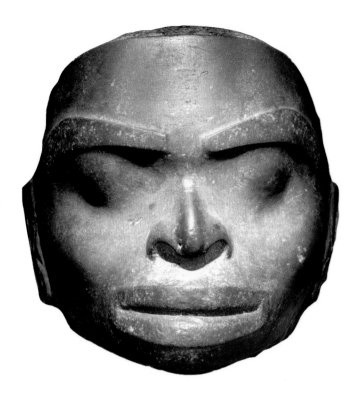

TSIMSHIAN MASK, BEFORE 1878

Kitkala or Port Simpson, BC
soapstone, iron oxide,
and copper oxide
24 x 22.5 x 18.2 cm

Anthropologists believe that this mask was used in the Tsimshian Naxnox ceremony as part of an enactment of their creation myth, which tells how light came to the world and how vision came to human beings. The mask here is one of a pair, but the two have unfortunately been separated. So we must imagine a second mask very much like this one, but with the eyes open. During the Naxnox ceremony, a dancer concealed the "open-eye" mask, which he held in place by biting on a wooden mouthpiece, behind the "closed-eye" mask, which he held with one hand. At the dramatic point when Raven, also known as "Thief," steals the sun and releases it over the Nass River of northern British Columbia to illuminate the dark world, the dancer removed the unsighted mask and, literally and metaphorically, opened his eyes to the light.

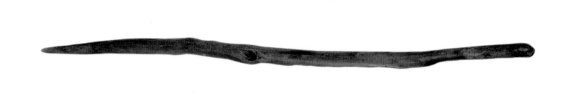

TSIMSHIAN CLAM-DIGGING STICK, APPROX. 2,000 YEARS OLD

near Prince Rupert, BC
wood
approx. 70 cm

The people who inhabited the north coast area of British Columbia, where the Tsimshian now live, used sticks to dig for clams – a staple of their diet. Because these sticks were made of wood, this example is rare. It owes its survival to the unusual circumstance that the Lachane site where it was found remained water saturated and bacteria free.

Salmon spawning in northwestern British Columbia

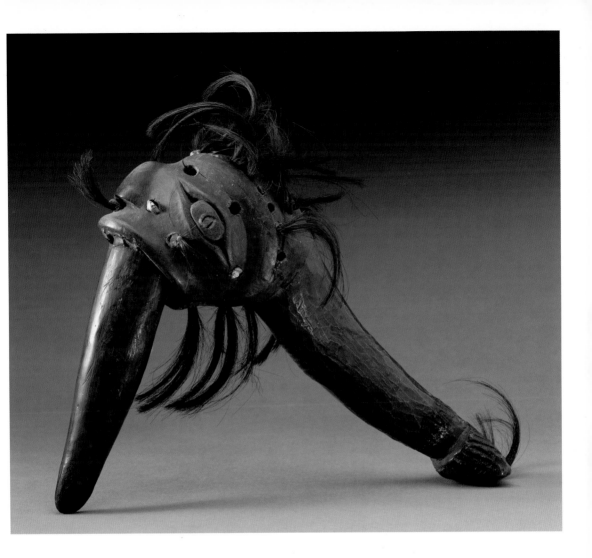

CLUB, BEFORE 1778

Nootka Sound, BC
wood with stone blade,
sea otter teeth, and human hair
31 x 26.5 x 11 cm

This menacing club was probably not used in combat but as a status emblem for a hereditary chief, whose authority and war-readiness it embodied. A stone blade that resembles a grotesquely swollen tongue protrudes from the club's mouth. No one knows how long such ceremonial objects were in use, but, by several centuries ago, hierarchical chiefdoms were well established among many West Coast peoples, including the ancestors of the Nuu-Chah-Nulth (Nootka).

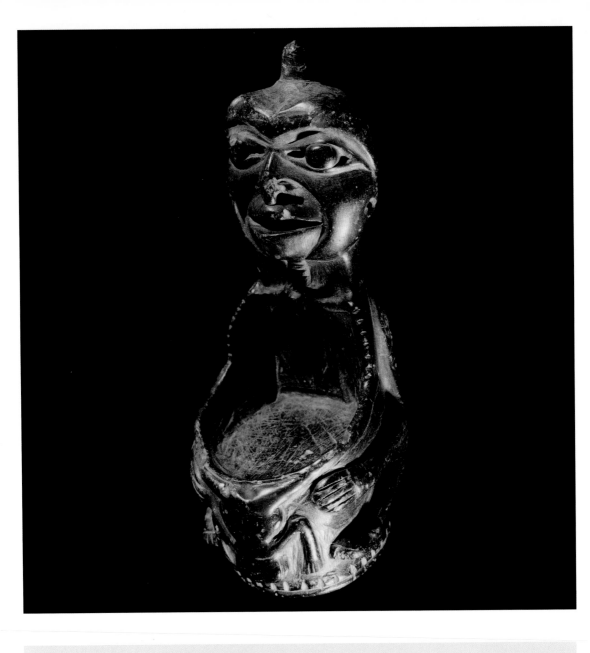

SEATED HUMAN FIGURE BOWL, APPROX. 200 CE

Fraser Valley, BC
steatite (soapstone)
14.9 x 6.3 x 8.1 cm

This type of seated-figure bowl has been found repeatedly in the
Northwest Coast and plateau regions (this one came from the area
where the Coast Salish live today). It may have held holy water for a
shaman hoping to obtain visions or, possibly, it was used in female
puberty purification rites. The human figure holding the bowl
presumably represents a shaman; the peg at the top of the head may
have anchored a "wig" of cedar bark or human hair.

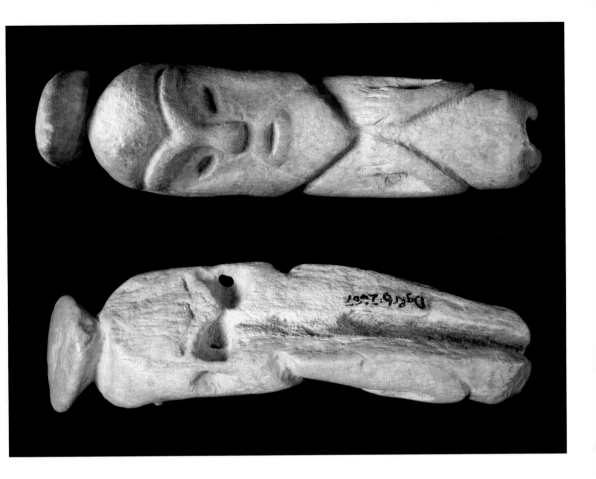

CARVED TOOL HANDLE (TOP: FRONT VIEW; BOTTOM: BACK VIEW), APPROX. 2,500 YEARS OLD

Greater Vancouver, BC
antler
approx. 4.8 x 10.7 cm

The slot carved into the back of this handle allowed for the insertion of a cutting edge, perhaps a beaver tooth, which would have turned it into a wood chisel. The figure may represent a spirit who aided those who carved in wood.

MYSTERY CARVINGS
The Yuquot Whalers' Shrine

I stare past the foreground tangle of salal bushes into forbidden depths, trying to "read" the meaning of this place. Human forms stare back at me, but they are sightless, armless, silent. Four figures stagger towards me, while at the back of the hut stands a line of wooden forms. Each carving has an unnerving individuality: some have open mouths as if singing, a couple smile secretly, one appears to groan in pain, another thrusts his penis forward. A carved whale and five human skulls lie at their feet. On the right, a bright glow illuminates a skull apparently suspended in mid-air. The Yuquot Whalers' Shrine is a place of almost tangible power and extraordinary mystery.

Yet it is a place we can visit today only by means of a photograph. On the small island off the west coast of Vancouver Island where the shrine was originally erected by the Mowach'ath band of the Nuu-Chah-Nulth (Nootka) people, all that now remains is a small patch of grass. Just after the turn of the nineteenth century the shrine was sold, dismantled, and sent to New York City. Since then, these strange sightless figures, whale carvings, and puzzling human skulls have been confined to packing cases in a storage room at the American Museum of Natural History on the island of Manhattan.

I wish I could visit it as it was in 1903, the year George Hunt took this photograph. Hunt, who had a European father and a West Coast native mother and who spoke Kwakwala (Kwakiutl), was interested in the shrine because he worked for the well-known anthropologist Franz Boas. But even Hunt would not have been able to tell me what the shrine meant, because he did not understand the Mowach'ath language. So I stare at the photograph, baffled by questions for which there are no answers.

Why, for example, do these carved figures look so different from the familiar First Nations art of the Northwest Pacific Coast, with its highly formalized designs characterized by flowing curvilinear lines, a colour scheme dominated

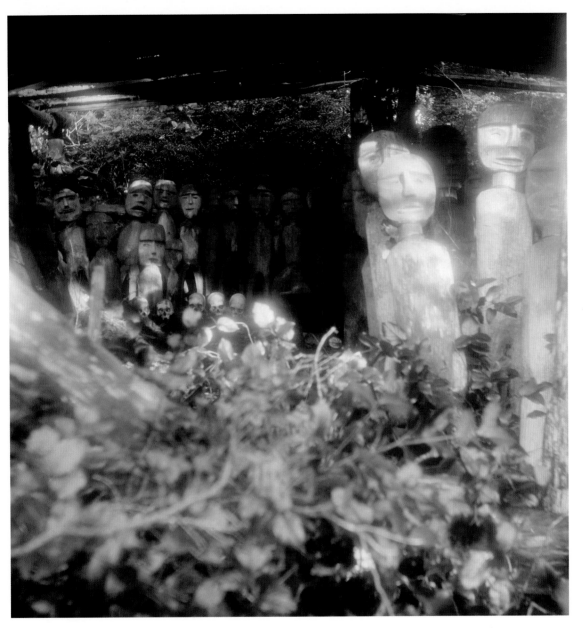

YUQUOT WHALERS' SHRINE, APPROX. 1650

Yuquot, BC;
contents acquired by
American Museum of Natural History in 1905
wood and human bone
92 carved wooden figures and whales
(approx. 10–100 cm long;
a few are approx. 59–153 cm long),
16 human skulls, and a small building

Before embarking on a whale hunt, chiefs of the Mowach'ath people of Nootka Sound visited this shrine to conduct rituals they believed would bring them success. This photograph was taken shortly before the shrine was sold to George Hunt, a collector working for the anthropologist Franz Boas. After its sale, the shrine was dismantled and sent to the American Museum of Natural History in New York City, where it currently resides in storage.

by black and red, and iconographic treatment of creatures such as the raven, beaver, and whale that loom large in their mythology? These eighty-eight sightless and impassive carved figures seem closer to Polynesian statues than to the elaborate totem poles or bulbous face masks of the Nuu-Chah-Nulth's neighbours. Who made these strange carvings? And what happened in this eerie place?

James Cook, who "discovered" the shrine in 1788, and later European visitors came up with few answers. One of Cook's men described the shrine as an overgrown "slovenly" temple with a handful of carved figures inside, in forlorn contrast to the thriving fishing village of three or four hundred inhabitants nearby. But the shrine was already a sacred place, forbidden to all but the chief. Villagers refused to go near it.

Thirty years later a French explorer named Camille de Roquefeuil visited a much more elaborate shrine on the site, by then called a "burying place." He counted five rows of statues and eight skulls, which implied there had been at least eight generations of whaling chiefs since the shrine had been built. (Aldona Jonaitis, author of the definitive book on the shrine, suggests that it originated in the mid-seventeenth century and was at least 160 years old in 1817.) De Roquefeuil underlined the shrine's mystical powers and Mowach'ath leader Chief Maquinna's success in promoting them. "The chiefs alone have the right to enter the cemetery, and [Maquinna] has killed those whom he knows to have been there....When [Maquinna] catches a whale, he goes in the night to tche-ha to render homage to the sun for the success of the day and to offer to his ancestors a part of his prey."

Whaling artifacts more than one thousand years old have been uncovered in archaeological digs at Yuquot, some of the earliest evidence of whaling found anywhere in the world. The Mowach'ath people fed on dead whales that washed up on their beaches, and they also paddled far out into the Pacific Ocean in open canoes to harpoon humpbacks. Their oral tradition relates the potent rituals surrounding whaling, which for the chief included lengthy

periods of sexual abstinence, frequent bathing in chilly streams, and invocations to the bones of his illustrious ancestors.

Once a whale was sighted at sea, the chief made the first strike. He must have been a magnificent sight, standing in the prow of his eight-man canoe, harpoon at the ready. After it had been killed, a lowly crew member got the job of jumping into the cold water and stitching closed the whale's mouth, so the massive carcass would not sink. The hunt was rarely successful, according to one early European observer – but that wasn't the point. It was an exercise of power and ceremony. And as Chief Maquinna explained to de Roquefeuil, the Whalers' Shrine played an important part in reinforcing his power.

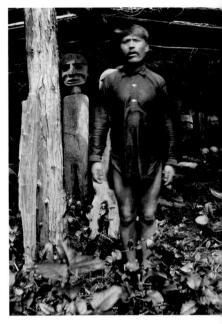

George Hunt's photograph of a singing Sesakhalas, one of the two Mowach'ath chiefs who "sold" him the Whalers' Shrine in 1904

Apart from Cook's and de Roquefeuil's accounts, the only other clues to the shrine's meaning come from George Hunt, who described in a letter to Franz Boas how he gained access to it. "They Brought a sick man to heleka or to get the sickness out of him for they say that I could not go to see the Whalers' Praying House onless I was pexala [shaman]." Hunt insisted he was a shaman. Luckily for him, the sick man miraculously recovered, so the outsider was granted access. But here is another puzzle. The shrine in the photograph Hunt took in 1903 is different from the shrine described by de Roquefeuil: there are more figures and fewer skulls. Had the rituals changed?

As soon as Boas learned of the shrine's existence, he told Hunt to acquire it immediately for the American Museum of Natural History, where he was the curator. An expert on Pacific cultures, Boas was also professor of anthropology at Columbia University and a fiercely acquisitive collector of

Northwest Coast native artifacts. "Please attend to this matter as soon as possible," he answered Hunt with undisguised excitement, "and I hope you will be able to conclude it to our satisfaction."

In 1904 Hunt returned to Yuquot, purchased the shrine for $500 from the two chiefs who claimed ownership, dismantled it secretly one night when the rest of the band was elsewhere, packed it up, and sent it to Boas. Along with the skulls and carvings went sixty-eight pages of narratives related to the shrine, which had been translated into English. Through myth and metaphor, they provide information on ritual bathing, drift magic (used to bring dead whales ashore), and the way that the skulls, carved whales, and wooden figures were used to invoke success in the whale hunt. But in 1905, after a tiff with the administrators, Boas abruptly left the American Museum of Natural History – and one of his finest acquisitions has never been reconstructed for public display.

In 1992 a documentary film crew brought some Mowach'ath people to New York City to visit the shrine in its museum storeroom. Since then, the community (which no longer lives at Yuquot and has dwindled today to a handful of families) has requested its return.

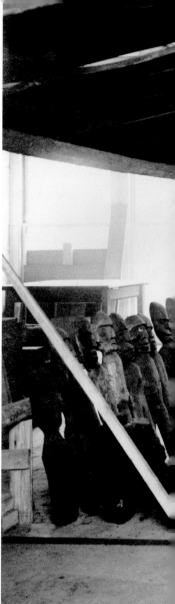

Although their nineteenth-century chiefs kept the shrine from public view, these contemporary descendants want it back at Yuquot. There has even been talk of reassembling it as a tourist attraction. For now, however, the artifact George Hunt regarded as "the best thing that I have ever bought from the Indians" remains a collection of strange carvings and old bones in storage. So long as it stays there, it can exert neither power nor mystery.

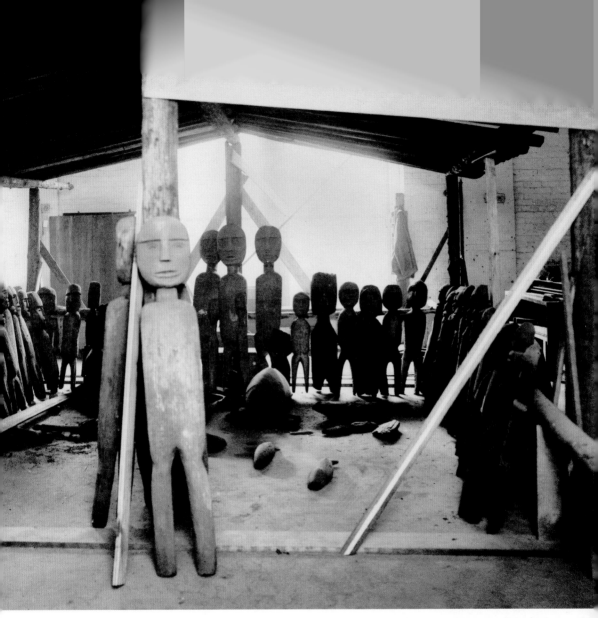

The Yuquot Whalers' Shrine as it was assembled in a non-public area of the American Museum of Natural History in 1909 during renovations to its Northwest Coast Indian Hall. It has been in storage ever since.

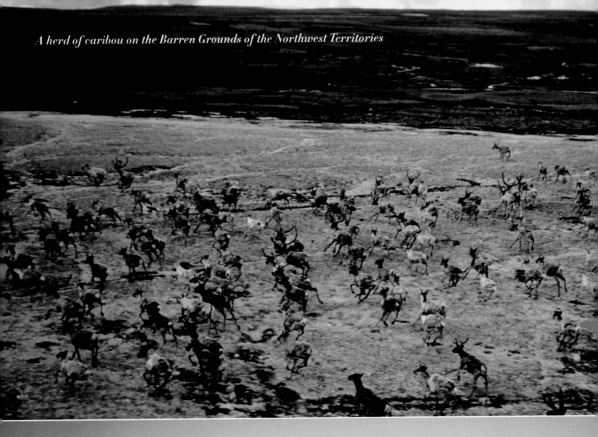
A herd of caribou on the Barren Grounds of the Northwest Territories

The earliest evidence of people in Canada's vast subarctic region dates to about 8,000 years ago. In this land of lakes and spruce forests and near-desert grasslands, inhabitants developed nomadic societies based on fishing and hunting – above all, woodland and barren ground caribou, a primary source of survival. One especially effective hunting technique involved constructing fences to direct the herds into a cul-de-sac, where they could be butchered at will.

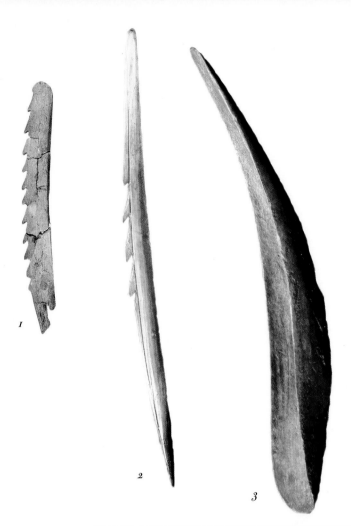

1 BARBED PRONG, APPROX. 3,000 YEARS OLD

southern Yukon
bone
12.5 x 1.4 x 0.5 cm

2 DENE SPEAR POINT, APPROX. 1750

northern Yukon
bone (caribou)
17.2 x 1 x 0.8 cm

3 DENE SPOON, APPROX. 1750

northern Yukon
antler (caribou)
18.7 x 4.4 x 2.8 cm

4 HAMMER, APPROX. 3,000 YEARS OLD

southern Yukon
antler
9.6 x 4.2 x 1.2 cm

These pre-contact tools, all made from the bone or antler of the caribou, demonstrate how the first inhabitants of the subarctic relied on this animal as a primary source of food and raw materials. The multi-purpose hammer may have been used to chip away stone flakes in the making of tools or perhaps in the process of tanning hides. The barbed prong was once part of a fish spear. The spear point is similar to tools being used to hunt the caribou today. The spoon is rare – the only one known that is carved from caribou antler.

DENE FISH LURE, APPROX. 1750

Old Crow, Yukon
bone
15.5 x 4.6 x 2.2 cm

This fish-shaped lure would have been used to catch larger fish such as trout or pike. Long after contact with Europeans, some subarctic peoples still consumed their fish and meat raw. They believed that cooked flesh had less taste and, with seal oil the only reliable fuel, cooking was not often practical. As it happens, raw meat and fish provide essential vitamins that are destroyed in cooking, so this preference explains how these peoples thrived on a diet almost completely devoid of fruit and vegetables.

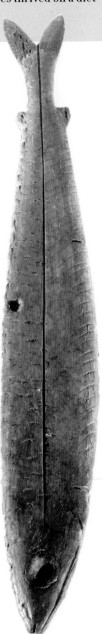

MacMillan River, Yukon Territory

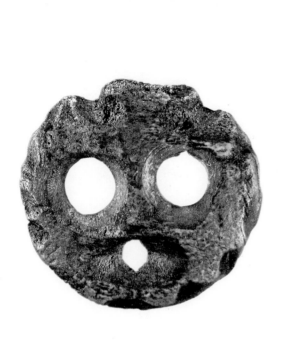

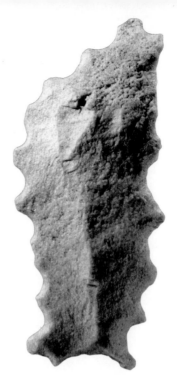

NASKAPI AMULET, PRE-CONTACT (ABOVE LEFT)

*possibly Labrador
ivory
0.2 x 1.5 cm*

No one knows for certain what this object represents or what it was used for, but it is easy to believe it is a human face. Its small size and apparent subject matter suggest it was a personal amulet, perhaps hung from a cord around the neck and worn to ward off evil spirits or to impart powers to the wearer.

"WHATZIT," 2,700–3,500 YEARS OLD (ABOVE RIGHT)

*Thelon River, NWT
probably stone or
quartzite
6.6 x 2.5 x 1 cm*

This artifact's serrated edges suggest it was a small tool, but its function is a mystery. No similar tools have been found, and no oral history is attached to it. Archaeologists call such a conundrum a "whatzit." This whatzit was used by the Taltheilei, vanished ancestors of the Dene.

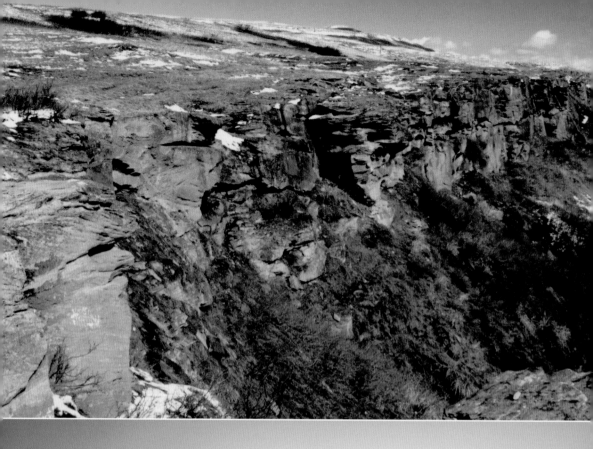

The original peoples of the Canadian plains maintained their Stone Age lifestyle longer than any of Canada's other indigenous groups. After hunting horses, woolly mammoths, and other large-game species to extinction, they came to depend on the plains bison, popularly referred to as buffalo. At its peak, Plains Indian culture developed the extremely efficient hunting technique of the buffalo jump – where hunters constructed a fence that funnelled a charging herd over a cliff. From this single species, the first peoples of the Canadian plains derived all the necessities of life. Their descendants include the Beaver, Blackfoot, Assiniboine, and Chipewyan.

Opposite: *A view over the cliff edge of Head-Smashed-In Buffalo Jump, Alberta, which served as a bison trap for almost 6,000 years, until the demise of the plains bison about 125 years ago.*

BISON EFFIGY, 1000–1600

near Melville,
Saskatchewan
quartz
7.2 x 12.2 x 4.2 cm

The people of the plains used bison figures, often more realistic than this one, in ceremonies such as the Sioux Sun Dance, an eight-day-long social ceremony held to request help from the spirits.

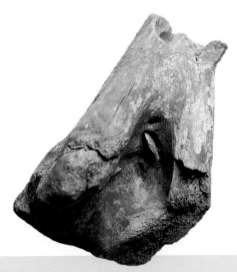

BISON (*BISON BISON*) HUMERUS, APPROX. 700 CE

Old Woman's Buffalo Jump,
Alberta
bone
15 cm

If you look carefully, you can make out the hunter's stone point embedded midway down this thigh bone from the front leg of a bison. Because the damaged bone has not healed around the arrowhead, we know that the bison died soon after being wounded.

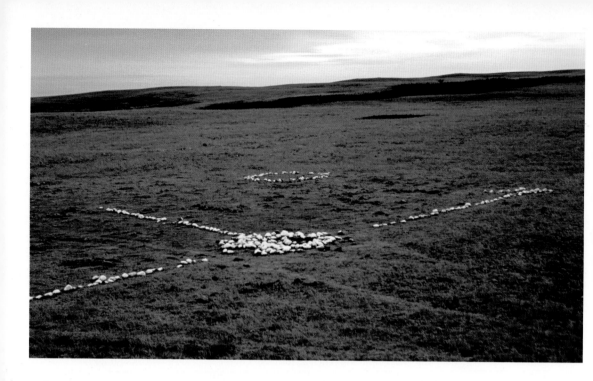

JELLY RANCH MEDICINE WHEEL, APPROX. 1000

*near Regina,
Saskatchewan
boulders from glacial drift
approx. 30 x 20 m*

This ancient monument, one of about seventy medicine wheels that have been found on the Great Plains, is named after the Saskatchewan ranch on which it was discovered. It consists of a circular central cairn of stones, three "spokes" of stones and the possible remnant of a fourth spoke, and the remains of forty-six tipi rings. Some believe it was built by Blackfoot people as a memorial to a great warrior or to several warriors, but older medicine wheels, some of which are up to 5,000 years old, may have been used for significant ceremonies or, possibly, to record astronomical events.

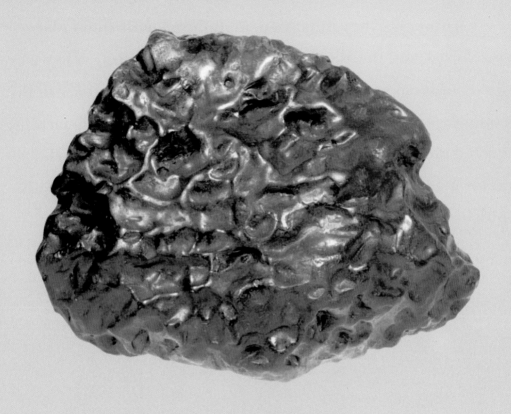

IRON CREEK METEORITE ("MANITOU STONE"), FIRST REPORTED IN 1810, AGE UNKNOWN

near Iron Creek, Alberta
iron, nickel, and cobalt
22 x 56 cm

This sacred stone entered the historical record in 1810, when fur trader Alexander Henry observed local Cree and Sarcee people gathered at an "Iron Stone" atop a hill near Iron Creek, Alberta. Close up, the stone's metallic surface displays a beautiful geometric pattern. According to tradition, the stone had been sent from the sky by a great spirit, so it became a focal point of veneration and communal ceremonies. Around 1866 Methodist missionaries removed the Manitou Stone, despite warnings from native elders that "sickness, war and decrease of buffalo would follow the sacrilege." And so it did.

The people of the northeastern woodlands, which stretched from west of the Great Lakes to the Atlantic shore, were as varied as the environments they inhabited, including fertile flood plains, dense forest, and thousands of kilometres of coastline. They were skilled hunters, experts at woodland travel, and, in the case of the Iroquoian peoples, experienced agriculturalists. Because farming required more stable settlement, villages remained in one location for many years. This sedentary culture developed a highly sophisticated political system, based on the longhouse.

A view of Lake Ontario from Burlington Bay to Hamilton Mountain.

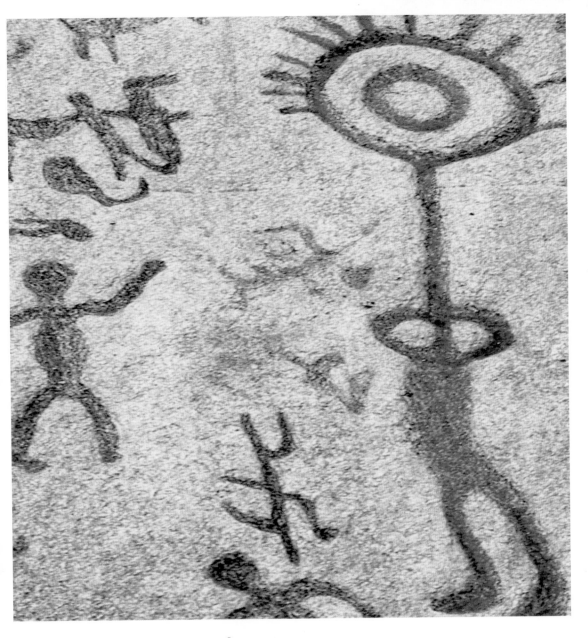

PETERBOROUGH PETROGLYPHS, 800–1400

Stoney Lake, Ontario
stone
total site 60 x 35 m

The group of rock carvings, or petroglyphs, on Stoney Lake near
Peterborough, Ontario, is one of the most extensive in North America. Called
"Kinomagewapkong," or "the rocks that teach," by the Ojibwa people, these
900 carvings were made using hard gneiss hammers to incise the softer,
gently sloping wall. This petroglyph shows several human figures, with a few
animals in the top left corner and one dominant figure whose head appears
to be the sun. The Ojibwa were not farmers, but they harvested the wild rice
that grew abundantly in their territory.

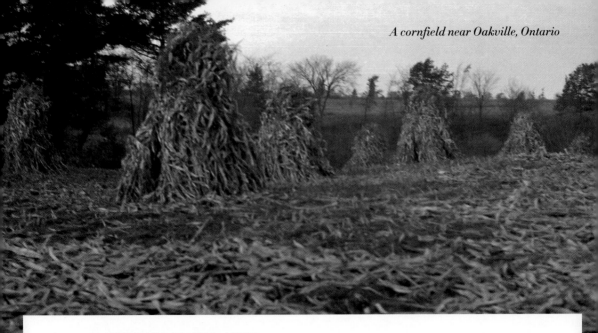

A cornfield near Oakville, Ontario

CORN AND GRINDING STONES, AFTER 500

Rivière Saint-Maurice, Quebec
size unavailable

Corn was the most important crop among the peoples who farmed in the region around Lakes Ontario and Erie and in the fertile St. Lawrence basin. It was ground into a coarse flour between two smooth stones. (The blackened pebbles are ancient kernels of corn; the charcoal-like sticks, ancient cobs.) By the time the Europeans made contact with the Iroquoian and other peoples of the area, they derived almost 80 percent of their nutrition from corn, beans, and squash, which they called the "three sisters." These agricultural products had worked their way northward from Central America, where they were first cultivated over 10,000 years ago.

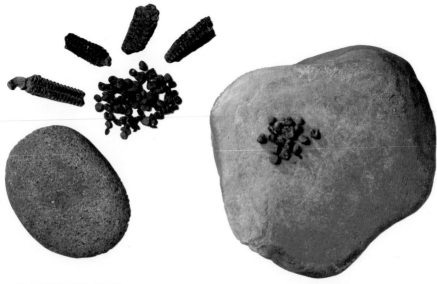

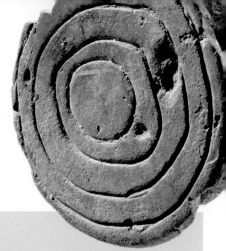

EAR SPOOL, APPROX. 2,000 YEARS OLD

southern Ontario
siltstone or sandstone
approx. 6.7 x 2.1 cm

This ear spool is remarkable for its close resemblance to those worn during this period by the people of the Ohio Valley and regions farther south, including the Mayan people of Mexico. Ear spools were large earrings that were placed into a hole in the earlobe. This example, found at a northeastern Woodland burial site in southern Ontario, provides evidence that more than agriculture had made its way north to what is now Ontario.

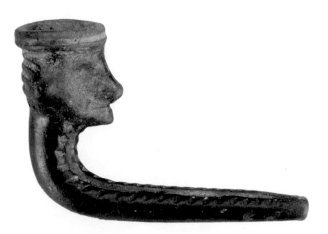

EFFIGY PIPE, APPROX. 1350–1615

Halton County, Ontario
ceramic
9 x 13 x 4.2 cm

About the time of the European Reformation, an Iroquoian man or woman smoked tobacco in this beautifully made clay pipe. The farming peoples who lived along the shores of the eastern Great Lakes and the St. Lawrence River began growing tobacco around the year 1000, and by the time the early French explorers and missionaries arrived, smoking was an important social and recreational activity as well as a symbol of peace. Pipes even more elaborate than this one were used to cement alliances, such as those that formed the Iroquois Confederacy, a powerful player in the early politics of New France.

Cape Split, NS, on the Minas Basin of the Bay of Fundy

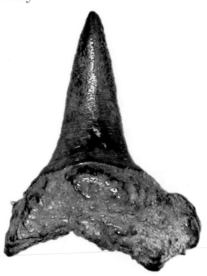

SHARK (*LAMNA NASUS*) TOOTH, APPROX. 1000

*St. Peters Bay, PEI
tooth
approx. 1.4 x 1.2 cm*

This shark tooth, which once belonged to a now-extinct relative of the great white shark called a porbeagle, was excavated from a shell midden, or prehistoric garbage dump. Its 2.5-metre-long owner was likely caught in a fishing weir. After the flesh was consumed, this tooth became a tool. The pattern of wear indicates that its aboriginal owner used it for making clothing, mats, or baskets from hides, bark, or rushes.

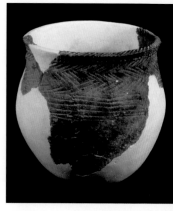

A Mi'kmaq round-bottom pot

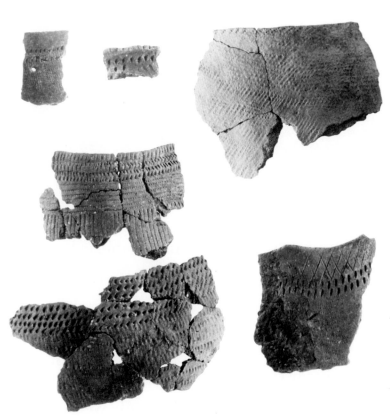

POT FRAGMENTS, APPROX. 2,100 YEARS OLD

Savage Island, NB
ceramic
size unavailable

The pre-contact Mi'kmaq cooked in round-bottom ceramic pots decorated with a variety of geometric motifs. Examples can be seen on these pottery fragments that eroded out of an embankment on the Saint John River after serious flooding in the spring of 1996. The fragments were discovered at a traditional meeting place, just across the river from the site of a village that was occupied until the late eighteenth century.

A permanent snowfield at Steensby Inlet on Baffin Island.

Just over 4,000 years ago, a group of people from Siberia known as the Paleoeskimos migrated by boat or by sea ice across the Bering Strait to the Arctic coast and islands of Canada. They moved eastward and, by 2,500 years ago, they had developed into what is known as the Tuniit, or Dorset, culture. About 800 years ago, a new wave of migrants swept eastward, a people we call the Thule. The Thule had a more sophisticated hunting technology than the Tuniit, and the Tuniit soon disappeared, by war or assimilation or both. The Thule are the ancestors of the modern Inuit.

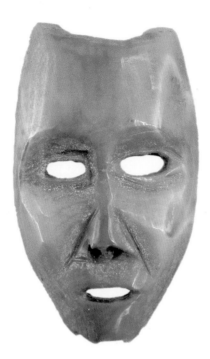

TYARA MASKETTE, APPROX. 2,000 YEARS OLD

Sugluk Island, Quebec
ivory
3.5 x 2 x 0.8 cm

This tiny maskette, named for the site on the Arctic coast of Quebec where it was found, is one of the earliest examples we have of the art of the vanished Tuniit people. Similar faces occur frequently in Tuniit art; a number are found among the petroglyphs in the same area where this mask was discovered.

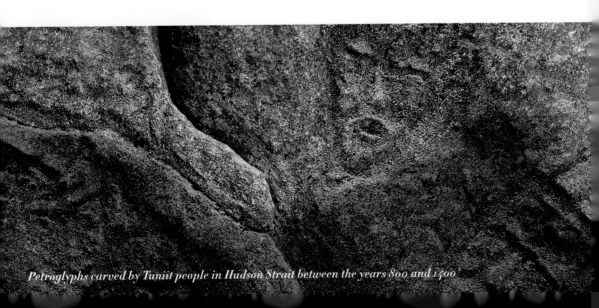

Petroglyphs carved by Tuniit people in Hudson Strait between the years 800 and 1400

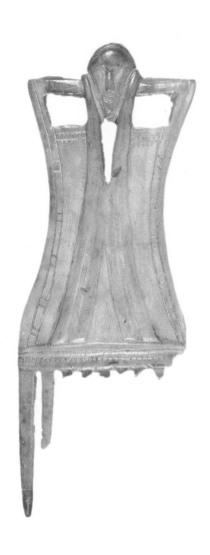

THULE COMB, 1000–1600

Kugaaruk (formerly Pelly Bay), Nunavut
walrus tusk
10.9 x 3.9 x 0.7 cm

Combs are among the most common works of art left by the Thule people. While the Tuniit often carved faces on items such as combs, thimbles, needle cases, and cooking utensils, the Thule rarely depicted figurative representations, which makes this artifact unique.

INUNNGUAQ, APPROX. 1850

Keewatin region, Nunavut
granite
approx. 1 m

The word *inunnguaq* (commonly known as inukshuk) means, roughly, "in the form of a person." The plural form, *innaguait*, refers to ancient stone cairns built to resemble a person. Most mark travel routes, fishing places, or camps, or are drift fences used for hunting, while some may mark the way to places of power or are themselves objects of veneration. The towering size of some *innaguait* suggests that their construction was often a communal effort. This inland *inunnguaq* points the way to a place deserving of respect.

First Contact Collection

500 to 1300

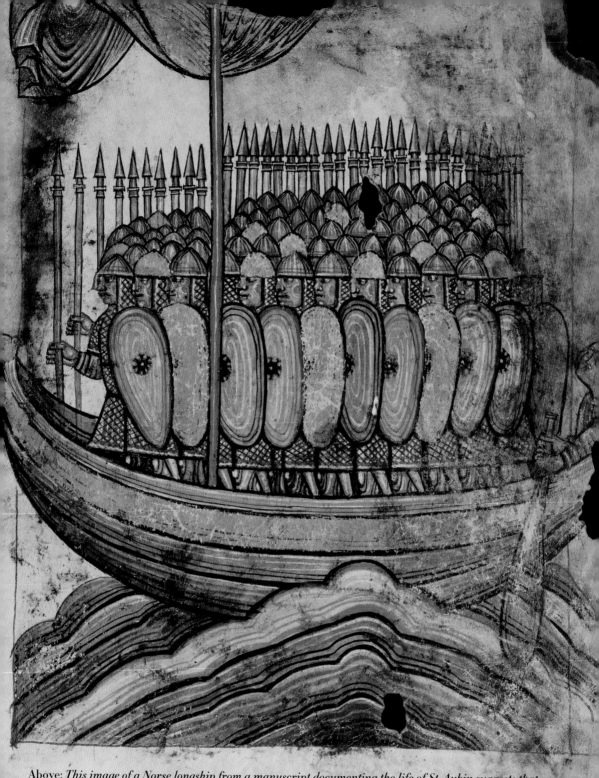

Above: *This image of a Norse longship from a manuscript documenting the life of St. Aubin suggests that Viking raids were facts of life along the Atlantic coast of France during the twelfth century.*
Opposite: *This prow of a ninth-century ship used for a burial shows the style of Norse shipbuilding.*

Those who attempt to piece together the early history of northern North America have little to go on. The original inhabitants left no written records of their lives before the first Europeans reached their shores. It is only with the earliest contacts between the aboriginal peoples of eastern North America and these foreign interlopers that some sort of narrative emerges. This fragmentary story is written by way of a few everyday objects that reflect the early interactions between the two groups. The first visitors from Europe are believed to have been Vikings, Scandinavian seafarers who were already feared along the coasts of England and continental Europe for their frequent and violent raids. Overpopulation in their home country (modern-day Norway) sent Norse explorers in search of land that could be farmed more easily than their native soil. They reached Iceland in about 875 and Greenland in around 985, setting up coastal farming communities similar to those back home. By 1000 they were venturing even farther west.

RINGED PIN, APPROX. 1000

L'Anse aux Meadows, Newfoundland
bronze,
with small amounts of zinc and iron,
and trace amounts of silver
pin, 6.7 x 0.4 cm; ring, 0.3 x 0.9 cm
(original length estimated 11.7 cm)

The discovery of this pin by Norwegian archaeologists in the summer of 1968 provided the first solid proof that Vikings had planted a colony in North America long before its official "discovery" by Christopher Columbus. The pin was probably used to fasten a man's cloak on his shoulder, allowing him to swing a sword or an axe.

MISSING LINK
The Norse Pin at L'Anse aux Meadows

Around 1000 a Norse settler in a tiny community on a bleak shore wrapped his woollen cloak tightly around him against the Arctic wind and fastened it with this slender bronze pin, neatly soldered to a small ring. The pin, made of a precious alloy by a skilled craftsman, must have been a valuable possession. Perhaps it denoted its owner's high social status, or maybe the proud possessor was a "her" rather than a "him." One day the cloak became unfastened, and the pin dropped onto the ground near the hearth in one of the turf houses scattered around the shallow bay. We can imagine the owner's horror on realizing that this precious piece of jewellery was lost.

Remains of an outdoor cooking pit used by the Norse at L'Anse aux Meadows

A few years later the Norse settlers deserted that windswept village huddled between the roaring ocean and a primal forest. As the centuries rolled forward, the turf houses on the inhospitable coast collapsed and the discarded fishing equipment rotted. The pin sank deeper and deeper into the earth, and with it the knowledge that people from across the ocean had ever visited this place.

Fast forward one thousand years to 1961. The Norwegian archaeologists Helge Ingstad and his wife, Anne Stine Ingstad, have carefully read the Icelandic sagas, written in the mid-fourteenth century, about the "Viking Age" – roughly 800–1100. The sagas describe the travels three hundred years earlier of Iceland-born Erik "the Red" Thorvaldsson and his sons. Helge, who is a specialist on

Viking culture, has developed the highly controversial theory that Norse ships crossed the Atlantic and made landfall in the New World centuries before Christopher Columbus or John Cabot. He is convinced that a country named in the sagas as "Vinland" and colonized by Erik's son Leif not only existed but must be Newfoundland or Labrador. So he and his wife set out to look for it.

Near the isolated village of L'Anse aux Meadows, on the west coast of Newfoundland's Great Northern Peninsula and within sight of the Labrador cliffs across the narrow strait, Helge and Anne examine some overgrown mounds. Helge is intrigued by the modern village's hybrid name, meaning "The Bay by the Meadows," which corresponds closely with one possible meaning of the name Vinland – "The Land with the Meadows." (Other interpreters have argued that Vinland means "The Land Where Grapes Grow," but they have been unable to identify which land this name might refer to.) He decides that the village could be a Norse site, perhaps the legendary settlement

of Leifsburdir founded by Leif Ericsson himself.

Over the next seven years, while her husband explores the Labrador coast, Anne and a team of archaeologists spend the brief Newfoundland summers excavating the remains of eight turf houses and a smithy, all of Norse type. They dig up Norselike artifacts such as sewing tools, lamps, and a spindle whorl. But a whiff of uncertainty lingers. They have still found nothing to prove conclusively that Norsemen, rather than local Inuit or Indian people, or European fishermen from a later period, built the houses.

Then, on the final day of the seventh season, it happens. A member of the team lets out a yell: "I've found bronze!" The others come running.

The Old Norse written on this page describes the discovery of Vinland by Leif Ericsson.

Anne Stine Ingstad carefully brushes away the dirt to reveal a ring-headed pin, now coated in verdigris. "We practically exploded with excitement," she wrote later. The bronze pin is the missing link they've all been hoping for. Neither Inuit nor Indians possessed bronze – an alloy of copper and tin – which requires sophisticated metalworking skills. The pin proves the hypothesis that the sagas are based on historical truth – that, more than a thousand years earlier, Norse explorers crossed the Atlantic to what is now Canada and tried to settle here.

This elegant bronze pin raises questions just as it provides answers. One question looms above all the others: Why didn't the Vikings maintain their grip on their Newfoundland colony?

The most likely answer is fear of the aggressive local Indians (likely ancestral Beothuks or Mi'kmaq). The Newfoundland settlement was never a farming

Opposite: Ridges forming visible mounds in a field near the village of L'Anse aux Meadows, Newfoundland, resembled the shapes of Norse longhouses. They convinced the Norwegian writer and explorer Helge Ingstad that they might be remains of the first attempt by Europeans to colonize North America.

colony, with an established way of life. Instead, it was a shore station for Norse adventurers from other North Atlantic islands, such as Greenland and Iceland, who were looking for timber, furs, and other tradable goods. But native attacks, graphically described in the Icelandic sagas, deterred the Viking voyagers from maintaining their toehold on North America. All the evidence suggests that, within a few decades of their arrival at L'Anse aux Meadows, the Norsemen were forced to pack their belongings into their wooden boats and retreat to Greenland.

Viking settlements elsewhere in the North Atlantic also fell on hard times, as the climate cooled, thwarting the settlers' efforts to farm. The Greenland settlements were wiped out, but Viking colonists clung to their other outposts. Norsemen became the founding people of Iceland and the Faroe Islands, and today are a major component of the Orkney and Shetland populations.

So this simple bronze pin tells a complicated and important tale of historic discontinuity. It marks the farthest reach of a tough, ambitious people who crossed a vast and dangerous ocean in search of a less populated and more fertile new world. At the same time it represents a remarkable example of aesthetic continuity. If the pin were made of polished pewter, it could easily pass for a modern Georg Jensen design. How different the history of my country might have been had that thousand-years-ago foothold become the foundation of permanent Norse settlement in North America.

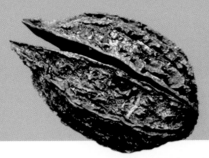

HUSK OF A BUTTERNUT (*JUGLANS CINEREA*), APPROX. 1000

L'Anse aux Meadows, Newfoundland
4.5 x 2.7 cm

Butternuts grow only as far north as New Brunswick, along North America's Atlantic seaboard, and nowhere on the island of Newfoundland – strong circumstantial evidence that the Norse settlers at L'Anse aux Meadows ventured well to the south.

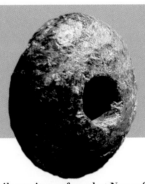

SPINDLE WHORL, APPROX. 1000

L'Anse aux Meadows, Newfoundland
soapstone
1.2 x 3.3 cm; hole 0.9 cm

This tiny object, similar to items found at Norse farms in Greenland, strongly suggests that women were present at L'Anse aux Meadows. A spindle whorl was used to stabilize the turning of the spindle while spinning thread. The soot on the bottom of this example indicates it was fashioned from a discarded cooking pot or oil lamp.

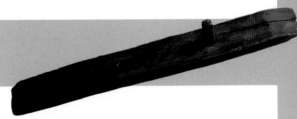

PLANK WITH TREENAIL, APPROX. 1000

L'Anse aux Meadows, Newfoundland
spruce (plank),
Scotch pine or red pine (treenail)
36.5 x 6 x 1 cm

This weathered piece of wood was discovered among the debris from what is believed to have been a carpentry shop at L'Anse aux Meadows; it was probably intended as a floorboard for a small boat. Treenails were used to attach floorboards to a lath or laths running parallel to a boat's keel. The treenails were driven in from above, then fixed in place with a wedge driven in from below. Tool marks on the wood indicate it was worked with a metal adze and a metal knife, objects that did not exist in pre-contact Newfoundland.

CONTAINER, APPROX. 1000

*L'Anse aux Meadows, Newfoundland
birch bark (probably white birch)
and spruce sapling
approx. 8.5 x 5 cm*

The Norse often made vessels out of birch bark, so they naturally turned to this familiar local material when they settled down in Newfoundland. (The abundance of white birch in the northwest of the island makes it the probable type.) The cylindrical sides of this cup or bowl were constructed from a single sheet of bark, with overlapping ends sealed by two strands of spruce sapling, then stitched in place with fine horizontal sapling stitches. Presumably it once had a wooden bottom, but no trace remains of it.

NAIL FRAGMENT IN WOOD (X-RAY), APPROX. 1000

L'Anse aux Meadows, Newfoundland
oxidized iron
shank, 2.5 x 0.5 cm; head, 1.5 cm

You are looking at the x-ray ghost of an iron nail that almost certainly held a plank in place on a Norse boat. All that remains of the original nail is rust, but the x-ray reveals the square shape of the head and the upper portion of its shank. It was found in line with four similar nail fragments, probably all belonging to the same plank, which was left to rot on the shore at Epaves Bay, where it was found. Archaeologists can be reasonably sure that the plank was part of a boat, since the West Norse never used iron nails in buildings. The five fragments are among the nearly one hundred such nail fragments found at the L'Anse aux Meadows site.

The Norse remains at L'Anse aux Meadows help us sketch in one part of the First Contact story, but they don't tell us which native peoples the visitors encountered or how that contact unfolded. For hints of this story we turn to objects found in the High Arctic, where Norse traders travelled from the thirteenth to the fifteenth century in search of goods to sell back home. The first people the Norse met were the Tuniit (also known as the Dorset), who at that time occupied the area. The Tuniit people disappeared or were assimilated about five hundred years ago, probably after a long period of conflict and competition with the more recently arrived Thule, the ancestors of the Inuit.

This detail from a 1539 map by Olaus Magnus depicts an encounter with a Skraeling, a pejorative term in Old Norse that meant something like "dried up," "withered," "sickly," or "weak." The Vikings used the word to describe the people they met across the Atlantic.

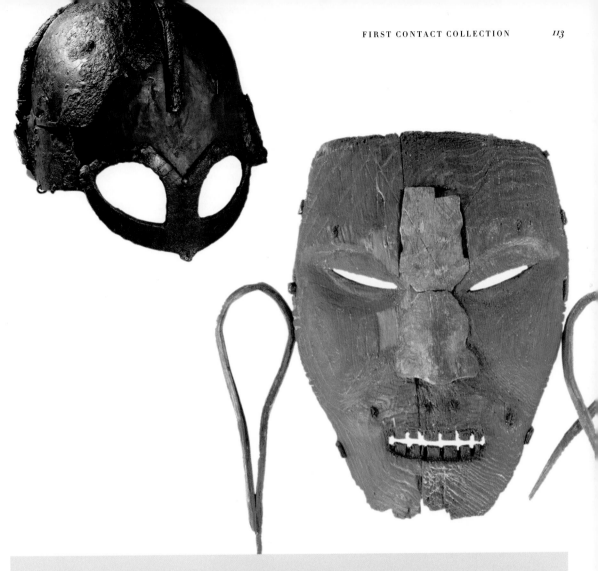

VIKING HELMET, APPROX. 750–1000 (ABOVE LEFT)

Gjermundbu, Ringerike, Buskerud, Norway iron, originally with strips of bronze or silver covering nose and eyes approx. 17.6 x 18.4 x 21.6 cm

The "Gjermundbu Helm," which was discovered in a burial mound in Norway, is the best-preserved Viking helmet ever found. The artifact's elegant design and fine craftsmanship indicate that the helmet belonged to an important man and contradict the image of the Vikings as artless barbarians.

DORSET MASK, 500–1000 (ABOVE RIGHT)

Bylot Island, Nunavut driftwood with red ochre paint 18.7 x 13.3 x 3 cm

This life-sized mask, carved from driftwood and painted with red ochre, originally included a fur moustache attached by pegs. It probably had a ceremonial rather than a warlike purpose, but, like the Gjermundbu Helm, it demonstrates the sophistication of its maker.

SPUN CORDAGE, APPROX. 1000

Baffin Island, Nunavut
Arctic hare
3 m, 2 ply

The Norse made garments by spinning and weaving the wool of sheep and goats; aboriginal Arctic peoples wore tailored clothing sewn from animal skins. This length of cordage recovered from a Tuniit site is spun from Arctic hare fur. It is similar to that in two Norse textile fragments known from Greenland, and hints at interaction between the Norse and the Tuniit people.

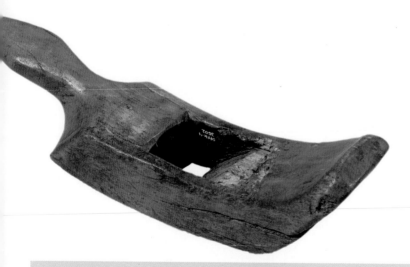

NORSE CARPENTER'S PLANE, APPROX. 1300

Skraeling Island,
Nunavut
birch
5.3 x 2.1 x 3.1 cm

This carpenter's plane was found in a Thule culture Inuit dwelling. The metal blade has been removed, probably to be refashioned into knives or weapons. Together with other European material found at this site, it is evidence of interaction between the Norse and the early Inuit.

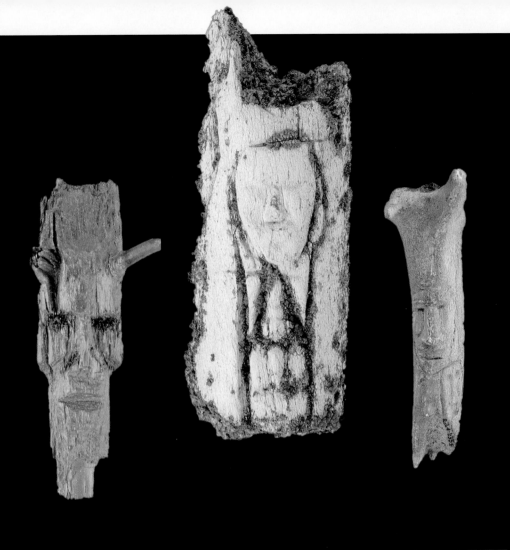

INUIT CARVING OF A
EUROPEAN-LIKE FACE,
APPROX. 1000–1300

*Baffin Island, Nunavut
driftwood
8.4 x 3.5 x 3 cm*

WAND WITH OPPOSING
FACES,
APPROX. 1000–1300

*Axel Heiberg Island,
Nunavut
antler
10.2 x 4.1 x 2.9 cm*

WAND,
APPROX. 1000

*Bathurst Island,
Nunavut
antler
14.7 x 3.7 x 2.5 cm*

Tuniit carvings occasionally portray human faces with European-like features, suggesting that the artists had encountered European visitors. Look especially at the two faces carved into the antler wand in the centre. The broad, rounded face with a small nose is typical of the way the Tuniit represented themselves, while the long, narrow face with a prominent nose, heavy brows, and what may be a beard probably portrays a European.

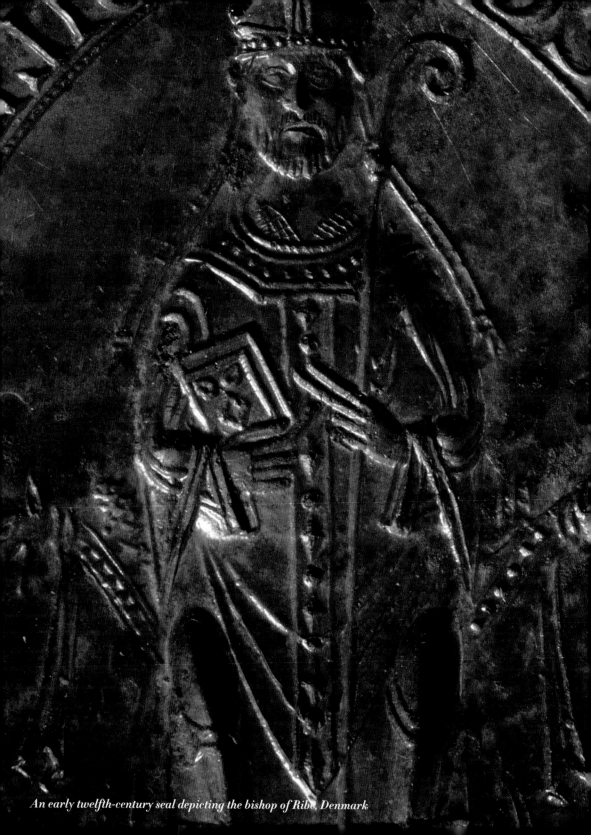

An early twelfth-century seal depicting the bishop of Ribe, Denmark

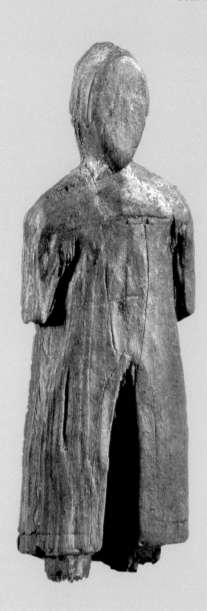

THULE CARVING OF A NORSEMAN ("BISHOP OF BAFFIN ISLAND"), APPROX. 1300

Baffin Island, Nunavut
driftwood
5.4 x 1.9 x 1 cm

Long known as the Bishop of Baffin Island because of its priestlike robes and the faintly incised cross on the chest, this finely realized figure has a featureless face and short arms, both characteristics of Thule carving of the period. Priest or not, this carving almost certainly depicts a Norseman.

WATER ROOM
1000 to 1693

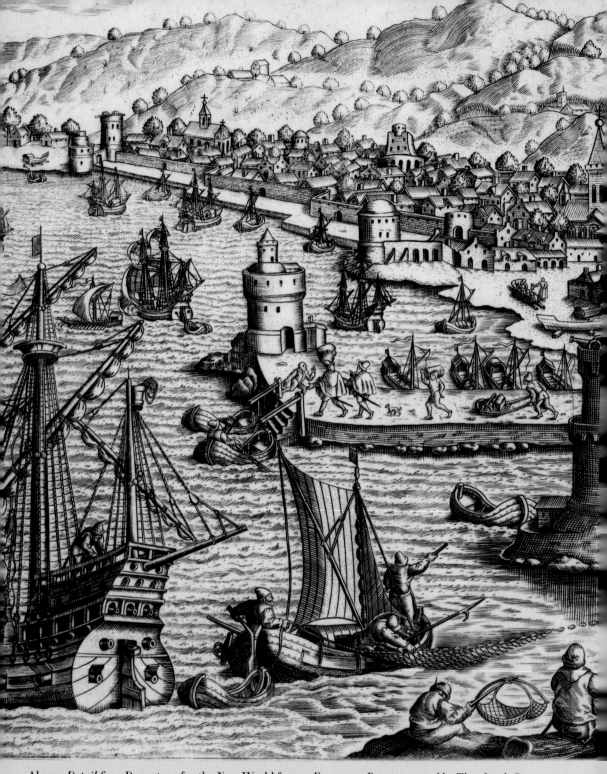

Above: *Detail from* Departure for the New World from a European Port *engraved by Theodor de Bry,
c. 1594.* Opposite: *Many European explorers who came upon an Arctic expanse of open water like this one,
looking north along Prince of Wales Strait, believed they had finally found the elusive North-West Passage.*

WATER ROOM
1000 to 1693

Water paved the road the Vikings took to L'Anse aux Meadows, the first known attempt by Europeans to settle in North America. And water provided the route for those who came after them. We know that the Vikings abandoned their Vinland colony around 1050, but we don't know when the last Norse sailor stepped off a Canadian shore. For almost five centuries the written record of contact goes blank. During that gap in the chronology there is evidence that Europeans fished the teeming waters of the Grand Banks, then dried and salted their catches of cod on the Newfoundland or Labrador shore before heading back the way they'd come. The first European we know for certain set foot in Canada arrived in 1497, only five years after Christopher Columbus's famous voyage. That explorer was a Genoese mariner named Giovanni Caboto in the pay of England's Henry VII, who called him John Cabot.

Circulus articus.

Occanus occidentalis

Has antilhas del Rey de castella.

Toda esta terra he descoberta p̃ mãdado do mui alto... rey...

A linha equinocialis.

Terra del Rey de portuguall

Elle he camino da mar castella; e portuguall

Mare geomani...

COPY OF A DETAIL FROM THE "CANTINO MAP OF THE WORLD," ORIGINALLY
ATTRIBUTED TO ALBERTO CANTINO IN 1502, COPY FROM 1883

Paris, France
paper
96.7 x 105.6 cm

After Christopher Columbus's first voyage in 1492, Spanish and Portuguese
explorers raced to claim new territories for their respective crowns. Soon
disputes between these two maritime powers forced Pope Alexander VI to
intervene. In 1493 His Holiness drew a north-south line through the known
world, decreeing that all lands found on its western side would belong to
Spain, and those found on the eastern side would go to Portugal. According
to this map (named for the Italian spy Alberto Cantino, who we now believe
commissioned it), a land that was likely the island of Newfoundland ("Terra
del Rey de Portugal") fell on the Portuguese side. Yet, although the Portuguese
explorer Gaspar Corte-Real had visited Newfoundland in 1500–01, Portugal
never pressed its claim.

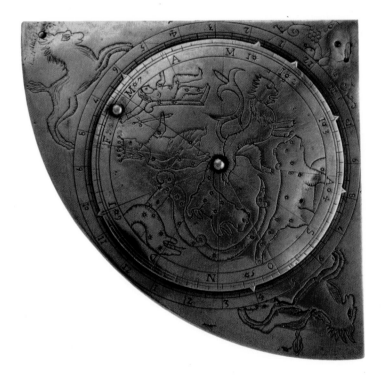

GUNTER QUADRANT, 1631

England
brass
8.9 x 8.7 cm

The quadrant, a simple astronomical instrument consisting of a quarter-circle of thin metal with an attached plumb line, had long been used by navigators to determine latitude. As Elizabethan explorers searched for the North-West Passage, navigational technology gradually improved, but not until the eighteenth-century invention of the sextant did mariners have a reliable instrument for calculating longitude.

BEOTHUK PENDANTS, APPROX. 1550

*Eastern Woodlands
bone (caribou)
with red ochre paint
left, 9.2 x 2 cm;
middle, 5.8 x 1.5 cm;
right, 3.7 x 1.2 cm*

John Cabot first came ashore somewhere on the coast of Newfoundland, or possibly Labrador, on June 24, 1497, and claimed this "New Founde Lande" for England. (The first use of this term on a map dates from 1503.) Whether he ever met any of the local inhabitants, the Beothuk, is not known, but he probably brought back evidence of their existence, such as these caribou pendants, the most distinctive relics of this now-extinct people. Most likely, the shy native families retreated inland at the first sight of Cabot's ships, leaving their coastal camps deserted and open to souvenir hunting. But it would be more than a hundred years before the British attempted permanent settlement on the island.

Opposite: *A mid-sixteenth-century woodcut evokes the wealth of the North Atlantic fishery.*
Opposite, far right: *Harpooned whale, detail from a 1546 "Map of the World" by Pierre Desceliers*

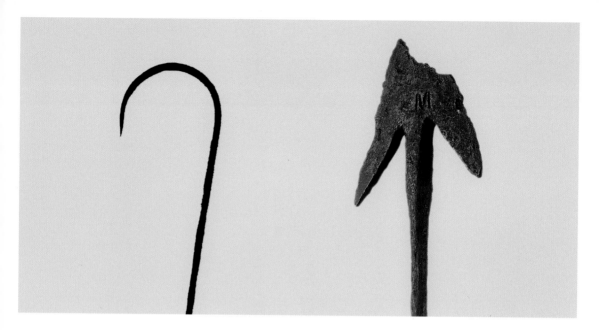

BASQUE FISH HOOK, APPROX. 1550 (ABOVE LEFT)

Red Bay, Labrador
iron
11 cm

This iron fishhook is evidence of a European presence in what is now Newfoundland before the establishment of a permanent settlement. The hook is unquestionably of European design and manufacture, since the native people of the area had no iron except for the goods they obtained through trade. Europeans were willing to travel across the Atlantic for the huge numbers of cod they found on the Grand Banks. This supply met the demand for fish created by the many meatless days in Catholic countries.

BASQUE HARPOON, APPROX. 1550 (ABOVE RIGHT)

Saddle Island,
Newfoundland
iron
36 x 9.6 x 1.2 cm

This whaler's harpoon is marked with the letter *M*, perhaps to identify its owner in case a wounded whale carried off the tool. The harpoon was found in the vicinity of the old Basque whaling port at Red Bay, Labrador, where archaeologists have discovered the remains of three ships. Red Bay was but one of roughly fifteen Basque whaling stations that thrived during the second half of the sixteenth century.

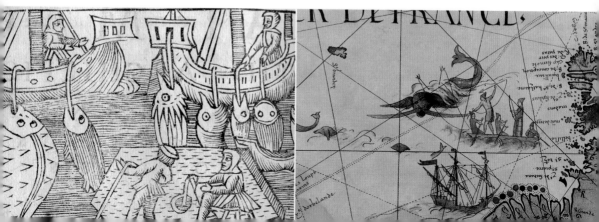

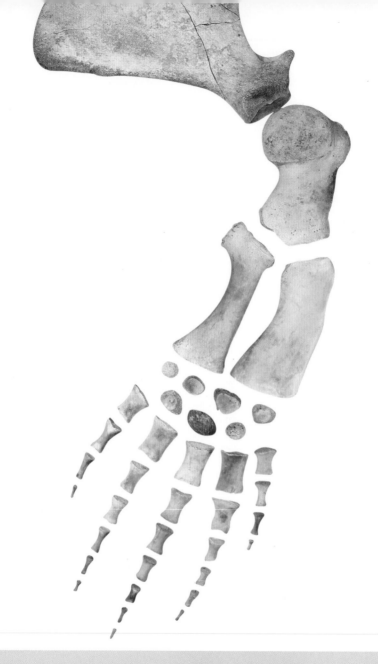

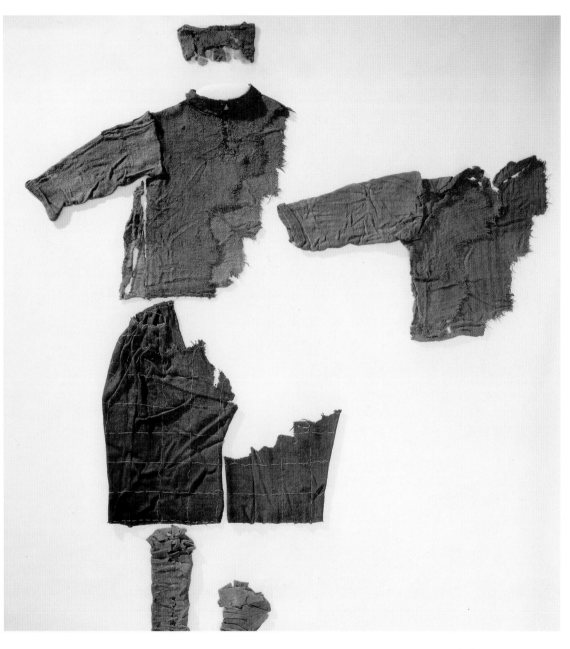

BASQUE SAILOR SUIT, APPROX. 1550

*Red Bay, Labrador
shirt, jacket, stockings:
wool; trousers: coarse
fabric, possibly goat hair
size unavailable*

This knitted cap, shirt, jacket, breeches, and stockings belonged to a Basque sailor. The costume was dug from a peat bog, along with relics belonging to 140 other sailors. The highly acidic peat preserved the sailor's clothing remarkably well but dissolved all his and his comrades' bones. Conservators have determined that the wool was undyed, which suggests that the clothes belonged to a lowly seaman who would have been unable to afford the more expensive coloured cloth.

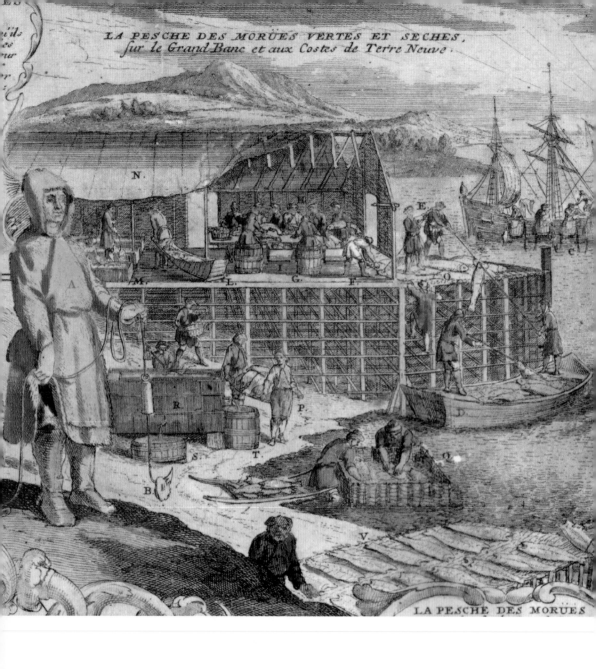

Illustration from a British map of North America showing how cod was split and dried

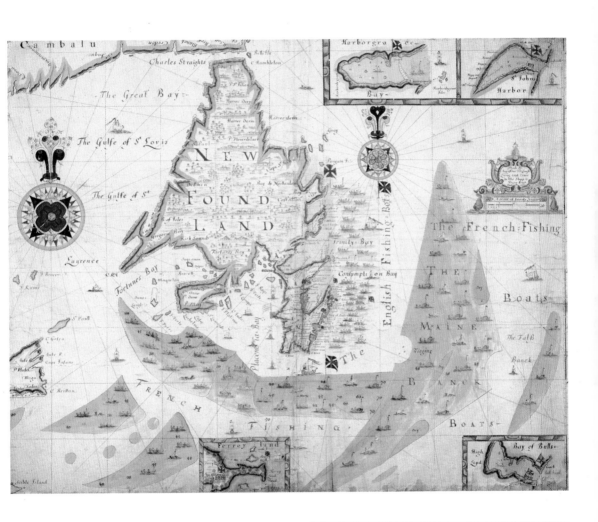

"CHART OF NEWFOUNDLAND AND THE FISHING BANKS," AUGUSTINE FITZHUGH, 1693

London, England
vellum or parchment
69 x 122 cm

This seventeenth-century map shows the partition of the fishing grounds off Newfoundland. The English brought their catches of cod ashore to dry them, and so held the shore bases. The French, however, because they had access to solar salt, were able to salt their catch at sea. And so, long before Britain attempted to colonize Newfoundland, English fishermen were well acquainted with what came to be known as the "English Shore" – the eastern coast of what is now the Avalon Peninsula.

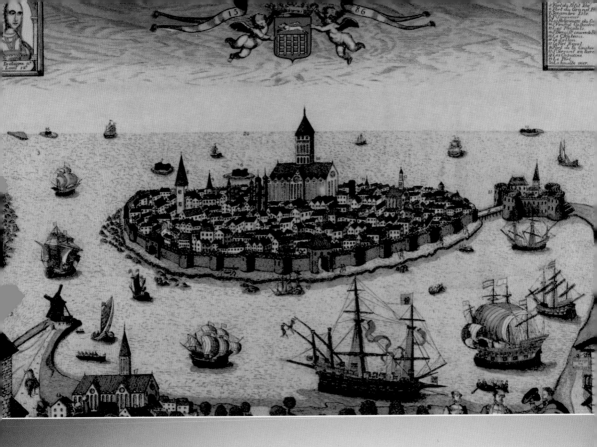

By the 1530s most of the Atlantic coast of North America had been claimed by European powers, but no permanent colony had yet been established, nor had a route to the East been discovered. And so, in 1534, King François I of France sent Breton seafarer Jacques Cartier to discover "certain islands and lands where it is said there are great quantities of gold ... as well, if possible, the route to Asia." On July 24 of that year, Cartier landed at what is now Gaspé Harbour and planted a cross bearing the coat of arms of his sovereign. The next year he explored the St. Lawrence River and claimed its shores for the French king.

❧ BRIEF RECIT, &

ſuccincte narration, de la nauiga-
tion faicte es yſles de Canada, Ho-
chelage & Saguenay & autres, auec
particulieres meurs, langaige, & ce-
rimonies des habitans d'icelles : fort
delectable à veoir.

Avec priuilege
*On les uend à Paris au ſecond pillier en la grand
ſalle du Palais, & en la rue neufue Noſtredame à
l'enſeigne de leſcu de frãce, par Ponce Roffet dict
Faucheur, & Anthoine le Clerc frères.*

1545.

BRIEF RECIT, & SUCCINCTE NARRATION ... (BRIEF ACCOUNT & SUCCINCT NARRATION),
TITLE PAGE, JACQUES CARTIER, 1545

Paris, France
paper
size unavailable

"The aforesaid Indians have assured us that this is the way to and the beginning of the great river of Hochelaga and the route to Canada," wrote Jacques Cartier on August 17, 1535, the day he arrived at the mouth of the St. Lawrence River during his second voyage to Canada. He then sailed up the river to Stadacona (Quebec City), before making his way to Hochelaga (Montreal).

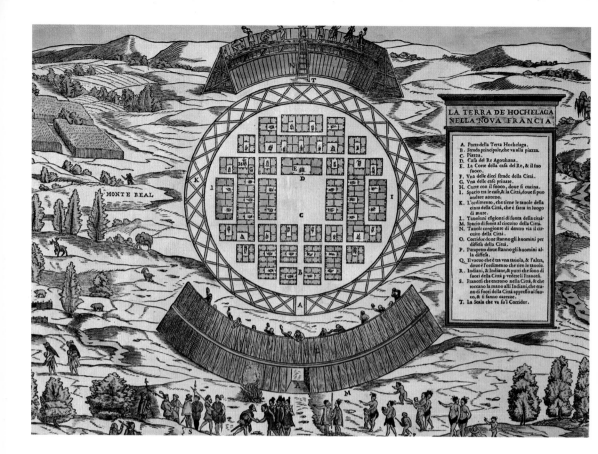

"LA TERRA DE HOCHELAGA NELLA NOVA FRANCIA" (THE LAND OF HOCHELAGA IN NEW FRANCE), GIOVANNI BATTISTA RAMUSIO, 1565

Venice, Italy
woodcut engraving
27 x 37 cm

Along the bottom of this map, the first plan of an existing urban settlement anywhere in North America, the Iroquois welcome Jacques Cartier and his men on their arrival at the future site of Montreal in October 1535. In an effort to impress the inhabitants, Cartier put on dress uniform and ordered that his soldiers enter the village to a trumpet fanfare. Later he climbed to the top of Hochelaga and renamed it Mont Réal (Mount Royal). Cartier returned to Canada for the third time in 1541, with a commission to help the Sieur de Roberval, a French courtier who had been appointed lieutenant-general of Canada, establish a colony. But Cartier resented Roberval's authority and returned to France before his leader arrived. The colony failed.

CROSS-SECTION OF EASTERN WHITE CEDAR (*THUJA OCCIDENTALIS*),
APPROX. 1000 YEARS OLD

Niagara Escarpment, Ontario
size unavailable

This wood sample comes from a white cedar that was alive during
Cartier's time. When Cartier's men fell sick with scurvy during his
second voyage, their Iroquois hosts told them to drink tea made
from the leaves or bark of the eastern white cedar, which is rich in
vitamin C. The cedar tea cured their scurvy, and Cartier continued
his journey.

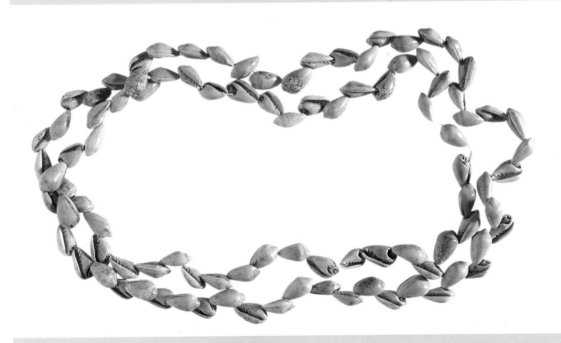

IROQUOIS NECKLACE, PRE-CONTACT

Eastern Woodlands
shell
73 cm

Cartier was impressed with Iroquois finery, which probably included shell
necklaces like this one. But it was their objects of gold, silver, and copper
that really caught his eye, leading him to believe he was on the brink of
reaching the riches of Asia.

Not wanting to be outdone by French explorers like Cartier, the English sent out at least eleven expeditions between 1576 and 1631 in search of a northern sea route to Asia. The first explorer to take up the quest for the fabled North-West Passage was a former pirate named Martin Frobisher. "It is the only thing left undone whereby a notable mind might be made famous and remarkable," said Frobisher of the challenge of finding the northern route to the Indies. What seems truly remarkable in retrospect is how many adventurers followed in Frobisher's wake and the enormous human suffering they endured before the passage was finally found.

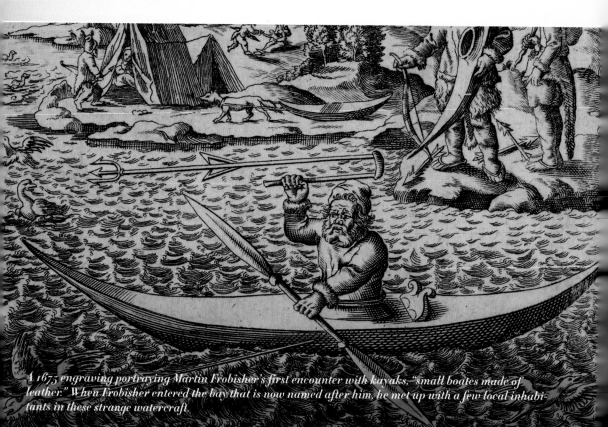

A 1675 engraving portraying Martin Frobisher's first encounter with kayaks, "small boates made of leather." When Frobisher entered the bay that is now named after him, he met up with a few local inhabitants in these strange watercraft.

"SEPTENTRIONALIUM TERRARUM DESCRIPTIO" (MAP OF THE NORTH POLE),
GERARDUS MERCATOR, 1595

Duisburg, Germany
printed from copperplate,
hand coloured
36.4 x 38.6 cm

Mercator was the first mapmaker to find a way to accurately portray the overall geography of the Arctic. But although this drawing looks like a contemporary map of the North Pole, much of its apparent accuracy is purely fortuitous. Its depiction of the Davis and Frobisher straits could have been based on an explorer's account, but the bay shown on the far left in the rough position of Hudson Bay is likely the cartographer's fancy. No European would report its existence until the early seventeenth century.

BLACK ORE IN THE WESTERN WALL OF DARTFORD MANOR HOUSE, BROUGHT TO
ENGLAND APPROX. 1576

Dartford, England
ore from Canadian Arctic
(around Baffin Island)
2–3 m

The wall of this house incorporates many pieces of black Baffin Island
rock brought back to England by Martin Frobisher. Although the rock was
initially believed to contain gold ore, it ultimately proved to be worthless.
Meanwhile, gold fever had launched Frobisher on his third and final
Arctic expedition.

DREAMS OF GOLD
Martin Frobisher and the North-West Passage

This stone wall is the sixteenth-century equivalent of a bathroom papered with share certificates issued by Bre-X Minerals, the Canadian gold-mining sensation that crashed spectacularly in 1997. The wall originally encircled a royal manor house once lived in by Henry VIII's fourth wife, Anne of Cleves, in the tiny mill-town of Dartford, down the Thames River from London. (Ever since it has been known as the Queen's House.) When I first looked at a photograph of the wall, I saw only a monotonously ordinary construction of Kentish ragstone and flint, speckled with several pieces of dark rock. Those dark rocks, however, come from the Canadian Arctic, and the tale of how they ended up in an English wall, 8,000 kilometres from their place of origin, is astonishing. They prove that, more than four centuries ago – years before either the fur trade or any British or French colonies had been established in North America – there was a working quarry on Baffin Island.

This 1577 portrait of Martin Frobisher by Cornelius Ketel shows the explorer at the peak of his fame.

The tale begins in the mid-sixteenth century with Great Britain's determination to challenge Spain's and Portugal's domination of the seas. Over the previous hundred years the two Iberian countries had divided the Americas between them, and they now controlled access, via Cape Horn, to the Pacific and the fabled wealth of China, or "Cathay." Their ships returned home loaded with gold, silver, silk, and spices. The British wanted a share of the action, so they began to dream of another water route to "the wealthe of all the Este Parts."

Enter Martin Frobisher, an illiterate Yorkshire-born mariner for whom the term "sea dog" might have been invented. By 1576 the forty-year-old Frobisher

Members of Frobisher's crew found a narwhal washed up on a Baffin Island beach in 1577. One of them drew the strange, mythic-looking beast, and the drawing was later made into this engraving.

had already established a reputation for belligerence and "strange oaths." He'd been kidnapped in Africa, served several jail terms, and made a fortune through piracy. But his aggressive patriotism had made him a surprising favourite of Queen Elizabeth I. With the backing of an ambitious London entrepreneur called Michael Lok, he proposed to find a route north of the American continent to China.

On June 15, 1576, Frobisher set off with thirty-seven men and three extremely small vessels. After a stormy crossing of the North Atlantic, the ships entered an inlet – "a greate gutte, bay or passage" – on the ice-encrusted Arctic shore. Frobisher immediately declared it to be the much-desired passage to Asia. However, the inlet, now named Frobisher Bay, penetrated only 100 kilometres into Baffin Island. Why did a sailor as experienced as Frobisher jump to such a hasty conclusion? Because he wanted it to be the fabled North-West Passage.

It was too late in the season to explore further, so Frobisher sailed home, taking with him a captured Inuk. In London his sealskin-clad hostage and his claim to have discovered a passage to Asia aroused less interest than a mysterious black stone collected by one of his sailors from a rocky Arctic beach. According to George Best, a seaman who chronicled Frobisher's voyages, the stone was "much lyke to a seacole in coloure, which by the waight seemed to be some kinde of metal or Mynerall. This was a thing of no accompt, in the judgement of the Captain at the first sight. And yet for novelty it was kept, in respect of the place from whence it came."

Frobisher's backer, Michael Lok, didn't see it as a novelty. Immediately he started prospecting among London's assayers for positive news about the

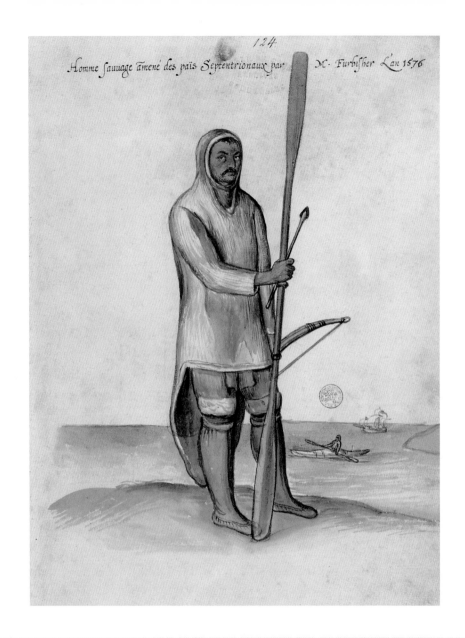

124

Homme sauuage amené des païs Septentrionaux par M. Furbisher L'an 1576

HOMME SAUVAGE AMMENÉ DES PAÏS SEPTENTRIONAUX PAR M. FURBISHER (PRIMITIVE
MAN BROUGHT FROM THE NORTHERN LANDS), LUCAS D'HEERE, 1576

*probably London, England;
possibly Ghent, Belgium
paper manuscript with coloured pictures
32.2 x 21.1 cm*

In 1576 Frobisher kidnapped this Inuit man and brought
him back to England, where he soon died. But his Asiatic
features helped convince Frobisher's backers that their man
had found the route to the Far East. Frobisher brought
home three Inuit from his second expedition in 1577 –
Arnaq, Nutaaq, and Kalicho who also died and were buried
in England.

stone's mineral content. The first three reported no precious metals, but the fourth, an Italian named John Baptista Agnello, told Lok what he wanted to hear: the stone contained gold worth £30 per ton of rock. When Lok asked why the other three assayists had missed it, Agnello replied enigmatically, "One must needs know how to coax nature."

People believed Agnello's alchemical fantasy because they wanted to believe it. An Arctic goldmine would give England a source of wealth to rival the booty Spain was carrying home from Central and South America. Rumours soon circulated that Agnello had underestimated the gold content. Like late twentieth-century Bre-X investors, Lok and his fellow speculators in London became crazed by the prospect of an instant fortune. The plan to find the North-West Passage was put on hold.

Kodlunarn Island today

Armed with Agnello's results, Lok quickly coaxed funds out of fellow merchants, wealthy aristocrats, and even Queen Elizabeth I for a second voyage. In May 1577 Frobisher sailed west again, this time with instructions to bring back as much "ore" as his three ships could carry. By July Frobisher had navigated them through fog, storms, and drifting ice to the northern entrance to Frobisher Bay. Although there appeared to be no more black rock on the beach where the original ore had been discovered, there was plenty on neighbouring islands. Frobisher decided to concentrate on the most accessible source: a seam of black ore on an island he named the Countess of Warwick's Island, and today called Kodlunarn ("white man's island" in the language of the Inuit).

For the rest of the brief Arctic summer, Frobisher's men worked like dogs, hacking tons of rock from a seam that ran down a cliff on the tiny island. Hour

DRIED PEAS, APPROX. 1578

Kodlunarn Island, Nunavut
approx. 0.5 cm

Many years after Frobisher's third and last voyage to the Arctic, these dried peas were discovered in the remains of the settlement on Kodlunarn Island, the centre of Frobisher's mining operations.

PIECE OF A BASKET, APPROX. 1578

Kodlunarn Island, Nunavut
wood (possibly willow)
size unavailable

The remains of this basket, which was used by Frobisher's men to carry ore to his ships, was discovered in the "Ship's Trench" mine on Kodlunarn Island. In recent years the Canadian Museum of Civilization has led a major effort to protect what's left of Frobisher's temporary settlements and his ten separate mining sites, the most productive of which was the Countess of Sussex site on the Baffin Island mainland.

after hour they chipped away at the seam, swatting off blackflies and mosquitoes, sweating in the midday heat or shivering in wet snow or clammy white fogs, working late into the summer twilight. They loaded the black boulders into baskets, carried the baskets to the boats, then rowed the boats out to the ships and tumbled the baskets into the holds. Each time they lifted their heads from their back-breaking labours, all they saw was a barren land and an empty sea. All they heard was the scream of gulls, the crash of waves, and the sighing of the wind.

While the 1577 haul of ore was carefully hidden away near Bristol, Michael Lok built furnaces to refine it on the lower Thames near Dartford. Meanwhile, in May 1578, the old sea dog set off on his third and most ambitious northern adventure. This time there were fifteen vessels – the largest fleet ever sent into the Arctic before the twentieth century – which carried along with their crews 150 miners from cosy Midlands mining villages.

A metal assayer at work. Engraving from De re metallica *by Georg Agricola, the main textbook on mining and metallurgy in Frobisher's day*

The Midlands miners must have found the stormy transatlantic voyage and the Arctic's treeless landscape terrifying. But they dutifully worked the Kodlunarn seam, as well as several others on neighbouring islands, chosen, according to Best, "by gesse of the eie." In October, when Frobisher's ships once again sailed up the Thames, they unloaded most of their cargo at Dartford, where Lok's smelter was now ready to refine it. According to Lok's account book, the smelter consisted of "two great work-housses, & two water mylles, with five great melting furnaces in the same houses, & one great Colehous, & other necessarye workhouses."

The results of the first two trials were "verye evill," and things went downhill from there. The ore contained no gold or silver. Shipowners, miners, and mariners were still unpaid; the costs of constructing the smelter had not been

met; and the investors were scared. Lok described Frobisher as "full of lyinge talke," and Frobisher retorted that Lok was "a bankerot knave." Lok went to jail and died penniless, while Frobisher's reputation suffered badly – although he once again proved himself a survivor. Queen Elizabeth soon forgave him, and ten years later he was knighted for helping to defeat the Spanish Armada. Most likely the scam was perpetrated by assayers rather than by Frobisher himself.

By 1580 local Dartford workmen were helping themselves to the pile of worthless Arctic rocks for use in the construction of the wall bounding the nearby Queen's Manor House. In the Arctic the efforts made by Frobisher's men are still visible: from a small plane, you can clearly see the 25-metre-long and 5-metre-wide scar on Kodlunarn's bleak cliffs. But Frobisher's "gold" was amphibolite flecked with mica, which, when heated, glows a deliciously misleading golden colour. The gold hue disappears as soon as the rock cools, but a wall built partly of Arctic amphibolite will last more than four hundred years.

BLACK ORE SAMPLE, APPROX. 1577

near Frobisher Bay, Nunavut
minerals in ore: hornblende (main),
feldspar, pyroxenes, mica,
spinel (in lesser quantities),
and gold (in very low quantities)
size unavailable

These otherwise quite uninteresting metamorphic rocks fooled Frobisher's backers because they were flecked with mica. The root of mica is probably the Latin word *micare*, which means to shine, to glitter. But, as the proverb says, all that glitters is not gold. The explorer would have been well advised to stick with his initial assessment of the rock: "That this was a thing of no accompt."

Salon de la Nouvelle France

1603 to 1734

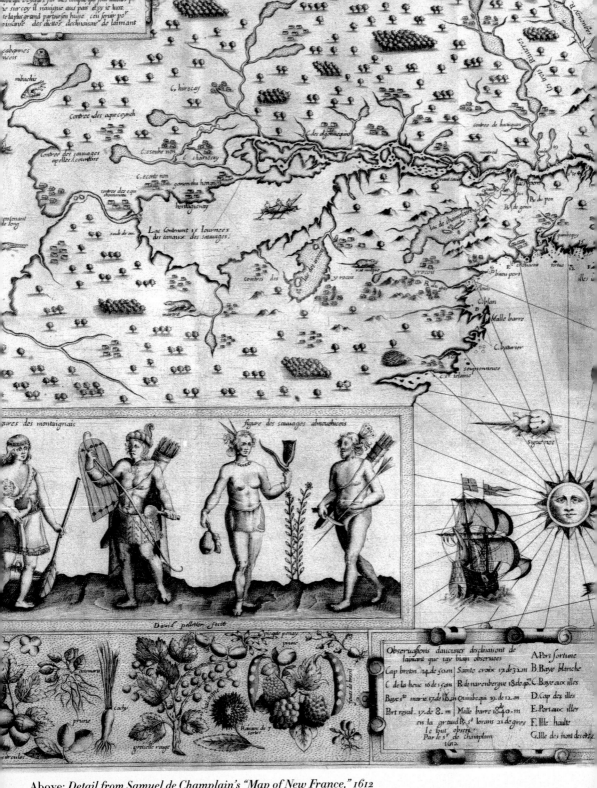

Above: *Detail from Samuel de Champlain's "Map of New France,"* 1612
Opposite: France Bringing the Faith to the Indians of New France, c. 1670

In 1604 a map-maker from Brouage, France, named Samuel de Champlain set out for Acadia, a region roughly corresponding to today's Maritime provinces. On the eastern shore of the Bay of Fundy he helped to establish Port-Royal, which would become France's first successful settlement in North America. In 1608 Champlain returned to the New World as the lieutenant-general of New France. He brought with him a commission to found a colony close to the thriving fur trade already being conducted from a post at Tadoussac, where the Saguenay River joins the St. Lawrence River. For his first settlement Champlain chose the place Jacques Cartier had known as Stadacona, a strategic site 200 kilometres upriver from Tadoussac at the foot of cliffs that rise almost 100 metres above the St. Lawrence. There he built a fortified town from which he could command the St. Lawrence, at a place where it narrows to roughly 1 kilometre in width. From Champlain's first *habitation* grew the city of Quebec, which developed as the capital of the new colony.

A view of Quebec City, c. 1900

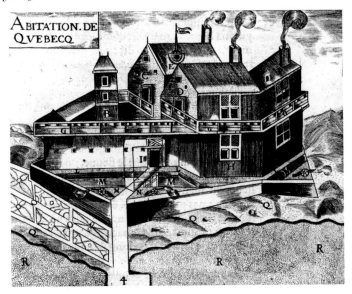

ABITATION. DE QVEBECQ

ABITATION DE QUEBECQ (HABITATION OF QUEBEC), SAMUEL DE CHAMPLAIN,
CONSTRUCTION BEGAN 1608, DRAWING PUBLISHED 1613

Quebec City, Quebec;
published in Paris, France
line and stipple engraving
13.1 x 15.9 cm

As soon as Champlain arrived at the site he had chosen in July 1608,
his men set feverishly to work to build enough of their settlement to
provide shelter over the coming winter. The palisade enclosing the
tiny town would not be completed until 1610, by which time its
founder could describe his first *habitation* as follows: "Our quarters ...
contained three main buildings of two storeys. Each one was three
fathoms long and two and a half wide."

VESTIGES OF THE NORTHWEST ANGLE OF THE MAIN DWELLING OF CHAMPLAIN'S SECOND HABITATION, 1624

Quebec City, Quebec
schist, limestone, granite (walls),
and white pine (floors)
size unavailable

Champlain's first *habitation* did not wear well in the Canadian climate and became almost impossible to maintain. So he decided to replace it with one of sturdier construction. The walls of his second *habitation* were made of schist, limestone, and granite. Its wooden floor was covered with red, pink, and yellow tiles. Bricks for the building came from France. He sited this second fortress atop the cliffs formed by the St. Lawrence escarpment and modelled its north façade after the medieval chateaux in the Loire Valley.

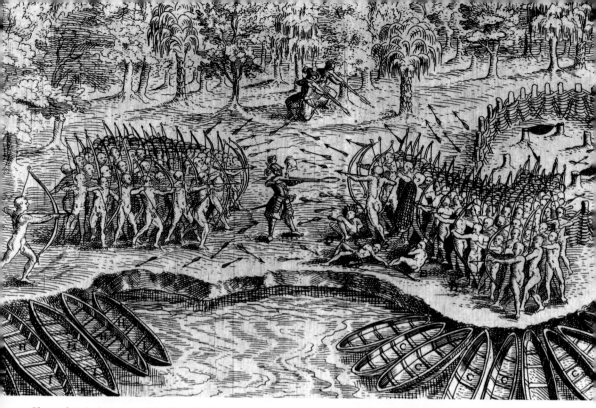

Champlain's drawing of the French victory over the Iroquois at Lake Champlain in 1609

SWORD GUARD, EARLY 17TH CENTURY

Quebec City, Quebec
wrought iron
approx. 8.6 x 11 cm

A sword guard, a piece of metal separating the blade from the sword handle, protects the holder's hand. This one likely belonged to a sword that saw action during the long struggle between the French and the Iroquois nations. The Iroquois were the traditional enemies of the tribes that supplied the French with fur – the Hurons, Algonkins, and others – with whom the French quickly allied themselves. The conflict ebbed and flowed but lasted for almost a hundred years.

Below right: An engraving from the 1619 edition of Champlain's Voyages *showing Indians with bows and arrows, spears, and what appears to be a paddle*

IROQUOIS CLUB, END OF 16TH CENTURY OR EARLY 17TH CENTURY

*Great Lakes area, Canada
wood with embedded shells
51 x 13 x 6.5 cm*

The five original groups of the Iroquois Confederacy – the Mohawk, Oneida, Onondaga, Cayuga, and Seneca – used war clubs like this one in battle. Sometimes, in advance of a skirmish, Iroquois warriors would leave a war club on the expected battlefield as a provocation to the enemy. The Iroquois were skilled fighters whose superior knowledge of the terrain and successful use of guerrilla tactics, such as ambushes, compensated for their lack of armour, arquebuses, and artillery.

An illustration from the first edition of Champlain's Voyages,
published in Paris in 1613

MARINER'S ASTROLABE, 1603

Made in France;
found near Cobden, Ontario
brass
19 x 14.5 x 3.1 cm

Did Samuel de Champlain lose this astrolabe while portaging from lake to lake in the area near Cobden, Ontario, in 1613? There's no doubt that the founding father of New France carried such an instrument during his travels, for it had replaced the quadrant as the preferred method of determining latitude. And it's reasonable to suggest that Champlain mislaid it near what is now called Astrolabe Lake, for he is known to have paddled on the lake that year. The astrolabe was discovered in 1867, 254 years after Champlain's visit there. It is in fine condition, missing only a small ring, originally attached to the bottom edge, from which a weight was suspended to keep it plumb. This missing ring disappeared sometime between the astrolabe's discovery and the present day.

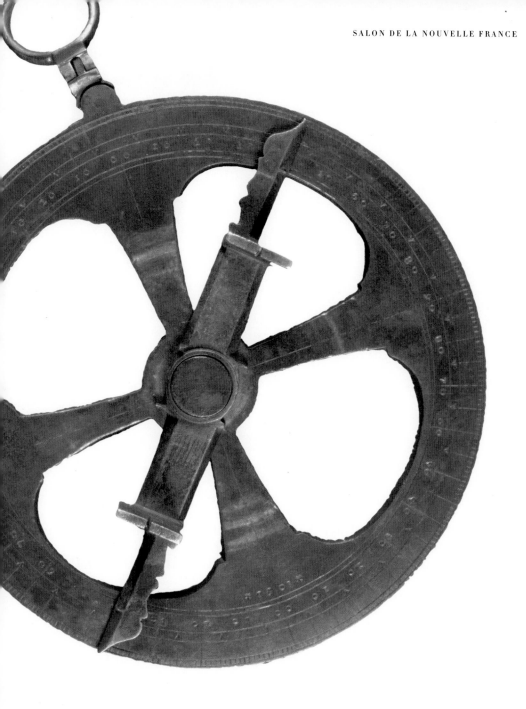

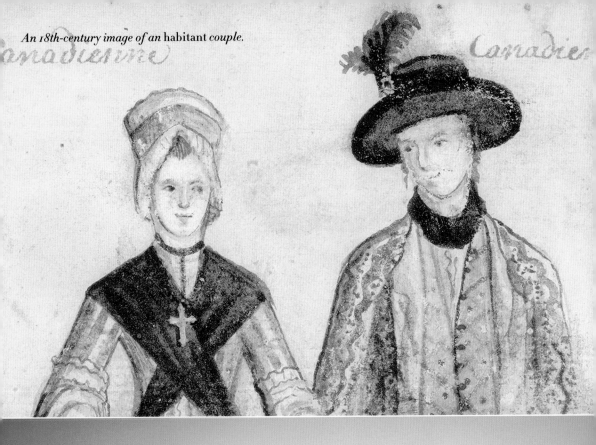

An 18th-century image of an habitant *couple.*

The first person to clear and cultivate land in New France was Louis Hébert, an apothecary who had visited Canada three times before he finally settled there for good in 1617. He was given about 4 hectares of land near the present location of the cathedral in Quebec City. For the next fifty years, however, the conflict with the Iroquois prevented any major agricultural development. Only in the relative stability following a peace treaty between the French and the Iroquois in 1667 did farming become widespread. Those willing to take up agriculture – the *habitants* (literally, "inhabitants") – were given grants of land, which they were expected to bring under cultivation.

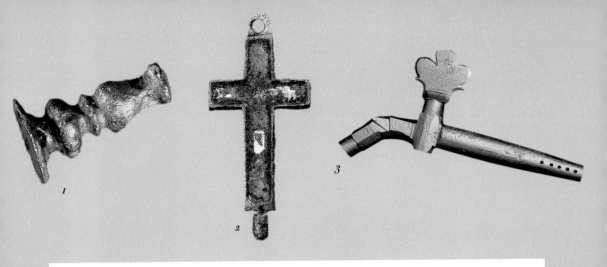

1 HANDLE OF A SPOON, 17TH CENTURY

Quebec City, Quebec
tin alloy
2.16 cm

2 CROSS, 17TH CENTURY

Quebec City, Quebec
copper
3.49 x 1.54 cm

3 BARREL TAP, 17TH CENTURY

Quebec City, Quebec; made in France
brass
15.5 cm

4 DRINKING VESSEL, 17TH CENTURY

Quebec City, Quebec; made in
Normandy, France
stoneware
24 x 16 cm

By the second half of the seventeenth century, French civilization had established a foothold in and around Quebec. The elaborate spoon handle indicates the emergence of a wealthier class in the colony (no *habitant* could have afforded such a fine thing). The cross, which would have been attached to a chain of rosary beads, confirms the hold of the Catholic Church. The barrel tap, which allowed liquid to be decanted from a barrel, and the gourdlike hip flask, which carried water or stronger drink, are further signs that leisure and domesticity had taken root in the colony.

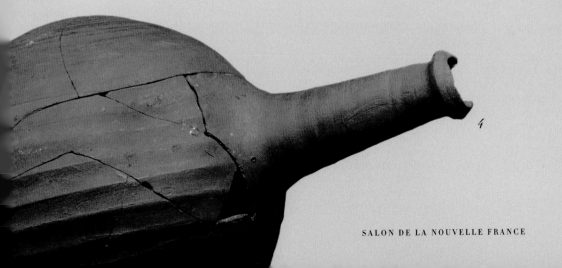

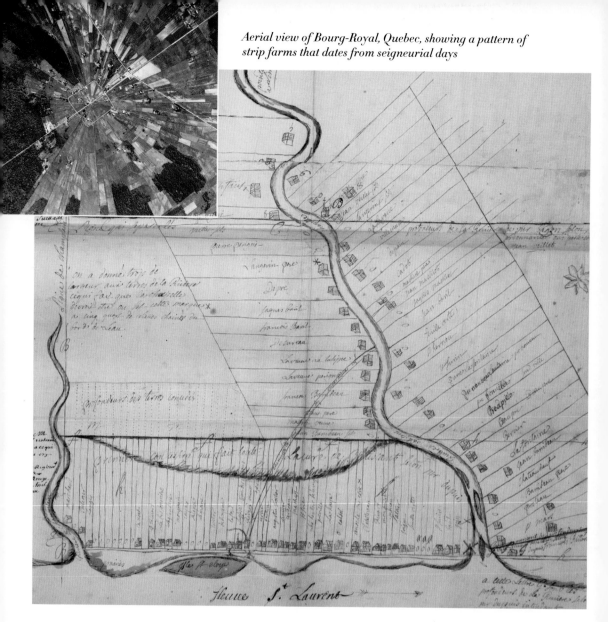

Aerial view of Bourg-Royal, Quebec, showing a pattern of strip farms that dates from seigneurial days

"LE PLAN CADASTRAL DE BATISCAN, SEIGNEURIE DES JÉSUITES" (CADASTRAL SURVEY OF BATISCAN, A SEIGNEURY BELONGING TO THE JESUITS), ANONYMOUS, 1725

New France
paper, watercolour,
and ink
47.3 x 62.6 cm

This map of an area of farmland on the north shore of the St. Lawrence River just east of Trois-Rivières depicts the typical settlement pattern that resulted from the seigneurial system, which was instituted in New France in 1623. Initially, land was granted to seigneurs – French aristocrats, successful bourgeois, or clergy. These colonial landlords were required, in turn, to parcel the land out to *habitants*. They usually did so in this "strip farm" pattern, so that each farm would have some river frontage. The seigneur built roads and a grist mill and provided common pasture land; in return, each *habitant* paid him a portion of his farm income.

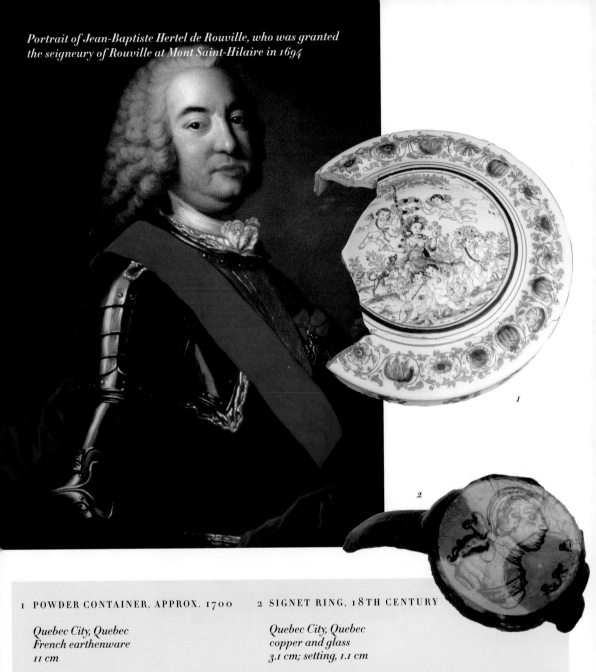

Portrait of Jean-Baptiste Hertel de Rouville, who was granted the seigneury of Rouville at Mont Saint-Hilaire in 1694

1

2

1 POWDER CONTAINER, APPROX. 1700

Quebec City, Quebec
French earthenware
11 cm

2 SIGNET RING, 18TH CENTURY

Quebec City, Quebec
copper and glass
3.1 cm; setting, 1.1 cm

By the end of the seventeenth century, New France had evolved into a stratified class society, a frontier echo of the mother country. The landed gentry (seigneurs), the clergy (the other big landowners besides the Crown), and the government officials formed the aristocracy, who, as these two artifacts attest, dressed and acted much like aristocrats back home. The decorated ceramic container held a supply of finely ground starch scented with orange flower, lavender, orrisroot, and other perfumes, which was used for powdering wigs. The signet ring would have been used to impress its owner's mark on the wax seal that closed letters or envelopes or to certify official documents. This one bears the portrait of a soldier and the initials *FKP*.

STATUE OF ST. URSULA, PIERRE-NOËL LEVASSEUR, APPROX. 1730

Quebec City, Quebec
polychrome wood
171 x 71.5 x 58.5 cm

This statue of St. Ursula is associated with the first female religious order in Quebec. As settlement expanded, the Jesuits and the Ursuline nuns took over formal education and religious indoctrination in the colony. The Ursulines opened a school for settlers' and native children in 1642, seven years after the Jesuits had established the first college in Quebec – and the same year that Samuel de Champlain died at the age of sixty-five.

EMBROIDERED CLOAK, APPROX. 1704

Quebec City, Quebec;
made in France
silk, cotton, brass, and gold
140 cm x 274.5 cm

This elaborately embroidered priest's robe dates from the early eighteenth century, but it is typical of the elaborate vestments worn by high-ranking Catholic priests in the early days of New France. This one was a gift from Louis XIV to Notre-Dame-de-Québec, Quebec's first church, built in 1633 by Champlain. It became the cathedral of New France in 1674, when Monsignor de Laval was installed as the colony's first bishop.

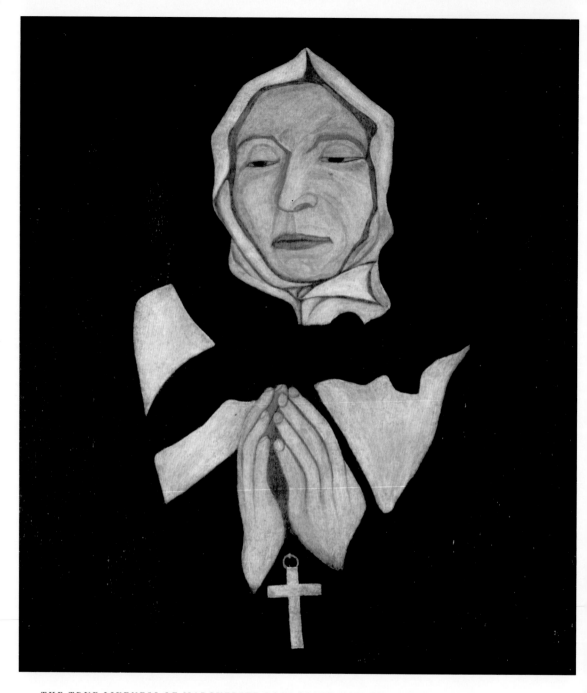

THE TRUE LIKENESS OF MARGUERITE BOURGEOYS, PIERRE LE BER, 1700

Montreal, Quebec
oil on canvas
62.3 x 49.5 cm

This is the earliest known painting by an artist born in Canada. For many years it lay hidden beneath a sweeter image, which was painted over this one in the nineteenth century. In 1963 the nuns of St. Marguerite's order had the painting x-rayed, and they discovered the original underneath.

THE KING'S DAUGHTERS
Marguerite Bourgeoys and the Birthing of New France

Tenacity and endurance gouged deep lines into the face of Canada's first female saint. In this deathbed painting (opposite) of seventy-year-old Marguerite Bourgeoys by Pierre Le Ber, we see a woman determined to fulfill her vocation despite poverty and privation.

Marguerite looks like the kind of woman we might admire today, while perhaps finding her a little overbearing. At some point in the mid-nineteenth century, however, the leaders of her order found Le Ber's portrait too harsh. They had the original painted over, replacing the stern survivor of the formative years of New France with a motherly, soft-skinned woman, her hands curled protectively around a crucifix and a smile tugging at her lips. The new Marguerite, hanging, as had the original, in Old Montreal's Bon Secours Chapel, radiated benevolence rather than determination, warmth instead of steel.

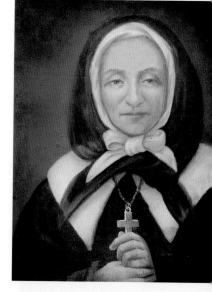

Around 1850 this image of St. Marguerite Bourgeoys was painted over Pierre Le Ber's image of her from 150 years earlier.

Why? Why, 150 years after Marguerite's death, did the sisters of the Congrégation de Notre-Dame smother her in sweetness? Why did they decide that their founder should project a softer, more traditionally "feminine" image? A campaign for Marguerite's canonization was gathering steam. Presumably, the unsmiling virago of Le Ber's portrait did not reflect their mid-Victorian views of how a female saint should look, especially one whose life story was intended to teach Christians about tolerance and compassion. No doubt the new, improved Marguerite was meant to reflect her greatest legacy, which was generally

agreed to be her work on behalf of families, women, and children in the formative days of New France.

Today it is the original face that speaks to us of the extraordinary woman Marguerite Bourgeoys was. She first felt her vocation back in France in 1640, when she was twenty. As a church procession paraded through her hometown of Troyes, young Marguerite locked eyes with the statue of the Virgin Mary and instantly knew she wanted to consecrate her life to God. After more than a decade working among the poor of France, she decided she must take the word of the Lord, along with her ferocious energies, to the newly founded settlement on the island of Montreal in New France.

In 1653 she arrived at Ville-Marie to find a bleak cluster of tents and wooden huts, housing a few unhappy colonists, encircled by dense forest. The total French-speaking population of New France was a mere 2,500, most of whom farmed around Quebec City. Iroquois warriors had already destroyed the large cross erected by the Ville-Marie colonists on the top of a nearby mountain. Theirs was a fragile outpost in a hostile land.

Life in New France satisfied Marguerite's hunger for discomfort and hardship. Until her death approached fifty years later, she slept on a straw mattress, shivered through bitter winters with only a blanket for warmth, and lived on a diet of rough bread, lard, and milk curds. She withstood disease, Indian raids, and harassment by the autocratic first bishop of Quebec, the Jesuit-trained François de Laval. She established schools for both French and Indian children, urged the construction of a chapel dedicated to Notre-Dame de Bon Secours, and founded the Congrégation de Notre-Dame.

But the survival of New France hung in the balance. There was only one woman for every ten to fourteen men in the colony, and there were constant threats from Iroquois warriors and English colonists

Louis XIV, king of France from 1643 to 1715

to the south. So Louis XIV was persuaded to sponsor a scheme to ship *filles à marier* (marriageable girls) to his North American possessions. Each woman had her transatlantic passage paid from the royal treasury, and many were also given a small dowry. There seems to have

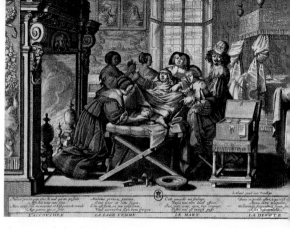

A scene of childbearing in eighteenth-century France

been no trouble attracting the first shipload of volunteer brides. Most were teenagers, many had lost one or both parents, and all could anticipate a life of poverty if they remained in France. The first shipment of thirty-six *filles* disembarked at Quebec City in 1663. Like brood mares purchased at a country fair, some were married before they had even left the wharf. Women considered "unworthy" beneficiaries of the scheme were shipped home. As the governor marched one heavily pregnant young woman back onto the boat, he declared: "This will ... prevent merchants from sending us such livestock." Only seventeen of the thirty-six original *filles* sailed on to Montreal, the larger community that now surrounded and dominated the original Ville-Marie.

"I went to meet them at the water's edge," Marguerite wrote in her memoirs, "believing that the house of the Blessed Virgin should be open to all girls." She lodged them in a small stone dwelling on Rue Saint-Paul, whose cramped quarters she shared so she could keep an eye on her new charges. "I had to live there because this was for the establishment of new families," she wrote.

At the house on Rue Saint-Paul, Marguerite saw to it that the newcomers would be well prepared for life on pioneer farms: they learnt how to sew, knit, spin, weave, launder, and cook, and how to make natural remedies from herbs and plants. She monitored the encounters between each girl and any prospective suitors, and witnessed many of their marriage contracts. And she dignified them with the title *Filles du Roi* (King's Daughters), the name they are known by today.

Ruins of the chapel built for Marguerite's congregation in 1675

Marguerite may have acted as their surrogate mother, but she would have been more like a school principal than a doting parent. She must have been impatient with the girls who failed to learn their catechism or who dilly-dallied about choosing a husband. She had to find homes for one year's residents before the next group arrived. Those thin lips must have tightened as she firmly told some reluctant bride that, if she refused a particular *habitant*'s offer, she would have to settle for a position as a household servant. The stern woman who had already survived a decade in the backwoods surely gave short shrift to any terrors a young Parisian might voice about Indians, bears, or snowstorms.

Eventually more than seven hundred women were sent to New France, 133 of whom passed through Marguerite's care. The *Filles du Roi* dutifully discharged their obligations: within ten years of the first arrivals, the population had almost tripled. Locally, Marguerite Bourgeoys was soon known as the "Mother of the colony."

In 1963 the sisters of the Congrégation de Notre-Dame x-rayed the portrait of their founder and discovered, underneath, the woman Pierre Le Ber had portrayed on her deathbed. This original was restored – and Marguerite didn't need their disguise after all. In 1982 Pope John Paul II declared her a saint.

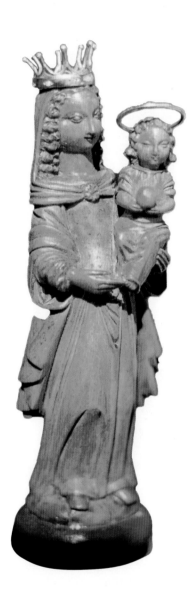

STATUETTE OF THE MOTHER AND CHILD, NOW KNOWN AS "NOTRE-DAME-DE-
BONSECOURS," GIVEN TO MARGUERITE BOURGEOYS IN 1672, MADE APPROX. 1572

Belgium
oak
approx. 16 cm

This statuette was given to Marguerite Bourgeoys in 1672 by the Baron de
Fancamp, a benefactor of the Société de Notre-Dame de Montréal. Although
made of wood, the statue miraculously survived the fire that later destroyed
the chapel.

1 POT, EARLY 17TH CENTURY	2 SPANISH COLONIAL COIN, 1734	3 WOMAN'S SHOE, 18TH CENTURY
Quebec City, Quebec *terra cotta* *6.9 cm; dia. base, 8.3 cm*	*Mexico City, Mexico* *silver* *4.1 cm*	*Quebec City, Quebec* *wood and leather* *9.5 x 25.8 x 8.2 cm*

These items – a pot (possibly for warming chocolate), a lady's shoe, and a foreign coin – are evidence of the sophistication of New France in its glory days of the late seventeenth and early eighteenth centuries. By this time, ships from the French possessions in the Caribbean regularly brought delicacies such as coffee and chocolate to Quebec. A Swedish visitor to New France in the mid-eighteenth century commented that the women wore such narrow, high-heeled shoes that he wondered how they were able to walk at all. And trade brought currencies from around the world into New France, including this Spanish coin.

VERSO RECTO

FACSIMILE OF BOTH SIDES OF A PLAYING CARD USED AS MONEY, FROM 1684 ONWARDS

Quebec or Paris
watercolour and India ink
43.2 x 44.8 cm

In 1684, faced with a shortage of coins, Intendant Jacques de Meulles, the chief administrator of the colony, began issuing playing cards like this one as legal tender. The money was used to pay the increasing number of soldiers who had arrived in New France since 1665 to help build the colony and protect it from Iroquois attacks. After the soldiers completed their military service, the Crown encouraged them to stay by offering them land.

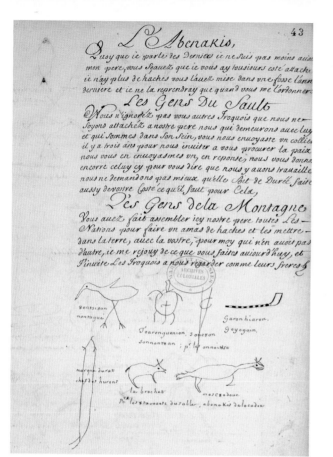

PAGES FROM "TRAITÉ DE LA GRANDE PAIX DE MONTRÉAL" (THE GREAT PEACE TREATY), 1701

Montreal, Quebec
manuscript paper
29.7 x 21 cm

The Great Peace signed on August 4, 1701, finally put an end to almost one hundred years of fighting between the French and the Iroquois Confederacy. The Iroquois, who were allied initially with Dutch traders in New York and then with the English, had plentiful supplies of firearms. Determined to dominate the lucrative fur trade that extended into New France, and possibly to obtain captives to replace lost warriors, they attacked the Hurons, Algonkins, and other groups that were allied with France. These vicious raids, known as the Iroquois Wars, dispersed all the rival groups but failed to bring the Iroquois the prosperity they wanted. Eventually, after Iroquois attacked the town of Lachine in 1689, the French countered with increasing

44

De ce que vous eclairez le soleil qui estoit obscure depuis la guerre,

Onanguisset Chef des Potrouatamis,

Je ne vous feray point un long discours mon pere, je n'ay plus que deux prisonniers que je mets a vos deux costez pour en faire ce qu'il vous plaira, voila un calumet que je vous presente pour que vous le gardiez, ou que vous le donniez a ces deux prisonniers afin qu'ils fument dedans chez eux, je suis tousiours prest a vous obeir iusqu'a la mort,

Misgensa Chef Ontagamis,

Je n'ay point de prisonniers a vous rendre mon pere, mais je vous remercie du beau jour que vous donnez a toute la Terre par la paix, pour moy je ne perdray iamais cette clarté,

Les Maskoutins

Je ne vous amene point d'esclaue iroquois par ce que je n'ay pas esté en party contre eux depuis quelque tems, m'estant amusé a faire la guerre a d'autres nations, mais ie suis venu pour vous obeir et vous remercier de la paix que vous nous procurez,

Les folles auoines.

Je suis seullement venu mon pere pour vous obeir et embrasser la paix que auez faite entre les Iroquois et nous,

Les Sauteurs et les Puants

Je vous aurois amené mon pere des esclaues iroquois si j'en auois eu, voulant vous obeir en ce que vous m'ordonnerez, je vous remercie de la clarté que vous nous donnez et ie souhaite quelle dure,

Les Nepissingues

Je n'ay pas voulu manquer a me rendre icy comme les autres pour escouter vostre voix, j'auois un prisonnier iroquois l'année passée que ie vous ay rendu, voila un calumet que ie vous presente pour le donner aux iroquois si vous le souhaité affin de fumer ensembles quand nous nous rencontrerons,

Les Algonquins

Je n'ay point de prisonniers a vous rendre mon pere, l'algonquin est un de vos enfans qui a tousiours esté a vous, et qui y sera tant qu'il viura, ie prie le maistre de la vie que ce que vous faites aujourd'huy dure,

La Mikois

N'ayant point d'autre volonté que la vostre j'obey a ce que vous venez de faire,

Signe, Le Chevalier de Calliere, S. *[illegible]* Champigny et autres,

force. After an epidemic of smallpox devastated the native population, the harried League of Five Nations returned to the negotiating table.

At the formal ratification of the Great Peace, 1,300 native delegates representing more than forty groups met in Montreal with French officials led by Governor Louis Hector de Callière. Each native leader signed the document with pictographs of totemic animals. But the treaty did little to revive the flagging economy of New France, suffering from a serious decline in the European appetite for beaver furs. In 1696 Louis XIV had already ordered all western French outposts to be closed. The future of France in the New World looked increasingly uncertain.

ATLANTIC PROMENADE

1600 to 1850

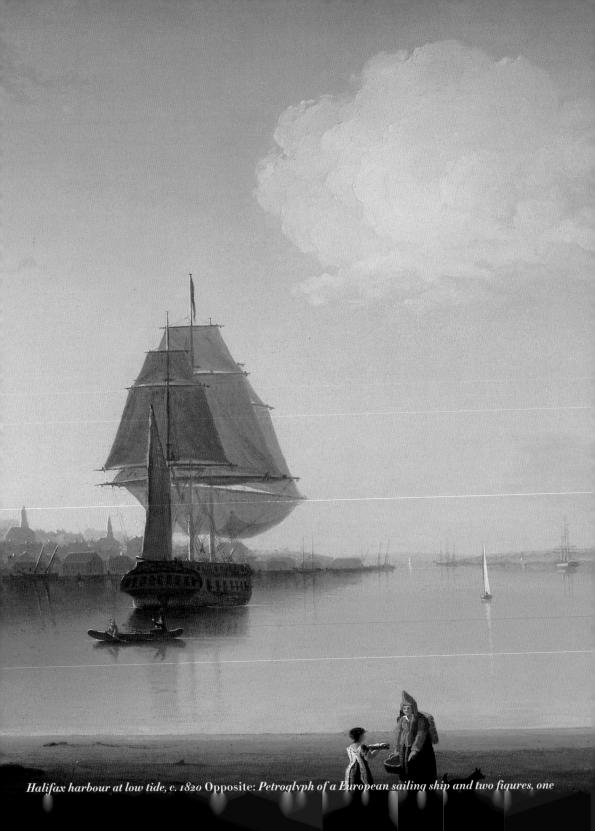

Halifax harbour at low tide, c. 1820 Opposite: *Petroglyph of a European sailing ship and two figures, one*

In contrast to the reasonably steady progress of France's colony, called Canada, settlement of the eastern coastline of northern North America was tentative and fitful. Champlain's first *habitation* at Port-Royal, built in 1605 on the east shore of the Bay of Fundy, was abandoned in 1607. In 1610 a second settlement was founded, only to be destroyed by marauding New Englanders in 1613. As for the British, who were already well established in colonies to the south, they had mixed feelings about putting down roots on the southeastern shore of Newfoundland. Powerful fishing interests feared that settlers would become rivals for Grand Banks cod, yet a colony was established in 1621. A few years later (in 1629) any stubborn French settlers who had remained at Port-Royal suddenly found themselves subjects of Sir William Alexander, the eldest son of a Scottish laird. His short-lived colonial experiment lasted only three years. In 1632 the Treaty of Saint-Germain-en-Laye restored the area to France. At that point, enduring Acadian settlement began.

THATCH, 1679-1755

Belleisle, NS
marsh grass
approx. 12 x 29 cm

The archaeological record of Acadian settlement is as fragmentary as this bit of roof thatch recovered from Belleisle, located several kilometres upriver from Port-Royal and the site of one of the earliest Acadian settlements. The enormous tides of the Bay of Fundy (which the French called the "Baie Française") created vast tidal flats. Using diking techniques brought by French settlers from Poitou and similar to those traditionally employed in the Netherlands, the Acadians transformed the tidal marshes into rich farmland. The village of Belleisle probably included about thirty houses built of clay and wood, with high, peaked roofs covered with thatch. Similar farming communities gradually spread along the coast. From just a handful of mostly male settlers brought to Port-Royal in the 1630s, their numbers grew to 500 by 1671 and 1,400 by 1707.

MARSH HORSESHOE, MID-19TH CENTURY

Westmorland County, NB
wood and metal
20.3 x 15.2 cm

Shoes like this one kept horses from sinking into the soft intertidal mud during the painstaking labour of dike-building. There were several types of marsh shoe; this is one of the simpler styles and uses a metal horseshoe to hold the shoe in place.

The exposed face of the Grand Pré dike, Grand Pré, Nova Scotia, 1926

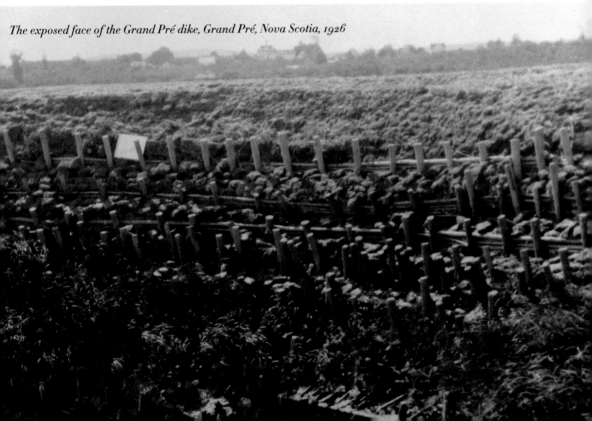

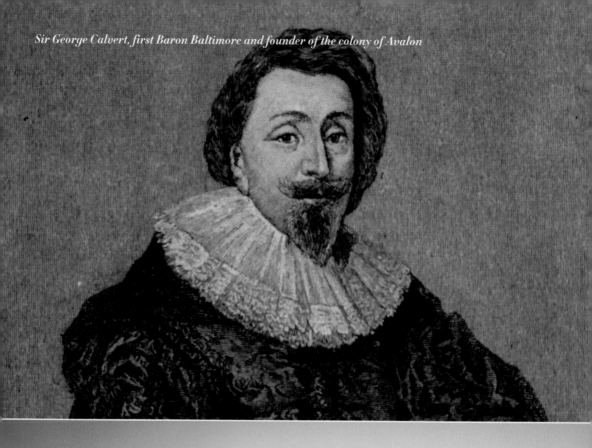

Sir George Calvert, first Baron Baltimore and founder of the colony of Avalon

Southeastern Newfoundland was the other area of Atlantic Canada to be settled early in the seventeenth century, this time by immigrants from Great Britain. They chose a site on the east coast of what is now the Avalon Peninsula, which had been visited by British fishermen for over a century. They came ashore to dry fish and mend nets, though they often faced raids from the Beothuks, the local native people. In 1621 an English nobleman named Sir George Calvert, the first Baron Baltimore, established a colony called Avalon. Its capital, Ferryland, was situated on a protected peninsula just south of Caplin Bay, about 60 kilometres south of present-day St. John's.

MODEL OF A BEOTHUK CANOE, 1819–20

Newfoundland
birch bark, spruce root,
wood, caribou sinew,
red ochre, seal fat
18 (bow), 13.5 (sheer)
x 80.5 x 18 cm

The Beothuk canoe's strongly hogged sheer (the central hump in the gunwhale) distinguishes it from all other native North American canoes. No full-size Beothuk canoe survives, but a number of smaller models, either recovered from graves or, like this one, made by one of the last surviving Beothuks, give us a reasonable idea of their construction. A skin of birch bark covered a spruce frame, which was reinforced with an interior keel, or keelson, to give the boat added strength for use at sea, catching fish or hunting sea mammals. Contemporary accounts describe these craft as being up to 6 metres in length, with room for four passengers. The hump in the gunwhale provided protection in heavy seas and allowed the canoe to heel over as much as 35 degrees as crews hauled in a catch.

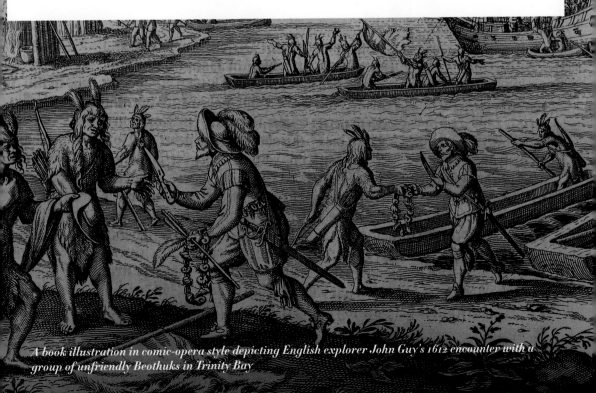

A book illustration in comic-opera style depicting English explorer John Guy's 1612 encounter with a group of unfriendly Beothuks in Trinity Bay

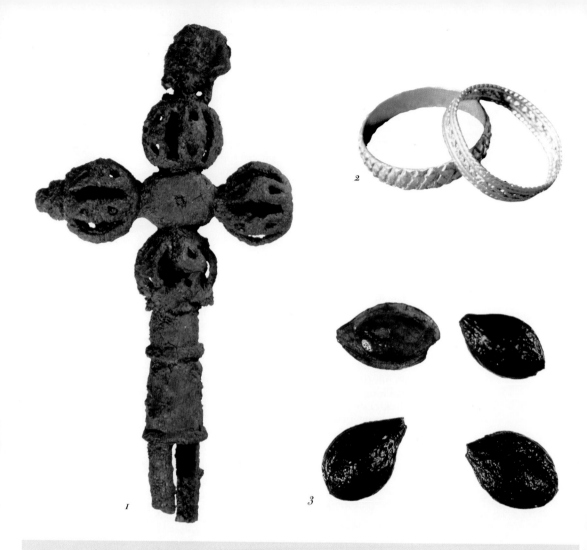

1 ORNATE CROSS,
MID-17TH CENTURY

Ferryland, Newfoundland
iron, wooden shaft with brass
lining, traces of gold
approx. 24 cm

3 PLUM PITS,
17TH CENTURY

Ferryland, Newfoundland
approx. 2 cm

5 PIPE,
LATE 17TH CENTURY

probably West African origin;
found at Ferryland,
Newfoundland
clay
remaining portion, 5 cm

2 FINGER RINGS,
LATE 17TH CENTURY

Ferryland, Newfoundland
gold and gold wire
approx. 2 cm

4 SPUR,
APPROX. 1600-50

probably made in England;
found at Ferryland,
Newfoundland
brass with gold plate
10.5 cm

6 CUFFLINKS,
LATE 17TH CENTURY

probably made in England;
found at Ferryland,
Newfoundland
silver and gold plate
face, 1.8 cm

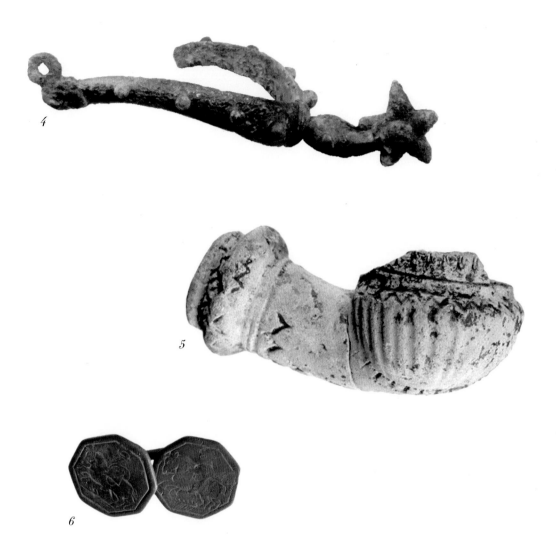

Archaeologists have recovered more than a million individual artifacts from the site of Ferryland. Items such as the gold-plated cufflinks and spur suggest that this tiny, isolated colony was fairly well off. The rings and the cross (which was discovered in the forge where it was being made) likely owe their style to the Irish origin of many of the settlers. Calvert (a convert to Catholicism) had visions of creating a religiously tolerant Eden in the New World. But when he finally moved with his family to his little colony in 1628, one harsh winter was enough to send him south to found the colony of Maryland. Still, the colony struggled along. By the mid-1630s there may have been as many as 150 settlers in Avalon from Ireland and England.

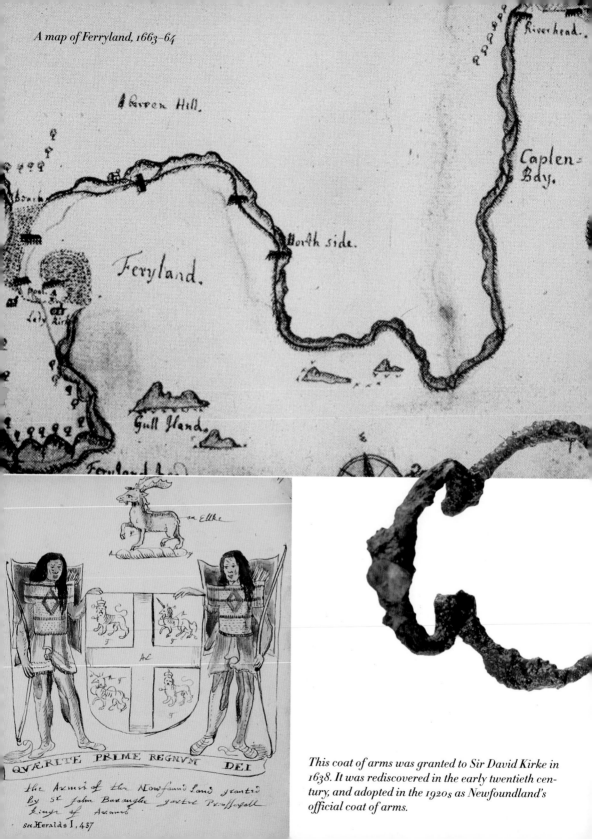

A map of Ferryland, 1663–64

This coat of arms was granted to Sir David Kirke in 1638. It was rediscovered in the early twentieth century, and adopted in the 1920s as Newfoundland's official coat of arms.

BASKET HILT, EARLY 17TH CENTURY

probably made in England;
found at Ferryland, Newfoundland
iron
original dimensions unknown

This hilt is all that remains of a sword that dates from the second major phase of Ferryland's existence, the reign of the Kirkes. In 1637 Charles I granted the "Newfoundland Plantation" to Sir David Kirke, in recompense for forcing him to return Quebec City to the French, from whom he had captured it in 1629. Sir David arrived with his family in 1639, took control of the colony, and renamed it the Pool Plantation. But when his royal patron was overthrown in the English Revolution, Kirke was summoned home, where he died in prison. His wife and three sons persevered, however, and became Newfoundland's first fish barons. They lost considerable property in 1665 and 1672, during raids by Dutch ships from New Amsterdam. Perhaps during one or both of these attacks a Kirke wielded the sword of which this is all that remains.

Port-Royal was attacked in 1654 and suffered a period of English rule in the 1660s. In 1662 France established an armed colony at Plaisance (now Placentia, Newfoundland) to protect the sea route to Quebec and its access to the Newfoundland fishery. From this base it invaded the English Shore in 1696, destroying farms and fishing boats. Great Britain countered by capturing Port-Royal for the last time in 1710. Under the Treaty of Utrecht in 1713, it gained title to all France's Atlantic possessions except Île Royale (Cape Breton) and Île Saint-Jean (Prince Edward Island). But the Acadians were accustomed to changes of civil authority. Their lives went on much as before.

Opposite: *Map of Île Royale by Louis Franquet,
1751, showing French settlement on the island
before its final capture by the British in 1758*

ATLANTIC PROMENADE *185*

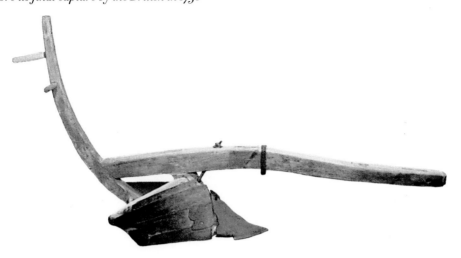

OX PLOUGH, 18TH CENTURY

*Kingsclear, NB
wood and iron
114 x 207.5 x 45 cm*

A single ox would have had no trouble pulling this plough through the rich
alluvial soil of the Acadian dikelands, where crops like wheat and barley
flourished. A fringe benefit of draining the marshes was the salt that could
be produced. This was used to cure fish, which, along with local game, pro-
vided plenty of food for the Acadian table. No wonder that Acadia's golden
age grew even more golden in the memory of those who had been forced to
leave their land.

*Early twentieth-century view of dikelands and the village of Grand Pré, which outwardly would have
changed little since the eighteenth-century*

LAN ET PROFIL
de la Tour de la
anterne a l'Entrée du
ort de Louisbourg.
our representer ce qui
este a faire pour la
rfectionner pendant
lannee 1733.

Ouvrage qui reste a faire pour
Aperfectionner la Tour.

Above: *Cross-section and elevation of the lighthouse tower at the entrance to the port of Louisbourg, 1733*
Above right: *Plan of the Dauphine Gate of the Louisbourg Fortress, 1733*

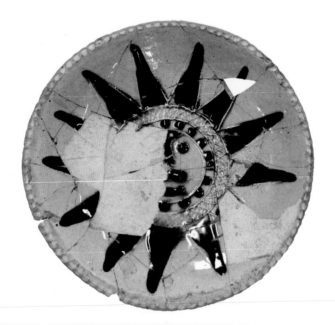

DISH WITH SUNFACE DESIGN, APPROX. 1722–50

*made in England;
found at Louisbourg, NS
Staffordshire-style slipware
approx. 22.4 cm*

This English plate from the Fortress of Louisbourg hints at the fort's enormous importance during the final phase of the struggle between France and Britain for control of North America. With Acadia and Plaisance now in British hands, the French constructed their strongpoint on the southeastern coast of Île Royale. By the 1740s it had developed into the largest, most cosmopolitan, and most prosperous French colony in North America, with a population of almost 3,000 souls.

DISHES, 18TH CENTURY

made in Jingdezhen, southern China; found at Louisbourg, NS porcelain approx. 22.4 cm

Archaeologists working at Louisbourg have collected over 69,000 fragments of fine Jingdezhen porcelain. This tableware was coveted by the aristocracy of New France, who were determined to live like their counterparts in the mother country. During its brief existence, Louisbourg became an important fishing port and mercantile centre. Total commerce at the fortress equalled that of the much older colony of Canada.

THE HALIFAX GAZETTE, MARCH 23, 1752

Halifax, NS
rag paper
39 x 24 cm

The city of Halifax developed quickly between its founding in the summer of 1749 by Colonel Edward Cornwallis (with 2,500 settlers, many of whom soon decamped for New England) and this first issue of the *Halifax Gazette* almost three years later. The fortified port town was built as a strategic counterweight to the French presence in Louisbourg and as a base for the English fishing fleet. This first newspaper published in Canada consisted of a single sheet, printed on both sides, featuring European, colonial, and local news along with advertising and official notices.

St. Paul's Anglican Church in Halifax,
Richard Short, c. 1760

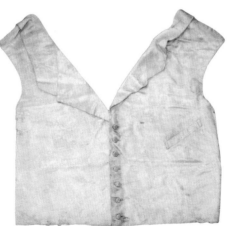

WAISTCOAT, 1750–1800

Glasgow, NS
silk, linen lining, cloth buttons,
nylon cord, hand sewn
52 x 49.5 cm

The delicate style of this silk waistcoat, decorated with leaves and flowers, dates it to the mid-eighteenth century. It belongs to the early days of British settlement in what are now Nova Scotia and New Brunswick.

Old French willows in Grand Pré, the heart of the Acadian countryside

Their capital might now be called Annapolis Royal and their property might now be part of a place called Nova Scotia, but the many Acadians who had stayed prospered during the first three decades of British rule, which historians refer to as Acadia's golden age, a time of rich harvests and increasing population. By 1750 there were about 9,000 Acadians living along the Bay of Fundy shore. But the good times couldn't last. As another war between France and Britain loomed, the Acadians' colonial masters grew increasingly fearful of the potential enemy within.

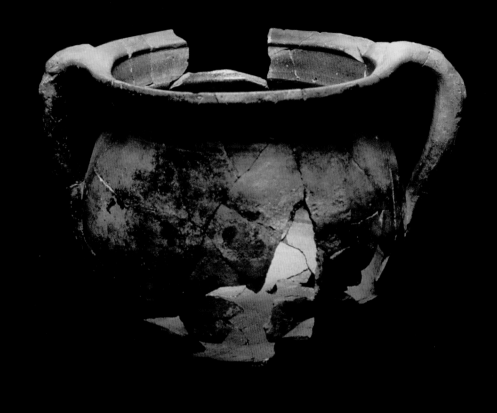

ROUND-BOTTOMED POT, BEFORE 1755

Melanson, NS
French earthenware
approx. 17 x 28 cm

This cooking pot was excavated from Melanson, on the north shore of the Annapolis River not far from Annapolis Royal. It evokes the hard-working daily lives of Acadian women, who not only cooked the meals and baked the bread (every house had an outdoor bake oven) but worked in the fields at harvest time and culled fish caught in weirs. Much of what the Acadians used they made themselves, but most ceramics, as well as objects of glass or metal, were imported. Villages were more like extended families, and the population was devoutly Catholic. One priest at Port-Royal in the late seventeenth century commented: "One sees no drunkenness, nor loose living and hears no swearing or blasphemy. Even though they are spread out four or five leagues along the shores of the river, they come to church in large numbers every Sunday and on Holy Days."

BLOCKHOUSE, ERECTED 1750

Windsor, NS
spruce timber
approx. 9 x 9 m

This blockhouse, the oldest in Canada and one of the few surviving mid-eighteenth-century buildings in Nova Scotia, is the only structure remaining from Fort Edward, built near present-day Windsor. It was intended to fore-stall attacks on Halifax by natives and Acadians and to intercept trade with the French fortress at Louisbourg, but it ended up playing a very different role. In July 1755 Nova Scotia governor Charles Lawrence offered the Acadians one final chance to swear an unconditional oath of allegiance to the Crown. They refused. So Lawrence and his council decided to solve the Acadian problem by deporting them to other British colonies or back to France. Fort Edward, which was one of the major assembly points during the expulsion, handled the deportation of approximately 1,000 men, women, and children. Between 1755 and 1763 more than 11,000 Acadians were forcibly removed from their homes.

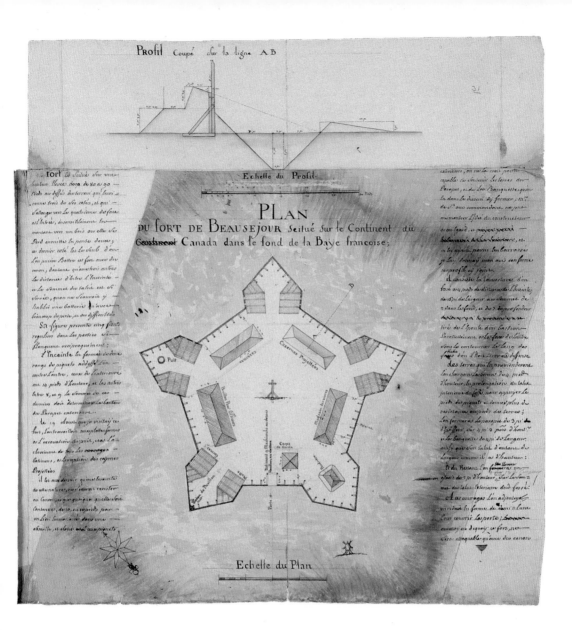

"PLAN OF FORT BEAUSÉJOUR, ON THE CHIGNECTO ISTHMUS," LOUIS FRANQUET, 1751

*Beauséjour, NS
paper (probably
linen paper)
42 x 39 cm*

In 1751, in order to block the British from spreading any farther west, the French built Fort Beauséjour on the isthmus that links present-day New Brunswick and Nova Scotia. In June 1755 a combined force of British regulars and Massachusetts volunteers besieged the fort, which capitulated two weeks later. The British renamed it Fort Cumberland and made it a strongpoint against New France during the Seven Years' War.

EXILE OF THE ACADIANS FROM GRAND PR

EXILE OF THE ACADIANS FROM GRAND PRE, ALFRED SANDHAM, 1850

London, England
wood engraving on paper
laid down onto light card
7.9 x 10.9 cm

The story of the expulsion and the subsequent return of many Acadians to what became the modern provinces of Nova Scotia and New Brunswick is part of the folk memory of the Acadian people. But it was not until an American poet named Henry Wadsworth Longfellow published *Evangeline, A Tale of Acadie*, in 1847, that the story took on the status of a national myth. The poem tells the story of a young Acadian girl, separated from her true love during the deportations from Nova Scotia. "Naught but tradition remains of the beautiful village of Grand-Pré," wrote the New England bard. But the fertile dikelands did remain, and today Grand Pré is an important site of Acadian pilgrimage.

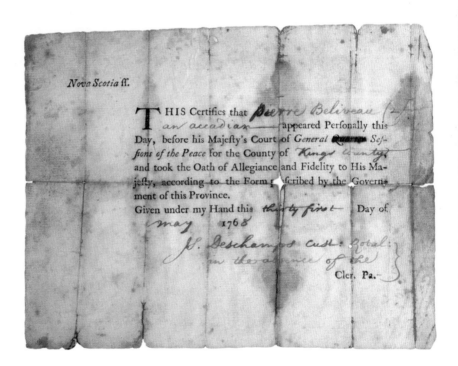

Nova Scotia ſſ.

THIS Certifies that *Pierre Beliveau* *an acadian* appeared Perſonally this Day, before his Majeſty's Court of *General Quarter* Seſſions of the Peace for the County of *Kings County* and took the Oath of Allegiance and Fidelity to His Majeſty, according to the Form preſcribed by the Government of this Province.

Given under my Hand this *thirty first* Day of *may* 1768

Jſ. Deschamps cuſt. Rotol: in the absence of the

Cler. Pa.

"OATH OF ALLEGIANCE" SIGNED BY PIERRE BELIVEAU, 1768

Windsor, NS
paper
16.7 x 21.1 cm

The first Acadians to return to Nova Scotia were those who had been deported to France, a place they found completely alien. In order to come back, they had to sign an unconditional oath of allegiance like this one. And when they returned to their homeland it was to start over: their lands and homes had been confiscated and remained the property of British settlers.

Late nineteenth-century view of Lunenburg harbour from Battery Point

VIEW OF LUNENBURG FROM BATTERY POINT.—SEE SUPPLEMENT, PAGE 392.

After Britain's acquisition of New France in 1763, all of Atlantic Canada belonged to British North America. In 1769 St. John's Island became an independent colony (later renamed Prince Edward Island). New Brunswick separated from Nova Scotia in 1784, and in 1785 Saint John became the first incorporated city in what is now Canada. In addition to the influx of Loyalists after the American Revolution, new immigrants began to arrive from the British Isles and the Continent. But as European settlement expanded, the space occupied by the area's original inhabitants shrank – and in some cases disappeared entirely.

TITLE PAGE OF *DER NEUSCHOTTLÄNDISCHE CALENDER AUF DAS JAHR CHRISTI 1789*

Halifax, NS
paper
size unavailable

This is the frontispiece of a German-language almanac published for the German population of Nova Scotia. Between 1750 and 1753 alone, some 2,400 Protestant German farmers and tradesmen had landed in Halifax with their families, as part of a policy aimed at countering the growth of Acadia. In 1753, 1,400 of them founded the port of Lunenburg.

MEMENTO MORI
Lady Hamilton's Portrait of "Mary March"

Under a magnifying glass, this exquisite miniature, painted on ivory in 1819, has an almost Van Gogh–like quality. The careful, flowing brushstrokes emphasize the rosy roundness of the twenty-three-year-old sitter's cheeks, her smoothly brushed hair, the rough sensuality of her fur collar, and her apprehensive expression. The subject, a young woman named Demasduwit, exudes a tired but trusting innocence.

From today's vantage point, however, the painter of the portrait was anything but innocent. Lady Henrietta Martha Hamilton was the wife of Sir Charles Hamilton, then governor of the British territory of Newfoundland. Henrietta entitled the portrait *Mary March*, using the name Demasduwit was given by the posse of angry Englishmen who had raided her encampment in the centre of Newfoundland and taken her prisoner in the spring of 1819. They called her March because she was captured on a bitter March day.

The angriest of the bunch was John Peyton, who ran a successful salmon fishing and fur business in Twillingate, an island in the mouth of the Exploits River on the northeast coast of Newfoundland. In the summer of 1818 a group of Beothuks had pinched Peyton's watch, some clothes, and a large amount of salted fish and sailing equipment. Peyton petitioned the British governor for permission to recapture his stolen property.

The British authorities had recently decided they had a duty to protect the Beothuk people, whose numbers by 1800 had dwindled to about 300 from a high of around 2,000 a couple of centuries earlier. Lady Henrietta's husband had naïvely thought he could use Peyton for two conflicting ends: the trader could recover his property and, at the same time, try to establish friendly relations with the Beothuks. Sir Charles granted Peyton permission to travel into the interior of Newfoundland "to take some of the Indians and thus through them open a friendly communication with the rest." When Peyton and his

PORTRAIT OF DEMASDUWIT (MARY MARCH), BY LADY HENRIETTA MARTHA HAMILTON, 1819

St. John's, Newfoundland The wife of the governor of Newfoundland created this miniature portrait
watercolour on ivory of the Beothuk woman Demasduwit shortly after she was captured by white
7.5 x 6.5 cm settlers. It is a unique and priceless record of a now-extinct people.

party stumbled into the Beothuk encampment on Red Indian Lake, they kept their guns hidden at first. But the encounter quickly deteriorated into a bloody battle in which Demasduwit's husband was killed and she was separated from the baby she had given birth to only days earlier.

None of Demasduwit's captors was able to ask her name in her own language. They were too busy chasing down her people, killing her relatives, and retrieving stolen goods to show her much compassion. After they were done, they dragged her off to Twillingate. Once the ice had left the harbour, she was conveyed to St. John's to meet the colony's British governor.

In the capital, Demasduwit was treated as a sort of *enfant sauvage*. She was "loaded down with presents by all parties," according to a contemporary account. "She was allowed to go into the shops, select whatever she fancied, and take it away without question." No other works by the governor's wife have survived, despite her obviously well-honed talent, so Henrietta Hamilton's decision to paint Demasduwit may have been a departure. The cultivated English gentlewoman must have wanted to record the dejected young woman as an interesting and increasingly rare anthropological specimen. She knew Demasduwit was one of only a handful of Beothuks ever captured by Europeans since the first recorded encounter over 400 years earlier; and she knew she was looking at one of the last surviving members of a dying people.

Whatever her motives, Lady Henrietta has left us our only picture of a Beothuk individual. The few Europeans who had encountered Beothuks always remarked on their unusual appearance. Unlike the local Innus, the Beothuks were as tall as Europeans; unlike the dark-skinned Mi'kmaq, Beothuk skin was a pale coppery gold, and their hair was brown rather than black. Twentieth-century anthropologists hypothesize that this Beothuk colouring was the result of intermarriage with Scandinavian merchants and settlers generations earlier. In this lovely miniature, the artist has faithfully depicted Demasduwit's golden skin and soft brown hair, characteristics that seem to confirm the case for Viking forebears.

From archaeological remains we know that the Beothuks inhabited Newfoundland long before any Europeans, including the tenth-century Vikings, came ashore. Demasduwit's ancestors spent their winters in pursuit of caribou, which provided them with meat to eat and hide for clothing. During the summer months they moved to the coast, where they hunted seals and whales and fished for cod and salmon. One Beothuk idiosyncrasy, smearing red paint (made from powdered ochre) on themselves, both as a decoration and a protection against insects, had long-lasting repercussions. The first Europeans who recorded their encounters with these people with red faces called them "Red Indians," a term that was soon generalized to cover all North America's aboriginal peoples. These early visitors were Basque fishermen, who began coming ashore to salt and dry their catches in the sixteenth century. From the moment the first Basque stepped on land, the Beothuks went on the attack, and the Europeans quickly learned to distrust them. The Beothuks were too hostile to share the interest in trade shown by the Mi'kmaq, Iroquois, Montagnais, or Cree peoples. As a result, they never acquired firearms with which to repel unwelcome visitors.

Those visitors arrived in ever-increasing numbers. Demand for fish in the Old World was enormous: the Roman Catholic calendar counted 153 meatless days a year. As European fishermen realized the extent of the great cod fishing grounds within Beothuk territory, their fleets crowded onto the Grand Banks. Their crews erected cod-drying racks, or flakes, on sites that the Beothuks used for summer fishing. The Beothuks tore down the flakes and stole equipment, but retreated into the interior of the island, emerging only for night-time raids on the invaders' settlements to steal "Sailes, Lines, Hatchets, Hookes, Knives and suchlike," in the exasperated account of one of the seventeenth-century "fishing admirals" of the Grand Banks. The Europeans

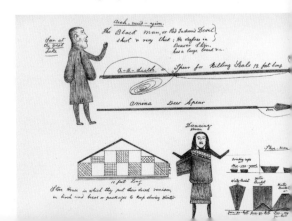

Drawings by Shawnandithit, the last-known surviving Beothuk, who died of tuberculosis in 1829

retaliated by killing Beothuks and destroying their property. There is a story, likely apocryphal, that over 300 Beothuks were driven out onto a peninsula near their favourite sealing site in 1800 and shot down like animals. Starvation and European diseases such as tuberculosis also took their toll. By the time Demasduwit arrived in St. John's in the summer of 1819, her people were on the verge of extinction.

After Demasduwit had spent a summer being indulged and painted in the noisy, bustling, squalid port, Sir Charles Hamilton decreed that "Mary March" must be returned to her own people. He hoped she would tell them how well she had been treated, so that friendlier relations might develop. But nobody could locate a single Beothuk. As winter approached, Demasduwit found herself back in Twillingate, lodged with a kindly Anglican missionary, the Rev. John Leigh. Before long, Mr. Leigh reported that his sweet-tempered lodger was painfully homesick. When a length of blue cloth went missing and his housekeeper searched Demasduwit's trunk, she found sixteen pairs of blue moccasins – one for each member of her family.

In the spring of 1820 Demasduwit died of tuberculosis. By the end of the decade, her Beothuk people were gone – a Newfoundland tragedy and a dreadful foretaste of what might lie ahead for aboriginal peoples in the rest of North America. Today Henrietta Hamilton's exquisite portrait of Mary March is one of the few pieces of physical evidence that an entire people ever existed.

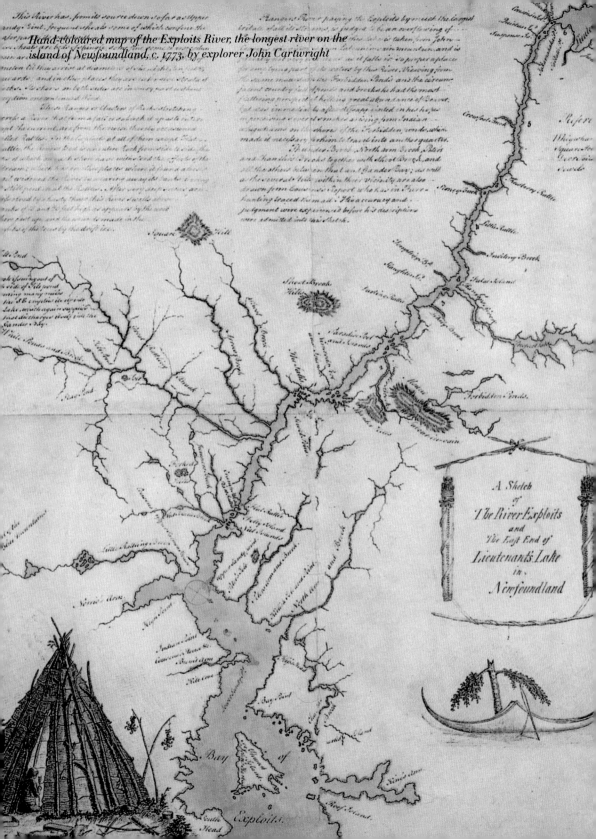

Hand-coloured map of the Exploits River, the longest river on the
island of Newfoundland, c. 1773, by explorer John Cartwright

A Sketch
of
The River Exploits
and
The East End of
Lieutenant's Lake
in
Newfoundland

TRAP ROOM
1627 to 1893

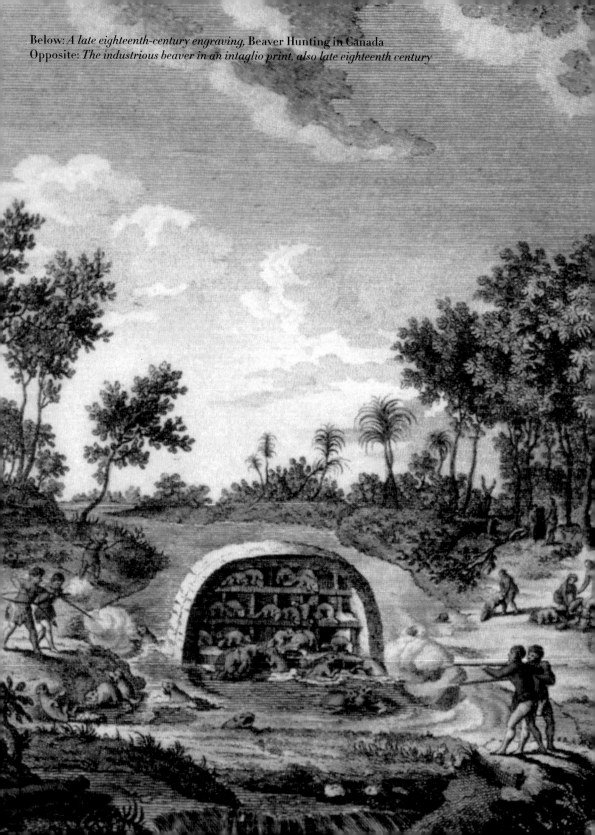

Trap Room
1627 to 1893

Long before Europeans visited Canada's shores, the aboriginal peoples of North America traded furs and other goods with each other, often over great distances. The first outsiders to barter for furs were the sixteenth-century sailors who came ashore to dry the fish they had caught. The furs they brought home fetched handsome prices, especially after the wide-brimmed felt hat became fashionable in the late 1500s. Beaver pelts, which made the best felt, were in such demand in Europe that, as the beaver population declined there, this insatiable market provided an economic impetus for permanent settlement in what is now Canada. The early French posts at Port-Royal, Tadoussac, and Quebec were established in the first decade of the seventeenth century, primarily as bases for the fur trade. Almost simultaneously the Dutch began trading along the Hudson River from their colony on the island of Manhattan. The quest to dominate the enormously lucrative North American fur trade was under way.

J. Ibbetson del.

J. Storer Sc.

Published by W. Darton, J. Harvey & W. Belch, London Aug.^t 1. 1797

SEAL OF THE COMPAGNIE DES CENT-ASSOCIÉS, 1627

France
wax
6.5 cm

This seal was the official mark of the Company of One Hundred Associates, the first enterprise to be granted the fur-trade monopoly in New France. The company, which was organized by Cardinal Richelieu, the powerful *éminence grise* at the court of Louis XIII, had a mandate to populate the colony, to convert the indigenous inhabitants to Christianity, and to trade French goods for furs. The front of the seal shows a woman standing on waves, holding a lily in her left hand and a Latin cross in her right hand, before a fleur-de-lys (the emblem of the French kings), with the motto *Me Donavit Lvdovicus Decimus Tertivus 1627* (Given to me by Louis XIII, 1627). The back of the seal shows a ship in full sail – presumably laden with furs on its way home to France – and the words *In Mari Viae Tvae* (The sea is your road).

BEAVER PELT, 20TH CENTURY

Chisasibi, Quebec
beaver skin and fur
48.1 x 37.4 cm

Prime beaver pelts like this one were the dominant currency of the North American fur trade. After the coarse guard hairs were removed, the short, barbed underfur of the beaver matted easily and made soft, durable, warm, and water-resistant felt for the large hats that were popular in Europe in the sixteenth century.

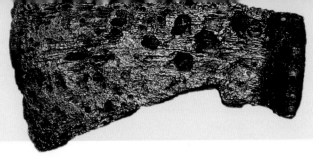

TRADE HATCHET, 17TH CENTURY

Quebec City, Quebec
iron
size unavailable

"I gave a hatchet to their chief who was as happy and pleased with it as if I had made him some right gift," wrote Samuel de Champlain in his journal in 1615. The Algonkian peoples, New France's first trading partners, valued objects such as axes, kettles, and knives.

EAR PENDANTS, BY ROBERT CRUICKSHANK AND JONAS SCHINDLER, APPROX. 1780

Montreal, Quebec
silver
5.8 cm

These ear pendants were collected by John Caldwell, who served in North America as an officer in the 8th Regiment of foot from 1774 to 1780 and was made an honorary chief of the Ojibwa Nation. They are the work of two Montreal silversmiths but their zigzag motif was extremely popular among Eastern Woodlands peoples.

BEAVER PENDANT, LATE 1700S

location unknown
white metal
(possibly silver or pewter),
moulded or pressed,
brass ring in head
4.45 x 1.9 cm

European craftsmen often modelled their work on traditional imagery such as beaver effigies, held to be of spiritual importance by the peoples of the Great Lakes region. This beaver pendant, stamped with the initials *DW* or *DVV*, may have been made in Montreal, the American colonies, or Europe.

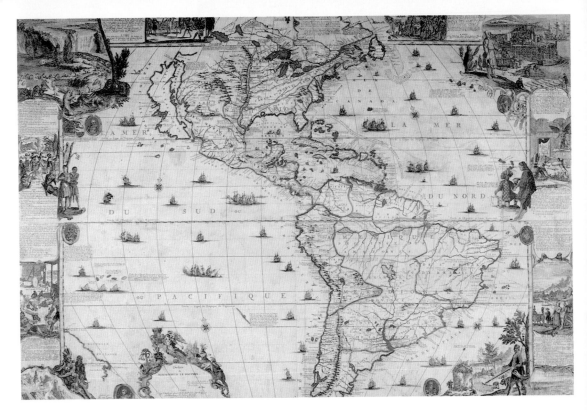

"L'AMERIQUE DIVISÉE SELON L'ETENDUE DE SES PRINCIPALES PARTIES: ET DONT LES POINTS PRINCIPAUX SONT PLACEZ SUR LES OBSERVATIONS DE MESSIEURS DE L'ACADEMIE ROYALE DES SCIENCES" (MAP OF AMERICA), NICOLAS DE FER, 1698

Paris, France
hand-coloured
engraving
89 x 99 cm

The western interior of this late seventeenth-century map is vague, and California is depicted as a vast island. The north and west of Canada are still a blank. However, the geography of the St. Lawrence basin and the Great Lakes is quite detailed, thanks to the European lust for beaver fur. By the time this map was drawn, the beaver and Canada were symbolically linked.

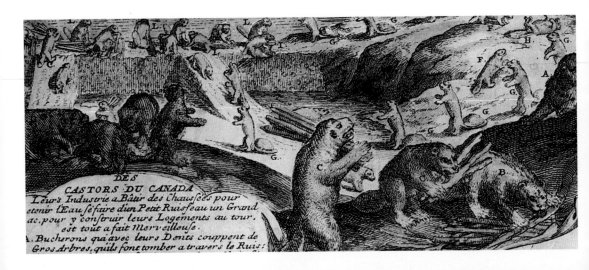

DES CASTORS DU CANADA
Leur's Industrie a Bâtir des Chauisées pour retenir l'Eau se fuire d'un Petit Ruisseau un Grand Lac, pour y construir leurs Logements au tour, est tout a fait Merveilleuse.
A. Bucherons qui avec leurs Dents couppent de Gros Arbres, quils font tomber a travers le Ruis.

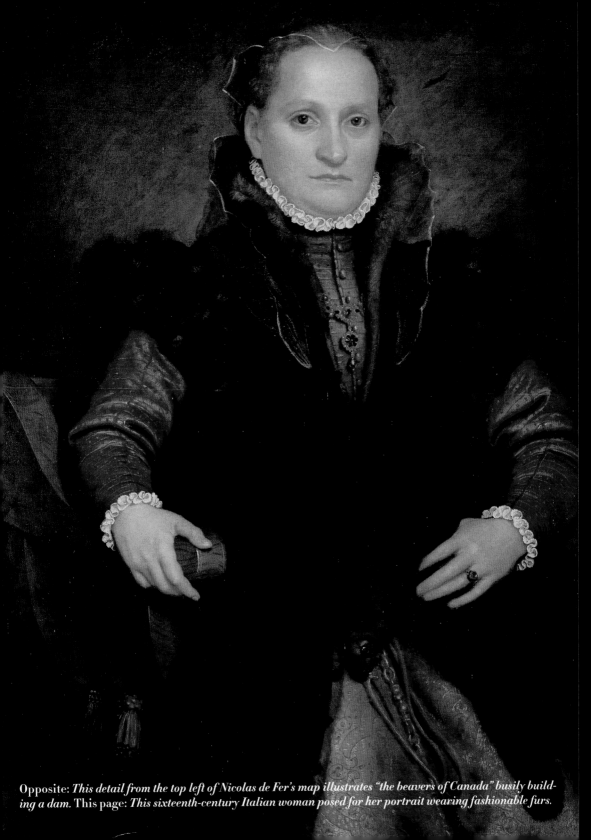

Opposite: *This detail from the top left of Nicolas de Fer's map illustrates "the beavers of Canada" busily building a dam.* This page: *This sixteenth-century Italian woman posed for her portrait wearing fashionable furs.*

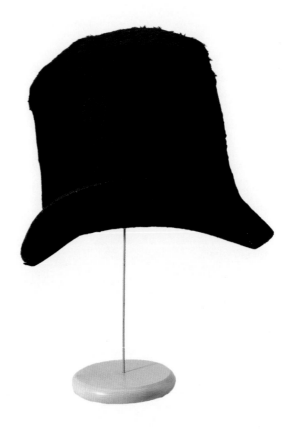

BEAVER HAT, 1820–40

Montreal, Quebec
beaver fur, silk lining
20 x 18.9 cm

This beaver hat in the "Wellington" style belonged to a solid Montreal citizen who would have worn it as a mark of status. Beaver hats stayed in fashion for roughly three hundred years, from the mid-1500s to the mid-1800s. During that long period almost every North American beaver pelt sold to European traders ended up as beaver felt for beaver hats. The felt-making process began with shaving the soft underhairs from a beaver skin and mixing them together with a vibrating hatter's bow. The loosely matted fabric that resulted was pummelled and boiled repeatedly, causing it to shrink and thicken into felt. The felt was then fitted over the hat-form block, where it was pressed and steamed into shape. Finally, the hatter brushed the outside surface to give it a nice sheen.

"CONTINENTAL."
COCKED HAT.
(1776)

"NAVY"
COCKED HAT.
(1800)

ARMY. (1837)

CLERICAL.
(Eighteenth Century)

(THE WELLINGTON.)
(1812)

CIVIL.

(THE PARIS BEAU.)
(1815)

(THE D'ORSAY.)
(1820)

(THE REGENT.)
(1825)

MODIFICATIONS OF THE BEAVER HAT.

An eighteenth-century engraving showing various shapes and styles of beaver hat

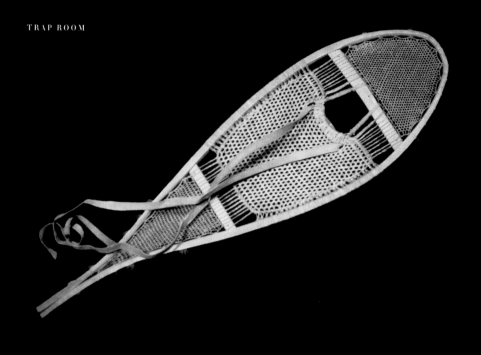

AMERINDIAN SNOWSHOE, LATE 18TH CENTURY (ABOVE)

North America
wood, animal gut and
wool
89 x 26 cm

The "strings" of this handmade snowshoe are made of animal gut, probably deer, moose, or caribou, and the wood is likely ash, which bends easily without breaking when heated with steam. The snowshoe was one of a number of native technologies, above all the canoe, that helped the French adapt to wilderness life, something a startling number of the young men of the colony chose over clearing and farming the land along the banks of the St. Lawrence. These *coureurs de bois* could make far more money in the fur trade, and they also enjoyed better prospects of finding female companionship.

CANOES FROM *CODEX CANADIENSIS*, LOUIS NICOLAS, 1675–80 (OPPOSITE)

Quebec (New France) and France
manuscript; brown ink and
watercolour on parchment
33.7 x 21.6 cm

This seventeenth-century drawing shows several different styles of First Nations canoes, though not all can be identified: 1) "Caneau de peau de tigre marin" (kayak); 2) "Canot de la nation du procpic" (Canoe of the Porcupine Nation); 3) "Canot des magoauchiwinouck"; 4) "Canot des amicouck"; 5) "Canot des algonkins" (Algonkin canoe). The figure at the top left is labelled "Sauvage de la nation des eschimeaux" (Eskimo). Eastern North American canoes were generally made with spruce frames sheathed in birch bark. They were sturdy but lightweight, easy to portage, quick to repair, and excellent temporary shelters – craft perfectly adapted to a world of forests, lakes, and rivers.

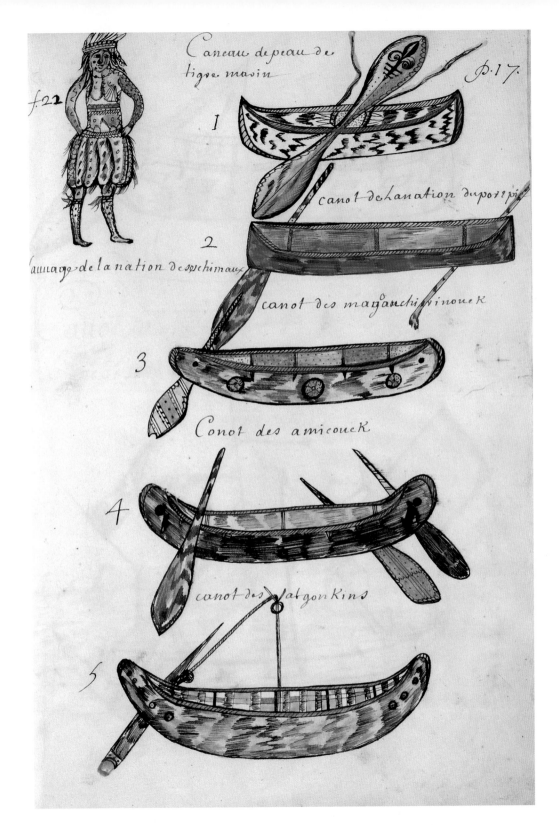

Caneau de peau de
tigre mavin

p. 17.

f. 22

1

canot de la nation du por? pic

2

Sauuage de la nation des seschimaux

canot des maganchisvinouek

3

Conot des amicouek

4

canot des Algonkins

5

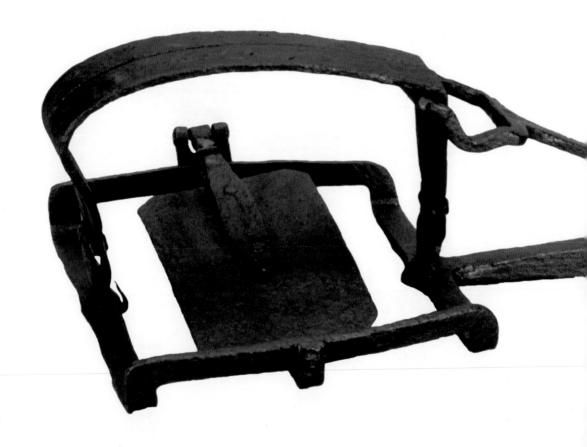

*How many ways can you catch a beaver? This 1703
drawing by a French trader illustrates a few options.*

SPRING TRAP, 1785–1850

*Quebec or Maine
steel
16.7 x 68 x 28.2 cm*

The exchange of technology between the French and the native peoples
went two ways. This imposing steel trap, whose heavy jaws and sensitive
spring mechanism caused it to snap shut like a giant mousetrap, was far
superior to traditional native traps such as the deadfall trap, in which heavy
logs or stones were rigged to fall and crush an animal. As the fur trade devel-
oped, metal traps made either in Europe or by the blacksmith at the local
trading post slowly made the old ways of trapping obsolete. A spring trap
would have been camouflaged with dead leaves or, in the case of beaver and
muskrat, submerged in water, so that the captured animal would drown.

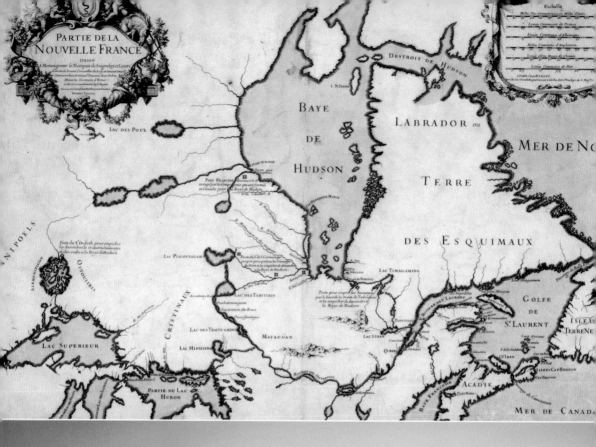

By the 1660s the French had established a trading network protected by a system of forts that extended to the limits of the St. Lawrence and the Great Lakes. The first real threat to this monopoly came in 1668–69, when the British ship *Nonsuch* wintered in James Bay and returned to England with a huge cargo of furs. The voyage was the brainchild of two renegade French-Canadian *coureurs de bois*, Pierre Radisson and the Sieur Des Groseilliers, supported by England's Prince Rupert. Two years later the prince became the largest investor in and the first governor of the Hudson's Bay Company.

Opposite: *This 1685 map of New France includes a*
reasonably accurate representation of Hudson Bay,
England's access route to the fur trade.

TRAP ROOM *219*

CHARTER OF THE HUDSON'S BAY COMPANY, 1670

London, England
parchment and handwritten text
80 x 65 cm

On May 2, 1670, England's King Charles II (whose portrait is top left) granted the company this founding charter, which proclaimed that "said Society as is hereafter expressed shall bee one Body Corporate and Politique in deed and in name by the name of the Governor and Company of Adventurers of England tradeing into Hudsons Bay." The grant included a trading monopoly over all lands that drained into the bay, a vast region to be known as "Rupert's Land."

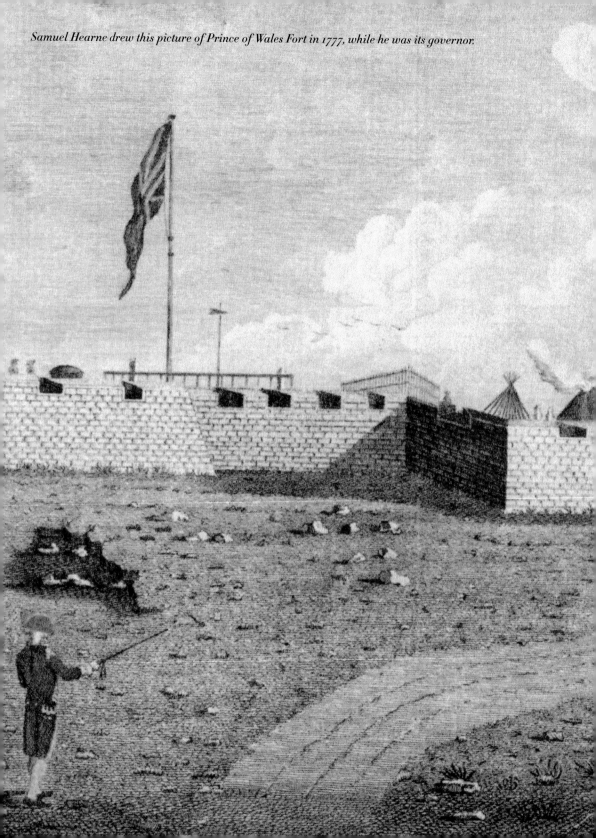

Samuel Hearne drew this picture of Prince of Wales Fort in 1777, while he was its governor.

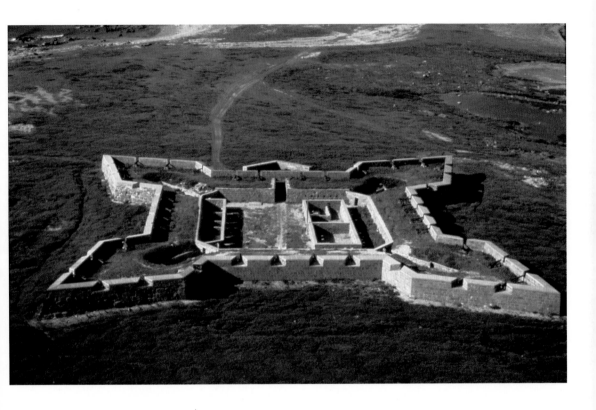

PRINCE OF WALES FORT NATIONAL HISTORIC SITE, 1731–71

near Churchill, Manitoba
quartzite and limestone
91.4 m square
(original fort outer walls,
6.5 x 11 m)

The Hudson's Bay Company built Prince of Wales Fort about 8 kilometres inland from the place where the Churchill River empties into Hudson Bay. It replaced an original post known as Churchill Factory, established in 1717, and served as a strongpoint against potential French attack and a convenient destination for native trappers with furs to trade. (It also served as a British base for the annual whale hunt.) Work on this classic star-shaped fortress with four protruding bastions began in the summer of 1731 and continued for the next forty years. While French traders penetrated deep into the interior to trade with the native peoples on their own turf, the British conducted much of their trade from a few fixed bases along the shores of James Bay and Hudson Bay. However, beginning in the 1770s with the establishment of Cumberland House, they moved inland to compete.

Hudson's Bay Company and North West Company forts face off at Île-à-la-Crosse, 1820

The North West Company had been established in the late 1770s by a partnership of powerful Montrealers to challenge the dominance of the Hudson's Bay Company. It quickly took over the St. Lawrence and Great Lakes trading route. Its agents, known as Nor'Westers, soon trespassed on the HBC's territory and gained control of the fur-rich Athabasca region, centred on Lake Athabasca in what is now northern Alberta and Saskatchewan. As a result, fewer furs reached York Factory and the other trading posts on the shores of Hudson Bay.

BEAVER CLUB JEWEL, 1792

Montreal, Quebec
gold
size unavailable

Retired luminaries of the North West Company established the Beaver Club of Montreal in 1785 and awarded each other "jewels," or gold medallions, engraved with their names and years of service. (This jewel was awarded to Archibald McLellan.)

Montreal fur barons Simon McTavish, James McGill, William McGillivray, and Joseph Frobisher

Buckwheat ... 5. 10

5 Almanaks ... 4. 5

4. 15. 1

Pd — 9 0

Scotch Game 6 yd — at 1. 6 yd — 9 0

1820 July 2 — 6 Am Norway Ho. Peter

1822 July 9 — 4 53. Harriet

1819 — June 18 — 5.45 — Margret — died July 21 8.55 Am Forks RR born at

1795 — June 20 — — 0. 8 Thomas York Factory

1798 Oct.r — 10 — 12.35 Charles Cumberland house

1800 Nov — 10 — 12.15 George Chesterfield house

1802 Nov — 26 — 2. 3 Sally Nottg house

1804 Oct.r — 12. 15. 42 Sacus oog gan Nottg Hou.

1806 Nov.t 29 — 22 50 andrew Cumb House.

1809 June 17. 4 — 0 alban Holy Lake

1811 June 27 20. 2 Mary. Chuck Portage

1813 aug.t 26 0 45 Faith at Slaters I.d red

River — Died at Brandon Hous 6 Oct at noon

Sacusoggan died 1814. march 7t 8 am — ill 24 Days

1814 Nov — 24 — 8 30 Clement Brandon H.

1817 March 5 — 11. 10 Colette Hatketts House

PAGE FROM HUDSON'S BAY COMPANY SURVEYOR PETER FIDLER'S NOTEBOOK, 1794–1816

Manitoba
paper and ink,
with some pencil notes
15.7 x 9.5 cm

Hudson's Bay Company surveyor and trader Peter Fidler recorded the births of all fourteen of the children born to him and his Cree wife, Mary. He was one of many employees of the North West Company and the Hudson's Bay Company who cohabited with native women and sired children who came to be known as Métis.

A COUNTRY WIFE
The Quite Remarkable Life of Mary Fidler

I've always wondered about the "country wives," as Hudson's Bay Company men called the First Nations women they bedded but seldom married. There are only brief mentions of them in the records of the HBC, and often the references include contemptuous terms like "bits of brown." Yet the list of births that the HBC surveyor Peter Fidler wrote in the back of one of his notebooks suggests a far more solid relationship than the imperial stereotype of easy-come, easy-go unions between "civilized" Europeans and ignorant natives. And Mary Fidler, the Swampy Cree woman who was the mother of Peter's fourteen children, was obviously a formidable person. In his notebook, Peter carefully listed not only the name of each child, and the date, hour, and minute of the birth, but also the place. Those place names are testaments to Mary's stamina and courage.

Take, for example, the birth of Valery, the Fidlers' fourth child, which Peter noted occurred on November 26, 1802, at 2:03 a.m. at Nottingham House – a solid-sounding name that suggests the safety of an established Hudson's Bay Company post. Nothing could be further from the truth.

Mary gave birth to Valery in a hastily built shelter on the barren shores of Lake Athabasca, in the far north of present-day Saskatchewan and Alberta. She had reached it after a gruelling forty-three-day journey begun at Cumberland House, on the Saskatchewan River, at 9 a.m. on August 7th. The Hudson's Bay Company had ordered Peter Fidler to establish an outpost in enemy territory: the Athabasca region was the source of the finest beaver and fox pelts but also the domain of the rival North West Company. Mary, who was the only woman on the expedition, was six months pregnant. She left three small children behind, most likely in the care of other country wives at the substantial post of York Factory.

In addition to Mary and her husband, the five birch-bark canoes loaded with provisions, guns, and trade goods carried seventeen HBC employees – tough men who were accustomed to long hours of paddling and brutal portages

HUDSON'S BAY COMPANY TOKEN, 1854

James Bay district,
Ontario/Quebec
brass
2.9 cm

In the vast domain controlled by the Hudson's Bay Company, the accepted unit of commercial value was the "made beaver" (one prime beaver skin in good condition). Eventually the HBC began issuing tokens or coins worth one made beaver or some fraction thereof. This example was issued in the Eastmain District (the area around the Eastmain, Rupert, and Whale rivers). One side bears the company's coat of arms and the other its value: 1 made beaver (1MB).

across peat moss or gravelly, spongy sphagnum that could shred moccasins and leggings. Mary must have knelt in the middle of a canoe for hour after hour, feeling her baby kick more and more vigorously as the trip lengthened. Perhaps she stoically carried her share at each portage, even as the baby grew heavier. As the expedition forged northward through uncharted rapids and unmapped bush, the days grew colder and shorter. By September there was frost at night; some mornings, Mary would have woken to find snow on the ground.

I imagine she bore this hellish journey without protest, despite the barely concealed hostility that HBC men always showed their bosses' native women. Peter would not have brought her with him had he not wanted her at his side or had he thought she would be any trouble. But it must have been a scramble, when they finally reached Lake Athabasca, to build the four-room wooden house with mud-smeared walls that would shelter them through the winter. Peter named it Nottingham House, after a town in his native Derbyshire.

When Valery arrived, did Peter grip a hunting knife in his gnarled, broken-nailed hands to cut the umbilical cord? Was the baby quiet or colicky? What must that first interminable winter on the shores of Lake Athabasca have been like? How did mother and baby fare on the monotonous diet of fish, pemmican, and boiled oatmeal? As the mercury dipped lower and lower, did Mary dip into Peter's private stash of rum, strictly off limits to his men? All we know for sure is that the entire party, including baby Valery, survived. Come spring, they travelled back to Cumberland House to pick up supplies, along with the three children left behind: Thomas, age seven; Charles, age four; and George, age two.

Peter's next birthday entry, dated October 12, 1804, and also at Nottingham House, proves that the outpost had survived for almost two years. It also suggests a subtle shift in his relationship with Mary, for they have called their fifth child and fourth son Decussoggan, a Cree name. Peter was probably fluent in the Algonkian dialect spoken by Mary's Swampy Cree people, and Mary probably learnt to speak some English. (Her children certainly did.) So their conversation would have gone far beyond the grunts and barked orders of many similar

liaisons, although it is unlikely that Mary could read her husband's nautical almanacs, mathematical texts, or copies of the company's *Monthly Magazine*.

That winter, their third at Nottingham House, Peter and his men fought off vicious attacks by the Nor'Westers, who burnt his watch-house and stole his fishing nets. He reported to his HBC bosses that his men were "much intimidated at the Rascally behaviour of the Canadians." But he doesn't mention the impact on his own small children of leaping flames, howling dogs, and human screams during bitter, ink-black northern nights – or how well Mary coped.

The sixth notebook entry, recording the birth of Andrew on November 29, 1806, at Cumberland House, suggests that the HBC had finally admitted defeat in its attempt to gain a foothold in the Athabasca region. Indeed, the previous June, the Fidlers and their party had abandoned Nottingham House and

returned to the relative civilization of the small and dirty trading post north-west of Lake Winnipeg. In all likelihood, Mary was the only woman there.

Over the next thirteen years, as the HBC ordered Peter from one remote inland trading post to another, his country wife would bear him eight more children. Their relationship survived Peter's return to Derbyshire in 1811 to visit his mother, the loss (carefully noted) of three of their infant offspring, Peter's increasing taste for brandy and rum, and the disapproval of HBC managers. (The governor in 1814 suggested that "his Indian family is some objection to him.") Judging from the frequency of the birth record, Mary was probably either pregnant or nursing throughout the twenty-seven years she spent at Peter's side.

By the end of Peter Fidler's career, he had travelled some 76,000 kilometres, completed surveys of 8,000 kilometres of rivers for his employers, and accumulated significant capital. His and Mary's children were well established in the growing Métis society of the Red River settlement near present-day Winnipeg. Their daughter Sally shared the bed of a Hudson's Bay Company governor, and their son George was an accomplished moose hunter.

In 1821, as her husband's health began to fail, Mary ensured her own financial future. On August 14, according to HBC records, "Peter Fidler of Manitobah and Mary, an Indian woman of the same place, were married at Norway House." The following year, Mary gave birth to their fourteenth child. Five months later Peter died, but not before having willed Mary a comfortable income of "£15 a year for life to be paid for her in goods from the Hudson's Bay store." Mary Fidler had been much more to him than a "country wife."

Opposite: *Quatoo, Atatoo, and Sasasis – three Métis children at Cumberland House in 1813, parents unknown*

GROUP OF BLACKFOOT BOYS AND GIRLS WITH THE REV. TIMS, HIS WIFE,
AND HIS ASSISTANT, 1886–93 (OPPOSITE)

near Calgary, Alberta
photograph
12.7 x 20.3 cm

The beaver hat fell from fashion in the second half of the nineteenth century,
and the once mighty Hudson's Bay Company ceded most of its lands to the new
Dominion of Canada in 1870, but the HBC continued to dominate the econ-
omy of Canada's north. This photograph supplies some solid evidence that
the area's native peoples had embraced the Hudson's Bay point blanket. The
points – marked by the number of coloured bars – indicated the blanket's
weight and, therefore, its value. In the heyday of the fur trade, one point had
the value of one made beaver.

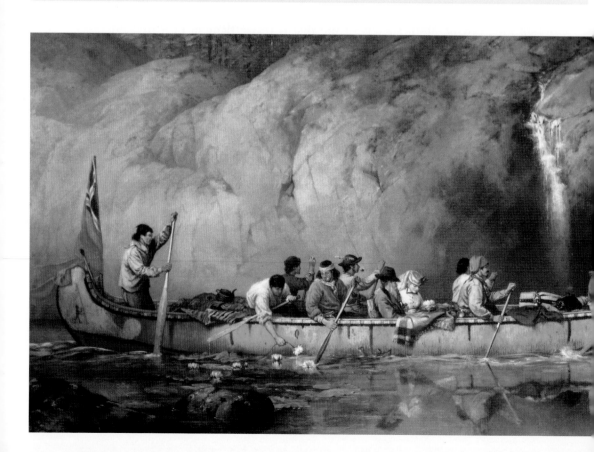

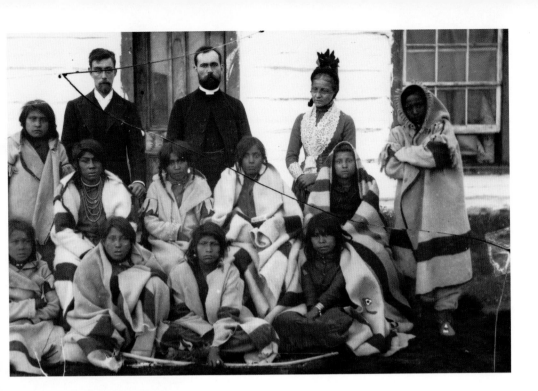

CANOE MANNED BY VOYAGEURS PASSING A WATERFALL, FRANCES ANNE HOPKINS, 1869 (LEFT)

Quebec
oil on canvas
73.7 x 152.4 cm

By the time Frances Anne Hopkins (seated in the centre beside her husband, HBC chief factor Edward Hopkins) painted this romantic image of voyageur life, the rivalry between the North West Company and the Hudson's Bay Company was long over and the fur trade in steep decline. In 1821 the HBC absorbed the NWC to create a North American fur-trading powerhouse, which retained the HBC name but was deeply influenced by NWC culture. Nor'Westers made up the majority of the company's officers, and birch-bark *canots de maître* like this one continued to return to Montreal laden with furs. However, as settlers increasingly moved into the vast territories once under HBC control, the fur trade became mostly a memory.

Hall of Martyrs
1636 to 1809

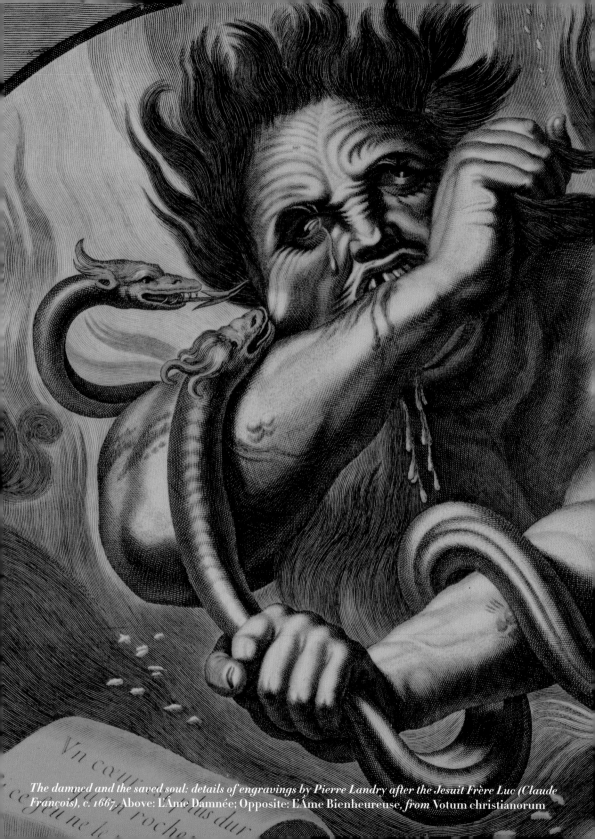

The damned and the saved soul: details of engravings by Pierre Landry after the Jesuit Frère Luc (Claude François), c. 1667. Above: L'Âme Damnée; Opposite: L'Âme Bienheureuse, from Votum christianorum

Jesuit missionaries arrived in France's fledgling New World colony in 1611, only three years after Champlain had built his first *habitation* at Quebec. They landed at Port-Royal (present-day Annapolis Royal, Nova Scotia), on the Bay of Fundy coast, the headquarters of the infant colony of "la Cadie" (Acadia). Despite a friendly reception from a local Mi'kmaq chief named Membertou, who had been baptized the previous year, the Jesuits retreated after the Americans burned Port-Royal in 1613. But they were not about to relinquish their mission: to convert "les sauvages" of New France to Christianity. They returned a little over a decade later, this time to Quebec, bringing with them once again the crusading zeal of the European Counter-Reformation, as well as a number of deadly European diseases.

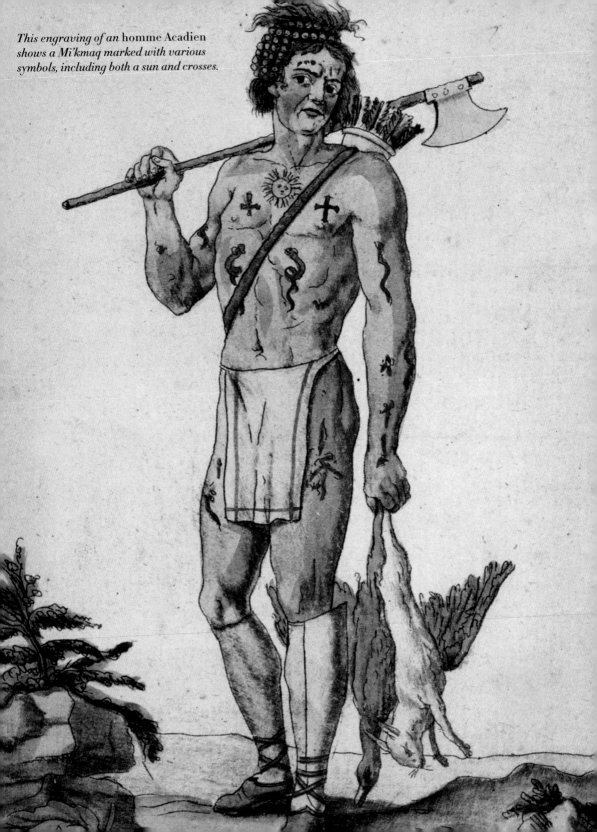

This engraving of an homme Acadien *shows a Mi'kmaq marked with various symbols, including both a sun and crosses.*

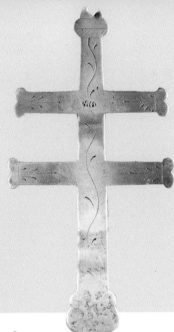

CROSS OF LORRAINE, APPROX. 1773–1809

*probably made in Montreal, Quebec;
found in Southampton, Ontario
silver
134 x 68 x 0.9 mm*

The Cross of Lorraine, which had first been used during the Crusades, was a powerful symbol carried by missionaries and settlers to the New World. Though this example is from a later period, French Jesuit missionaries likely carried crosses like this one on their visits to Huron encampments. This particular Christian symbol may have inadvertently helped the missionaries in their efforts to convert the Native peoples they encountered because the two-armed cross resembled existing local imagery.

PIPE TIP, BEFORE 1790

*Minnesota, USA
stone
3.5 x 18 x 10.5 cm*

After the Jesuits arrived in Acadia in 1611, they travelled through the Mi'kmaq lands in an effort to convert the people to their mystical brand of Christianity. In their zeal they were likely scornful of the indigenous religion and its spiritual artifacts, such as this pipe bowl, originally part of a longer pipe.

HURON BOWL, APPROX. 1760

Ontario
wood
40.2 x 42.2 x 11.8 cm

This bowl was used in festivals linked to the cultivation of corn, which, along with beans and squash, was a staple crop for the Hurons. Like their traditional enemy the Iroquois, who spoke the same language, the Hurons practised subsistence agriculture and lived in settled villages. It was this relatively stable society that attracted the Jesuits to Huronia, where in 1634 they re-established a mission that had first been attempted by Recollet friars in 1615. Wherever they went, the Jesuits recorded what they observed in a series of detailed reports, which were subsequently published back home in France in many volumes under the collective title *Relations des Jésuites* (Jesuit Relations).

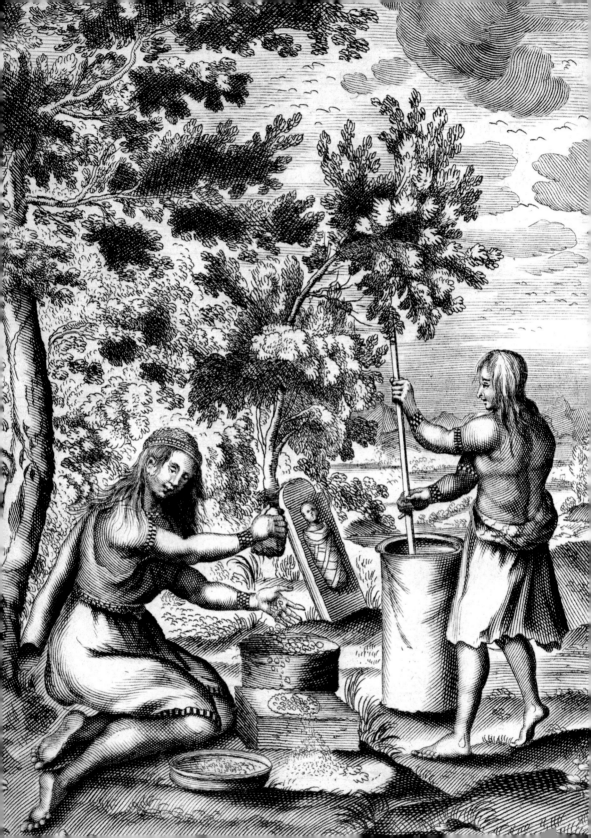

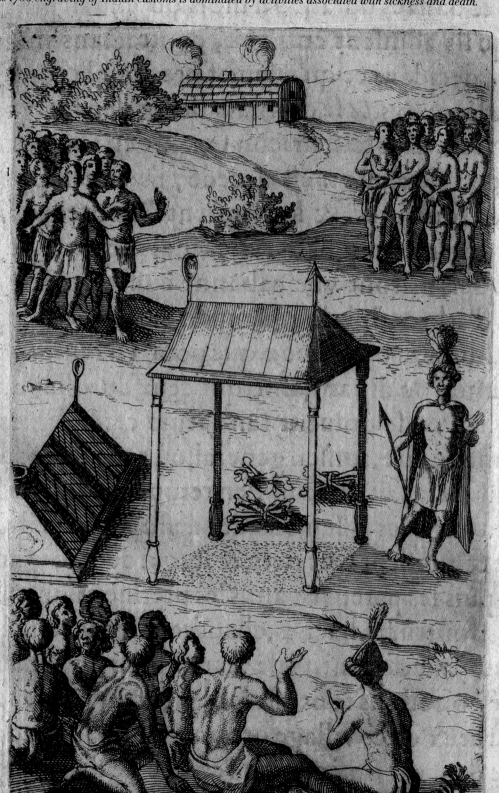

This 1706 engraving of Indian customs is dominated by activities associated with sickness and death.

MORTAR, 1636

found near Parry Sound, Ontario
bronze
size unavailable

Many Jesuits were trained to tend the sick, and they knew how to make drugs from medicinal plants. They used mortars like this one to mix medicines. But they had no cure for the smallpox, influenza, and measles they passed on to those they ministered among. The population plummeted so drastically that whole villages had to be abandoned and entire families were left without any adult males. Inevitably the Jesuits became associated in the native mind with disease and death, a link that helps explain why many of their Huron converts ultimately turned against them.

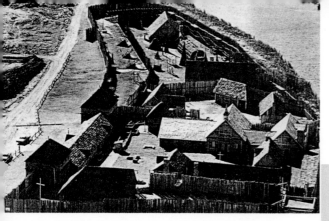

*A view of the modern reconstruction of Ste. Marie
Among the Hurons*

Universis Christifidelibus p.
quodam fidelium religionem et
utriusque sexus Christifidelibus vere,
Societatis Jesu Residentiae S. Mariae &
S. Josephi, a primis vesperis usque a
Christianorum Principum concord
ad Deum preces effuderint, ple
misericorditer in Domino concederis
alias Christifidelibus, in quacumque
visitantibus, aliquam aliam inde
sebimus, quodque si pro impetra
vel minimum detur, aut etiam
 Datis Romae apud S. Petrum
anno vigesimo primo.

 Gratis pro Deo et

Urbanus. PP. VIII.

litteras inspecturis salutem et apostolicam benedictionem. Ad au-
rum salutem coelestibus Ecclesiae thesauris pia charitate intenti, omnibus
tibus et confessis, sacra communione refectis, qui ecclesiam Presbyterorum
nullius Dioecesis, Provinciae Huronum Novae Franciae, die festo
num solis festi hujusce, singulis annis devote visitaverint et ibi pro
erecum exterpatione ac Sanctae Matris Ecclesiae exaltatione pias
omnium peccatorum suorum indulgentiam, et remissionem,
escentibus ad septennium tantum valituris. Volumus autem ut, si
i die dictam ecclesiam seu capellam aut altare in ea situm
am, perpetuo vel ad tempus nondum elapsum duraturam conces-
praesentatione, admissione seu publicatione praesentium aliquid
oblatum, recipiatur, praesentes nullae sint eoipso.
annulo Piscatoris, Die XVIII Februarii, MDCXXXXIV, Pontificatus Nostri

ra

M. A. Maraldus.

PAPAL BULL, 1644

Rome, Italy
parchment
15.5 x 33 cm

This document represents the first papal correspondence sent from Rome
to Canada. It grants pilgrims to the Jesuit mission at Ste. Marie "a Plenary
Indulgence each year and the remission of all their sins." In 1639 Jesuits led
by Fathers Jérôme Lalemant and Jean de Brébeuf established a fortified
missionary settlement, Ste. Marie Among the Hurons, on the outskirts of
what is now Midland, Ontario. Ste. Marie became the Jesuit headquarters in
Huronia, a forward base from which they travelled among the Huron, Petun,
Nipissing, Ottawa, and Ojibwa peoples. By 1648 it housed more than sixty
people, including nineteen priests and eight soldiers.

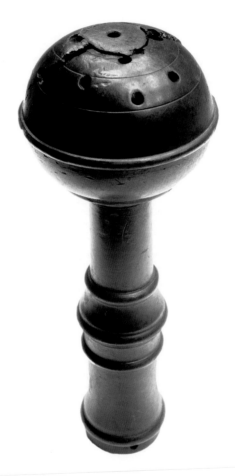

HOLY WATER DISPENSER, 17TH CENTURY

Ste. Marie Among the
Hurons, Ontario
probably copper
10.5 x 3.5 cm

This piece of liturgical paraphernalia was one of the many Jesuit artifacts recovered during the excavation of the Ste. Marie site in the 1940s and 1950s. A Jesuit priest once used this sprinkler to splash drops of holy water on his congregants during mass.

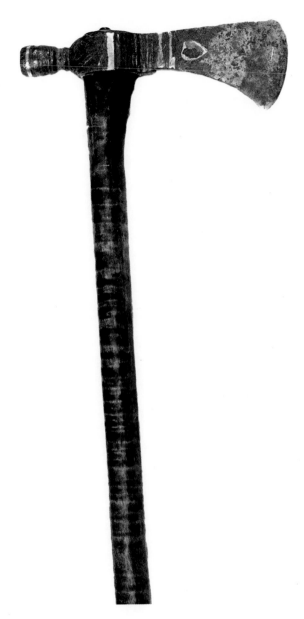

TOMAHAWK, APPROX. 1760

France
iron head, wooden haft
5 x 43.5 x 16 cm

Small battle-axes known as tomahawks were used by both the Iroquois and their enemies the Huron. With its iron blade, this example takes advantage of European materials to forge a more effective weapon as well as a useful woodworking tool. Many tomahawks saw use only as status symbols.

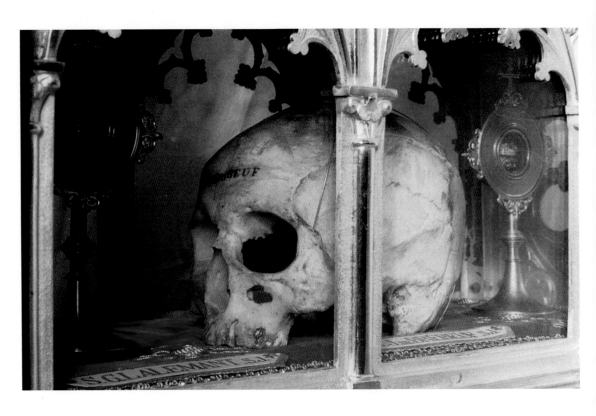

RELIQUARY FEATURING THE HALF-SKULL OF JEAN DE BRÉBEUF, 1649

Ste. Marie Among the Hurons, Ontario
reliquary: brass and glass;
skull: bone and wax
reliquary, 81 x 64 x 35.5 cm

This half of Brébeuf's skull was awarded to the Jesuits. It can now be venerated in its reliquary at the Church of the Martyrs near Midland, Ontario.

A MORBID COMPROMISE
The Fate of Jean de Brébeuf's Skull

"They took them both and stripped them entirely naked and fastened each to a post ... They tore the nails from their fingers. They beat them with a shower of blows with sticks on their shoulders, loins, legs and face, no part of their body being exempt from this torment. Although Father de Brébeuf was overwhelmed by the weight of these blows, the holy man did not cease to speak of God ... A wretched Huron renegade ... whom Father de Brébeuf had formerly instructed and baptized, hearing him speak of Paradise and holy baptism, was irritated and said to him, 'Echon (Father de Brébeuf's Huron name), thou sayest that baptism and the sufferings of this life lead straight to Paradise; thou shalt go thither soon, for I am about to baptize thee...' The barbarian having said this, took a kettle of boiling water which he poured over his head three different times in derision of holy baptism."

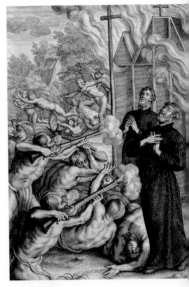

Jesuit Martyrs. The death of Father Antoine Daniel and Father Charles Garnier, about 1680

The ghastly torture of Jean de Brébeuf and his fellow Jesuit missionary Father Gabriel Lalemant continued all that chilly March afternoon in 1649 at the settlement of Saint-Ignace, 4 kilometres east of the Ste. Marie mission (today on the outskirts of the Ontario town of Midland). The smell of roasting flesh filled the air as Brébeuf's Mohawk captors slung a collar of six red-hot axe heads round his neck and a belt of burning pitch and resin round his waist. When the fifty-six-year-old priest continued to cry *"Jésus traiteur*, Jesus, have mercy on us," his tormentors cut out his tongue and sliced off his nose and lips. Then, according to eyewitness accounts later recorded by Christophe Regnault, the priests' assistant, the Mohawk began to saw the living flesh off

FRAGMENT OF CHARRED WOOD, 1649

Ste. Marie Among the Hurons, Ontario
cedar
6 x 15.5 x 5.5 cm

Jesuits believe that this piece of charred wood formed part of the stake at which Jean de Brébeuf was burned. An even smaller wood fragment is thought to be from the stake to which Gabriel Lalemant was bound while he watched Brébeuf suffer and die. He then endured his own torture for a remarkable seventeen hours before he was hacked to death.

his limbs, to cook and eat it in front of him. As Brébeuf slid into unconscious-ness, a warrior slit open his chest, tore out his heart, and roasted and ate it. Father Lalemant, who was tied to a post, was forced to watch his fellow Jesuit's ordeal. After his brother's death, the younger missionary was tortured for sev-enteen hours until finally an Iroquois, wearying of the entertainment, killed him with a hatchet. By the following morning, little was left of Brébeuf and Lalemant other than charred and blackened bones.

Until his death, Jean de Brébeuf was a gentle, black-robed mystic who had lived for fifteen years among the Huron (or Wendat, as they are known today) south of Georgian Bay, learned their language, and converted thousands to the Roman Catholic faith. Lalemant had joined him in the mid-1640s.

The loyal Christophe Regnault immediately recognized that the two men had died for their faith, which marked them within the Roman Catholic Church as martyrs and candidates for sainthood. If they were canonized, their bones would become objects of venera-tion. So it was that, within days of those hideous deaths, Brébeuf's skull began its own strange afterlife – an existence that also involved competition between powerful groups and an unimaginable further mutilation.

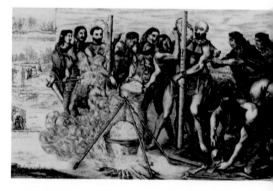

A detail from the "Bressani map" of 1657 is the earliest known depiction of the martyrdom of Brébeuf and Lalemant.

Four days after the murders, Regnault walked east through the thick forest from the Ste. Marie mission to the place where the atrocities had been committed. He examined what remained of the corpses of his fellow Frenchmen ("I saw and touched their arms and legs, stripped of their flesh to the bones ... I touched Father de Brébeuf's scalped head and torn lips") and arranged for their burial. Less than a year later, when the Jesuits abandoned their mission on Georgian Bay, Regnault had the bodies

exhumed, then carefully boiled all the bones he found in lye, scraped the remaining flesh off them, packed them in silk-lined chests, and sent them to Quebec City. By the time they were unpacked in the Jesuit College on Rue Dauphine, these bleached white bones were already objects of profound reverence. Lalemant's skull was sent to his sister, a Carmelite nun, in France and was subsequently destroyed during the French Revolution. The finest relic of them all, Brébeuf's skull, remained in New France, lovingly encased in a silver and ebony reliquary that Brébeuf's nephews had sent from France.

For the next 150 years the skull of Jean de Brébeuf sat in the Jesuit College chapel. But after the British conquest of New France in 1763, the Jesuit order in Canada was effectively suppressed by a ban on recruitment: by 1800, Father Cosot was the only Black Robe left in the colony. Before his death that year, he handed the precious skull over to the hospital nuns of the Hotel-Dieu in Quebec. Throughout the nineteenth century the nuns quietly lobbied for the martyr's beatification, while devout Roman Catholics made pilgrimages to visit the relic in the Hotel-Dieu chapel. Thanks to Christophe Regnault's careful account, Brébeuf was on the fast track to becoming a saint. Martyrs require only one miracle for beatification and one for canonization, in contrast to the two miracles required at each stage by other contenders.

In the 1840s, when the Jesuits reappeared in Canada, they asked the nuns to return the skull, but they refused. As yet the New World boasted no saints: the relic of the continent's strongest candidate, with its promise of miracle making, was a valuable possession. Since the Middle Ages, European shrines that contained saints' relics, such as Lourdes in France or Santiago de Compostela in Spain, had prospered from the thousands of pilgrims who visited each year.

The dispute reached a crescendo in 1925, when Pope Pius XI moved to canonize Jean de Brébeuf, Gabriel Lalemant, and six other murdered Jesuit missionaries. As sainthood loomed, the two religious communities in Quebec City agreed to a compromise. A local physician, Dr. Charles Vézina, was

PLAQUE, APPROX. 1649

Ste. Marie Among the Hurons, Ontario
lead
5 x 9.5 x 0.5 cm

This plaque, thought to have marked the graves of Brébeuf
and Lalemant, was unearthed in 1954 during the archaeological
excavations at Ste. Marie. The letters incised into its surface
read "P. Jean de Brebeuf / bruslé par les Iroquois / le 17 de mars
l'an / 1649" (Father Jean de Brébeuf, burned by the Iroquois, 17
March 1649).

invited to dissect the skull from front to back. One half stayed with the nuns in the Hotel-Dieu chapel; the Jesuits triumphantly carried the other half two blocks down the road to their chapel on Rue Dauphine. A local craftsman modelled a wax facsimile of the missing half of the cranium for each skull. In 1930, when the eight murdered Jesuit missionaries were finally canonized, both chapels had bona fide skulls of Saint Jean de Brébeuf to which the faithful could pay homage.

Today the Jesuits' half of Brébeuf's skull resides in an elaborate new reliquary in the Martyrs' Shrine Church in Midland. It arrived there, along with relics of Gabriel Lalemant and one other saint, when the Jesuit Chapel in Quebec City closed in 1998.

I made my own pilgrimage to the Martyrs' Shrine one warm fall day. The twin-spired church, built in 1926, sits on a bluff overlooking the palisaded reconstruction of the seventeenth-century village of Ste. Marie Among the Hurons, which is surrounded by marsh and forest as it was in Brébeuf's day. As I entered the shrine's cool, dark interior and approached the brass reliquary, a whiff of incense lingered in the air. I stared through the glass at the holy relic, at the toothless upper jaw, at the empty eye sockets, both haunting pools of darkness. The skull's asymmetry was unnerving. Over the years the wax has shrunk, so that the side farthest from the viewer is noticeably smaller and slightly yellower in colour.

I felt a strange compulsion to pass my hand through the reliquary's window and cup it round the cranium of the patron saint of Canada. I wanted to feel the difference between the two hemispheres of that holy head – dusty planes of bone on one side, the texture of wax on the other. What else might I feel? Would my hand receive a ripple across the centuries – of this Jesuit's spirituality or of the intellect that allowed him to master native North American languages and record Indian customs? Or would my palm burn from an aftershock of one of the most brutal murders in our history?

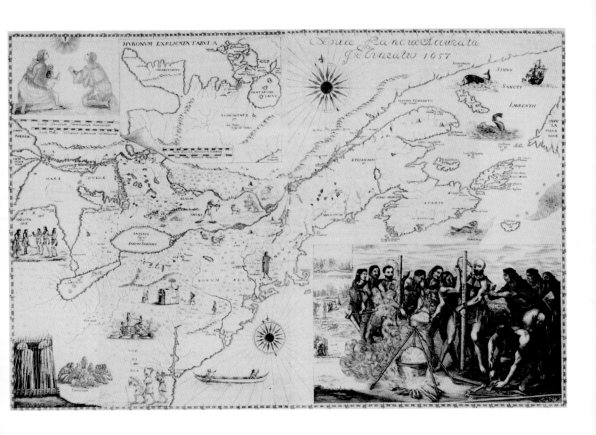

"NOVAE FRANCIAE ACCURATA DELINEATIO" (MAP OF NEW FRANCE),
FRANCESCO BRESSANI, 1657

Italy
printed from copperplate
52.7 x 77.8 cm

Like Lalemant and Brébeuf, Father Francesco Bressani worked as a
Jesuit missionary among the Hurons. Like them, he was tortured by
Mohawks and horribly mutilated. But unlike the two famous martyrs, he
was rescued, and he returned to missionary work before retiring to Italy.
This map, which was meant to accompany Bressani's history of the Jesuit
missions in Canada, is particularly interesting for its illustrations. In
addition to the dramatic scene of the Lalemant and Brébeuf martyrdom,
it includes remarkably accurate illustrations of daily Indian life, images
that cleverly contrast unconverted savages with devoutly praying converts.

NORTH-WEST GALLERY
1723 to 1809

Above: *A European drawing of the plains bison, 1724.*
Opposite: *Ruins of the Hudson's Bay Company fort at Rocky Mountain House, Alberta*

The exploration of the "new world" was driven by economic forces. The settlement of Acadia and New France came as the European powers vied for control of the North Atlantic fishery and the North American fur trade. The mapping of the Arctic came about as a fringe benefit of the hunt for a shorter shipping route to the riches of the East. And the fur trade was the main impetus behind the exploration of the western half of North America, above all the fierce competition between the Hudson's Bay Company and the North West Company. In the waning days of New France, enterprising traders moved ever farther westward in their quest for fresh sources of fur. To these first Europeans to enter North America's "heart of darkness," the unknown North-West began where the easy canoe route ended: at the western end of Lake Superior. Apart from the High Arctic, this vast area, which stretched all the way to the Pacific Ocean, was the last unexplored territory of what is now Canada.

"CARTE CONTENANT LES NOUVELLES DÉCOUVERTES DE L'OUEST EN CANADA, LAC, RIVIÈRES ET NATIONS QUI Y HABITENT" (MAP WITH THE RECENT DISCOVERIES MADE IN THE WEST OF CANADA ...), ANONYMOUS, 1740

probably Paris, France, or Montreal, Quebec manuscript 45 x 84 cm

Imagine this map turned counter-clockwise, so that the "Fond de la Baie Hudson" (Hudson Bay) is at the top, and north is where it's supposed to be. Now it begins to correspond to a modern map of northwestern Ontario (with the northwest corner of Lake Superior), much of Manitoba, and a northern slice of Minnesota, including Lac Rouge (Red Lake).

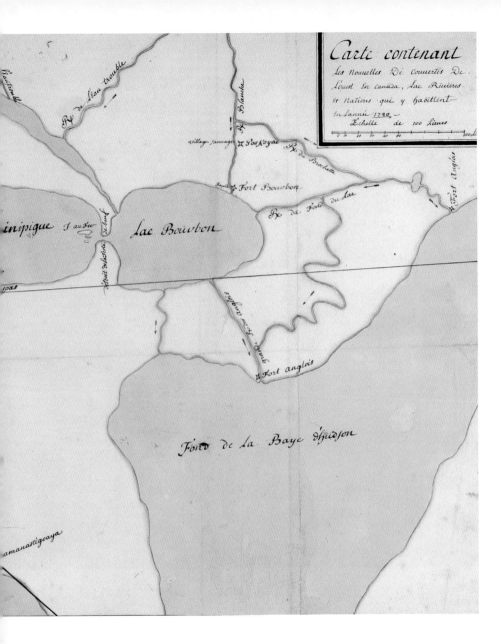

Carte contenant
les Nouvelles De Couvertes De
l'ouest En canada, Lac Rivieres
Et Nations qui y habittent
En l'année 1740 —
Echelle de 100 Lieues

But distances and size relationships are only approximations. Hudson Bay practically rubs shoulders with Lake Winnipeg ("Lac Binipique" and "Lac Bourbon"), which in turn is far too close to Lake Superior. "Fort Loraine" (Fort La Reine) on the Assinboine River is at the site of present-day Portage la Prairie, Manitoba. This fort and the other French forts marked on the map were founded by Pierre Gaultier de Varennes de La Vérendrye, a farmer turned fur trader from Trois-Rivières. Between 1731 and 1746 he and his sons opened up this part of the North-West, but when he died in Montreal in 1749, he had still found no sign of the fabled "western sea" he'd dreamed of reaching.

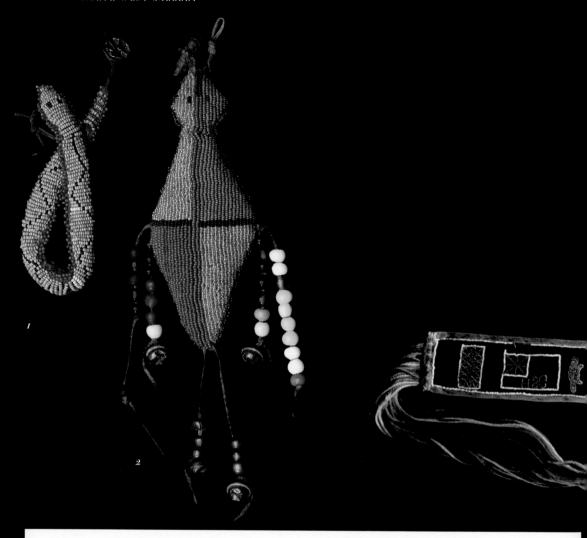

1

2

1 BLACKFOOT SNAKE AMULET,
EARLY 20TH CENTURY

Southern Plains, Alberta
buckskin, glass beads, cotton thread, brass bell
7.6 x 48.3 cm

2 BLACKFOOT LIZARD AMULET,
LATE 19TH CENTURY

Siksika (near Calgary), Alberta
buckskin, glass beads, sinew,
brass bells, fossilized shell
5 x 12.7 cm

In 1754 Hudson's Bay Company factotum Anthony Henday travelled farther into the Canadian West than any explorer before him. He had volunteered to seek new trading partners for his bosses at York Factory. When he reached what is now central Alberta, he became the first European to record a meeting with people from the Blackfoot Nation. No doubt the children he encountered wore brightly beaded good-luck amulets like this lizard (for a girl) and this snake (for a boy). Originally each amulet contained its owner's umbilical cord, which would have been removed before the amulet was sold or given away. Otherwise, the new owner might gain power over the child.

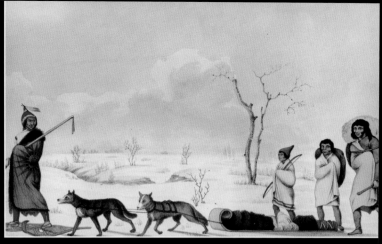

A Souteaux Indian, Travelling with His Family in Winter near Lake Winnipeg, H. Jones, c. 1825. Originally from the area near modern Sault Ste. Marie, the Saulteaux moved west and were living in the Red River valley by the time the first European settlers arrived.

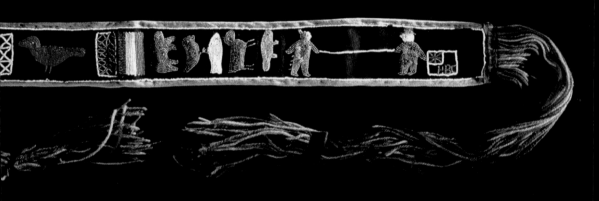

OJIBWA BELT, 19TH CENTURY

*Parklands region, Manitoba
wool stroud with beads,
blue twill braid edges,
and wool fringe
89.5 x 8 cm (excluding fringes)*

All the images woven into this belt, with the exception of the rectangles on the far left and on the far right, represent different Ojibwa clans, which originally inhabited the wilderness of rivers, lakes, and forests that stretched from Georgian Bay to the eastern part of Lake Superior. The rectangles probably stand for the Hudson's Bay Company flag. The one on the right is linked to the adjoining Ojibwa figure (possibly a shaman or a spirit) by a "power line" – denoting a spiritual connection but also suggesting the importance of the trading relationship between the HBC and the Ojibwa.

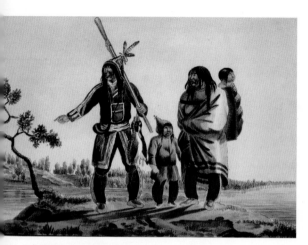

An 1821 watercolour, with pencil, pen, and ink,
entitled A Hunter-Family of Cree Indians
at York Fort

2

1

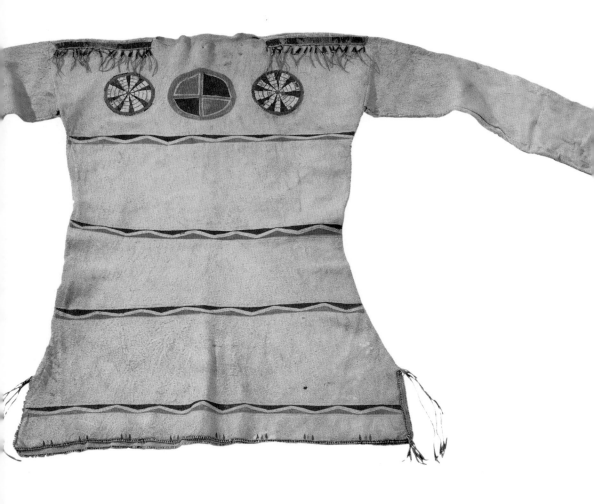

1 CREE-TYPE HAT, APPROX. 1800

Parklands region, Manitoba
skin, feathers, and paint
23 cm

2 CREE-TYPE SHIRT, APPROX. 1724

Parklands region, Manitoba
mooseskin, quills, and pigment
90 x 63 cm

When La Vérendrye and the explorers who followed him travelled into Manitoba early in the eighteenth century, they met the Parklands Cree people, who wore shirts and caps decorated with porcupine quills, feathers, and natural pigments. As regular trade between the natives and the newcomers developed, glass and metal beads replaced traditional quillwork, of which the shirt is a fine example.

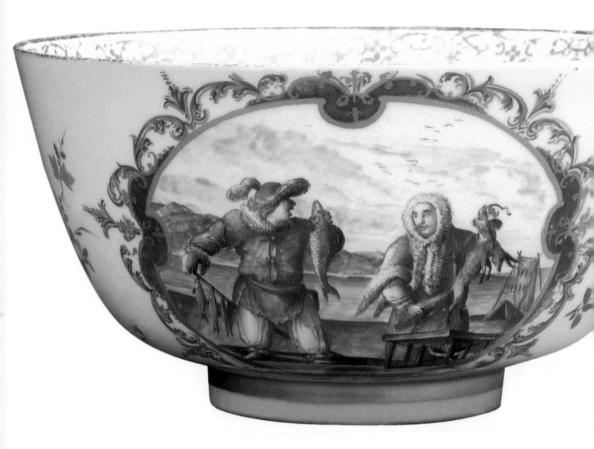

THE CANADA BOWL, 1723–24

Meissen factory near Dresden, Germany
porcelain
24 cm

As fur traders moved west, they also moved north. In 1770–71 Samuel Hearne followed the Coppermine River all the way to the Arctic Ocean. Twenty years later Alexander Mackenzie "discovered" the river that now bears his name, but was disappointed to learn it flowed north, not west. These and other adventurers helped shape the European image of the far North, of which the Canada Bowl is an early example. The first representation of Canada to appear on porcelain, it is typical of early European depictions of the Arctic. On it a European-looking man and a woman dressed in furs hold a fish and what is probably meant to be a fox. Johann Horoldt, Meissen's director of painting, based these figures on two illustrations in a book published in Amsterdam in 1695: *Orbis Habitablis, Poddida and Vestitus* by Carel Allard. But it is likely that neither the original artist nor the expert copier had ever seen a real Inuit or even a realistic picture of one.

The first European to reach the northwest coast of North America by water may well have been Francis Drake, whose voyage around the world in 1577–80 probably included landings on the coasts of Oregon and Vancouver Island. The first official visitor was the Russian Vitus Bering, who in 1728 explored the strait that would be named after him, and proved that Asia and North America were separate continents. It was largely because of Russian incursions that the Spanish began their explorations northward from their colonies in California. Meanwhile, fur traders were gradually opening up the western interior of North America and seeking a route through the mountains to the Pacific.

An Englishman's view of mountains seen from Nootka Sound on Vancouver Island, untitled, William Ellis, 1778–79

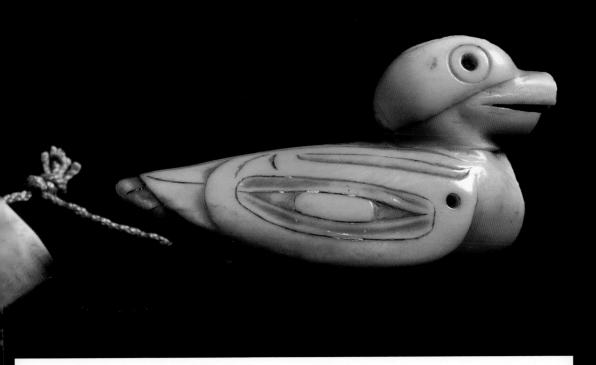

HAIDA BIRD AMULET, APPROX. 1744

Queen Charlotte Islands, BC
whale tooth and string
4.4 x 7 cm

This beautiful amulet was collected in 1774 by Juan Joseph Perez Hernandez, the first Spanish explorer to sail along the British Columbia coast. It is the earliest surviving example of the artistic style of the people who had inhabited the Pacific northwest for hundreds of years. The painted colours have worn away with age, but the same distinctive pattern of decorative lines is found in contemporary Northwest Coast art. The amulet was given to Perez by "an Indian woman who wore it around her neck with a string of teeth that appeared to be those of a baby alligator," probably the teeth of a sea otter.

RESOLUTION AND DISCOVERY IN SHIP COVE, JOHN WEBBER, 1778

Nootka Sound, BC
paper, pen, ink, watercolour
58 x 147 cm

This painting depicts Captain Cook's two ships at anchor in Ship Cove, now known as Nootka Sound, a strategically located harbour on the west coast of Vancouver Island. Cook and his crew were the first Europeans to visit the sound, where they spent the month of April in 1778 refitting their ships, taking observations using the tents and instruments that can be seen in the centre of the painting, and making records of their encounters with the local people. Many of Webber's drawings and paintings were engraved for the British Admiralty's account of the expedition published in 1784.

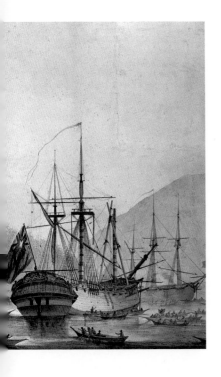

An Alien Point of View
John Webber and Captain Cook's Canadian Tour

Look at those trees. They resemble the conifers of Switzerland more than the fir trees of the Pacific northwest. And the two ships are disproportionately large, as if their tall masts and magnificent rigging can subdue the menacing rocks and desolate shoreline. Moreover, all the figures on the beach are Europeans engaged in disciplined activities: sailors rolling barrels, blacksmiths forging fittings for the mast, and two scientists making observations of the sky. The massive British naval ensign gently stirring in the foreground breeze dwarfs the canoes belonging to the people indigenous to this inhospitable region – the Nootka, or Nuu-Chah-Nulth, Indians – who paddle around the imposing ships and chatter excitedly with the crew. *Resolution and Discovery in Ship Cove* tells us more about the man who painted it and the world he came from than the harsh realities of Canada's west coast in the late eighteenth century.

"Mr. John Webber, draughtsman and Landskip painter," was only twenty-four in 1777, when he was engaged by the Lord Commissioners of the Admiralty "to proceed in His Majesty's Sloop" *Resolution* to "make drawings and paintings of places she may touch on, at a payment of 100 guineas a year." Webber's qualifications to join the renowned Captain James Cook on the high seas were, frankly, skimpy. The son of a Swiss sculptor, he had trained as an artist in Switzerland and Paris with leading landscape painters and then worked in London as an interior decorator. But a couple of his landscape paintings exhibited at the Royal Academy of Arts in 1776 had apparently caught the favourable attention of the British Admiralty.

Although Webber had never been to sea before, he must have leapt at the chance to accompany such a celebrated explorer. Engravings, etchings, woodcuts, and aquatints taken from drawings completed on the first and second of Captain James Cook's voyages were among the most sought-after (and pirated) images of the era, so the chance to cash in on the Cook vogue would have been irresistible. But more important, the voyage would allow him to see the world with one of the great men of his age – the cool, raw-boned captain in his brass-buttoned frock coat who had resolved, as he once wrote in his journal, to go "as far as I think it possible for man to go."

When Cook, the most brilliant navigator in the Royal Navy, was first given command of a ship, roughly one-third of the world's map was either a blank or filled with fanciful drawings of monsters and imaginary places. By the time his third voyage reached the west coast of North America, he had managed to correct the geographic delusions and oversights of more than two centuries. He had not charted in detail all the coastlines, but he had outlined the continents. Webber's opportunity would be to show Europeans what the inhabitants of the newly charted landmasses really looked like.

A portrait of John Webber in middle age

Since Webber didn't keep a journal, we don't know how he managed his first long year at sea. In those months Cook's two ships sailed down the western coast of Africa, battled gales as they rounded the Cape of Good Hope, called in at Tasmania and New Zealand, and crossed the badly misnamed Pacific Ocean from south to north for the first time, discovering along the way the last great chain of islands to have eluded Western explorers: the Hawaiian archipelago. In late February Cook's ships left that tropical paradise and set sail northwards through an empty ocean in rapidly falling temperatures.

After a voyage of five weeks, the men aboard *Resolution* and *Discovery* caught their first glimpse of the snow-covered mountains of Vancouver Island.

By the time the two ships sailed into Nootka Sound, Webber would have prepared his sketchbook, pencils, and brushes. His *modus operandi* was to make preliminary pencil sketches and then work the sketches up into more formal compositions later. He also took advantage of newly developed papers that made rapidly executed watercolours possible. Part of the young artist's commission was to prepare a large, panoramic landscape painting for each major landfall: the bay, the land formation, trees, and boats, and the people engaged in their normal activities. But there was little he could do for the first several days after the ships sailed into Nootka Sound on March 29 for their first North American landfall, as a hard westerly gale with rain and sleet raged. Finally the clouds lifted and Cook led a landing party ashore.

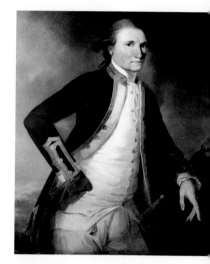

Webber's portrait of James Cook.

"During the time I was at this village," Cook recorded in his journal, "Mr. Webber, who had attended me thither, made drawings of everything that was curious, both within and without doors." Cook's plain prose described what he saw and his opinion of it, but Webber's sketches and paintings brought this strange world to life. "The women were always properly clothed, and behaved with the utmost propriety," reads Cook's journal, "justly deserving all commendation, for a bashfulness and modesty becoming their sex." But it was Webber who caught the expression of confused uncertainty on an individual face in his pen sketch *A Woman of Nootka Sound.* And he paid more attention than the artists on Cook's previous voyages to getting anthropological details right.

Once Webber had embarked on a composition, he pursued it relentlessly. On April 22 he followed his captain into a Nootka house and settled himself in a corner with pencil and sketchbook. The occupants appeared unconcerned until Webber began to sketch two large "idols," or carved house-posts. A man

*Vancouver Island
(west coast), BC
alder wood, abalone shell,
nettle fibre, paint traces
11.1 x 22.9 x 6.4 cm*

This haunting work of art, collected at Nootka Sound in
1778 during Captain James Cook's visit to Vancouver
Island, was probably of considerable age at the time of
its acquisition. Cracks and faults in the mask have been
stitched together using cord made from nettle fibre, a
Nuu-Chah-Nulth technology, and its iridescent eyes
made of inlaid abalone shell still seem to gleam with
supernatural power. When worn in winter ceremonies,
the mask would have sat on the wearer's head, with the
beak protruding down over the face.

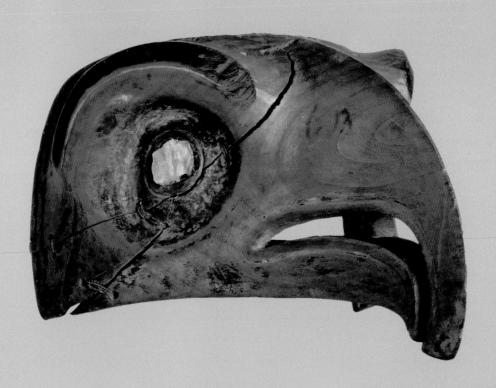

appeared before him brandishing a knife, and when the artist ignored him, he deliberately blocked his view of the carvings by sitting on a mat in front of them. Webber offered the man a brass button off his coat. "This instantly produced the desird effect, for the mat was remov'd and I left at liberty to proceed as before," Webber recalled years later in a letter. "Scarcely had I seated myself and made a beginning, but he return'd and renew'd his former practice, till I had disposed of my buttons, after which time I found no further opposition in my further employment." Webber's faithful depiction of this scene of women weaving, salmon drying, and children playing was the first realistic West Coast Indian domestic interior to circulate back home.

Yet below the surface of Webber's depictions of the human body lurk years of drawing classes sketching classical statuary. His Nootka hunters have the physique of long-legged Greek warriors rather than the stocky build of West Coast Indians. And he portrays his Nootka woman as notably well-scrubbed and wholesome, although Cook records that they took "particular pains to daub their Hair and faces well with red oaker." In *Resolution and Discovery in Ship Cove*, the artist's depiction of the massive solidity and technology of Cook's vessels, compared with the flimsy and primitive Nootka canoes, is almost a caricature of how Europeans perceived "uncivilized" societies.

As May approached and the days grew longer, Captain Cook weighed anchor and left Nootka Sound to sail north into the Bering Sea and beyond in search of the elusive North-West Passage. Less than a year later, on a return visit to the island of Hawaii as he sailed for home, he would be killed. But Webber and the rest of Cook's two crews sailed safely back up the Thames in 1880. Soon, engravings and etchings based on Webber's work were everywhere.

The sketches made by John Webber in Nootka Sound and elsewhere reveal a talented young artist struggling to fit the magnitude of the Pacific coast into European conventions of what landscapes and "savages" should look like, shoe-horning West Coast life into European stereotypes. His paintings and drawings gave eighteenth-century Europeans their first glimpses of

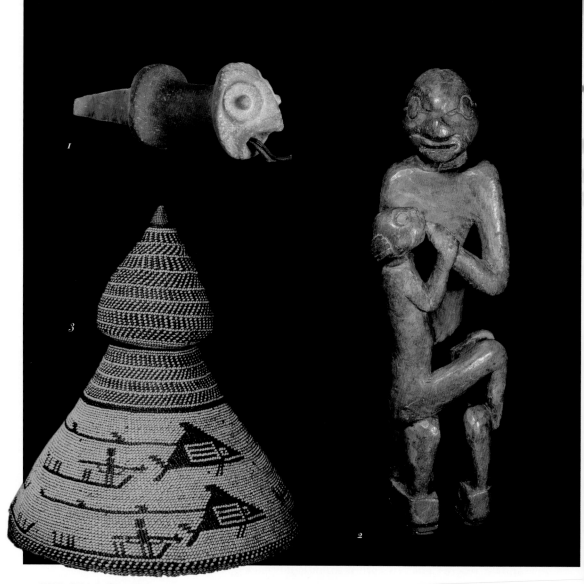

1 NUU-CHAH-NULTH
(NOOTKA) MONOLITHIC
DAGGER, APPROX. 1778

Vancouver Island (west coast), BC
stone with leather
and paint traces
30.2 x 10.5 cm

2 NUU-CHAH-NULTH
(NOOTKA) FIGURINE OF
WOMAN AND CHILD,
APPROX. 1778

Nootka Sound, BC
wood
27.5 cm

3 NUU-CHAH-NULTH
(NOOTKA) CHIEF'S HAT,
APPROX. 1778

Nootka Sound, BC
cedar bark, spruce or cedar
root, and grass
28.5 x 27 cm

Whenever Cook and his men went ashore they brought back souvenirs, among them these three fine
examples of Nuu-Chah-Nulth artistry. Wood sculptures, such as the woman and child, suggest the artistic
range of the local artisans. The hat, which depicts chiefs hunting for whales, is among the most famous
artifacts Cook collected at Nootka Sound.

the other side of the world and its peoples. From them, the empire-building British could conclude that the continent and its inhabitants were ripe for conquest. We can only guess at how the Nootka fit the strange white men and their curious ships, firearms, scientific instruments, and brass buttons into their world view.

Below left: *Webber's pencil sketch of a Nuu-Chah-Nulth house interior.* Below right: *In* A Woman of Nootka Sound, *Webber placed a chief's hat on a female figure.*

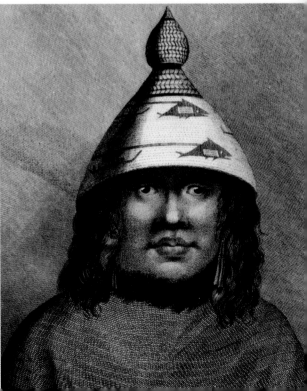

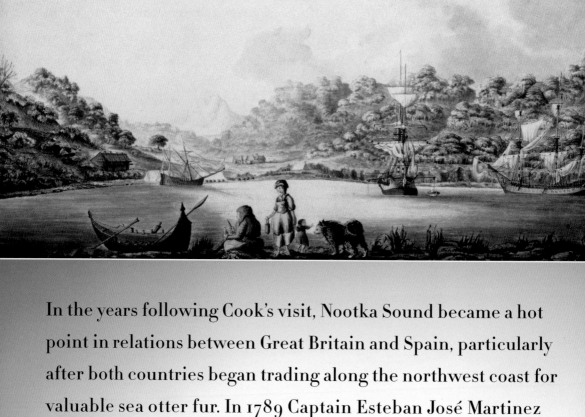

A View of Vancouver Island, Vancouver (British Columbia), *J. Ross, 1792*

In the years following Cook's visit, Nootka Sound became a hot point in relations between Great Britain and Spain, particularly after both countries began trading along the northwest coast for valuable sea otter fur. In 1789 Captain Esteban José Martinez seized four English vessels he discovered trading in Nootka Sound, triggering the Nootka Crisis, which almost led to war between Spain and England. Tensions eased with the negotiation of the first Nootka Convention in 1790, giving the two countries shared access to the region's anchorages and resources. Meanwhile, explorers from beyond the Rockies drew ever closer to reaching the Pacific Ocean overland.

CHRONOMETER NO. 176, JOHN ARNOLD, 1791

London, England
mostly brass
dial, 11 cm

George Vancouver used this chronometer – a timepiece whose accuracy was useful in calculating latitude – on his 1791–95 voyage, when he charted the entire British Columbia coast (from what is now the Washington state border to Port Conclusion, Alaska) and conducted a little diplomacy on the side. Presumably the chronometer helped him find his way to Nootka Sound, where, in August 1792, he met with Juan Francisco de la Bodega y Quadra, the Spanish commandant, to discuss how their two countries would observe the Nootka Convention. The watch is engraved on the back with the words *Invt et Fec.* (invented and made by) *John Arnold, London,* and its serial number, *176.* Arnold was a renowned watchmaker who designed precise timepieces for travellers, as well as the first pocket watch. This chronometer was returned to England and later belonged to Captain William Bligh, of *Mutiny on the Bounty* fame.

1

2

1 MUSKET BALLS, APPROX. 1809

Jasper, Alberta
lead
1.2 cm

2 PORTABLE WRITING DESK, APPROX. 1790

Canada
mahogany with brass strengthening straps,
corners, and handles, green felt
18 x 45 x 25.3 cm

The three small, white spheres may look like marbles, but they are early nineteenth-century bullets, or musket balls, thought to have been left in the Jasper area by David Thompson in 1809. Between 1792 and 1812 Thompson surveyed and mapped much of the Prairies and British Columbia, giving the world its first comprehensive view of the vast northwestern interior of North America. Wherever Thompson's explorations took him, he carried this miniature desk (now inscribed "David Thompson/Explorer and Surveyor, 1770–1857"), on which he drew his careful maps and recorded his detailed observations of flora and fauna. He began his career as an HBC trader and surveyor, but eventually grew frustrated by his employer's lukewarm support and joined the rival North West Company.

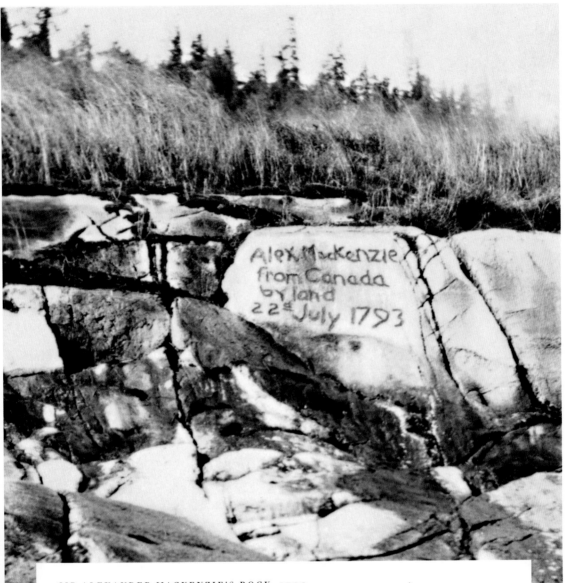

SIR ALEXANDER MACKENZIE'S ROCK, 1793

*Bella Coola, BC
stone, paint
(original mixture
made of vermilion
and bear grease)
size unavailable*

When North West Company explorer Alexander Mackenzie
reached the mouth of the Bella Coola River on the Dean Channel,
he painted this memorial inscription with a mixture of bear grease
and vermilion pigment ground from the mineral cinnabar, a
brilliant red paint commonly used for marking bundles of furs.
Mackenzie became the first European travelling overland to reach
Canada's west coast, almost three hundred years after John Cabot
had first stepped ashore on his "new founde lande." Mackenzie's
inscription was touched up in 1926 and is perfectly legible today.

GENERALS' COLLECTION
1727 to 1780

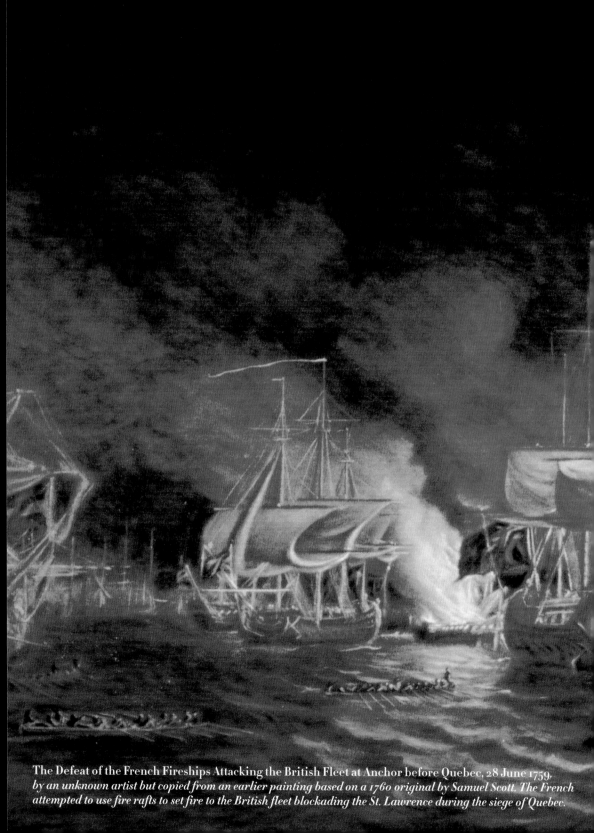

The Defeat of the French Fireships Attacking the British Fleet at Anchor before Quebec, 28 June 1759, by an unknown artist but copied from an earlier painting based on a 1760 original by Samuel Scott. The French attempted to use fire rafts to set fire to the British fleet blockading the St. Lawrence during the siege of Quebec.

In the first half of the eighteenth century the North American colonies belonging to France and to Great Britain were on a collision course. Acadia had passed into British hands in 1713, leaving only the Fortress of Louisbourg at the eastern tip of Île Royale (Cape Breton) to guard the supply route to Quebec and guarantee France's share in the profitable cod fishery. To the south, the New England colonies were growing at an alarming rate, pushing their influence west and north. In 1745 a force of British naval vessels and New England militia successfully laid siege to Louisbourg. Although the fortress was subsequently returned to France as part of a European peace treaty, tensions continued to mount. With war looming, a new commander arrived in Canada in April 1756 – Louis Joseph de Montcalm-Gozon, Marquis de Montcalm. He would meet his match in a young British general, James Wolfe, in a battle that sealed the fate of New France.

MONTCALM'S ALTAR STONE, APPROX. 1756

made in France
size unavailable

When the Marquis de Montcalm was posted to North America, he brought with him this makeshift altar, which had been blessed by a Catholic clergyman in France. Prayer may have been important to this nobleman, fighting for a king who ruled by Divine Right, but Montcalm's need to pray at an altar consecrated at home seems in keeping with his distaste for all things *canadien*. Montcalm despised the undisciplined Canadian militia and was appalled by the brutal behaviour of its "uncivilized" Indian allies. From the moment he arrived in New France, he was as much at odds with the locals as he was at war with the British.

Opposite: *Initially, Montcalm's leadership proved successful. His first victory over the British came at Fort Oswego* (shown here), *which capitulated after a brief siege in August 1756. He also won key victories at Fort William Henry in 1757 and at Fort Carillon, or Ticonderoga, in 1758.*

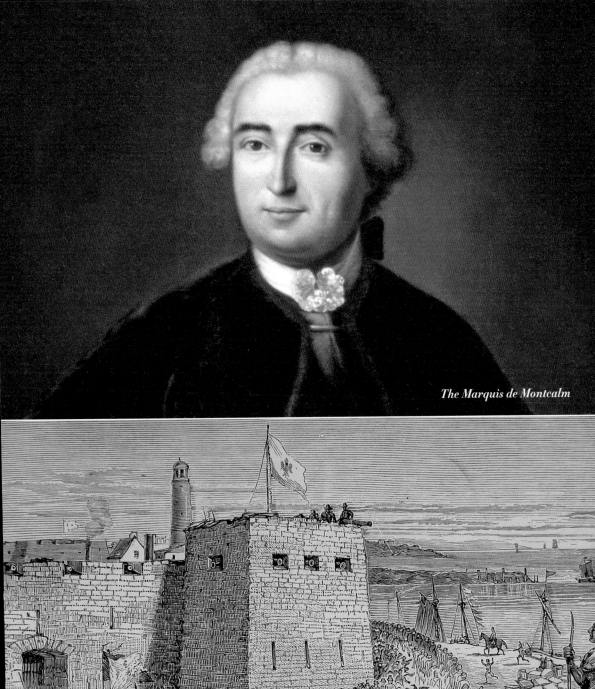

The Marquis de Montcalm

FRAGMENT OF A SCULPTURE SHOWING A ROMAN HELMET, BEFORE 1745

made in France;
found in Louisbourg, NS
stone
approx. 12 x 8 cm

This fragment of sculpture, which was made in France and shipped to decorate the Fortress of Louisbourg, represents part of a Roman helmet, a symbol of military strength. The fortress, however, wasn't strong enough to withstand the determined British siege in the summer of 1758, during which a thirty-one-year-old brigadier-general named James Wolfe distinguished himself. The victors reduced the fortress to rubble.

This map, drawn by General Wolfe, shows the positions of the three British divisions just before the attack on Louisbourg.

Portrait of James Wolfe c. 1765

SNUFFBOX, APPROX. 1759

tortoiseshell, silver, steel
7.4 x 5.4 x 2.5 cm

Perhaps James Wolfe calmed himself with a pinch of snuff from this snuff-box before the fateful battle that sealed his own fate and that of New France. Wolfe's propensity for snuff (a form of powdered tobacco inhaled through the nostrils) is well documented, and it is almost certain this snuffbox belonged to him, but whether he had it with him in Canada is not known.

NO MERCY TO CAPTIVES BEFORE QUEBECK, GEORGE TOWNSHEND, 1759

Quebec
sepia ink, wash,
graphite on laid paper
21.5 x 25.4 cm

This cartoon by one of Wolfe's subordinates satirizes the British commander's brutal scorched-earth policy in Quebec, in which British troops pillaged and burned over a thousand *habitant* farms and raped scores of women. Wolfe is depicted briefing his adjutant, Isaac Barré, on his plans for the pretty women of Quebec. The aristocratic Wolfe, at centre, says, "We will not [let any] of them escape, my dear Isaac – the pretty ones will be punished at Headquarters," to which Isaac replies, "I understand you completely, General – strike 'em in their weakest part. Egad," while the standing onlooker wonders if he'll get "his share." Townshend's unflattering carica-tures of Wolfe grew more popular among his officers as the siege of Quebec wore on. An attempt to establish a beachhead at Montmorency had been repulsed, with heavy British losses. By the end of the summer the British had suffered hundreds of casualties, and sick and ill-fed troops were deserting to the enemy.

CANNONBALL, APPROX. 1759

Quebec City, Quebec
cast iron
size unavailable

The English fired about 40,000 cannonballs into Quebec during the siege, reducing much of the town to ruins. This example, now encased in a living tree in the city, may have been fired from one of the English ships in the river below or by one of the field guns the British dragged up the cliffs and used during the Battle of the Plains of Abraham.

Drawings of the French cannons that guarded the governor's residence at Quebec. These guns were captured by the English in 1759 and put on display at the Tower of London.

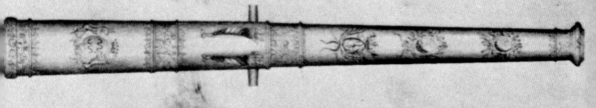

Pounders taken at Quebek before the Governors love in 1769 Deposited in the Grain around in the Tower of London

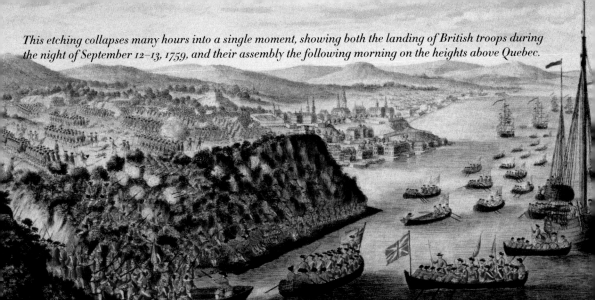

This etching collapses many hours into a single moment, showing both the landing of British troops during the night of September 12–13, 1759, and their assembly the following morning on the heights above Quebec.

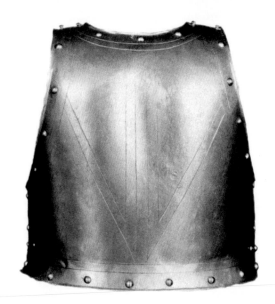

CUIRASS, BEFORE 1759

France
forged steel
approx. 45 cm (neck to waist)

Montcalm wore this piece of body armour as he rode a black horse into his final battle on the morning of September 13. Although cuirasses were of little practical use in the age of firearms, French officers favoured them as a mark of rank and status. Montcalm's cuirass didn't prevent him from being fatally wounded in the stomach and leg by lead grapeshot as his forces retreated before the advancing British regulars.

WOLFE'S MILITARY CLOAK, APPROX. 1759

England
woollen material
approx. 1.5 m

Wolfe wore this cloak against the morning chill as he led his troops into battle. On the Plains of Abraham his men met the hastily mustered French forces head on and at close quarters, leaving virtually no room for either side to manoeuvre. When the French launched their infantry attack, Wolfe was wounded in the wrist (the cloak is splattered with a few small bloodstains). Later in the fight, which lasted a mere fifteen minutes, he was more seriously wounded in the gut and chest. While his army pursued the routed French, he bled to death on the field he had won.

from K.L.
Neptune at Sea

A N

E L E G Y

WRITTEN IN A

Country Church Yard.

THE NINTH EDITION.

L O N D O N:

Printed for R. and J. DODSLEY, in Pall-mall;

And sold by M. COOPER, in Pater-noster-Row. 1754.

[Price Six-pence.]

TITLE PAGE FROM *AN ELEGY WRITTEN IN A COUNTRY CHURCH YARD*, THOMAS GRAY, 1751; PUBLICATION DATE, 1754

London, England
paper, leather binding
24.6 x 18.8 cm

This copy of Gray's *Elegy*, the popular eighteenth-century poem on mortality (note the shovels, skulls, and crossbones in the decorative bands above and below the title), was given to James Wolfe by his fiancée, Katherine Lowther, before he set sail for Canada in 1758.

INTIMATIONS OF MORTALITY
Wolfe's Copy of Gray's Elegy

In the cool, hushed reading room of the Thomas Fisher Rare Book Library in Toronto, I examine a box constructed from thick, slate-coloured cardboard with neatly carpentered edges. It is about the size of a small cereal box but much heavier. The lid, as tight-fitting as a corset, squeaks while I remove it. Within the upper of the two interior sections is a stiff slipcover, custom-made of faux red leather, on whose spine is embossed "Wolfe's study of Gray's Elegy, London 1754." Out of this casing I finally slide the artifact itself: an elegant eighteenth-century volume bound in gold-trimmed, chestnut-brown leather, faintly stained with sweat where it has been held. It releases the familiar archival smell of dusty old paper.

This book was the seven millionth volume acquired by the University of Toronto Library (of which the Fisher is part). Given its role in our cultural heritage and its 1988 price tag of $400,000, it is one of the library's most valuable holdings. No wonder it is as securely protected from damp, decay, and careless handling as the *Mona Lisa*.

A portrait of Katherine Lowther "from an original pastel in the possession of Lord Londsdale"

We can trace the volume's early history in the jigsaw of inscriptions, annotation, and paper pasted into its pages. It was given to General James Wolfe on the eve of his departure on HMS *Neptune* for North America in 1758 by his fiancée, a beautiful and well-born young Londoner called Katherine Lowther. By now the poem was so well known that the ninth edition's title page doesn't even mention its author, the great English poet Thomas Gray (1716–71).

In the top left hand corner, Wolfe wrote:

From K.L.

Neptune at Sea.

At this time Britain was fighting France on four continents; the following year, after making his mark during the assault on Louisbourg, young James Wolfe was selected to command the expedition against Quebec City.

The slender, thirty-two-year-old army officer loved Gray's melancholic meditation on death: it matched his own gloomy nature. In the weeks leading up to the September 1759 attack on Quebec City, the commanding general was made wretched by his senior officers, who were older, richer, and better-connected than he was. Wolfe, who was ravaged by syphilis and a lung infection, found Gray's sombre verses soothing. He underlined phrases with particular appeal, such as "The paths of glory lead but to the grave." And he scribbled despondent thoughts in the margin: "How ineffectual are often our own unaided exertions, especially in early life? How many shining lights owe to Patronage and Affluence what their Talents would never procure them?"

This portrayal of the siege of Quebec appeared in the London Gazette, *October 18, 1759.*

Not long after he made this annotation, Wolfe died on the Plains of Abraham. His copy of Gray's *Elegy* returned to England with one of his officers and was presented to Katherine Lowther. Katherine went on to marry the Duke of Bolton, and Bolton's bookplate, embellished with a splendid family crest featuring deer, swords, and crown, is on the inside cover. A handwritten

inscription on the third page describes how, in 1809, Katherine, now the Dowager Duchess of Bolton, felt a last spurt of generosity towards her personal maid. The inscription was made by the recipient's daughter and reads: "Given to my Mother, Mrs. J. Ewing, by her Mistress the late Duchess of Bolton as having belong'd to the celebrated Gen'l Wolfe. L.D."

The next stage of the book's journey is murkier. It is known to have been in Paris in the mid-nineteenth century; it turned up again in London in 1912; and it was finally sold to a New York bookseller in 1916. The Thomas Fisher Rare Book Library acquired it from the bookseller's son seventy-two years later with the help of a grant from the federal government. In the intervening 229 years, the slender volume had become "a national treasure, representing a direct link with a critical point in Canada's history."

Its place in General Wolfe's campaign luggage is only half the charm of this particular artifact. For 150 years after its owner's death, the poem itself played a key role in the legend of his heroic self-sacrifice. Almost every nineteenth-century account of the Battle of the Plains of Abraham includes a stirring scene in which Wolfe recites lines from Gray's *Elegy*. Sometimes he stands alone in the bow of the lead craft as his flotilla sails silently upriver in the dark, and recites to his men the whole poem by heart. Other times he murmurs a single line – "The paths of glory lead but to the grave" – as the thirty ships creep along the St. Lawrence River in the shadow of the north-shore cliffs. In yet other accounts, the moving moment is said to have occurred the night before the battle, as he visits some of the sentry posts. But every account includes the assertion that Wolfe paused after the recitation, then added, "Gentlemen, I would sooner have written that poem than take Quebec."

So poignant. So romantic. And, in the view of modern historians, such rubbish.

The anecdote can be traced to John Robison, a young man who sailed with Wolfe but did not take part in the fighting. Almost half a century after the Battle of Quebec, Robison was the esteemed professor of philosophy at Edinburgh University, where he became acquainted with the novelist Sir

Walter Scott. On one occasion he regaled Scott with a version of the story of General Wolfe and Gray's *Elegy*. Scott, who rarely let facts get in the way of a good yarn, spread it far and wide. It was soon picked up by historians eager to glorify Wolfe's death as noble self-sacrifice in the larger cause of painting the globe imperial pink.

But in the early twentieth century, as the British Empire's glory started to fade, historians demanded better evidence that Wolfe had uttered these touching lines. They scoffed at the idea that a seasoned commander would recite poetry as he advanced in stealth under the enemy's nose. They even suggested that Wolfe's celebrated victory was not the crucial turning-point in the British conquest of New France that their Victorian predecessors had claimed, since there were several more months of fighting before the French capitulated. Wolfe never gave us his version, although he could have. In his copy of Gray's *Elegy*, only six of the thirty-three creamy vellum pages are occupied by the poem: the rest are blank. I stare regretfully at these empty spaces. Then I close the volume, manoeuvre it back into its slipcase, fit the slipcase into the upper tier of the box, and replace the lid on a national treasure.

Opposite: *In the left margin of page 11 of his copy of Gray's* Elegy, *Wolfe highlighted the line, "A Youth to Fortune and to Fame unknown," and inscribed this response: "Yet were he on this score less happy?"*

' The next with dirges due in sad array
' Slow through the church-way path we saw him born,
' Approach and read (for thou can'st read) the lay,
' Grav'd on the stone beneath yon aged thorn.

The EPITAPH.

HERE rests his head upon the lap of Earth
 A Youth to Fortune and to Fame unknown,
Fair Science frown'd not on his humble birth,
And Melancholy mark'd him for her own.

Large was his bounty, and his soul sincere,
Heav'n did a recompence as largely send.
He gave to Mis'ry all he had, a tear,
He gain'd from Heav'n ('twas all he wish'd) a friend.

No farther seek his merits to disclose,
Or draw his frailties from their dread abode,
(There they alike in trembling hope repose)
The bosom of his Father and his God.

FINIS.

CREST BEARING THE FRENCH ROYAL COAT OF ARMS, 1727, TAKEN FROM QUEBEC CITY,
QUEBEC, IN 1759

made in France
eastern white pine
118 x 96 x 20 cm

This royal crest, at whose centre is an oval shield bearing the fleur-de-lys of
the French kings, adorned the gates of the governor's mansion in Quebec.
After the British took the city in September 1759, they removed the crest and
took it home to England. It would be four more years, however, before French
North America was formally transferred to Britain in the Treaty of Paris.

"A SONG. ON THE TAKING OF MONT-REAL BY GENERAL AMHERST," COMPOSED BY JOHN WORGAN, 1760

London, England
paper
approx. 30 x 18 cm

General Amherst, who had been Wolfe's superior at Louisbourg, assumed command of the British invading force after Wolfe's death and completed the campaign of conquest. It culminated with the fall of Montreal on September 8, 1760, and the final capitulation of New France to the British by its only Canadian-born governor, Pierre de Vaudreuil. Worgan composed this boastful ballad to celebrate his victory:

> I fill not the Glass, to some favourite lass,
> A hero engrosses my Lays;
> Thy Trumpet, O Fame!
> His deeds shall proclaim,
> And spread round the Globe Amherst's praise.
> And spread round the Globe Amherst's praise.

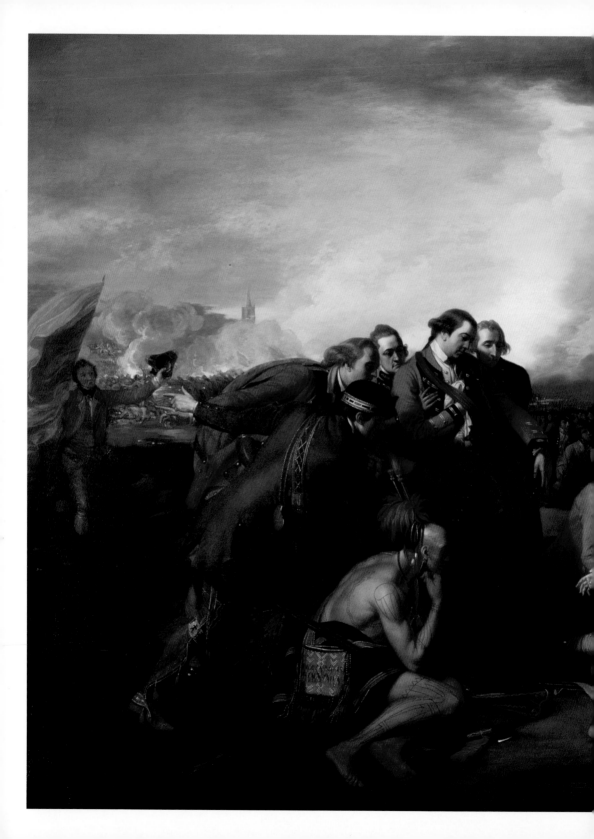

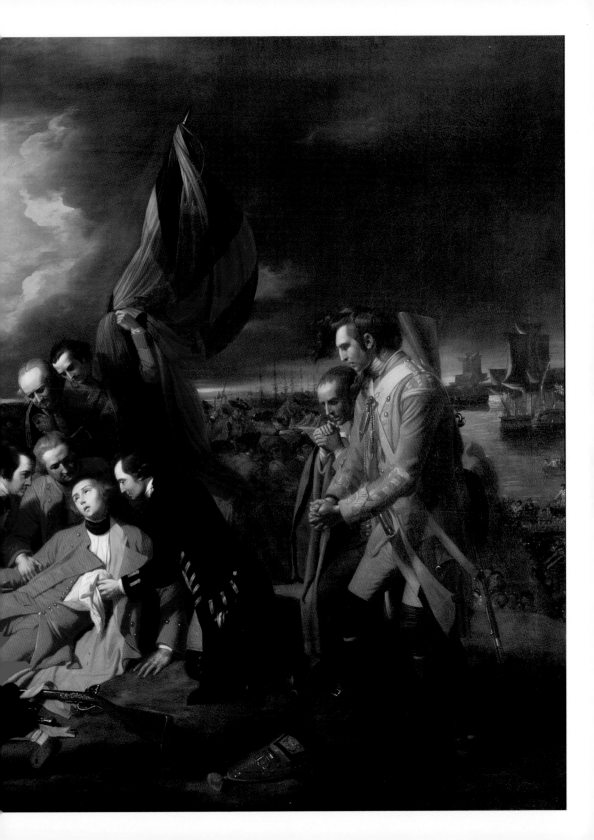

THE DEATH OF WOLFE, BENJAMIN WEST, 1770

London, England
oil on canvas
188.5 x 268.5 cm

Though ridiculed in life by the troops he led, in death James Wolfe became an instant hero, the ultimate imperial example of patriotic sacrifice. His death was celebrated in commemorative plaques, medals, monuments, paintings, ceramics, and even on tavern signs. By far the most dramatic and popular of these depictions was Benjamin West's epic canvas *The Death of Wolfe.* Highly romantic and historically inaccurate (it includes a number of people not actually present), West's version emerged as the definitive image of that event. Long lines of eager viewers greeted its unveiling at the Royal Academy of Arts in London in 1771. And so popular did it become that West painted five similar versions of this painting for wealthy patrons, among them King George III.

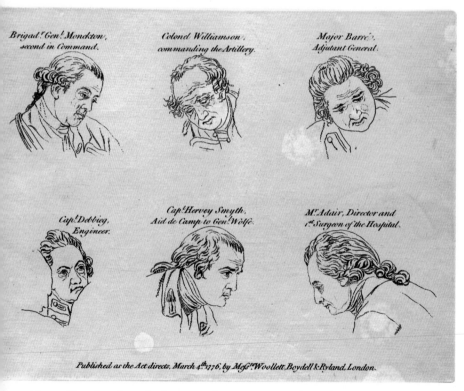

Brigad.^r Gen.^l Monckton, second in Command.

Colonel Williamson, commanding the Artillery.

Major Barré, Adjutant General.

Cap.^t Debbieg, Engineer.

Cap.^t Hervey Smyth, Aid de Camp to Gen.^l Wolfe.

M.^r Adair, Director and 1.st Surgeon of the Hospital.

Published as the Act directs, March 4.th 1776, by Mess.^{rs} Woollett, Boydell & Ryland, London.

Above: *Key identifying the figures in* The Death of Wolfe, *author anonymous*

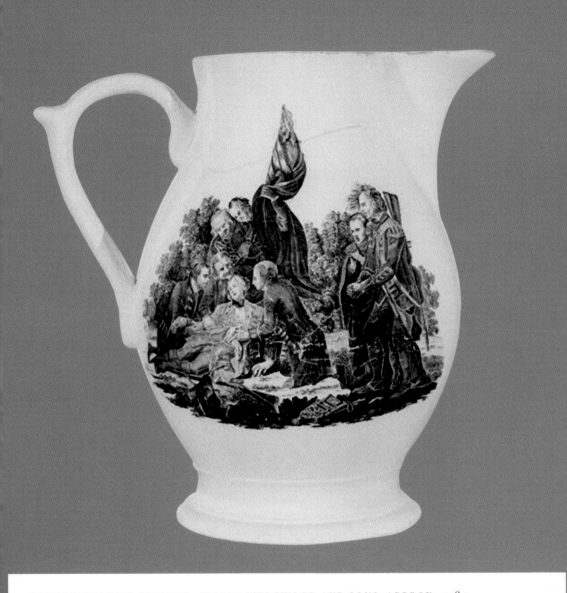

COMMEMORATIVE PITCHER, JOSIAH WEDGWOOD AND SONS, APPROX. 1780

Burslem, Staffordshire, England
creamware
with transfer-printed decoration
27.3 x 25.8 x 20 cm

One side of this pitcher is decorated with a scene from *The Death of Wolfe*; the other bears the dedication "Good Health and Success to the Right Honble. the EARL OF DERBY / Long may he live / Happy may he be / Blest with Content / And from Missfortune [sic] free." Thanks to the recent invention of transfer printing (today the standard method of decorating ceramics), West's patriotic image could now be mass-produced.

LOYALIST LODGE
1755 to 1794

The Treaty of Paris in 1763 closed the book on France as a North American power, granting it only fishing rights off northern Newfoundland and title to the islands of St. Pierre and Miquelon, but it did not change the French facts on the ground. The inhabitants of Britain's latest North American possession spoke French and practised the Catholic religion, a reality that irked the devoutly Protestant New England colonies. In the decade following the official birth of the Province of Quebec in October 1763, the *habitants* continued their lives much as their parents and grandparents had done. But the world around them was changing. Thirty seigneuries were soon turned over to English landowners, while English-speaking newcomers took over the commercial life of Quebec City and Montreal. In the public realm, the French and the English legal codes coexisted uneasily, while to the south rebellion was brewing. Would Canada join the revolt or remain loyal to Great Britain?

Inhabi

Quebe

profes

mish Religio

subject to the

Inhabitants of Quebec may profefs the Romifh Religion, fubject to the King's Supremacy, as by Act 1 Eliz.; and the Clergy enjoy their accuftomed Dues.

No Perfon profeffing the Romifh Religion obliged to take the Oath of 1 Eliz.; but to take, before the Governor, &c. Oath.

QUOTATIONS FROM MARGINS OF QUEBEC ACT, 1774

London, England
paper
size unavailable

The Quebec Act is only five pages long and contains eighteen clauses, but it is one of the most important constitutional documents in Canada's history. It was largely the creation of Sir Guy Carleton, the governor of the colony after 1768, who had been a colonel in Wolfe's army at the capture of Quebec. The Act extended the boundaries of the colony to include the fur-trading region of the Great Lakes Basin, established civil government (but not an elected assembly), and introduced British criminal law, while maintaining the French civil code. Through this compromise, the Act guaranteed freedom of religion in the colony and the maintenance of the seigneurial system.

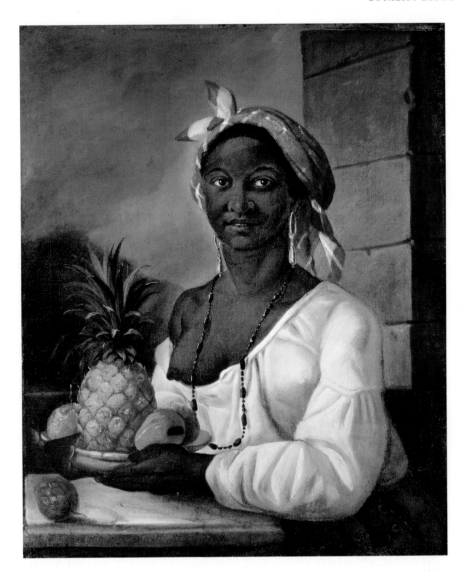

LA NEGRESSE, FRANÇOIS MALÉPART DE BEAUCOURT, 1786

probably Montreal, Quebec
oil on canvas
72.7 x 58.5 cm

Most paintings produced in Canada during the late eighteenth century were either commissioned portraits or variations on religious themes, so this portrait by the Montreal-born Malépart de Beaucourt is particularly notable. The artist's relationship with the sitter, who was his slave and, possibly, his mistress, may help explain why he chose to portray her with a bared breast and holding a bowl of "exotic" fruit. Regardless, he betrays an easy acceptance of the institution of slavery, which would technically remain legal in Canada until it was abolished throughout the British Empire in 1834.

George Washington, commander-in-chief of the Continental Army

After a period of growing tension, the American Thirteen Colonies rose in rebellion against Great Britain. In the fall of 1775, almost a year before the Declaration of Independence, the rebels went on the offensive. An army under General Richard Montgomery advanced towards Montreal, and a separate force under General Benedict Arnold sailed for Quebec. In late October, after Montgomery captured Fort Saint-Jean, just south of Montreal, Governor Carleton fled the city, which the Americans occupied on November 13. Montgomery then took 300 men to reinforce Arnold, who had already laid siege to Quebec.

GOODWIN DRUM, APPROX. 1755

*made in England or
New Brunswick
wood, skin, cord
43.2 x 41.3 cm*

We don't know whether this drum saw action during the American Revolution, but it belonged to the Goodwin family of New Brunswick and was probably used by a ten-year-old drummer boy named Enoch Goodwin when he served at Fort Cumberland (formerly Fort Beauséjour), close to the north end of the Bay of Fundy. Perhaps young Enoch was present when American rebels unsuccessfully attacked the fort in 1776. Drummer boys performed menial duties around camp, provided the beat for drills and marches, drummed coded messages between officers, and sometimes took up arms in an actual battle. The drum now bears two insignia: the cipher of King George III (visible on the front) and the name of the 2nd Battalion, Westmorland County Militia, with which a later Goodwin served. Westmorland County is near the present-day city of Moncton, New Brunswick.

HEAD FROM A BUST OF GEORGE III, JOSEPH WILTON, 1765, SHIPPED TO QUEBEC, 1766

England
marble
33 x 26 x 28 cm

This neoclassical head of George III, from a statue that stood at Place d'Armes in Montreal from 1766 until the spring of 1776, did not enjoy an easy life. In 1775 a group of English-speaking Quebecers vandalized it as a protest against the privileges accorded their francophone fellow-citizens under the Quebec Act. Some time later a few equally irate French-speaking citizens painted the statue black, hung a string of potatoes around its neck, placed a bishop's mitre on its head, and left a sign that read "This is the pope of Canada." In 1776 it was smashed by the American troops who had been occupying the city since the previous November. They dumped the head down a well, from which it was recovered in 1834.

*Benjamin Franklin, as he looked in the years immediately following
the American Revolution*

> Dear Sir
> Montreal 11th May 1776
>
> We desire that you will shew to Mrs Walker
> every civility in your power, and facilitate her on her
> way to Philadelphia; the fear of cruel treatment from
> the enemy on account of the strong attachment to, and
> zeal of her husband in the cause of the united Colonies
> induces her to depart precipitately from her home; &
> to undergo the fatigues of a long and hazardous journey.
> We are sorry for the occasion of writing this letter
> & beg your attention to alleviate her distress; your
> known politeness & humanity, we are sensible,
> without this recommendation from us, would prompt
> you to perform the friendly office. We are with
> great esteem & sincere regard for yourself & family
>
> Dr Sir
> Yr affectionate hum Servts
> Sam. Chase
> Ch. Carroll of Carrollton
> B Franklin

"LETTER OF SAFE CONDUCT FOR MRS. THOMAS WALKER," SAMUEL CHASE, CHARLES CARROLL OF CARROLLTON, AND BENJAMIN FRANKLIN, 1776

*Montreal, Quebec
laid paper
21 x 19 cm*

This letter, signed by American revolutionaries Samuel Chase, Charles Carroll of Carrollton, and Benjamin Franklin, was intended to guarantee safe passage for Mrs. Thomas Walker on her journey from Montreal to Philadelphia. The letter is dated two days after the American forces, which had been occupying Montreal for nearly six months, began to abandon the city. Montreal citizens had shown little inclination to join the revolution, but Mrs. Walker's husband, a wealthy fur trader and justice of the peace, had been one of the few to side with the invaders. Now, as American troops decamped, the Walkers had little choice but to leave with them.

SHORT SABRE REPUTEDLY CARRIED BY GENERAL RICHARD MONTGOMERY AT THE TIME
OF HIS DEATH IN 1775, MANUFACTURED APPROX. 1755–65

England
(blade may be of German origin)
steel with a silver and horn hilt
83.8 cm

Montgomery carried this sword into his last battle, the pre-dawn
American attack on Quebec on December 31, 1775, one day before
the term of service of many of his militia was due to expire. In the
attack his second-in-command, Benedict Arnold, managed to gain
the Lower Town before being repulsed, but Montgomery and his
senior officers died leading a separate assault. The sabre, whose
decorative hilt is the work of a skilled English silversmith, was sub-
sequently returned to Montgomery's widow by Governor Carleton.

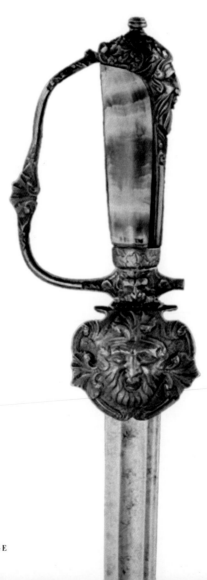

SASH, APPROX. 1775

Quebec City, Quebec
silk
224 x 30.5;
tassels, 25.4 cm

This silk sash, with twisted warp fringes, is torn and stained with blood from the wound that killed General Richard Montgomery during the disastrous attack on Quebec. The sash is made of "Sprang" plaiting, a technique that produces a loose-woven, netlike fabric. After Montgomery's death, Benedict Arnold remained camped outside the city until the spring, when he abandoned the siege and led his surviving force to Montreal.

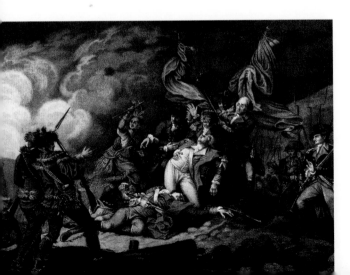

The Death of General Montgomery in the Attack on Quebec in Dec. 1775, *painted in 1786 by John Trumbell in conscious imitation of Benjamin West's* The Death of Wolfe

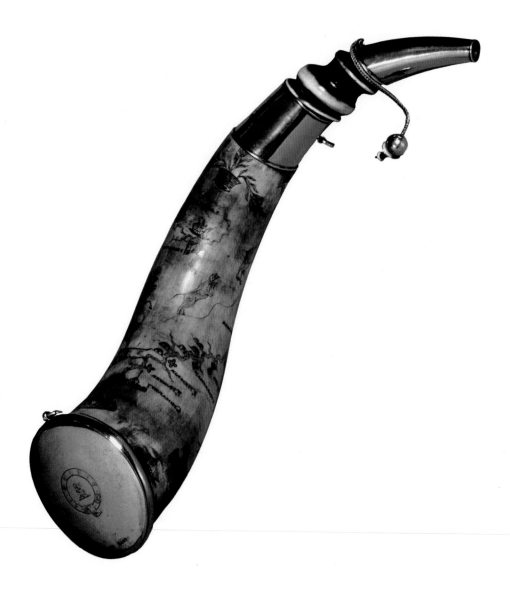

POWDER HORN, 1761 (WITH SUBSEQUENT ALTERATIONS)

North America
animal horn, silver, and ink
45 x 10 cm

This powder horn belonged to William Hazen, a Loyalist settler in what became New Brunswick. He probably bought it as a souvenir of his soldiering days in the British Army.

A Tale of Two Loyalties
William Hazen's Powder Horn

This elaborately decorated powder horn has two tales to tell. Its immediate story, of a long march, is incised on its surface in dark brown lines picked out in red. That march, however, is part of a much larger narrative about the upheavals and scars that wars create. The second tale can only be deduced from what we know of the horn's original owner, William Hazen.

The first story, the one written on the horn itself, is easy enough to decipher. It depicts a military operation conducted during the decisive phase of the North American campaign of the Seven Years' War fought between France and Britain (1756–63). At the wide end of the horn, New York City's wealth is represented in a busy scene of houses, steeples, windmills, and a bustling harbour, while the city's strength and loyalty is represented by the Union Jack and a cannon in the background. Travelling up the horn's diminishing width, the map is punctuated by place names, some of which still exist (though with different spellings) and others no longer identifiable: Fort Henrik, Canada Creek, Royal Blokhous, Lake Onyda (with tiny ships on its carefully sketched waves), Fort Onterio, the Three Revers, the Hundert Ilands, Niagra, the Sint Lorance River. Popular eighteenth-century motifs flourish in the open spaces: a stag fleeing a hound, a lush plant, and a royal coat of arms with lion and unicorn and two mottoes: *Honi Soit Qui Mal Y Pense* and *Dieu Et Mon Droit*.

This long march from New York towards Montreal in the summer of 1759 was made by the Massachusetts Rangers, a unit of the colonial militia under the command of General Jeffrey Amherst. And one of the marchers was a twenty-one-year-old named William Hazen, who followed the general north and was present the following year when the city finally surrendered to Amherst and his cannon. (British troops under General Wolfe had meanwhile defeated the French in Quebec City in September 1759.) William would certainly have required a powder horn for the battles fought in the advance up

Lake Champlain: soldiers were expected to provide almost all their own equipment, including sleeping blankets, knapsacks, and even guns. But we can't be sure that William used this particular horn to load a musket – only that it is a typical powder horn for its time.

Once such a horn had been taken from the carcass of a cow or an ox, it was boiled briefly and the inside scraped thin and smooth. Then the large end (through which the horn was refilled) was sealed with a wooden plug, and the small end (through which powder was funnelled into the musket) was stopped with a removable stopper. Perhaps William found a skilled carver within the army who decorated his powder horn after the Montreal victory, or perhaps he met the craftsman once he was back home in Massachusetts. More likely, given the horn's excellent condition, he acquired it as a souvenir of his soldiering days.

The second part of the story is about war in a very different sense: how it disrupts lives and creates horror, hardship, and opportunities. To fill in this story, a good deal of speculation is required. Let's start with the date incised right after William Hazen's name in an oblong cartouche near the large end of the powder horn: 1761. By this date, Hazen had left the army and found a more

Portland on the St. John, *Charles Platt, 1882*

profitable way of serving the interests of his king and country. Before the Seven Years' War had reached its conclusion, William had set himself up as a merchant in Newburyport, Massachusetts, buying and selling the staples of coastal trade – furs and fish from Nova Scotia (which in those days included both present-day Prince Edward Island and New Brunswick), rum from the West Indies, timber from New England, manufactured goods from Britain. He soon had a partner, James

A house built by a Loyalist settler in Springhill, NB, in 1790

Simonds, who operated from Portland Point, a trading post on the Saint John River that would later become the town of Saint John, New Brunswick.

William prospered, but he could smell trouble. Relations between Britain and its colonies, particularly Massachusetts, were deteriorating. Where did his loyalties lie – to the royal coat of arms on his precious powder horn or to his fellow New Englanders? If the Thirteen Colonies declared their independence from Britain, would business be better in a new nation or an old empire? His older brother, Moses, faced the same dilemma. He owned land in the rich valley of the Rivière Richelieu just south of Montreal: if a revolutionary army decided to attack Britain's northern colonies, it would march through his property.

The Massachusetts-born brothers spent the summer of 1775 pondering their options and came to different conclusions. When revolution broke out in the fall, Moses threw in his lot with the Yankees, ultimately becoming a general. William, five years his junior but much more cautious, calculated that, whatever happened, British sea power would still control the trade routes. So he packed up his family and possessions, including his prized powder horn, and prepared to resettle in the Saint John River Valley.

If William Hazen thought the struggling settlement of Portland Point was a safe distance from the hostilities, he was mistaken. In the summer of 1777 he

and his business partner were taken prisoner by American rebels; later the same year they watched marauding rebel privateers ransack their stores. But once the revolution was "won," it was William's brother Moses who had to count up his losses: he tried and failed to win compensation for the lost Quebec estates that had been pillaged by both armies. Meanwhile, in the fast-growing colony of Nova Scotia, William's business interests flourished. As he had anticipated, Halifax replaced Boston and New York as Britain's most important American port. Through his Halifax contacts, William began shipping furs to London, and he soon made a fortune selling spruce, birch, maple, and pine to a Royal Navy busy building warships to send against Napoleon's France.

Eight years after William's arrival at the mouth of the Saint John River, he found himself particularly well placed to profit from the first shipload of Loyalist refugees that landed in the harbour in May 1783. These remnants of a

Loyalist burial ground, Saint John, NB,
photographed c. 1875

dozen defeated British regiments evacuated out of New York had been promised land, provisions, and implements for tilling the soil. William's firm was happy to supply the colonial administration with lumber, manufactured goods, and supplies at the market price.

The swelling ranks of Saint John River Loyalists regarded most Nova Scotian merchants as men of dubious loyalty who had prospered during the revolution, while they themselves had suffered hardship and humiliation. They pressed for Nova Scotia to be partitioned and for a separate and distinct province to be fashioned in the north, beyond the control of Halifax. But, somehow, William managed to escape the stigma of being a "pre-Loyalist" war profiteer. Perhaps he prominently displayed the powder horn in his office as proof that he, too, had fought for king and country and was an unwilling refugee from his Massachusetts birthplace. Whatever the truth,

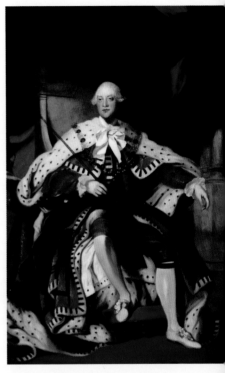

Portrait of George III in coronation robes, c. 1767, after a painting by Joshua Reynolds

when the province of New Brunswick was established in 1784, he was one of only two non-Loyalists on Governor Thomas Carleton's first council.

When he died in Saint John in 1814, William Hazen had laid the foundations of a commercial empire, with interests in lumber, shipbuilding, coastal trade, and fishing. His eleven sons and five daughters were leading New Brunswick citizens, and his powder horn had become a family talisman. A Victorian grandchild took it to London, where a silversmith replaced the wooden plug at the wide end with a heavy silver boss and added a sterling silver band, funnel, and stopper. Today it is displayed in the New Brunswick Museum as one more piece of the proud Loyalist history of the province its original owner helped to establish.

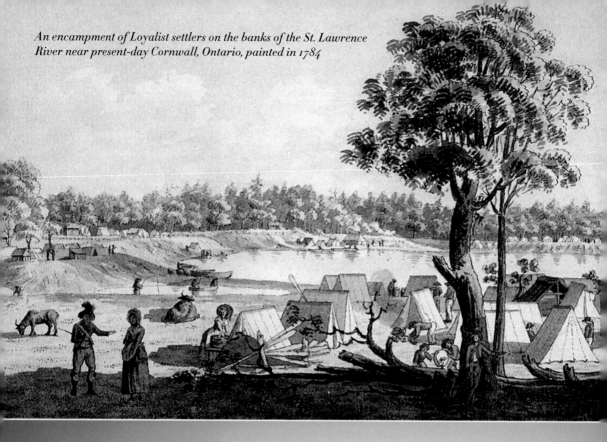

An encampment of Loyalist settlers on the banks of the St. Lawrence River near present-day Cornwall, Ontario, painted in 1784

The massive influx of Loyalists following the American War of Independence transformed the political and social landscape of what remained of British North America. In the part of Nova Scotia to the west of the Bay of Fundy, the population jumped rapidly from fewer than 4,000 people to more than 18,000, leading to the creation of the new colony of New Brunswick in 1784. A great number of Loyalists also settled along the north shore of Lake Ontario around Kingston and the Bay of Quinte as well as in the Niagara Peninsula, in what would shortly become the Province of Upper Canada.

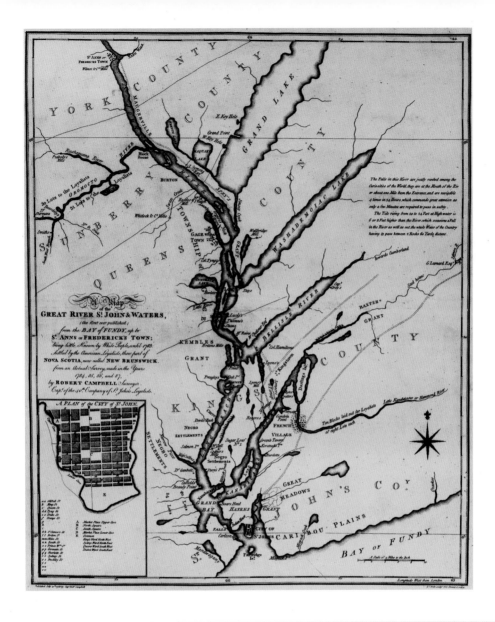

"A MAP OF THE GREAT RIVER ST. JOHN & WATERS, FROM THE BAY OF FUNDY, UP TO ST. ANNS OR FREDERICK'S TOWN," ROBERT CAMPBELL, 1788

probably London,
England
paper
51 x 41 cm

This map records the early days of Loyalist settlement along the Saint John River in what is now New Brunswick. Place names like Baxter's Grant and Kemble's Grant identify land taken up by the newcomers. The label "Negro Settlement" refers to a community made up of some of the 3,000 loyal African-Americans who moved north after the war, many of whom had served in the British Army. (Similar settlements appeared in Upper Canada.) The "French Village" is presumably a vestige of the original Acadian population.

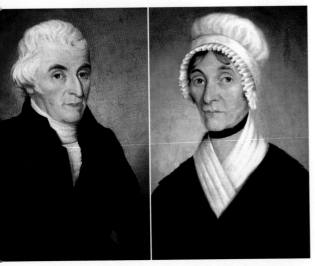

Late eighteenth-century portraits of the Rev. John Stuart, bishop's commissary for Upper Canada, and his wife, Jane, Pennsylvania-born Loyalists who chose the monarchy over the new American republic

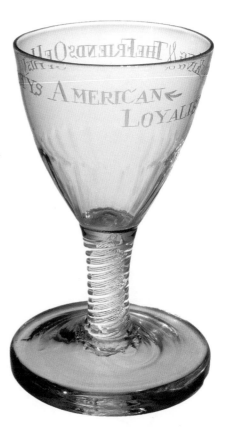

ENGRAVED WINEGLASS, APPROX. 1775

England
glass with "air-twist" bubble stem
10.9 x 6 cm

Glasses with twisted air-bubble stems were the height of fashion in England and America at the time of the revolution. Fragments of them often turn up during archaeological excavations, but it is rare to find an engraved example. The inscription reads "The King & the friends of His Majestys American Loyalists."

CANDLESTICKS, 1762–63

London, England
silver
27.3 x 12.7 cm

This pair of silver candlesticks, whose twisted stems and floral decorations on their square bases identify them as British in style and late eighteenth century of manufacture, were among the few personal possessions Sir John Johnson managed to carry away with him when he left New York in 1783 during the American Revolution. Johnson had been a wealthy landowner who was knighted for his services to the Crown during the Seven Years' War. When the hostilities broke out, he and his family were captured by rebels but managed to escape to Quebec. With his family safe, Johnson returned to organize Loyalist and Indian regiments in New York and Pennsylvania, including the King's Royal Regiment of New York, which he commanded with considerable success. The Johnson family crest (a hand grasping an arrow), engraved at the base of each candlestick, identifies them as precious family heirlooms. After the war, Sir John helped to manage the Loyalist refugee crisis. In July 1784 he was able to report to Governor Guy Carleton of Quebec that, as a result of his efforts, 3,776 people had been resettled in the area near Kingston.

M7043A

NE YAKAWEA
YONDEREANAYENDAGHKWA
OGHSERAGWEGOUH,

NEONI YAKAWEA
NE ORIGHWADOGEAGHTY
YONDATNEKOSSERAGHS

NEONI

TEKARIGHWAGEHHADONT,

OYA ONI

ADEREANAYENT,

NE TEAS NIKARIWAKE
RADITSIHUHSTATSYGOWA
RONADERIGHWISSOH
GORAGHGOWA A-ONEA RODANHAOUH.

ONI,

WATKANISSA-AGHTOH
ODDYAKE ADEREANAYENT,
NEONI TSINIYOGHT-HARE NE
KAGHYADOGHSERADOGEAGHTY,
Newahòeny Akoyendarake neoni Ahhondatterihhonny.

A-onea wadiròroghkwe, neoni Tekaweanadènnyoh Kanyen-
kehàga Tsikaweanondaghko, ne neane Raditsihuhstatsy ne
Radirighwawakoughkgowa ronadanhã-ouh, Kanyenke waon-
dyc tsi-radinakeronnyo Ongwe-oewe.

KEAGAYE ASE YONDEREANAYENDAGHKWA.
ONI TAHOGHSONDEROH
St. MARK RAORIGHWADOGEAGHTY,
Tekaweanadennyoh Kanyenkehàga Rakowànea
T'HAYENDANEGEA,
Roewayats.

LONDON:
KARISTODARHO C. BUCKTON, GREAT PULTNEY STREET,
GOLDEN SQUARE. 1787.

FRONTISPIECE

TITLE PAGE FROM *THE BOOK OF COMMON PRAYER*, TRANSLATED
BY JOSEPH BRANT, 1787

London, England
leather, paper, cardboard, and fibre
20.5 x 13 cm

One of the most famous Loyalists to settle in Canada after the
American Revolution was a man known in Mohawk as
Thayendanegea and in English as Joseph Brant. He was not only a
loyal subject but also an Anglican missionary, and he translated
the prayer book into Mohawk. At the outset of the war, when
Governor Carleton turned down his application to lead an all-
Mohawk regiment against the rebels, Chief Brant sailed to
England to plead his case before the king. George III granted his
wish and, for the duration of the war, he led what were known as
Brant's Volunteers. In 1784, as a reward for his loyal wartime
service, the Six Nations of the Iroquois Confederacy were
granted 275,000 hectares in the Grand River valley northwest of
present-day Hamilton, Ontario. Brant led 1,800 followers to settle
the area, where he helped found the first Anglican church in
Upper Canada and worked on translating the Bible into Mohawk.

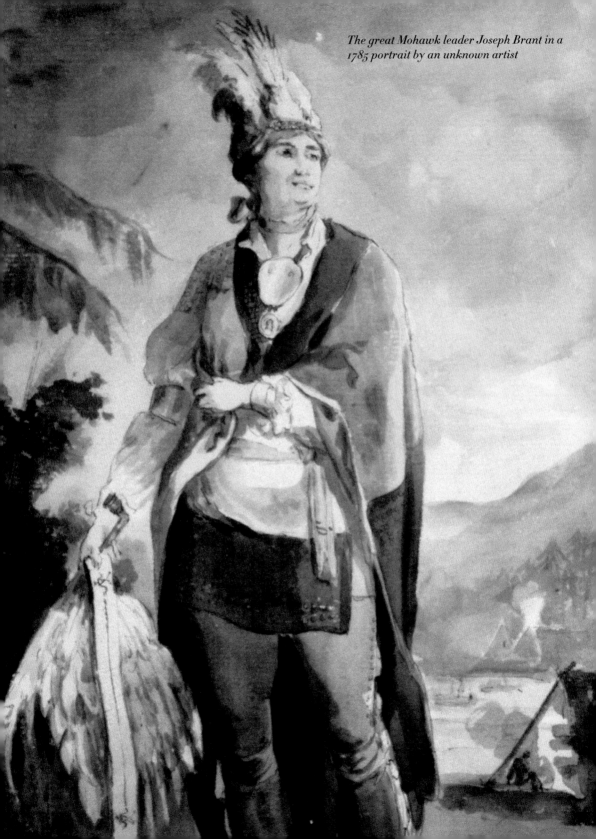

The great Mohawk leader Joseph Brant in a 1785 portrait by an unknown artist

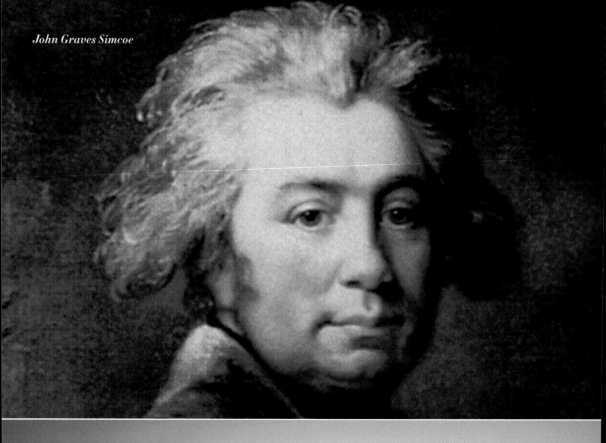

John Graves Simcoe

Great Britain was determined that its remaining North American colonies would not go the way of the rebellious thirteen. In 1791 the Parliament at Westminster passed into law the Constitutional Act, which divided the Province of Quebec into Lower Canada and Upper Canada. John Graves Simcoe, the first lieutenant-governor of Upper Canada, which had already become a haven for Loyalist refugees, immediately began granting land to Loyalist settlers while doing his utmost to keep a lid on their more democratic tendencies.

RULES

AND

Regulations

OF THE

HOUSE of ASSEMBLY,

LOWER - CANADA.

QUEBEC:

PRINTED FOR JOHN NEILSON.

M.DCC.XCIII.

Mr Delavaltrie

MACE OF UPPER CANADA, APPROX. 1792

Niagara-on-the-Lake, Ontario
pine and brass
142.2 x 11.4 cm

RULES AND REGULATIONS OF THE HOUSE
OF THE ASSEMBLY, LOWER CANADA, 1793

Quebec City, Quebec
paper
19 x 11 x 1.3 cm

The Constitutional Act, 1791, established elected assemblies in both Upper and Lower Canada, but made sure that their powers were strictly limited and more than balanced by legislative councils appointed by the governor from among the colony's elite. This title page of the Lower Canada assembly's *Regulations* comes from a copy used by Pierre-Paul Margane de Lavaltrie, the member for the riding of Warwick and seigneur of Lavaltrie. The mace was carried by the Speaker at the first meeting of the Upper Canada Legislative Assembly, held on September 17, 1792, in Niagara-on-the-Lake.

SIGN FOR THE KING'S HEAD INN, 1794

Burlington, Ontario
painted pine
77.2 x 66.2 cm

This sign once hung outside the King's Head Inn, which Lieutenant-Governor Simcoe ordered built as a military post and way station on the strategically important road between York and Niagara. The building would be burned to the ground after being bombarded by two American schooners during the War of 1812. But it was not the threat from the south that would push Canada toward a more democratic system. That impetus came from within.

REBEL HALL
1810 to 1840

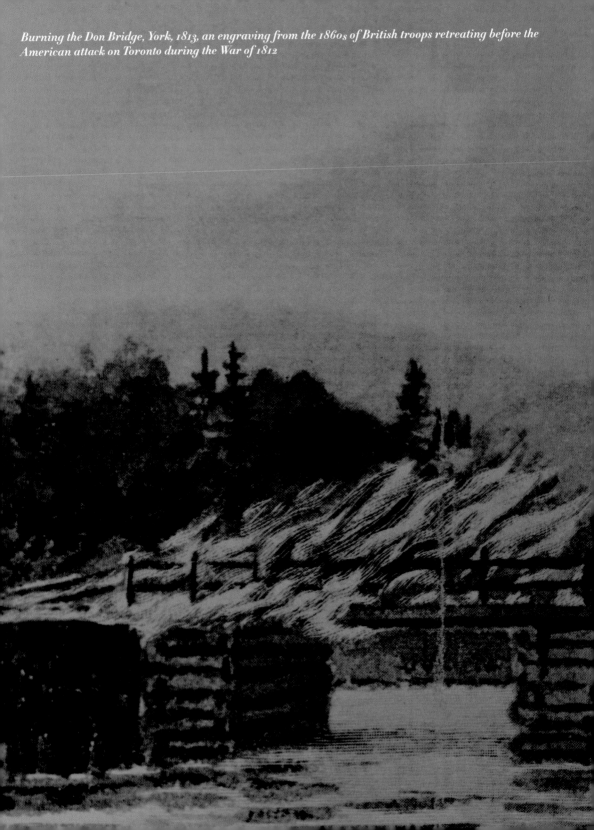

Burning the Don Bridge, York, 1813, an engraving from the 1860s of British troops retreating before the American attack on Toronto during the War of 1812

While the new colonists of British North America toiled to clear the land, set up local industries, and develop their political institutions, war once again interfered. In 1811, when the recently independent United States allied itself with Napoleonic France, Britain began boarding American vessels that attempted to reach French ports. In retaliation, President James Madison declared war against Britain's North American colonies on June 18, 1812. Given that the number of British regulars in the Canadas was a little short of 2,000, and with Upper Canada largely populated by refugees from the Thirteen Colonies, the Americans expected an easy conquest. But the Canadian militia and their native allies fought with surprising tenacity, and a wily young British general named Isaac Brock outmanoeuvred the Yankees early in the conflict.

SIR ISAAC BROCK'S COAT, APPROX. 1812

*probably made in
London, England
wool, metal, and gold,
gilded brass buttons
113 x 60 x 36 cm*

Major-General Sir Isaac Brock wore this elegant coat on October 13, 1812, at the
Battle of Queenston Heights. That day American troops, intent on avenging
their defeat at Fort Detroit the previous August, crossed the Niagara River
near Niagara-on-the-Lake and attacked Brock's strategic position on Queenston
Heights. Brock's troops, a mixture of British regulars and Canadian militia,
successfully repulsed the American invasion, but an American sniper put a
fatal bullet hole through the coat just below the collar.

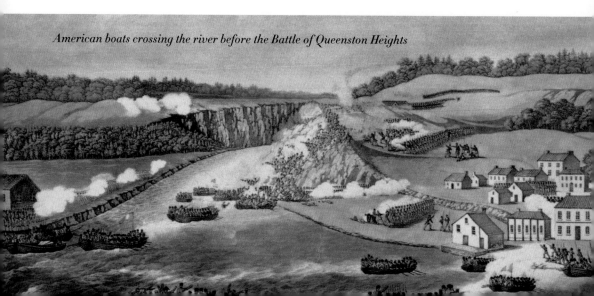

American boats crossing the river before the Battle of Queenston Heights

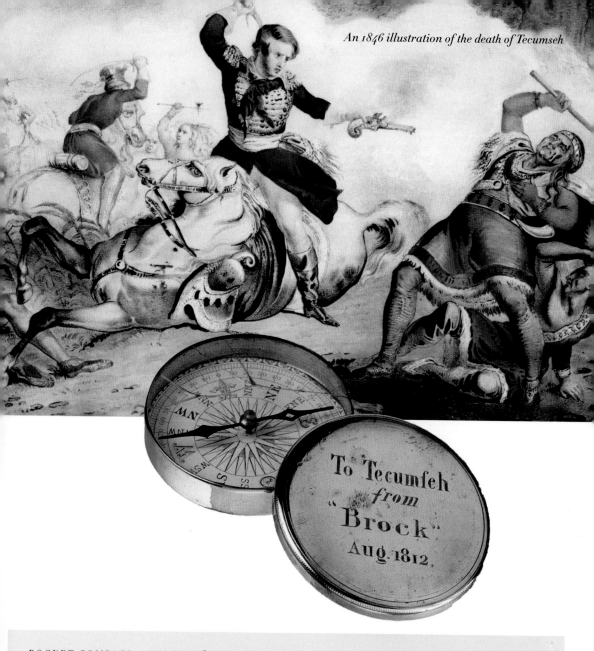

An 1846 illustration of the death of Tecumseh

To Tecumseh
from
"Brock"
Aug. 1812.

POCKET COMPASS, APPROX. 1810

England
brass
1.5 x 5.5 cm

According to popular belief, General Brock gave this pocket compass to his native ally, Tecumseh, when they met to plan their celebrated attack on Fort Detroit, which surrendered without putting up a fight in August 1812. The victory briefly boosted the great Shawnee chief's quest to unite the Indians of the Midwest in a confederacy against westward expansionism by the United States. After Tecumseh's death at the Battle of the Thames on October 5, 1813, one of the chief's warriors requested that the compass be engraved in his memory. No doubt Brock would have approved.

Tentative Legal Tender
Canada's First Banknote

Everything about this 1817 banknote oozes reliability. The engraved vignette (top centre) of Montreal's busy harbour illustrates a city teeming with trade. The helmeted (and busty) figure of Britannia with ship and lion (in the lower oval) emphasizes British North America's close links with mighty Great Britain. And the elaborate copperplate script should reassure anybody that the note is worth real money: "The President and Directors and company of the MONTREAL BANK promise to pay _____ or bearer in Montreal at the Bank twenty dollars on demand out of the Joint Funds of the Association and no other." And then two handwritten signatures: "E.W. Griffin, Cashier" and "John Gray, Pres."

Today we are so accustomed to dealing with paper money that we take its value for granted. We barely glance at the $20 bills as they flow in and out of our wallets, knowing they will always be redeemed at face value. How could we not accept without question the word of such a solid-sounding citizen as John Gray, Pres? Why would anybody doubt that, if he or she turned up at the bank with this note, Mr. Griffin (sporting well-groomed whiskers and a spotless linen shirt) would cheerfully hand over twenty dollars' worth of silver coins?

Yet if you handed this splendid banknote to a merchant, ship's captain, or lawyer in 1817, he might well have laughed in your face. He would know that, for all its official-looking appearance, this piece of paper was a bold bit of entrepreneurship. It had no government backing, and only Mr. Gray's reputation, to guarantee that E.W. Griffin, cashier, would actually exchange it for $20 in coin. If the merchant did not know you personally, he would immediately demand coins, with real metal value, rather than a flimsy bit of printing.

$20 BANK NOTE FROM THE MONTREAL BANK (NOW THE BANK OF MONTREAL), 1817

Montreal, Quebec
made from intaglio printing plates,
printed on paper (cotton/wood pulp mix)
7.5 x 17.5 cm

This $20 bill was one of the first banknotes to be issued in Canada. After the War of 1812, the thriving port city of Montreal consolidated its position as the commercial centre of Upper and Lower Canada, making a more sophisticated monetary system a priority and a commercial opportunity.

This was, after all, Montreal, just after the end of the War of 1812. True, it rivalled Quebec City for the title of largest city in British North America, and it boasted a handsome Catholic cathedral and several colleges and convents, but its citizens also suffered regular cholera outbreaks, and there were no paved streets. The city had thrived since the early eighteenth century on the fur trade and, more recently, the lumber business. Wharves were piled high with masts, spars, planks, shingles, and squared timbers, bound for Britain and the West Indies. Cargoes of rum, manufactured goods, sugar, tea, and other foodstuffs waited to be unloaded from the vessels that crowded the harbour. The cobbled squares and wharfside bars teemed with soldiers, sailors, colonial officials, domestic servants, traders, and merchants. A few blocks north, Scots merchants, who ran all the shipping and trading companies, had built themselves magnificent stone mansions with massive carved portals and panelled dining rooms.

For all this bustle of construction, commerce, and industry, however, Montreal possessed an inadequate monetary system. All transactions were conducted either in coins or on terms of barter, or with unreliable IOUs. The system had just about worked when Montreal was an overgrown small town, where all the fur traders and ship captains knew each other and where the total population had not reached 10,000. But now, as immigrants began to pour in from the British Isles, the local currency was stretched beyond its limits. In desperation, some merchants had started writing chits, called *bons*, because the merchant wrote on each chit *Bon pour* (good for) a certain amount. But each *bon* was only as good as its backer – some of whom regularly faced bankruptcy. Even the coinage, which everyone preferred to *bons*, was chaotic and in short supply, since British North America had no mint. The city's commerce was conducted in a confusing mélange of buttons and British crowns and Portuguese "Joes" and underweight French *écus*.

This confusion did not matter so much in less-developed colonies like Upper Canada or New Brunswick, where farmers and fishermen continued to

rely on barter. But in the city of Montreal, the absence of a decent currency was holding back the economy. And the government in Quebec City, dominated by petty-minded colonial bureaucrats who didn't understand trade, appeared to have no interest in dealing with the issue.

Into this commercial breach stepped nine canny Montreal merchants under the leadership of another Scot, John Gray. In England, banks had been issuing paper money for over a century. In the United States, banking had expanded from only three banks in 1784 to eighty-nine in 1811 – and, by 1814, bank notes formed 77 percent of the total American money in circulation. Gray and his colleagues saw a golden market opportunity: a homegrown Canadian financial institution.

In 1817 they pooled resources and founded the Montreal Bank as a joint stock enterprise. They commissioned a Connecticut printer to design and print a $20 note with wide popular appeal. The bank's directors astutely insisted that each note in the series ($5, $10, and $50 bills were also produced) bear a different vignette. As the bank's Articles of Association put it, this distinction would ensure that "the most illiterate can ascertain the amount by inspection without being able to read."

The journalistic welcome given the new paper money reflects the relief of Montreal's professional classes: "The utility of banking establishments has been so generally acknowledged in every civilized country, that any argument against having them in this country should have little or no weight," pronounced the *Montreal Herald* on May 10, 1817. "Some solitary objections might indeed be started, but those could only originate in little or prejudiced minds."

The new bank's directors worked hard to convince potential clients of their institution's dependability. In 1818 they renamed it the Bank of Montreal (three words have so much more *gravitas* than two) and built an imposing three-storey building on Montreal's St. James Street. With its classical pediment and Doric columns, it looked more like a church than a house of mammon. It is the ancestor of the Bank of Montreal today.

At first ordinary Montrealers must have greeted the new money with understandable skepticism, given previous "funny money" schemes in the colony. Only a few decades earlier, New France's colonial administrators had announced that a playing card bearing an official seal was legal tender – a primitive attempt to increase the money supply so that the government could pay its own bills. Soon merchants in Montreal and Quebec City were trading aces and jacks alongside what regular currency there was. The playing-card money stayed in circulation for years, with no one quite believing that the French government would ever redeem it. Their fears were justified. By 1750 this currency was worth only one-fifth of its face value, and most residents of New France refused to accept it. After New France fell to the British in 1760, the cards became worthless.

The 1817 banknote might look convincing, but it didn't defeat the hucksters. It was widely counterfeited. The bank survived, however, because Mr. Gray was an honest merchant and his colleagues needed his notes. By 1820 Montreal had overtaken Quebec City in population and wealth. Rival banks in both Upper and Lower Canada appeared, the economy of British North America began to boom, and Canadians embraced their homegrown paper money. By mid-century their banknotes slipped in and out of wallets just as easily as ours do today.

Opposite: *By 1860 the Bank of Montreal would occupy this impressive neoclassical head office; the original Bank of Montreal is to its left.*

Three reformers: (left to right) Upper Canada's William Lyon Mackenzie, Nova Scotia's Joseph Howe, Lower Canada's Louis-Joseph Papineau

The common call of reform-minded politicians throughout British North America was for "responsible government," the code phrase for a political system that included a broader franchise and a more powerful legislature. In Upper and Lower Canada, democratic reform was stymied by the power of the British governors, who ruled with little regard for the wishes of the elected representatives. In Lower Canada, where the *Canadien*-dominated assembly was consistently ignored by the British governor and where the English commercial class formed the de facto aristocracy, rebellion was in the air.

THE GRANGE, 1817

Toronto, Ontario brick and other materials original size: approx. 18 x 12 m

This two-storey Georgian-style home, with its columned wooden portico and circular window in the pediment above, was built for D'Arcy Boulton Jr., the eldest son of one of Upper Canada's most prominent families. To William Lyon Mackenzie, the reformist editor of the *Colonial Advocate*, such grand edifices symbolized the unearned wealth and privilege of Toronto's close-knit ruling class, which he contemptuously dubbed the "Family Compact" because of its control of the colony's affairs. In 1834, the same year he was elected the first mayor of the newly incorporated City of Toronto, Mackenzie presented his *Seventh Report on Grievances*, a 500-page critique of British government of Upper Canada, which demanded responsible government and local control of the budget.

PRINTING PRESS, APPROX. 1829

Hartford, Connecticut
iron and wood
50.8 x 76.2 cm

On New Year's Day in 1835 Joseph Howe published a letter in his newspaper, the *Novascotian,* charging the governing elite of the colony with corruption and mismanagement of its affairs. Like Mackenzie and Papineau, the thirty-year-old editor of Nova Scotia's reformist newspaper advocated responsible government and local control. But Howe also strongly supported the British connection and disliked radical tactics. The Maritime provinces did not join the rebellions of 1837.

STATUE OF ALBION, APPROX. 1836

Montreal, Quebec
wood
193 cm

This statue of Albion, with her shield symbolizing the strength of the British Empire and her trident representing the power of the Royal Navy, crowned the north pediment of the Customs House on St. Paul Street in Montreal when the building was completed in 1836. The statue must have infuriated Louis-Joseph Papineau and his Patriotes, whose demands for reform continued to be ignored. The British government had yet to respond to Papineau's *92 Resolutions,* which he had presented personally in London two years earlier. Papineau's wish list included greater power for the House of Assembly, so it would have the perquisites, privileges, and immunities enjoyed by the British Parliament. In March 1837 the British government finally gave Papineau his answer: No on all ninety-two counts.

PATRIOTE BANNER, 1837

Lower Canada
cotton
106 x 158 cm

Lower Canadian rebels brandished this banner during their 1837 uprising. Above a spray of sugar maple leaves, a wreath of pine encircles a *maskinunge* fish (muskellunge) and the letters *C* and *J-B*, which probably stand for "Canada for St. Jean-Baptiste," Quebec's patron saint.

Opposite: *Jane Ellice painted these Patriote rebels in 1838 while she and sixty other Loyalists were being held hostage in the presbytery of Beauharnois, Lower Canada.*

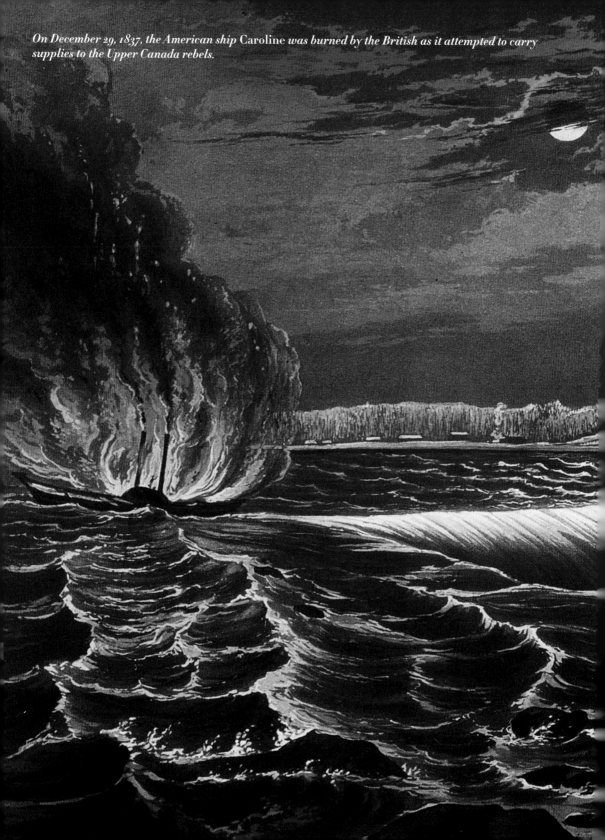

On December 29, 1837, the American ship *Caroline was burned by the British as it attempted to carry supplies to the Upper Canada rebels.*

BIDWELL *and the* GLORIOUS MANORITY

1837 *and* A GOOD BEGINNING.

VICTORIA *the* 1*st and* REFORM.

REBEL BANNER, 1837

Toronto, Ontario
wool, linen thread, cotton letters
approx. 270 x 90 cm

Although this banner is marked by powder burns, it was never used for its intended purpose. On December 7, 1837, William Lyon Mackenzie and his supporters assembled at Montgomery's Tavern, an inn on Yonge Street just north of the town limits of York (near present-day Eglinton and Yonge). Their plan was to march down Yonge, seize power, and set up a provisional government. But Lieutenant-Governor Sir Francis Bond Head had caught wind of Mackenzie's scheme and sent troops to surprise the rebels, who were dispersed before they could even begin their march or raise their banner in defiance. The banner was recovered from the ruins of the tavern, which was burned to the ground by government troops. The top slogan refers to Marshall Bidwell, who served as the leader of the Reform majority in the Legislative Assembly as well as its Speaker. The lower slogan appears to be a feeble attempt to equate loyalty to empire with the forces of reform.

Following the failed rebellions in Upper and Lower Canada, London dispatched a statesman and colonial administrator known for his reformist beliefs to deal with the situation. Lord Durham recommended in 1839 that Upper and Lower Canada be united into a single province and granted responsible government. Durham's report was warmly received by English-speaking reformers in both colonies, but not by French speakers, who feared they would be assimilated. Only one of Durham's two main recommendations was accepted: the creation of a single colony.

Originally built as a hospital, this building in Kingston was home to the Parliament of the United Canadas from 1841 to 1844.

STAINED-GLASS WINDOW, BEFORE 1841

Kingston, Ontario
glass, lead, and wood
84 x 53.5 x 4.5 cm

This window overlooked the legislative debates held in the Parliament of the United Canadas from 1841 to 1844. Its striking bands of red, white, and blue echo the British Union Jack, while the prominent use of sugar maple leaves adds a distinctly Canadian symbol to the design. When the legislators convened in Kingston on June 15, 1841, the majority of the members from the new Canada West (Ontario) were reformers, while the majority from Canada East (Quebec) were French-speaking. Of necessity, coalitions between the two groups were soon forged. Led by Robert Baldwin from Canada West and Louis-Hippolyte LaFontaine from Canada East, the reform coalition continued to press for responsible government and greater political autonomy for the colony.

Confederation Gallery

1845 to 1869

Busts of Canadian prime ministers in Ontario's Provincial Museum, early 1900s;

Confederation Gallery
1845 to 1869

The 1841 Act of Union, which created the United Province of Canada, solved none of the underlying problems it was intended to address. The megacolony it established struggled with a split personality that kept shifting its capital and had difficulty forming stable governments. The French–English coalitions that emerged, however, presaged the binational politics of the future dominion. Meanwhile, the maritime colonies of Nova Scotia, New Brunswick, and Prince Edward Island moved towards responsible government. Far to the west, the thriving colony that was emerging on the Pacific coast seemed to be attracted to the increasingly powerful American Union, while the vast space in between remained mostly unsettled, except for the tiny Red River Colony, where tensions between the Métis community and the Anglo-Scots settlers were mounting. The chances of British North America uniting into a single political entity looked poor.

PORTRAIT OF JOHN A. MACDONALD IN A GOLD LOCKET, APPROX. 1845–50

*Ontario
daguerreotype
2.8 cm*

It's possible that a twenty-nine-year-old Kingston lawyer named John Alexander Macdonald carried this locket with him when he first took his seat in the Legislative Assembly of the Province of Canada after the 1844 election. If so, it carried an earlier picture of his first wife, Isabella (whom he married in 1843), rather than the miniature painting now on its obverse, which is of Isabella and their son Hugh John, who wasn't born until 1850. Macdonald moved up fast. He was brilliant and charming and eloquent (as well as quick to anger and overly fond of strong drink). In 1854 he was appointed attorney general, and in 1856 he became joint premier of the province with Étienne-Paschal Taché, a Canadien Liberal from Canada East. Taché was succeeded by his colleague George-Étienne Cartier in 1857, which marked the beginning of a long partnership with Macdonald that cemented the political alliance that ultimately became the Liberal-Conservative Party – the original name for the Conservative Party.

"PARLIAMENT BUILDINGS, OTTAWA," THOMAS FULLER AND CHILION JONES, 1859

Ottawa, Ontario
manuscript paper
59.1 x 95.4 cm

In 1857 Queen Victoria chose the rough-hewn lumber town of Ottawa as the new capital of the Province of Canada. These drawings formed part of the plans for the new Parliament Buildings, which began construction two years later. The buildings were designed in a Gothic Revival style reminiscent of the recently completed British Parliament. (They would open in 1866, on the eve of Confederation.) The site for the capital was not selected by royal whim. Ottawa was well served by rail transportation, yet far enough from the border to make it safer in the event of an American invasion.

An 1865 painting of the American Union's Ulysses S. Grant and his generals. Right: *Dead Union soldiers after the battle at Gettysburg, Pennsylvania, in July 1863*

KETCHUM'S PATENT HAND GRENADE, WILLIAM F. KETCHUM, 1861

Buffalo, NY
metal and wood
approx. 8 x 31 cm

No American hand grenades were ever lobbed at Canada's new Parliament Buildings, but during the 1860s the possibility seemed real enough. What if the massive military machine built up in the northern states during the Civil War turned on Canada? Newfangled weapons like this one – it was thrown like a dart and ignited on impact – had already given the Union army a tactical advantage over the Confederacy. In an invasion of Canada, the United States would now make a far more formidable opponent than American forces had done during the War of 1812. Such considerations contributed to growing support for a confederation of the small and poorly defended British colonies strung precariously along the northern U.S. border.

Mary Ann Shadd Cary, between 1845 and 1855

NATURALIZATION CERTIFICATE OF MARY ANN SHADD CARY, 1862

*Kent County, Ontario
paper
33.5 x 21 cm*

This certificate, granting "all the rights and capacities of a Natural-born British [woman]," was issued to Mary Ann Shadd Cary twelve years after she emigrated from Pennsylvania to the town of Chatham in Canada West. The certificate is a "fill-in-the-blank" form issued by the court of the County of Kent. Mary's name, place of origin, place of settlement, and the date of naturalization (which appears to be in the 1860s) are filled in by hand. Although born free from slavery in 1823, Mary was African-American, which made her emigration to Canada a violation of the Fugitive Slave Act. (Between about 1840 and 1860, some 30,000 black refugees arrived in Canada.) By 1862 Mary had proved herself a solid potential citizen: she had taught school and, in 1851, published a handbook called *Notes from Canada West* for use by African-Americans who were contemplating immigration to Canada.

CANADA,
NEW BRUNSWICK
AND NOVA SCOTIA.
BY SIDNEY HALL.

In the early 1860s the potential military threat from the United States was one of several factors pushing the East Coast colonies of British North America towards some sort of maritime union. A united front would also give them a stronger bargaining position during the next round of negotiations for an intercontinental railway to link them and their seaports to the Province of Canada and beyond. In addition, business leaders in the robust economies of Nova Scotia and New Brunswick worried that American protectionism was once again on the rise.

GROUP OF MERCHANTS, 1855

Mason Hall, Yarmouth, NS
half-type daguerreotype
10.8 x 14 cm

This early photograph, or daguerreotype, is the work of a professional photographer who travelled from town to town in the Maritime provinces looking for business. Among the Yarmouth worthies who posed for their group portrait was Loran Ellis Baker (front row, seated centre). Baker was only twenty-four when this picture was taken, but he was already launched on a stellar career as shipowner, banker, and politician. He was elected to the Nova Scotia legislature in 1878 and served until 1900.

DETAILS OF "CONFEDERATION" QUILT (SHOWING LEFT, "FANNIE", RIGHT, "1864"), 1864

Charlottetown, PEI
embroidered silk,
tartan satin, taffeta, and
brocade
both details, approx.
16 x 20 cm;
quilt, 155 x 180 cm

These are details of the quilt made by the Charlottetown dressmaker Fannie Parlee, who created her work from scraps of material she had left over after making dresses for the wives of local dignitaries who attended the numerous social functions at the Charlottetown Conference.

A PATCHWORK COUNTRY
Fannie Parlee's Confederation Quilt

Stitched into this shabby-looking quilt is far more history than we might ever imagine. The quilt is put together conventionally enough. Oddly shaped pieces of fabric have been basted to a foundation of firm cotton, and the seams are embroidered with gold and silver thread. The quilt is obviously made by an expert seamstress. It was a point of honour with quilt mavens to display at least one hundred different stitches in one throw – stitches with names like "turkey tracks" and "creeping vine" – but the profusion of different stitches here is remarkable. The patches have been sewn into squares, and the quilt consists of sixteen full squares and four half-squares, with a weighted silk ruffle to finish the edges. It is a good size and, on one turquoise silk patch, the date 1864 is embroidered in chain stitch. In short, it is a typical crazy patchwork quilt, a style that was all the rage in the 1860s. What is less typical about this particular quilt is the grandness of the material: embroidered silk, tartan satin, shiny taffeta, and delicate brocade, the kinds of fabrics used for evening gowns.

The 1860s was a well-dressed decade, thanks largely to the influence of Alexandra, Princess of Wales. Style-conscious Canadian women pored over the engravings in the *Illustrated London News* and *Godey's Lady's Book*, which showed this elegant Danish princess, the wife of Edward, Prince of Wales, wearing pretty little hats and voluminous skirts. On the evidence of this quilt, Princess Alexandra's partiality for bright colours, rich fabrics, stripes, and tartans had crossed the Atlantic. The quilt even includes scraps of silk dyed in two of the most up-to-date colours available: mauve and magenta, both produced by a new process involving coal tar. Since the crinoline skirts that elegant ladies wore in the

Fannie Parlee's "Confederation" quilt

1860s required 15 metres of fabric, a wealth of scraps was available for a quilt maker. But most women would have only one gown for "best."

How did the woman who made this quilt lay her hands on scraps from such a variety of different gowns? In all likelihood, she was a dressmaker. According to the Parlee family, who gave this quilt to the King's County Museum, New Brunswick, where it is displayed today, their great-grandmother Fannie Parlee was the Charlottetown seamstress who made gowns for the wives and daughters of Prince Edward Island's leading citizens.

Fannie was particularly busy that summer of 1864. In September a group of distinguished Maritime delegates was scheduled to arrive in town to discuss a possible union between Nova Scotia, New Brunswick, and the Island. Shortly before the conference began, Islanders heard that the local politicians would be joined by delegates from the Province of Canada (present-day Ontario and Quebec) and that the notion of a federation of all the British colonies in North America would be raised.

The Island's elite decided to show the "come-from-aways" what little PEI could do when it pulled out all the stops, and there was a frantic rush to choreograph some gracious entertaining. Mrs. Parlee's clients discovered simultaneously that nation-building involves a whirlwind round of lunches and dinners, for each of which they needed a different "best" outfit. Fannie Parlee's needle must have been busy from dawn to dusk.

Who wore, I wonder, that delicate lemon silk embroidered with gold stars? Was Mrs. Dundas, wife of the lieutenant-governor, a vision in yellow when she welcomed all the distinguished visitors to Government House on Thursday, September 1, the opening night of the conference? And what did she wear on Tuesday, September 6, when everybody was invited to a ball at the beautiful Georgian mansion, with its shady verandah and lofty portico, that remains to this day the official residence of

Two women on Rustico Beach, PEI, c. 1900

the Island's head of state? Did the black silk with a raised pattern belong to the formidable Mrs. William Pope, mother of eight and wife of the Island's provincial secretary, who on Friday, September 2, graciously entertained the conference delegates to a grand *Déjeuner à la fourchette* – oysters, lobsters, champagne, and, as George Brown wrote to his wife, "other island delicacies"? According to Brown, the founder of the Toronto *Globe* and a delegate from the Province of Canada, this splendid buffet lunch "killed the day and we spent the beautiful moonlight evening in walking, driving or boating ... I sat on Mr. Pope's balcony looking out on the sea in all its glory." And what about that piece of pink, yellow, and black plaid? Is this a remnant from a gown that Mrs. Parlee quickly ran up for the English-born wife of Colonel John Hamilton Gray, the former Guards officer who was the Island's premier and the chair of the conference? On Saturday, September 3, Mrs. Gray ("a most excellent person" in Brown's opinion) was hostess at a particularly grand dinner party at the Grays' country estate, "Inkerman."

The festivities in the Island's mansions were not the only social events. The eight delegates from the Province of Canada (including George-Étienne Cartier and John A. Macdonald) had arrived at Charlottetown in a 191-tonne steamer called the *Queen Victoria*, which lay at anchor in the harbour. On the Saturday, they invited all the other politicians present to lunch on board (they had thoughtfully packed $13,000 worth of champagne). The following Wednesday they invited the wives of the Maritime delegates to lunch on what had already been nicknamed the "Confederate Cruiser." On Thursday, September 8, the final night of the conference, there was a ball in the Parliament Buildings that began at 9 p.m. and was still going strong six hours later. Even the Toronto sophisticate George Brown was impressed by this "very grand affair – two bands of music, fine supper, and so forth."

Room where the 1864 Charlottetown Conference was held

Before September 1864, few Maritimers even knew what a Canadian looked like, while Canadian ignorance of the East Coast was proverbial. The Maritimes and "Canada" were really two separate countries, with different histories and traditions. Maritimers regarded central Canadians as pushy *arrivistes*, whilst Upper and Lower Canadians thought the easterners hopelessly provincial. But at the endless parties the delegates from different colonies established the trust that helped the business sessions go forward. As Brown wrote to his wife, "Whether as a result of our eloquence or of the goodness of our champagne, the ice became completely broken ... and the banns of matrimony between all the Provinces of B.N.A. having been formally proclaimed and all manner of persons duly warned there and then to speak or forever after to hold their tongues. No man appeared to forbid the banns and the union was thereupon formally completed and proclaimed!" When, nine days after the *Queen Victoria* arrived at Charlottetown, it steamed off to the next round of constitutional talks in Halifax, the destiny of British North America had been laid out.

The Charlottetown Conference left many loose ends, not least the issue of a Maritime union. But the main principles of Confederation were agreed: a patchwork of provinces would be sewn together. And Mrs. Parlee was left with a luscious mountain of silk and satin scraps on the floor of her workroom. I wonder if she pondered the symbolism of her actions as she sorted out the ones she would use for her quilt.

Opposite: Prelude to Confederation, *by Rex Woods, a twentieth-century painting showing the Fathers of Confederation on the deck of SS* Queen Victoria, *the ship that carried them from Quebec City to the Charlottetown Conference in 1864*

The soon-to-be Fathers of Confederation posed for posterity on the steps of Government House, Charlottetown, before moving their discussions to Quebec. Among the leading lights: John A. Macdonald, attorney general, Canada West (seated on steps, centre, with hat on knee); George-E. Cartier, attorney general, Canada East (standing front row, facing Macdonald with hat in right hand); George Brown, president, Executive Council, Canada (standing, front row, far right, with right hand on raised right knee); Thomas D'Arcy McGee, minister of agriculture, Canada (standing with hands behind his back, between Macdonald and Cartier); Charles Tupper, provincial secretary, Nova Scotia (back row, second from left); H.L. Langevin, solicitor general, Canada East (standing, front row, third from left, hat in right hand); John Hamilton Gray, chairman of the convention, Prince Edward Island (standing to the immediate right of Macdonald, holding a scroll of paper).

TITLE PAGE FROM "QUEBEC CONFERENCE RESOLUTIONS," WITH DOODLES BY SIR JOHN A. MACDONALD, 1864 (OPPOSITE)

Quebec City, Quebec
paper
19.5 x 32 cm

In early October 1864, a few weeks after the Charlottetown Conference ended, delegates from the colonies of British North America gathered at Quebec City to hammer out the legislative framework that would become the foundation of the Dominion of Canada. This page, thought to be from Macdonald's working copy of the "72 Resolutions," as the final Quebec document was known, suggests that the delegate from Canada West was a dab hand at caricature.

REPORT

Of Resolutions adopted at a Conference of Delegates from the Provinces of Canada, Nova Scotia, and New Brunswick, and the Colonies of Newfoundland and Prince Edward Island, held at the City of Quebec, 10th October, 1864, as the Basis of a proposed Confederation of those Provinces and Colonies.

1. The best interests and present and future prosperity of British North America will be promoted by a Federal Union under the Crown of Great Britain, provided such Union can be effected on principles just to the several Provinces.

2. In the Federation of the British North American Provinces, the system of Government best adapted, under existing circumstances, to protect the diversified interests of the several Provinces, and secure efficiency, harmony, and permanency in the working of the Union, would be a General Government charged with matters of common interest to the whole Country, and Local Governments for each of the Canadas and for the Provinces of Nova Scotia, New Brunswick, and Prince Edward Island, charged with the control of local matters in their respective sections,—provision being made for the admission into the Union, on equitable terms, of Newfoundland, the North-West Territory, British Columbia, and Vancouver.

3. In framing a Constitution for the General Government, the Conference, with a view to the perpetuation of our connection with the Mother Country, and to the promotion of the best interests of the people of these Provinces, desire to follow the model of the British Constitution, so far as our circumstances will permit.

4. The Executive Authority or Government shall be vested in the Sovereign of the United Kingdom of Great Britain and Ireland, and be administered according to the well understood principles of the British Constitution, by the Sovereign personally, or by the Representative of the Sovereign, duly authorized.

5. The Sovereign, or Representative of the Sovereign, shall be Commander in Chief of the Land and Naval Militia Forces.

6. There shall be a General Legislature, or Parliament, for the Federated Provinces, composed of a Legislative Council and a House of Commons.

7. For the purpose of forming the Legislative Council, the Federated Provinces shall be considered as consisting of three divisions: 1st—Upper Canada; 2nd—Lower Canada; 3rd—Nova Scotia, New Brunswick, and Prince Edward Island—each division with an equal representation in the Legislative Council.

8. Upper Canada shall be represented in the Legislative Council by 24 Members, Lower Canada by 24 Members, and the three Maritime Provinces by 24 Members, of which Nova Scotia shall have ten, New Brunswick ten, and Prince Edward Island four Members.

9. The Colony of Newfoundland shall be entitled to enter the proposed Union with a representation in the Legislative Council of four members.

10. The North-West Territory, British Columbia, and Vancouver, shall be admitted into the Union on such terms and conditions as the Parliament of the Federated Provinces shall deem equitable, and as shall receive the assent of Her Majesty; and in the case of the Province of British Columbia or Vancouver, as shall be agreed to by the Legislature of such Province.

11. The Members of the Legislative Council shall be appointed by the Crown under the Great Seal of the General Government, and shall hold office during Life. If any Legislative Councillor shall, for two consecutive Sessions of Parliament, fail to give his attendance in the said Council, his seat shall thereby become vacant.

12. The Members of the Legislative Council shall be British Subjects by Birth or Naturalization, of the full age of Thirty Years, shall possess a continuous real property qualification of four thousand dollars over and above all incumbrances, and shall be and continue worth that sum over and above their debts and liabilities; but in the case of Newfoundland and Prince Edward Island the property may be either real or personal.

13. If any question shall arise as to the qualification of a Legislative Councillor, the same shall be determined by the Council.

14. The first selection of the Members of the Legislative Council shall be made, except as regards Prince Edward Island, from the Legislative Councils of the various Provinces, so far as a sufficient number be found qualified and willing to serve; such

SHEET MUSIC FOR "LA CONFÉDÉRATION QUADRILLE," LÉON CASORTI, APPROX. 1867

Montreal, Quebec
lithograph
38.2 x 25.5 cm

Not every citizen of the new country welcomed its creation. And the theme of future strife is already evident on the satiric cover page of "La Confédération Quadrille," where Quebec's religion, language, customs, and laws are shown chained to a royal chariot driven by an Upper Canadian beaver (labelled *HC* for Haut-Canada). The beaver cracks his whip over a stoic Lower Canadian beaver (labelled *BC* for Bas-Canada) while waving a banner of racial superiority ("Race Supérieur") over the French. In the upper right-hand corner a couple fights beneath the heading "The Union Made by Force."

ANTI-CONFEDERATION BANNER, 1867

Bridgewater, NS
stamped cotton,
paint
134 x 86 cm

In many parts of Nova Scotia and New Brunswick, the creation of Canada was greeted with public protests. This banner was carried by nine-year-old Robert Dawson Jr. of Bridgewater, Nova Scotia, during an Anti-Confederation parade in 1867. Perhaps Joseph Howe, the veteran reformer who had become the leading "anti" voice in the province, addressed the rally. That same year in the County District of Lunenburg, where Bridgewater is located, federal election results were 905 for Confederation and 1,557 against.

(Clockwise from top left): *D'Arcy McGee; book about the trial of Patrick Whelan; "Inspecting the Volunteers for Fighting the Fenians," Champs de Mars, Quebec, c. 1866; poster advertising the reward for the capture of D'Arcy McGee's killer*

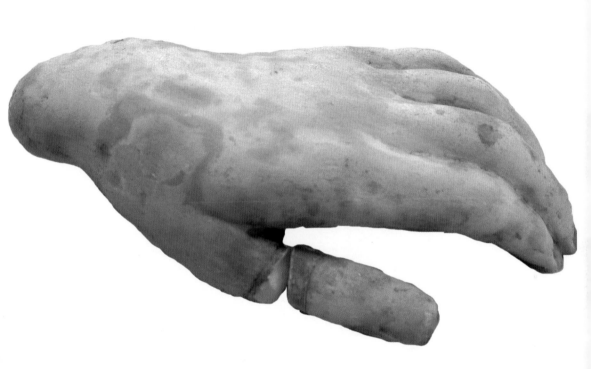

D'ARCY MCGEE'S DEATH HAND, 1868

Ottawa, Ontario
plaster
21.6 x 9.8 cm

This white plaster cast of the left hand of Thomas D'Arcy McGee may represent his skills as a writer, journalist, historian, and poet. By general consent, this Irish-born immigrant, who spent many of his adult years in the United States agitating on behalf of his fellow expatriates, was the most eloquent of the Fathers of Confederation. But it was his eloquence on another topic – his opposition to the Fenian movement – that probably led to his assassination on April 7, 1868, in Ottawa. Patrick Whelan, the man hanged for killing him, was a Fenian. Although it is doubtful that Whelan was the assassin, Fenian wrath remains the most probable motive. In Victorian times it was common to take a cast of the deceased's face for a "death mask," but unusual to cast a hand. McGee was shot in the head, however, so little may have remained of his face.

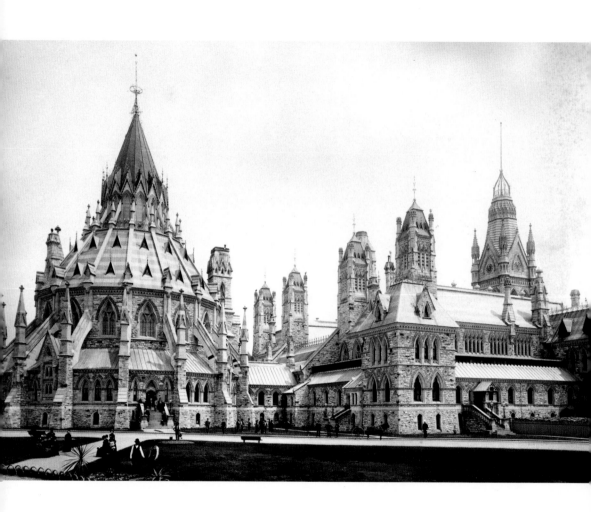

A view of the new Parliament Buildings in Ottawa in 1880, with the Library of Parliament on the left

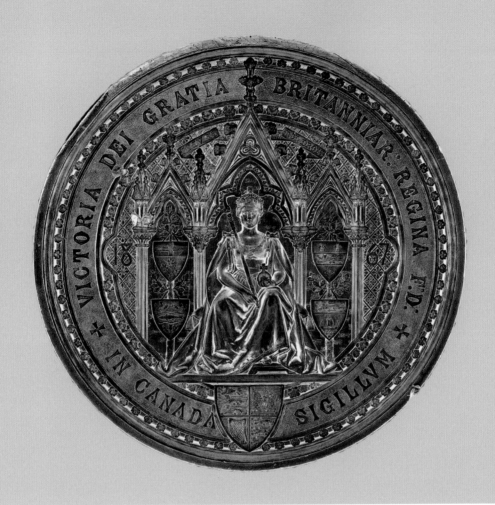

GREAT SEAL OF CANADA SHOWING QUEEN VICTORIA, DESIGNED BY A.S. AND J.B. WYON, 1869

London, England
silver
12.4 cm

The new Dominion of Canada had to wait two years before the chief engravers of Her Majesty's seals delivered this intricately engraved symbol of the new country. Appropriately for a nation that as yet had no clear sense of itself, the seal has something of a divided personality. The central image is of Queen Victoria, seated on a throne beneath three Gothic arches and holding the royal sceptre and orb. At her feet are the Royal Arms of the Realm, bearing the emblems of England, Ireland, Scotland, and Wales. But she is flanked by the coats of arms of the four original provinces, whose primary symbols then included both European and Canadian elements (usually maple leaves). Around the seal's circumference are the Latin words *Victoria Dei Gratia Britannia Regina F.E., In Canada Sigillum* (Victoria by the Grace of God Queen of Britain, Defender of the Faith, Seal in Canada). The seal was in use from May 7, 1869, until September 30, 1904.

WESTERN SALON
1817 to 1885

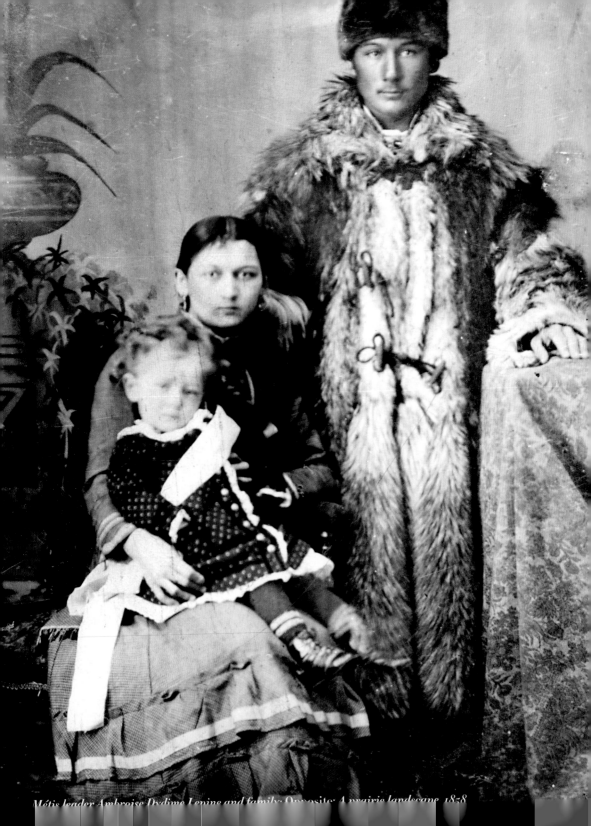

Métis leader Ambroise-Dydime Lépine and family. Opposite: A prairie landscape, 1858.

While the established colonies of British North America were embroiled in the War of 1812, the fertile valley of the Red River in what is now southern Manitoba became the focus of the first Canadian attempt to establish a permanent farming settlement in the West. The visionary behind this scheme was a wealthy Scottish nobleman named Thomas Douglas, Earl of Selkirk, who dreamed of founding a number of Gaelic-speaking outposts in Canada. In 1811 the Hudson's Bay Company, of which he had become a controlling shareholder, granted him a 300,000-square-kilometre parcel of land encompassing an area that covers part of southern Manitoba and Saskatchewan, a chunk of northern North Dakota and northwestern Minnesota, and a piece of northwestern Ontario. Before the end of the same year the first contingent of settlers in the Red River Colony established a base at the confluence of the Red and Assiniboine rivers (which is now in downtown Winnipeg). The land was good, but the harsh climate and the hostility of both the North West Company traders and the local Métis, people of mixed native and European ancestry, made its survival doubtful.

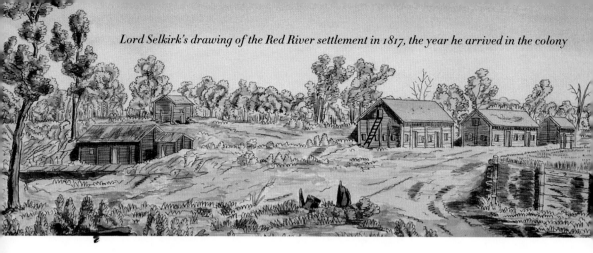

WOOL CARDERS, APPROX. 1835

Kildonan, Manitoba
wood with metal bristles,
leather pad, leather strips,
and metal nails
23.5 cm

These carders belonged to Mrs. Robert McBeth, the first woman of European ancestry to be born in the Red River Colony. Mrs. McBeth's parents were probably among the displaced Scottish Highlanders Selkirk brought with him in 1817 (along with a considerable number of sheep) to join his settlement in the Canadian West. She used these carders to comb raw wool after it was sheared from the sheep but before it was spun.

ASSOMPTION SASH (ALSO KNOWN AS THE MÉTIS SASH), 19TH CENTURY

Assomption, Quebec
wool
192.5 x 22.5 cm

It is believed that Jean-Baptiste Lagimodière, a voyageur from Trois-Rivières and the grandfather of Louis Riel, owned this Assomption sash, an article of clothing that takes its name from the town of Assomption, near Montreal, where it was woven by hand. Known also as a *ceinture flèche* (or "arrow belt," after its arrow pattern), this type of sash was part of the voyageur's unofficial uniform and was used as a belt, a cloth for washing, a towel for drying, a saddle blanket, and even an emergency bridle. Lagimodière settled in the Red River area around 1800. The *ceinture flèche* grew so popular among the Métis that it became a symbol of the Métis people.

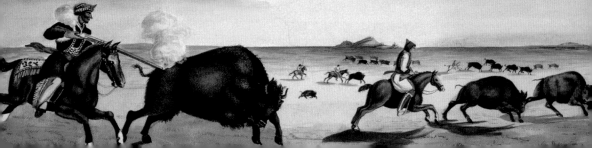

The Métis hunting buffalo in this painting of life in the Red River area before 1824 are wearing Assomption sashes.

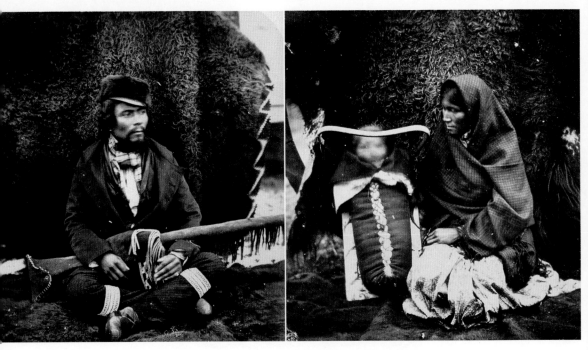

Photographs of a part-Ojibwa Métis and of an Ojibwa woman and child at the
Red River settlement in the 1850s

MAP CONVEYING LAND ADJOINING THE RED AND ASSINIBOINE RIVERS FROM INDIAN
CHIEFS TO LORD SELKIRK, JULY 18, 1817 (OPPOSITE)

probably Red River settlement, Manitoba
laid paper with brown ink
(possibly iron-gall);
notations and marks in graphite;
blue watercolour wash
approx. 20 x 30 cm

This map delineates the land covered by the 1817 Selkirk
Treaty, the first agreement signed between Europeans
and the aboriginal peoples of the Canadian West. The
treaty, which formalized the transfer of the Assiniboine
Valley and the Red River Valley from their Cree and
Objibwa inhabitants to Lord Selkirk's Red River Colony,
was designed to ensure peace between the settlers and
the Indians. The animal figures on the left side of the
map are the signatures of the native chiefs who agreed to
the treaty. For an annual fee of 100 pounds of tobacco,
each chief granted the use of his lands and promised that
settlers would "not be molested." The local Métis, who
were not party to the treaty, along with their North West
Company allies, strongly opposed Selkirk's settlement,
which had been established in the middle of their fur-
supply route.

Lake Winnipeg

Dead River

Mause Rat river or rivière Champignon

Manitoba

Portage de la Prairie

ossiniboine River

R la Sale

Muskrat river

Gratias River

Red River

Pambina

Two Rivers

Little river

Park River

Salt River

Turtle River

Red River

Red Lake river

about Lat 48

HUDSON'S BAY COMPANY

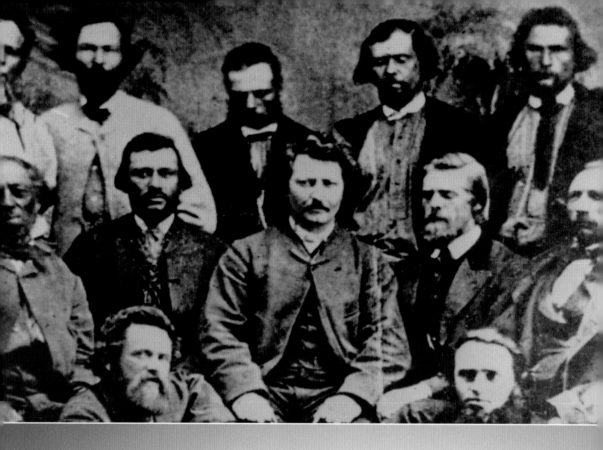

After violent early confrontations between the Métis and the Red River settlers, the rivalry between the two peoples subsided and many Métis joined the Red River Colony. After Confederation, however, many of the inhabitants in the settlement increased their demands for Canada to annex their colony – a prospect that greatly alarmed the Métis population. In the winter of 1869–70 a Métis named Louis Riel led an uprising of his people there. Riel and his supporters wanted the Red River Colony to join Canada, but on Métis terms that respected Métis rights. The Red River Resistance had begun.

Opposite: *Louis Riel and his provisional government in 1870*

KNIFE, APPROX. 1801–50

Red River Colony, Manitoba
size unavailable

This simple knife, with its decorative handle, played its part in the Red River Resistance (often referred to as the "Red River Rebellion"). As head of the provisional government, Riel ordered the arrest of a number of pro-annexation colonists, including Dr. John Schultz, who had armed themselves against the insurgents. On January 23, 1869, after Schultz had been imprisoned for almost a month, he used this knife in his escape to Ontario. There he joined the Canada First movement, which helped stir up English-Canadian anger over the revolt.

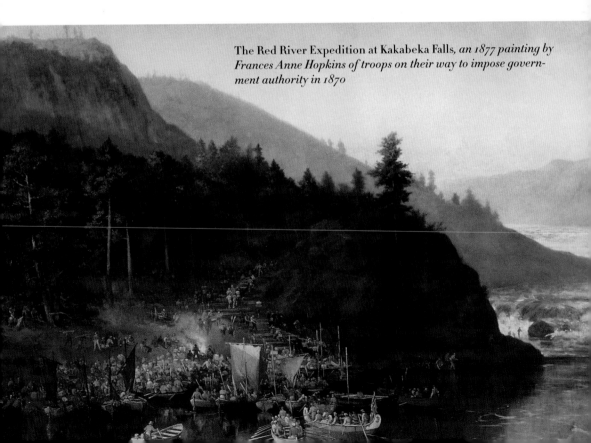

The Red River Expedition at Kakabeka Falls, *an 1877 painting by Frances Anne Hopkins of troops on their way to impose government authority in 1870*

CAMPAIGN RIBBON, APPROX. 1870

issued to veterans of the
Red River Campaign;
exact location unknown
silk, gold
approx. 6 x 20 cm

Colonel Garnet Wolseley wore this commemorative ribbon (on which his name is misspelled) in honour of his part in putting down the Red River Resistance in 1870. Wolseley led a force of 400 British regulars and 800 Canadian militiamen on a gruelling journey from York to the Red River Colony, through unfamiliar forests and over lakes, rivers, and bogs. By the time he and his men arrived at Upper Fort Garry on August 24, 1870, however, Riel and the rebel leaders had fled to the United States and the resistance had collapsed.

LOUIS RIEL.

COMPLIMENTS OF

S. Davis & Sons, Montreal,

LARGEST CIGAR MANUFACTURERS IN THE
DOMINION.

PHOTOGRAPH OF LOUIS RIEL (INCLUDED IN CIGAR BOX), 1863–76

Montreal, Quebec
cardboard
10.2 x 6.4 cm

This souvenir card, which portrays Louis Riel as an outlaw, was included in packages of cigars sold in English Canada in the late 1870s. During the same period in French-speaking Canada, he was already a hero, revered as a defender of the French language and the Catholic faith. His popularity in francophone Manitoba was undiminished, despite the collapse of the uprising he had led. In the federal elections of 1873 and 1874 he was elected an MP, even though an Ontario warrant for his arrest prevented him from taking his seat in Parliament.

Photograph of a Cree camp near what is now Vermilion, Alberta, taken by Charles Horetzky in September 1871 while travelling with a party surveying the route for the railway to the Pacific

In 1870 the Hudson's Bay Company formally transferred Rupert's Land to the new Dominion of Canada, opening up this vast territory to potential settlement. The difficulties encountered by the Red River settlers, however, including devastating plagues of locusts and floods followed by years of little rain, heightened concerns that the Prairies might not be suitable for agriculture. There were also concerns about the current inhabitants, predominantly First Nations peoples still living in traditional ways.

PICTOGRAPH ROBE, EARLY 20TH CENTURY

Siksika (Blackfoot Nation)
near Calgary, Alberta
unsmoked, dehaired moosehide, paint
152 x 152 cm

This "story robe" belonged to a man called Raw Eater, a distinguished leader of the Siksika tribe of the Blackfoot Nation in the 1800s. The robe portrays a number of different episodes in his life. In one, Raw Eater has tethered his favourite horse beside his tipi and gone to bed (top right). He awakens to discover a Cree warrior stealing his horse, so he gives chase. In the other scenes, Raw Eater fights and kills a number of Cree. Among his trophies are a new gun, a Cree scalp, and a new horse.

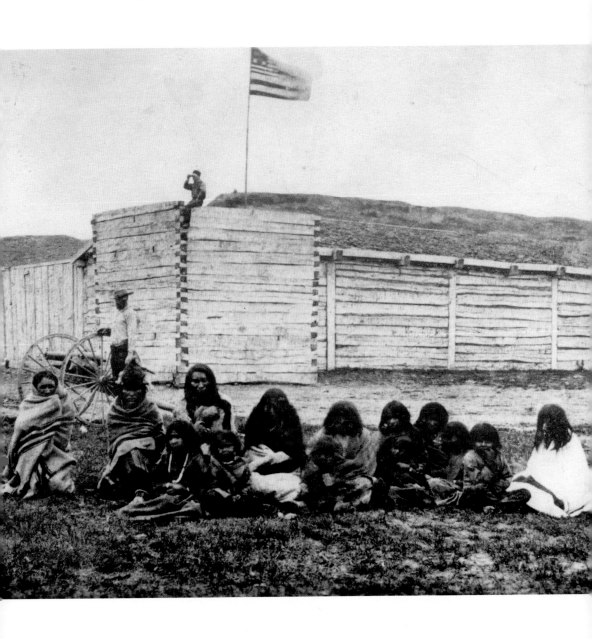

A group of Blackfoot in front of Fort Whoop-up (near Lethbridge, Alberta), the most notorious of the "whisky forts" that flourished in the lawless Canadian West before the arrival of the North-West Mounted Police

FORAGE CAP, APPROX. 1875

probably made in England
wool, gold purl button, gold lace,
Russia braid, satin lining,
leather sweatband
8.5 x 18 x 15. 8 cm

J.H. McIllree wore this cap, jauntily tilted to the right side of his head and held on with a thin black leather strap, when he marched west from Manitoba in the spring of 1874. He was one of the 300 Mounties dispatched to keep the peace in the lawless "whoop-up country." The force's original scarlet uniforms and forage caps, modelled after those worn by the feared Hussar regiments of the British Army, were meant to send a message of authority. As it turned out, their reputation preceded them. By the time the Redcoats arrived at Fort Whoop-up, most of the whisky traders had fled.

Superintendent R. Burton Deane of the North-West Mounted Police in 1898. Deane was one of the officers who developed a dress code for the new police force.

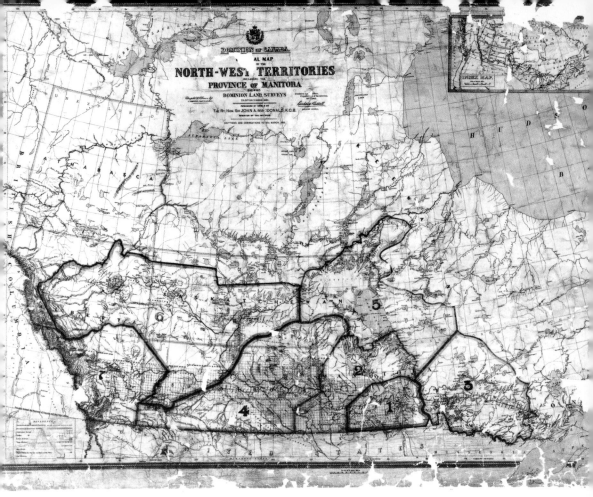

Map of the "North-West Territories including the Province of Manitoba" in 1883, showing the territories covered by the western Indian treaties up to that date. The areas covered by Treaties 6 and 7 are shown near the bottom left.

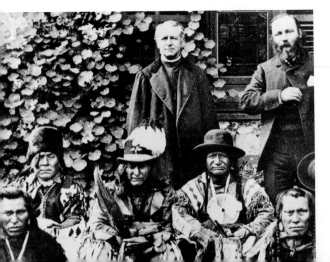

Blackfoot Chief Crowfoot (centre, with feather), signatory of Treaty 7, posing during a visit to Ottawa in 1886. Father Albert Lacombe, an Oblate missionary to the Cree and Blackfoot known as "The Man of the Good Heart," is standing, centre.

PLAINS CREE TREATY TICKET AND POUCH, 1880s

Saskatchewan (probably Battleford)
paper card, ink, hide, glass beads,
brass beads, bone pipe beads,
cowrie shells, conch shells,
and wool stroud
pouch, 31 x 9 cm; ticket, 7 x 6 cm

These two plain objects are part of the larger story of the First Nations' troubled relationship with the new Dominion of Canada. When a Plains Cree man came to collect his annual payment under his band's treaty agreement with the English Queen, he wore a pouch like this one, which carried his identity card. Of the numbered treaties signed in the years following Confederation, Treaty 6 with the Cree in 1876 and Treaty 7 with the Blackfoot in 1877 were two of the most important and influential. In these and other treaties, native bands were promised various benefits such as reserves, schools, farm equipment, annuities, and famine relief. Faced with the option of signing a treaty or fighting a futile fight, most bands signed. One of the last leaders to submit was the Plains Cree chief Big Bear.

.22 CALIBRE VICTOR REVOLVER, 1878

probably Montana, USA
nickel-plated steel, brass,
wood (possibly walnut)
7.8 x 13.5 x 2.5 cm

Louis Riel may have purchased this revolver while he was in exile in Montana, then brought it with him when he returned to Canada in 1884. He came back at the urging of Gabriel Dumont and a group of Métis, who were outraged at the federal government's failure to recognize their land claims. When Métis forces, led by Dumont, anticipated a police advance out of Fort Carlton (just west of Duck Lake), they occupied Duck Lake, the halfway point between their provisional capital of Batoche (the main Métis settlement in what is now Saskatchewan) and the fort. The North-West Mounted Police advanced on Duck Lake on March 26, 1885, and in the ensuing battle, both sides lost men. This encounter marked the beginning of the North-West Rebellion.

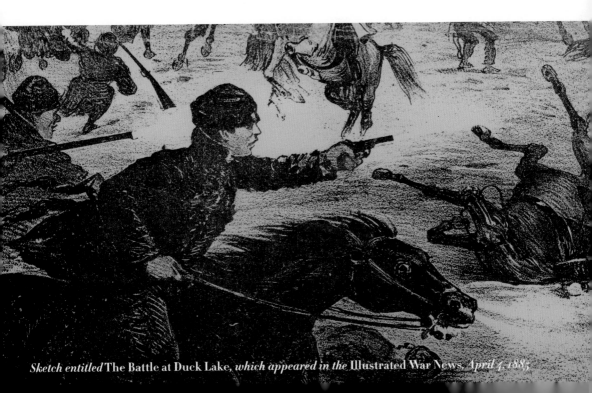

Sketch entitled The Battle at Duck Lake, *which appeared in the* Illustrated War News, *April 4, 1885*

General Middleton's troops on their way to engage Louis Riel's rebels at Fort Qu'Appelle, in what is now Saskatchewan

DESROCHES'S HAT, APPROX. 1885

Quebec
felt, canvas, leather, thread, ink
approx. 16 x 38 cm

Alfred Desroches, a Québécois who volunteered to fight on the federal side in the North-West Rebellion, recorded some of what he saw on this military-issue hat: a fort, a portrait of Chief Mamonhook, and a manned First Nations canoe. Desroches belonged to Quebec's 65th Battalion under General T.B. Strange. It, in turn, formed part of the 3,000-strong army of Canadian regulars and militiamen under the command of Major-General Frederick Middleton, which was dispatched to snuff out the North-West Rebellion.

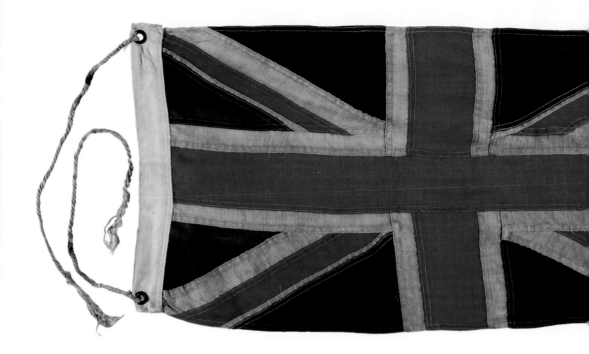

UNION JACK, APPROX. 1885

probably Ottawa, Ontario On May 9, 1885, General Middleton's troops carried this symbol of Anglo-
cotton with brass Canadian power into the Battle of Batoche, where they confronted a Métis
grommets and hemp rope force under Riel's command. Now outnumbered and facing a better-armed
45 x 90 cm adversary, Riel soon surrendered.

The shelling of Batoche by Middleton's artillery

Camp North of Indian Camp
Rifle-pits

June 2nd 1885.

Big Bear:

I have utterly defeated Riel, at Batoche with great loss, and have made Prisoners of Riel, Poundmaker, and his principal chiefs, also the two Murderers of Payne, and Tremont, and I expect that you will come in with all your prisoners, your principal chiefs, and give up the men, who have committed Murders at Frog Lake. And I am glad to hear that you have treated them fairly well. If you do not, I shall pursue & destroy you, and your band, or drive you into the woods to starve.

Fred. Middleton
M. General

MAJOR-GENERAL FREDERICK MIDDLETON'S LETTER TO CREE CHIEF BIG BEAR, 1885

Saskatchewan
paper, pencil
approx. 22 x 16 cm

"If you do not [surrender], I shall pursue and destroy you, and your band, or drive you into the woods to starve." So ends General Middleton's letter to the Cree chief, Big Bear. But, amid the confusion, Middleton had it wrong. Big Bear, ever the wily negotiator, wanted to get a peaceful settlement for his starving people. He was actually leading them north, away from the conflict and some rebellious young men in the band, when pursuing troops caught up with them at Loon Lake, Alberta. He turned himself in – and his surrender marked the end of the North-West Rebellion.

Chief Poundmaker, Chief Big Bear, and Gabriel Dumont, after their capture

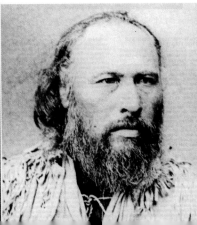

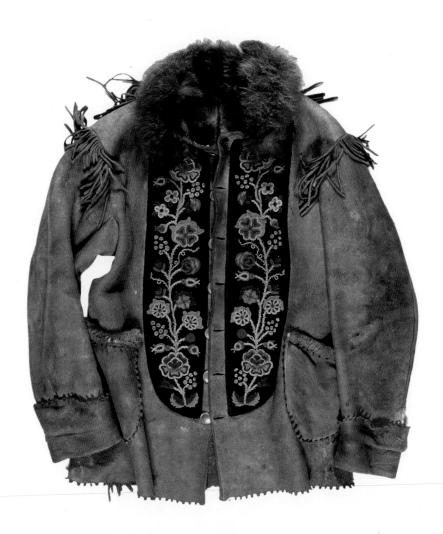

MÉTIS COAT, APPROX. 1885

Saskatchewan
deerskin, glass, unidentified metal and fur
78 x 44 cm

This Métis jacket, dating from around the time of the
North-West Rebellion, may have been worn by Louis
Riel. It shows the diverse cultural influences typical of
Métis handicrafts.

Rebel Wear?
The Case of Louis Riel's Coat

This deerskin coat, with its raccoon collar and muskrat edging on the pockets, is evidence that trapping and the fur trade were still big business in the infant province of Manitoba in the second half of the nineteenth century. The coat's design also reflects the fusion of peoples in the Red River area, where the garment was made. The cut of the coat and its brass buttons are European, but the pink and yellow flowers and tiny white berries that sparkle on the black velvet lapels are Métis. Such floral motifs were unknown in northern Canada before the arrival of European nuns and fur traders in the 1700s, and by around 1880, when this jacket was carefully hand tailored, Métis, Cree, and Saulteaux were all stitching tiny glass beads into patterns of prairie roses and curly vine tendrils.

A man could feel both elegant and tough in this piece of clothing. But which man? According to the label in the First People's Hall at the Canadian Museum of Civilization, where the coat is displayed, it is "Said to have belonged to Louis Riel." It was acquired by the museum from the National Museum of Ireland in 1974, where it had lain undisturbed since the late nineteenth century. The Dublin museum had acquired it from an Irishman named Harry Green, who had served with the North-West Mounted Police on the Canadian Prairies during the North-West Rebellion. Green claimed that the rebel leader Louis Riel had worn the coat in May 1885 at the Battle of Batoche, the fateful

North-West Rebellion camp and tents, 1885

confrontation in which government forces defeated the "half-breeds," as Europeans called the Métis at the time. Green said that Riel gave him his coat after he surrendered.

The National Museum of Ireland bought both the Irishman's story (which was scribbled on a piece of paper and stuck in the coat pocket) and the coat, although Riel was hardly a household name in the Dublin of the era. Almost a hundred years later in 1974, however, when the museum's curators tried to authenticate the coat's history, they discovered that the NWMP had no record that a Constable H.R. Green was even in the area south of present-day Prince Albert, Saskatchewan, where the Battle of Batoche was fought. Besides, in every known photograph of Louis Riel, he is wearing a European suit or overcoat; there is no evidence that the Montreal-educated intellectual ever wore Métis

The captured Louis Riel stands outside his tent in Major-General Middleton's camp

dress, let alone a heavy deerskin jacket in the thick of battle on a hot May day. And when three NWMP scouts (none of whom was named Green) came upon the rebel leader leaning against a fence after the battle, they noted that he was "coatless, hatless and unarmed."

Harry Green was not the only European to acquire an attractive Métis artifact and then embellish its provenance. Following the Battle of Batoche, NWMP constables ransacked Métis homes, looking for moccasins, knife sheaths, or anything else they could carry triumphantly back east as battle trophies. The Museum of Civilization owns a second coat Riel is supposed to have worn at Batoche, and there are similar garments with similar claims in other museums. You can also find a remarkable number of pieces of the rope with which the forty-one-year-old Riel was hanged for treason in Regina on November 16, 1885. If all the putative sections of Riel's noose were joined together, the famous rope would be long enough to hang a whole army.

Like the debate over the authenticity of Riel's coat, there is considerable disagreement about the historical significance of the man who may or may not

have worn it. From the moment the Métis leader dropped through the gallows in 1885, his image has ricocheted between martyr and megalomaniac, hero and traitor. In French Canada he has always been regarded as the noble champion of French-language and Roman Catholic rights within Confederation. During Riel's trial, Wilfrid Laurier, the Quebec MP who would later serve as prime minister, proclaimed, "Had I been born on the banks of the Saskatchewan, I would myself have shouldered a musket." In late nineteenth-century Ontario, in contrast, Riel was seen as a murderous fanatic determined to obstruct the orderly expansion of just and civilized institutions. Prime Minister Sir John A. Macdonald couldn't wait to get rid of him, regardless of the cost to Anglo-French relations: "He shall hang though every dog in Quebec bark in his favour," he is said to have snapped.

More recently, Riel has been touted as a prototype defender of First Nations people within an increasingly racist society and as an early advocate of western interests against a rapacious central Canada. In the 1960s he morphed into a sort of Prairies Che Guevara, fighting for the simple life against a capitalist onslaught from the east. But a 1998 proposal that he should be recognized as a Father of Confederation (for his role in the 1869–70 foundation of Manitoba) reignited the nineteenth-century debate.

The shifts in the Riel legend prompted historian George Stanley to call the Métis leader "our Hamlet, the personification of the great themes of our human history." Later, another historian, Douglas Owram, declared him the "ultimate example of the usable in history." Harry Green certainly saw him as usable: he used the Louis Riel myth to get a good price for a fine Métis coat.

Montreal's La Presse *claimed to have sold more than 50,000 copies of this portrait of the "martyr" Louis Riel following his execution.*

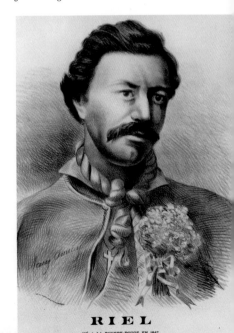

RIEL

NÉ A LA RIVIÈRE-ROUGE EN 1847.

1

2

3

4

1 PIECE OF ROPE, APPROX. 1885

Regina, Saskatchewan
hemp
approx. 28 x 1.7 cm

2 EXECUTION HOOD, APPROX. 1885

Regina, Saskatchewan
cotton, cotton thread, elastic
36 x 30.5 cm

3 MOCCASINS, APPROX. 1885

Regina, Saskatchewan
deerhide, sinew, porcupine quills, mercerized cotton
thread, horsehair
right: approx. 14.5 x 26.5 x 9.5 cm;
left: approx. 14.5 x 25.7 x 9 cm

4 STATUETTE OF ST. JOSEPH
(MISSING HEAD), 1880s

found in Regina, Saskatchewan
ceramic (possibly porcelain)
10.7 x 4.6 x 4 cm

After the hanging of Louis Riel on November 16, 1885, his clothing, the contents of his prison cell, and even locks of his hair turned up in private hands as relics of a secular martyr. Other trophies included the rope purported to have come from his noose; his execution hood (originally a piece of military headgear to protect the wearer from the sun); and the moccasins he wore. Until recently, one moccasin was held in the St. Boniface Historical Society collection, and the other at the Queen's Own Rifles regimental museum (both are now in St. Boniface). Riel was said to have kept this statuette of Joseph, the patron saint of the Métis, with him in his prison cell. When the statue fell to the floor and the head broke off, Riel considered it a bad omen.

LOST & FOUND COLLECTION

1789 to 1909

A cairn built by Robert Peary to celebrate what he claimed was the first successful expedition to the North Pole
Opposite: Enterprise *and* Investigator, *two ships that joined the first official search for the missing Franklin expedition in 1848*

In the sixteenth and seventeenth centuries a series of British explorer/navigators, among them William Baffin, John Davis, and Henry Hudson, had searched in vain for the fabled North-West Passage. In the eighteenth century, however, with the British Navy's attention distracted by continental wars, most of the important Arctic exploration was accomplished by adventurers travelling overland, people like Samuel Hearne and Alexander Mackenzie. With the conclusion of the Napoleonic Wars in 1815, the Royal Navy could once again send ships and men to the Canadian Arctic. Those who returned to tell their tales of exploration and endurance helped paint a mystical picture of the Arctic that lodged firmly in the European imagination. The first of these legendary voyages was led by a seasoned sailor named John Ross. On August 31, 1818, two Royal Navy ships under his command entered Lancaster Sound, the channel that runs between the northernmost coast of Baffin Island and Devon Island, and headed westward. The great period of nineteenth-century Arctic exploration had begun.

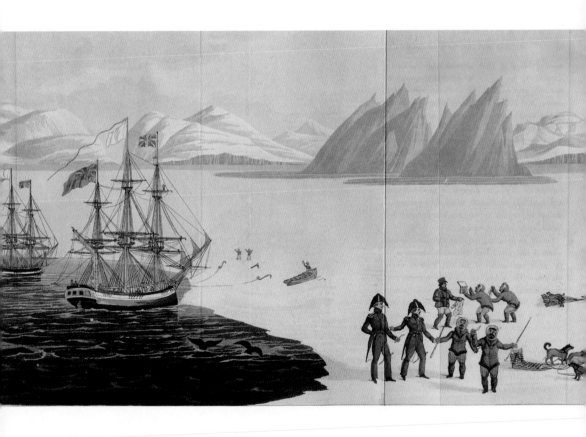

John Ross and William Parry meeting natives of northwest Greenland during their first voyage

JIGSAW PUZZLE "THE SORCERER OF THE NORTH POLE OR CAPTAIN ROSS'S VISION,"
APPROX. 1820

place of manufacture unknown
wood
70 pieces, one missing;
43.5 x 33.5 x 0.5 cm

The title and content of this puzzle are meant to poke fun at John
Ross and his 1818 expedition. (On the right-hand side of the puzzle
the explorer is being chased by a polar bear.) Only a few hours
after he entered Lancaster Sound on August 31, Ross concluded
that a mountain range blocked his westward path and abandoned
his search for the North-West Passage. His second-in-command,
Lieutenant William Parry, disagreed, and when the Ross expedi-
tion returned to England in 1819, Parry went public with his
doubts – doubts shared by the creators of this puzzle. When Parry
was later proved right, Ross waxed philosophical: "In reality," he
said, "the whole history of navigation is full of such errors and
false conclusions."

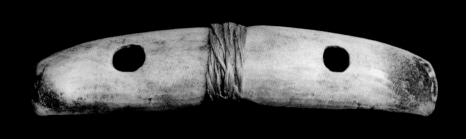

IGLULINGMIUT SNOW GOGGLES, EARLY 19TH CENTURY

Winter Island, Nunavut
caribou antler
12.5 cm

Inuit peoples had used goggles for thousands of years to pro-
tect their eyes from snow blindness and cold. William Parry,
one of the first European explorers to adopt Inuit technol-
ogy, collected this pair during his second Arctic voyage of
1822–23. On this first voyage as a commanding officer, Parry
sailed well west of John Ross's imaginary Crocker Mountains,
wintering at Melville Island, achingly close, if he had only
known it, to the Beaufort Sea.

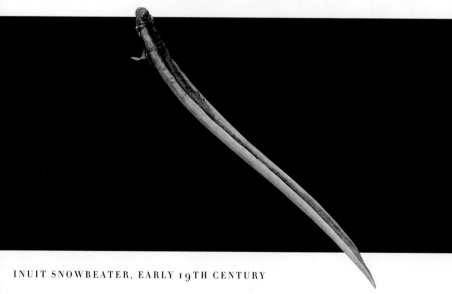

INUIT SNOWBEATER, EARLY 19TH CENTURY

Eastern Arctic (Nunavut)
hollowed caribou antler
41.5 x 2 cm

The Inuit used snow beaters to remove ice and snow that would
otherwise melt and make clothes wet and cold. This example
was collected by William Parry.

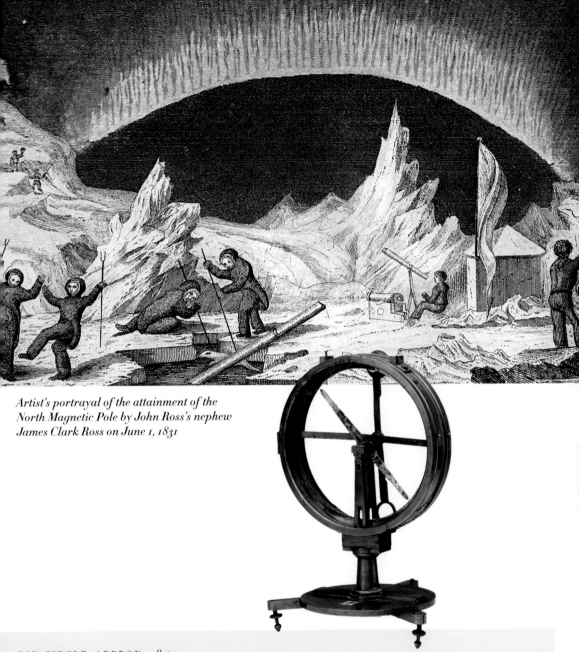

*Artist's portrayal of the attainment of the
North Magnetic Pole by John Ross's nephew
James Clark Ross on June 1, 1831*

DIP-CIRCLE, APPROX. 1840

*London, England
brass and silver
28.6 x 21.6 x 21.6 cm*

A dip-circle is essentially a compass standing on its side that is used to measure the earth's magnetic field close to a magnetic pole. At the pole, the needle points straight down. James Clark Ross used a dip-circle to discover the North Magnetic Pole during his Uncle John's second Arctic adventure (1829–33). The voyage lasted four years after their ship became trapped in ice. All but three of the crew survived, finally making Ross Senior famous.

 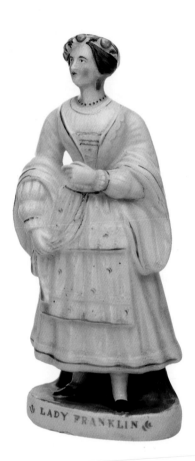

FIGURINES OF SIR JOHN AND LADY FRANKLIN, APPROX. 1850

Staffordshire, England
earthenware (pottery) with paint
Sir John, 27.5 x 12 x 8 cm
(including hat);
Lady Franklin, 26.5 x 11.5 x 8.5 cm

These ceramic figures reflect the folk-hero status of the
Franklins after Sir John failed to return from the Arctic, where
his two ships had last been seen, tethered to an iceberg, on June
25, 1845. Sir John is dressed in a naval uniform and hat. Lady
Franklin wears a wreath of flowers, a dress with oversleeves, and
an apron. The name of the subject is painted in gold on the base
of each statue.

THE LADY AND THE LEGEND
Searching for the Franklin Expedition

The anonymous potter who designed these figures of Sir John Franklin and his formidable wife, Lady Jane Franklin, is unlikely to have met his subjects. When he carved the three press moulds for each figure – one for the front, one for the back, and one for the base – he was probably working from smudgy illustrations found in popular magazines. He may even have adapted some of his standard moulds, such as those for a shepherd and a shepherdess. Celebrity rather than accuracy was the main appeal of Staffordshire figures, which were produced by the working class for the working class and sold by the thousands at country fairs and trinket shops. There this pair successfully competed with brave soldiers, glamorous actresses, popular villains, and Queen Victoria herself – a figure of the monarch was *de rigueur* for the well-dressed chimney mantel.

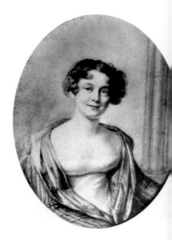

Jane Griffin in 1816, twelve years before her marriage to Sir John Franklin

Yet these two pottery figures are more true to life than their maker could possibly have known. John Franklin appears to finger his telescope nervously, and he looks overwhelmed by either his task or the public attention – or both. Jane Franklin, taller and better looking than her husband, radiates drawing-room poise and inner steel. Look at the determined tilt upwards of her chin. Look at the way her left hand is poised in front of her chest, as though about to point north in a gesture of fierce command. Doesn't she look like a nineteenth-century Margaret Thatcher, determined to bend the will of a nation to her agenda?

The humble potter has caught the essence of the personalities behind the myth. In theory, John Franklin was the hero who sailed off to discover the North-West Passage and never returned. But it was Lady Franklin who emerged as the personification of bulldog British spirit for her refusal to abandon the

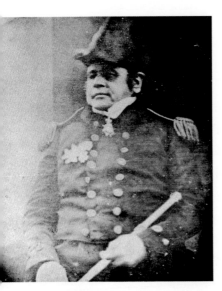

An 1845 daguerreotype of Sir John Franklin, taken shortly before his final voyage

search for her husband. Stocky John had the official top billing, but it was iron-willed Jane who made their name famous.

Without Jane, John might be almost forgotten today. His modest beginnings augured no great career, and a dogged lack of imagination characterized his early achievements. The younger son of an undistinguished Lincolnshire merchant, he went to sea at the age of fourteen, did well in the Napoleonic Wars, and in 1819, at thirty-three, was rewarded with command of a naval expedition to chart the north coast of the American continent. By 1827 he had completed two overland Arctic journeys, and he returned in triumph to London. But his sheer survival was due as much to luck and courageous comrades as to his leadership. On his first expedition he insisted on starting down the Coppermine River when it was already too late in the season. Despite advice from experienced voyageurs, he took inadequate rations. The Hudson's Bay Company fur traders who met him were appalled by his stubborn determination to carry out instructions regardless of setbacks or changing circumstances.

In the 1820s, polar explorers were "hot" in Great Britain. Doors to literary salons and smart clubs opened to the recently knighted but still gauche sailor. Franklin, whose first wife had died while he was away on one of his expeditions, now found himself taken up by the London literati. Parlour poets asked him to describe an iceberg; distinguished authors questioned him about Arctic winters. And an imposing, well-travelled bluestocking called Jane Griffin set her cap at him. In November 1828 they were quietly married. John was forty-two; Jane, thirty-six.

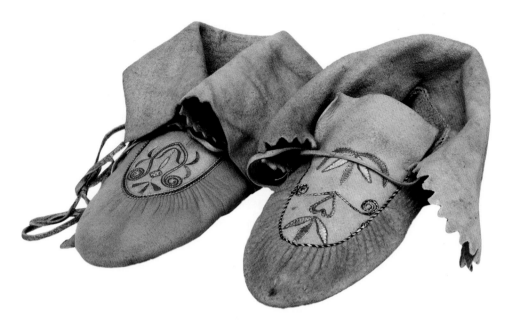

CREE MOCCASINS, 1819–34

Arctic (Nunavut) mooseskin with quillwork embroidery 11.5 x 27.5 x 18.5 cm

These untanned moccasins were collected by George Back, an artist/explorer who accompanied Franklin on his first two overland expeditions to the Canadian Arctic in 1819–22 and 1825–27. On the earlier one, Franklin became known as "the man who ate his boots." He and his men were forced to eat scraps of leather when, after surviving a gruelling trek to their winter camp, they discovered that the promised cache of food had not been left.

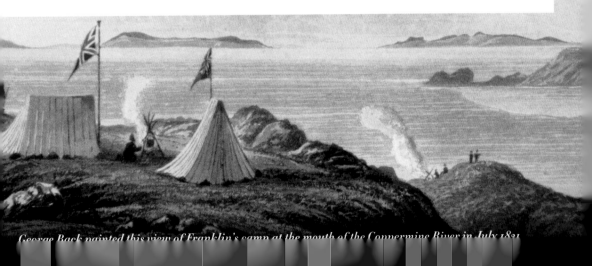

George Back painted this view of Franklin's camp at the mouth of the Coppermine River in July 1821.

It was a strange union. The awkward, ice-battered explorer couldn't match his wife in intellect or wit. His bland benevolence exasperated her: "You describe every body alike," she once wrote to him, "that I cannot tell one from the other." But for Jane, the marriage provided the perfect camouflage for her adventurous, bossy personality. Had she been born a man, she would probably have risen to dizzy heights in the administration of the British Empire. Now she poured her energy into exotic travel. When her new husband was given a command in the Mediterranean, she promptly set off without him to visit Egypt, Palestine, Greece, and Turkey. A retinue of servants carried her luggage, including a brass bed. When Franklin subsequently became lieutenant-governor of the convict colony of Van Diemen's Land (now Tasmania), she became the first non-native woman to go overland from Melbourne to Sydney, Australia.

After Franklin left Van Diemen's Land in 1843 under a cloud, due to his incompetence in dealing with the colony's politics, the vigour of Jane Franklin's character came into focus. As the tenacious guardian of her husband's interests, she did not want his Arctic reputation sullied. Despite the fact that he was now fifty-nine years old and panted when he climbed the stairs, she successfully lobbied for him to be given command of a proposed new polar expedition. In May 1845 the ships *Erebus* and *Terror* sailed from the River Thames, provisioned for three years and under the command of Sir John Franklin. Jane never saw her husband again.

When Franklin's ships had not reappeared by 1847, the Admiralty found itself under enormous pressure from his wife to send search parties to the Arctic. Through judicious manipulation of press and politicians, Jane created the Franklin myth, then played a starring role in it herself. In an era that glorified both fearless explorers and dutiful wives, the British public took Lady Franklin to its collective heart. Charles Dickens and Wilkie Collins co-wrote a play, *The Frozen Deep*, which was partly inspired by the Franklin story. Music halls resounded with plaintive ballads on the theme:

Poor Lady Franklin in great despair,

In anguish wild she tore her hair,

Saying Ten thousand pounds I'll give for news

Of my loving Franklin and his brave crews.

The upshot was one of the greatest rescue operations in the history of exploration. In 1850, the year these figures were fired, fifteen ships threaded through the Arctic labyrinth in search of the missing explorer and his 129 men. Between 1847 and 1859 there were thirty such expeditions, with Jane taking a leading part in their organization and even outfitting five ships at her own expense. The British public followed the progress of the search with as much interest as, a century and a half later, we all followed the search for Osama bin Laden.

Ironically, the fate of the Franklin expedition had been decided even before these carefully moulded figures – he in his shiny black shoes and gold-braided epaulettes, she with her elaborate double-fronted skirt – hit the market. That first winter of 1846–47, Franklin's two vessels were locked into the ice. Sir John had died the following spring, on June 11, 1847. None of his sailors ever reached home: most starved to death while trying to walk south across the frozen ocean. More than a decade later, when Jane Franklin finally accepted her husband's miserable fate, she turned her attention to securing his recognition as the discoverer of the North-West Passage – and to organizing a complete circumnavigation of the globe for herself.

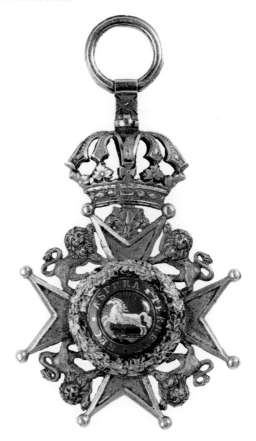

BADGE OF A KNIGHT COMMANDER OF THE ROYAL HANOVERIAN GUELPHIC ORDER, AWARDED TO SIR JOHN FRANKLIN, JANUARY 25, 1836

place of manufacture unknown; found at Repulse Bay, Nunavut gold and enamel 8.5 x 6.5 x 1 cm

The massive hunt for Franklin involved over thirty naval expeditions from several nations, as well as whaling crews and private adventurers, trappers, prospectors, and employees of the Hudson's Bay Company. Dr. John Rae, an HBC surgeon who was charting the Boothia Peninsula in 1854, recovered this badge and other items belonging to Franklin from the Inuit. These relics earned Rae the reward for definitive proof of Franklin's fate. Other items belonging to Franklin were subsequently recovered, but his body has never been found.

Opposite: "They forged the last link with their lives." *The North-West Passage: HMS Erebus and Terror, by Thomas Smith, based on Francis McLintock's description of a boat on a heavy sledge. McLintock discovered the boat during the 1859 expedition that found some remains of Franklin's men on King William Island.*

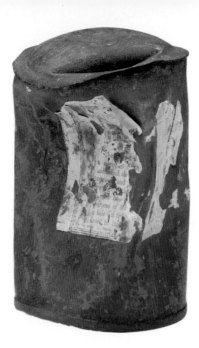

GOLDNER SOUP TIN, 1845

London, England
sheet iron, red paint
10.2 x 7.6 cm

It's likely that canned food poisoned Franklin and his men before they could starve to death. This tin of soup, recovered by the Schwatka Expedition (1878–79), was part of the store of goods supplied to Franklin by a British manufacturer. By the time it was opened and heated over a spirit stove, its contents would have been permeated by lead from the soldering and quite possibly infected with bacteria.

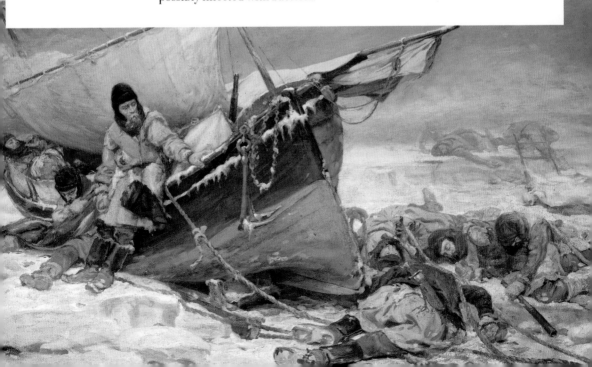

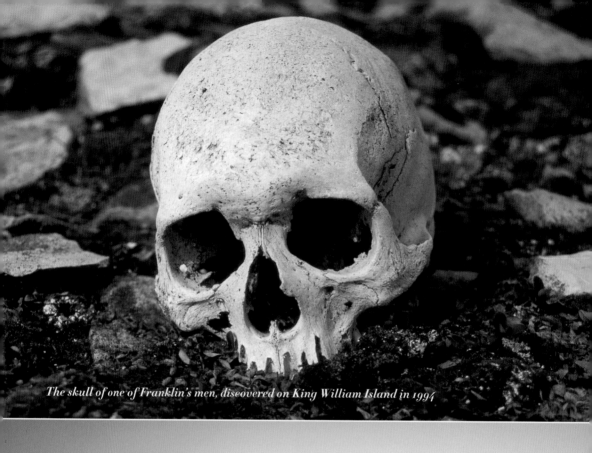

The skull of one of Franklin's men, discovered on King William Island in 1994

The £20,000 reward offered by the British Admiralty for definitive news of Franklin's fate prompted a multi-year manhunt that resulted, indirectly, in a vast charting of the Arctic Archipelago. In 1850, while searching for Franklin from the west, Lieutenant Robert McClure guided his ship, *Investigator*, into the Bering Strait and then along the coast of the Beaufort Sea until he reached Cape Parry. In so doing he navigated the missing link in the North-West Passage and officially became its discoverer. Following McClure's achievement, the quest to reach the North Pole became the last great challenge of Arctic exploration.

George Strong Nares's ship photographed at Discovery Bay, North-West Territories, in 1876

POCKET CHRONOMETER, THOMAS EARNSHAW, 1789

London, England
mahogany, brass, steel
7.1 x 5 x 1.3 cm

Robert McClure used this chronometer to fix his east/west position and prove that he had finally found the North-West Passage. When the sun was directly overhead – noon at McClure's current position – he calculated the difference between noon and Greenwich Mean Time (at which the chronometer was always set). The time difference could then be converted into degrees of longitude, yielding his precise position west of Greenwich. McClure was ultimately forced to abandon his ship, and he continued eastward on foot until he was rescued by the Belcher expedition, then sailed home with them. He thus became the first European to transit the North-West Passage, although he did so partly on foot.

An 1896 advertisement for Cadbury's Cocoa

IN THE ARCTIC REGIONS.

Expeditions in search of the North Pole are of such absorbing interest that every
concerning them is the subject of eager curiosity, particularly the Food, which has to be s
with the utmost care. Dr. Nansen took with him a supply of about 1,500 lbs. of **Cadb**
Cocoa Essence and Chocolate in hermetically sealed tins, it being considered the best an
nourishing food, and especially suitable for men requiring all the vitality and strength nec

SEALSKIN SUIT, 1875

*England
(British version of an Inuit design)
wool, known as "duffle" or "sealskin"
cap, 30 x 26 cm;
jacket, 88 x 61 x 16 cm;
trousers, 125 x 59 x 2 cm;
mitten, 47.5 x 25 x 3 cm*

George Strong Nares wore a suit like this one during the last major British expedition to the Arctic Archipelago before the Dominion of Canada assumed sovereignty in 1880. In 1875–76 he charted the coasts of Greenland and Ellesmere Island, hoping to determine how far north land extended and the feasibility of an attempt to reach the North Pole. Nares was one of the navy's ablest navigators and a pioneer in the field of oceanography, but a neophyte at Arctic survival. The coarse woollen duffle tended to overheat the wearer and make him sweat. If the sweat froze, so did the wearer. Looser native clothing, made of animal skins, worked better because it allowed the wearer's body to breathe and any moisture to evaporate rather than freeze.

PERSONAL FLAG OF ADMIRAL ROBERT PEARY, APPROX. 1908

wool
61.5 x 91.5 cm

Peary flew this personal flag, which combines his last initial with a star representing the North, or Pole, Star, on his 1908 expedition to the North Pole. When he returned to New York City in September 1909, he announced that he had reached his goal. However, five days earlier, Frederick Cook had claimed that he reached the pole a full year before Peary. Neither could prove he had even reached the pole, let alone precisely when, but their quarrel caused an international sensation. Peary ultimately won the public relations battle and came to be regarded as the rightful claimant to the honour, but the controversy continues to this day.

POSTCARD HONOURING THE ANNEXATION OF THE ARCTIC ARCHIPELAGO FOR CANADA BY CAPTAIN BERNIER, 1909

paper
approx. 10 x 14 cm

In 1904 Prime Minister Sir Wilfrid Laurier commissioned Captain Joseph-Elzéar Bernier to patrol the waters of the Arctic Archipelago for five years – the time period required by international law for a country to lay claim to an area. Bernier completed his mission in 1909 and formally laid Canada's claim. In the postcard celebrating this event, Laurier and Bernier are pictured in front of a photograph of the captain and his crew. Although Britain had ceded ownership of the Arctic Archipelago to Canada in the nineteenth century, Canada had never established formal control of this vast, resource-rich area.

Bernier and his crew pose in front of a memorial tablet they have placed on Parry's Rock, White Harbour, NWT, Canada

SPACE & TIME ARCADE
1820 to 1920

division of the day into two sets of twelve hours similarly

named has positive disadvantages. In these days of Railways

the ~~chance~~ of error is increased, and this is no light consid-

-eration. In the printing of time-tables, the giving and

receiving train orders, a mis-print or misapprehension of a

single letter may cause a mistake or mishap, while the degree

of uncertainty which in some cases exist, may lead to confusion

and confusion not infrequently results in consequences more or

less serious.

The 24 hour notation, ~~so called~~, removes all doubt, and

~~promotes~~ safety. / It has been ~~in use in wide sections of~~

Canada for four or five years, where it continues to ~~be employ~~

~~with~~ increased ~~favor~~. / The change from the old custom is

easily effected, and without danger. X ~~All~~ Hours having a

A Taken pag 18

...e known to belong absolutely to the

...e having a higher number to the

...new notation is now in use on all

...ian Empire and in China. According

...e last annual meeting of the Americ...

...there is every prospect of the

...llways of North America at an early

...nts out that while at the beginning

...on was in use on less than 4000 mil...

...closed it was permanently adopted

In the mid-nineteenth century, people had a different sense of space and time from the one we carry in our heads today. Take, for example, the concept of distance. Where we routinely travel thousands of miles in a few hours, the Victorian Canadian was lucky to travel more than a hundred miles in several days. The small town of Newmarket, Ontario, which now takes about forty-five minutes to reach by car from downtown Toronto, was a good day's ride by stagecoach or horse and buggy in the mid-1800s. A letter mailed in Quebec City took ten or more days to reach Windsor, Ontario, before the Grand Trunk Railway was completed in 1857. And when it came to keeping time in the nineteenth century, the watchword was chaos. Timepieces counted the minutes and hours with reasonable accuracy, but which minutes and which hours? Time was local: high noon in Quebec City was several minutes different from high noon in Montreal, and that was different again from noon in Toronto. Modern notions of space and time were about to be invented, and Canadians were among the inventors.

ODOMETER, SIR WILLIAM LOGAN, 19TH CENTURY

Canada
wood
approx. 100 cm

William Logan's odometer belonged to a family of inventions for measuring distance travelled over land or water. Most land odometers were attached to the wheel of a vehicle. By counting the number of revolutions, you could calculate the distance covered. Since Logan was walking, often over rough terrain, he used an odometer that consisted of a single wheel, whose revolutions the odometer counted as if it were attached to a carriage.

And Miles to Go
Sir William Logan's Odometer

I can grasp the function of most scientific instruments, but their invention and construction often lie beyond my comprehension. So I embrace the elegant simplicity of Sir William Logan's odometer. Made of polished hardwood, it looks like an eighteenth-century carriage wheel, but it is precisely calibrated so that a complete revolution of its ten spokes covers exactly 10 feet; 528 revolutions adds up to 1 mile. A clockwork counting mechanism on the handle, attached to the hub by a chain (which has since disappeared), counts up the revolutions.

In the display case behind the odometer is an enlargement of a sketch by Logan, showing the makeshift tent (a blanket held up by two poles) in which the father of Canadian geoscience slept while out in the field. Hanging from one of the cross-bars is a pair of tough blackleather boots. The boots, however, were never

Sir William Logan in his Montreal laboratory

tough enough to survive more than a couple of Logan's many rugged tramps along coastlines and inland trails, with his buggy odometer bumping along behind him as he paced and counted distances. At regular intervals, Logan left his odometer resting on its kickstand and scaled a nearby hill, where he pulled a prismatic compass or a micrometer telescope out of his bag and calculated, by triangulation, the distances between features he had already surveyed – river systems, rocky outcrops, lakes. Wherever he paused, he filled his pockets and his collecting basket with rock samples and fossils. No question, William Logan was a man passionate about his profession.

Yet, when he was born in Montreal in 1798, that profession barely existed. His early dream was to be a doctor, but after only one year of medical studies at

Edinburgh University, he traded his stethoscope for an accountant's sharp pencil and Scotland for London, then Wales. There he kept the books for an uncle who owned coal mines, stone quarries, and a copper smelting business and learned two crucial lessons: the importance of accurate record-keeping and the fascinating nature of rock formations. In Wales he also taught himself to use surveying tools, such as a compass and a theodolite, an instrument that measures horizontal and vertical angles and looks like a small telescope on a tripod. He quizzed miners about the extent of underground coal seams, then prepared detailed geological charts. He was the first person to construct geological cross-sections, hypothetical slices of the earth's crust showing the succession of strata beneath the surface. He is still cited as a co-author of geological maps of south Wales. William Logan instinctively thought like a modern geologist, and Wales wasn't big enough or uncharted enough to hold him.

In 1841 the Province of Canada (roughly, the southern halves of Ontario and Quebec) consisted of 2 million inhabitants scrabbling to make a living from farming, fishing, and logging. There was no industry to speak of, a paltry 8 kilometres of railway track, and the mere whisper of self-government. But the Industrial Revolution had come to Britain and the United States, which were growing rich on booming, clanking, roaring new industries, fuelled by their coal and iron resources. Naturally, Canadian politicians wondered whether their young colony couldn't do the same. Only a scientific exploration of the wilderness could answer this question. So the legislators voted £1,500 sterling for a quick and dirty survey of their colony, which then stretched from the Gaspé Peninsula in the east to Lake Huron in the west.

William Logan drew the sketches on these two pages during his survey of the Gaspé in 1844.

They hoped the survey would turn up coal and kickstart a mining industry.

When William Logan heard there was an opening for the position of chief (and only) geologist of the Province of Canada, he lobbied hard and got the job, thanks to his Canadian birth, British reputation, and Montreal connections. He was appointed in April 1842. The following spring he established an office in Montreal and began to gather the tools (including the buggy odometer, ordered from a local manufacturer) he would require for a much more thorough survey than the one the politicians had imagined they needed.

Logan was perfectly aware that his odometer (like his theodolite) was not primarily a geologist's tool. The study of rocks and rock formations requires hammers (with which to collect rock chips) and chemicals (to detect the composition of rock and soil samples). An odometer is a surveyor's tool, used to measure distances in the preparation of topographical maps. But when Logan took up his appointment, there were no accurate maps, let alone solid data about the geology of the province. Before he could ascertain what lay beneath the landscape, he had to map its surface.

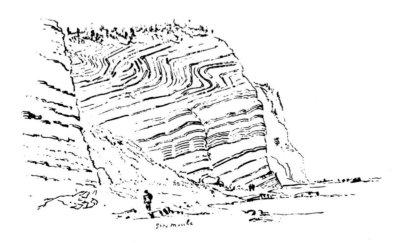

The first director of the newly established Geological Survey of Canada (GSC) began by hiring an assistant – Alexander Murray, a former naval officer – and dividing up the territory. Logan sent Murray to map the area between Lake Erie and Lake Huron in Canada West. He gave himself the far more challenging Gaspé Peninsula, the easternmost part of Canada East. On his early field trips, Logan recalled nostalgically in later years, he lived "the life of a savage, sleeping on the beach in a blanket sack with my feet to the fire, seldom taking my clothes off, eating salt pork and ship's biscuit, occasionally tormented by mosquitoes." He seems to have thrived on discomfort. As he doggedly zigzagged his way around the Gaspé coastline or scrambled along overgrown trails in the interior, onlookers wondered about the sanity of the red-bearded enthusiast trailing what looked like an old carriage wheel. "I fancy I cut the nearest resemblance to a scarecrow," he wrote of himself. "What with hair matted with spruce gum, a beard three months old ... a pair of cracked spectacles ... [and] a waistcoat with patches on the left pocket where some sulphuric acid, which I carry in a small vial to try for the presence of lime in the rocks, had leaked through."

The scarecrow earned his keep. The field work conducted in the first two summers enabled the surveyor/geologist to divide the Province of Canada into several broad geological areas: folded Paleozoic rocks covering the Gaspé and the Eastern Townships, flat Paleozoic rocks extending west from Montreal to Lake Huron, and an area of much older rocks stretching an unknown distance north from Ottawa and Montreal – rocks that soon proved to be the southern limit of the Precambrian Shield. Since all the formations he charted were older than the earliest known coal-bearing formations, Logan correctly concluded that there was no coal.

By the fall of 1844, the end of Logan's second season, the government grant of £1,500 had been spent, along with some of Logan's own money. But he persuaded the provincial assembly to continue funding the GSC, on the grounds that he had identified such a range of valuable rocks and minerals that a thriv-

ing mining industry must soon develop. He also decided to remain director of the GSC, despite the offer of a better-paid position as geologist in India.

William Logan was knighted in 1856 for his outstanding collection of Canadian minerals and his geological map of Canada, which had been exhibited in the Great Exhibition in London five years earlier. He finally retired in 1869 at the age of seventy-one. In his twenty-seven years spent mostly tramping through the Canadian bush, he identified and charted the major geological structures of Ontario, Quebec, and the Maritime provinces and managed to coauthor the 983-page *Geology of Canada* (1863), which remains a basic geology text. Along the way, he had proved beyond doubt the importance of a well-funded geological survey in a country made up mostly of rock. As he had confidently predicted, Canada is a mineral treasure chest. His trusty odometer, which he had dragged thousands and thousands of miles, bears the scars of its travels. Sir William's successors undoubtedly have more precise and less labour-intensive instruments, but I doubt they have anything so elegant or easy to understand.

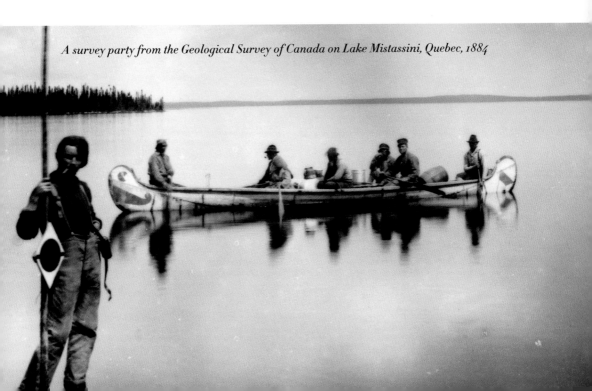

A survey party from the Geological Survey of Canada on Lake Mistassini, Quebec, 1884

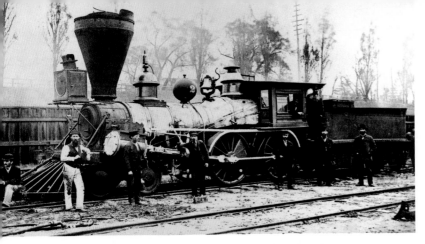

Toronto No. 2, the first locomotive built in any of Great Britain's colonies, entered service in 1853.

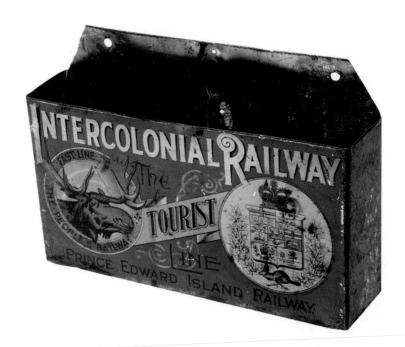

TICKET BOX, 1875–1919

Quebec
steel
16.5 x 24 x 6 cm

This box bears the logo of the Intercolonial Railway, built to link the former Province of Canada with New Brunswick and Nova Scotia. Construction of the railway was a condition for the two Atlantic colonies to enter Confederation, and work began shortly after July 1, 1867. The engineer in charge was Sandford Fleming. The 1,100-kilometre line between Halifax and Quebec City was completed on July 1, 1876.

SECTION OF CABLE, APPROX. 1858

Manufactured in New York City, USA
metal and fibre
1.9 x 10.2 cm

The growth of the telegraph paralleled the development of the rail-roads. The first lines were strung along track rights-of-way, and the system itself was invaluable for managing the movement of trains. After the first successful laying of the transatlantic cable, of which this is a small sample, electronic communications jumped conti-nents, and messages that had taken days by ship arrived in minutes. By the 1870s Canso, Nova Scotia, the nearest place on the North American mainland to Ireland, could boast three separate cable stations, receiving and retransmitting messages between Europe and New York.

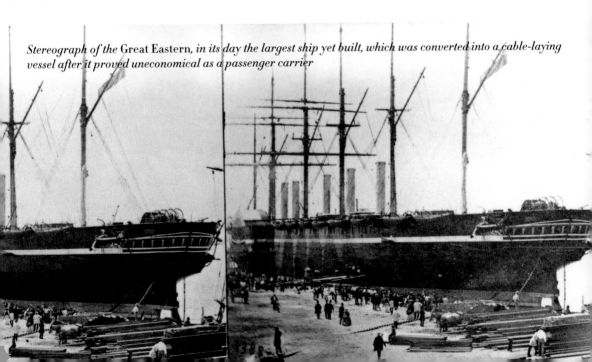

Stereograph of the Great Eastern, *in its day the largest ship yet built, which was converted into a cable-laying vessel after it proved uneconomical as a passenger carrier*

Plants collected
in
Captain Palliser's

British North America

Exploring Expedition

———————

1858

———————

Western Canada
(Manitoba and Alberta)
paper and preserved,
 pressed plants
28 x 22 cm

Eugene Bourgeau, regarded as one of the finest botanists in the British Empire, is believed to have collected these and the other plant specimens in this book while he was a member of the Palliser Expedition. He is supposed to have given the specimens later to Dr. John Lindley, a friend and fellow botanist who taught at the University of London. In turn, Dr. Lindley appears to have given this book to his daughter Sara (née Lindley) Crease, who immigrated to Victoria, British Columbia, around 1860. The Palliser Expedition spent nearly three years (1857–60) exploring large areas of what is now western Canada, while also studying its geology, flora, and fauna.

Ribes
hirtellum

Phlox
Hoodii

Dodecatheon
Meadia

Liatris
punctata

SKETCHES OF A TELEPHONE, ALEXANDER GRAHAM BELL, 1876

*Brantford, Ontario
paper and pencil
approx. 32 x 19 cm*

Alexander Graham Bell drew this sketch in the summer of 1876 to explain to his cousin Frances Symonds how his newfangled telephone idea was meant to work. Bell had first successfully spoken over the telephone the previous March. That summer, while staying with his family at Brantford, Ontario, he kept working on his device and carried out a number of successful tests on it. The middle drawing is closest to his actual invention and closely resembles the one he submitted with his patent application.

Weighing close to 3 kilograms, this headset would have been quite a burden for the operator obliged to wear it during her shift at the switchboard (and they were almost all women).

A CPR train crosses a horseshoe trestle bridge in British Columbia around 1890.

SKETCH BELIEVED TO BE OF SIR JOHN A. MACDONALD, WILLIAM C. VAN HORNE, 1885

Canada
newsprint
6.4 x 3.2 cm

This is hardly the portrait of a visionary, yet it was Macdonald's national dream of a country stretching from the Atlantic to the Pacific that ultimately triumphed against the forces of continental economic and political integration. Crucial to that dream was the building of a transcontinental railway, the promise of which convinced British Columbia to join Confederation in 1871. Macdonald's dream was temporarily derailed when the Pacific Scandal revealed that he and other members of his government had profited from negotiations to build the Canadian Pacific Railway. The caricature is the work of an American named William Van Horne, who oversaw the railroad project after Macdonald returned to power in 1878.

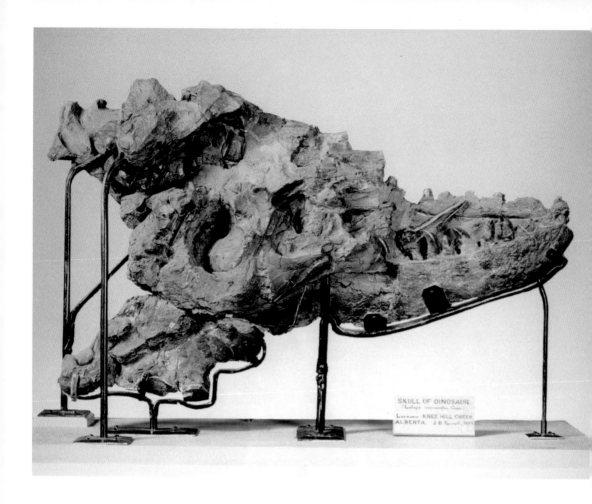

PARTIAL SKULL OF *ALBERTOSAURUS (ALBERTOSAURUS SARCOPHAGUS)*, FOSSIL, FOUND
IN 1884, APPROX. 70 MILLION YEARS OLD

near Drumheller, Alberta
sandstone
approx. 69.6 x 96.5 cm

While conducting a survey of the Red Deer River valley in southern Alberta
for the Geological Survey of Canada in the summer of 1884, geologist and
explorer Joseph Burr Tyrrell found this fossil, part of the first *Albertosaurus*
remains ever discovered. But the partial skull is more than a piece of
Canada's prehistory; it helped launch the North American dinosaur hunt.
Earlier that June, Tyrrell had discovered the first dinosaur bones in Canada,
bringing our previously unimaginable ancient past vividly into the present.

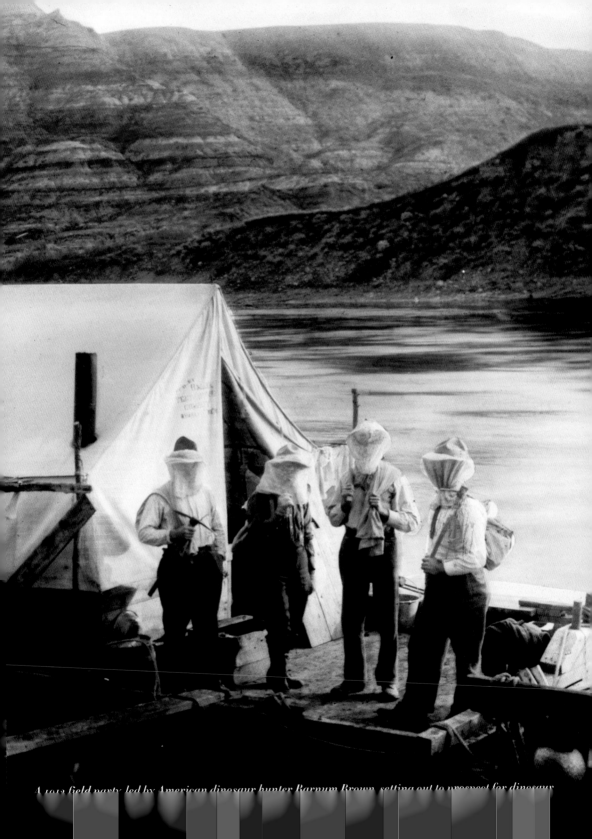

A 1912 field party led by American dinosaur hunter Barnum Brown, setting out to prospect for dinosaur

Cox's Patent INFOLD. Canada, Nov. 10th, 1883; U.S., May 27th, 1884.
To open, tear off the colored label at the perforated mark.

THE GREAT NORTH WESTERN TELEGRAPH COMPANY OF CANADA.

OPERATING THE LINES OF THE MONTREAL DOMINION AND MANITOBA TELEGRAPH COMPANIES.

This Company transmits and delivers messages only on conditions limiting its liability, which have been assented to by the sender of the following message.

Errors can be guarded against only by repeating a message back to the sending station for comparison, and the Company will not hold itself liable for errors or delays in transmission or delivery of unrepeated messages, beyond the amount of tolls paid thereon, nor in any case where the claim is not presented in writing within sixty days after sending the message.

This is an unrepeated message, and is delivered by request of the sender, under the conditions named above.

H. P. DWIGHT, General Manager. ERASTUS WIMAN, President.

Money orders by telegraph between principal telegraph offices in Canada and the United States.

TELEGRAM.

Use this space for Continuation of Lengthy Addresses, OR INSTRUCTIONS TO MESSENGER.

To Rt Hon Sir
J. A. Macdonald
K C B

No. 3 Check 27

Rec'd No.	From	Sent by	Rec'd by	Time

Ottawa, 188

From Craigellachie Eagle pass BC

Thanks to your far seeing policy and unwavering support the Canadian Pacific Railway is completed the last rail was laid this (Saturday) morning at 9:22

W. C. Van Horne

TELEGRAM, 1885

Ottawa, Ontario
paper
13.5 x 12.2 cm

William Cornelius Van Horne, chief engineer of the Canadian Pacific Railway and the man directly responsible for finishing the line, sent this telegram to Sir John A. Macdonald on November 7, 1885. That morning the last spike had been driven on the Canadian Pacific Railway line connecting eastern Canada with the Pacific. Macdonald's dream was at last a reality.

RAILROAD SPIKE, APPROX. 1885

made in Quebec;
used in British Columbia
iron
3.3 x 15 x 2.7 cm

This is the legendary last spike that CPR president Donald Smith drove into a railway tie at Craigellachie, British Columbia, on November 7, 1885, to mark the completion of Canada's transcontinental railway and the symbolic linking of the east coast to the west. The spike, which had bent while being driven, was later pulled from the tie and straightened. Then small portions of it were cut off and used to make jewellery for the wives of the railway's board of directors.

The Hon. Donald A. Smith driving the last spike to complete the Canadian Pacific Railway

hours. At the end of the first hour the sun will be over
a meridian which may appropriately be termed the first hour
meridian; at the end of the second hour the solar passage
will have advanced to another meridian, which may be
distinguished as the second hour meridian; at the end of
the third hour it will be at the third meridian, and so
passing over the whole twenty-four.

possess
for eve
perfect
certain
point
never w
by nati
humanit

on the
earth's
through

that we
precision
arked by
the more
tarting
en can
provided
which

r is
any

given hour is indicated by the solar passage, the sun will
be vertical over every part of that meridian in both hemi-
spheres. Accordingly, the earth's surface being divided
into twenty-four sections or zones, each extending 7 1/2°

seven and a half degrees

(14)

REFORMS IN TIME RECKONING
by Sandford Fleming

It is only within the last fifteen years that special
attention has been directed to the false principles, the
untenable theories, and the curious old usages which still in
many quarters prevail with respect to Time, its measurement and
notation. In spite of the advance in science in other
directions, which makes the incongruities in question the more
remarkable, we have remained until now rooted in observances
which cannot be defended on any rational or scientific ground.
We do not suppress our ridicule at many ancient customs
which at the present day appear to us absurd; we remain blind
to the fact that some of our everyday practices in the reckoning
of time, are not less irrational, based on theories which
cannot be sustained.

The three great divisions of time with which we are
most familiar are the year, the month, and the day. The latter
is the smallest measure of time revealed to us in nature, and is
dependent upon the diurnal rotation of the earth. Alth-
subdivision of the day is of extreme antiquity,there
when hours were unknown. The word hour is not found
or in Xenophon. For the first time it is met with at the
period of the Macedonian rule at Athe In the early
literature of Greece the Hours (Horai) are mentioned, not as
the divisions of the day, but as the goddesses of the seasons,
as maidens of beauty bearing the products of the earth, and
attendant upon Venus as she rose from the sea.

With

Horai]

captain
+ oblige
We

andrez

DRAFT OF ARTICLE "REFORMS IN TIME RECORDING," SANDFORD FLEMING,
APPROX. 1891

Canada
paper
size unavailable

These two pages come from the typescript of an article written by Fleming
and published in the Canadian Institute's periodical *Transactions*. In it, he
explains his greatest "invention" – standard time. The story has it that
Fleming became convinced of the need for standardized time zones after a
chilly night spent in a railway waiting room because of a missed connection,
caused by two different railways working on two different times. Fleming's
system had been adopted at the International Time Convention held in
Washington in 1882, and both Canada and the United States adopted stan-
dard time on November 18, 1883.

CANADIAN PACIFIC
ATLANTIC
STEAMSHIP
SERVICE

Taking on the Pilot

THE "EMPRESSES"

ATLANTIC STEAMSHIP SERVICE BROCHURE, 1910

semi-gloss paper
22.9 x 10.2 cm

This Canadian Pacific brochure's boast, "Less than four days at sea," is a slight exaggeration, omitting to mention the day and more that the ship would spend working down the St. Lawrence and into the Atlantic Ocean. Nevertheless, it is a strong reminder of how much the world had shrunk by the opening decade of the twentieth century. Canadian Pacific maintained a fleet of ocean-going ships intended, in part, to feed its railways. A passenger could leave Britain, land in Montreal and board a Canadian Pacific train, then travel across the country and board another Canadian Pacific ship for the trip to China and Japan.

"Shackleton Bros. Threshing Outfit," 1898

In the late 1890s Wilfrid Laurier's minister of the interior, Clifford Sifton, began aggressively recruiting immigrants to settle on the Canadian Prairies. In the first decade of the twentieth century, hundreds of thousands of people streamed into the country from Britain and the United States, Scandinavia, and the Russian, German, and Austro-Hungarian empires. Most of them headed west on the CPR, setting off a prairie population explosion. The number of people living in the area that would later become Saskatchewan jumped from fewer than 100,000 in 1900 to almost half a million in 1910.

PAMPHLET FOR CANADA WEST, 1909

Ottawa, Ontario
paper
28 x 20 cm

This pamphlet was produced under the direction of the Canadian government, expressly to entice immigrants from Great Britain and the United States. The slogan "The Last Best West" positioned the Canadian Prairies as the last great tract of fertile agricultural land in the world as yet unsettled. These pamphlets appeared annually for several years in both British and American editions. The 1909 cover features a bountiful harvest, a farmer and his team of horses, and many red and gold maple leaves – already synonymous with Canada.

Recently arrived Russian immigrants in Quebec City, c. 1911, photographed by William Topley

TRUNK, APPROX. 1820

Iceland
wood
59.3 x 129 x 68.5 cm

This trunk, bearing the name Anni Knuttsdotter, fetched up first in the United States during the great Scandinavian exodus to the American Midwest. From there, the family headed north into Canada.

1

2

5

4

3

WOMEN'S SHAWLS, APPROX. 1835–1920

*1. Scotland; 2. unknown; 3. Montreal,
Quebec; 4. Toronto, Ontario; 5. Europe
1. unidentified fibre; 2. unidentified fibre;
3. silk, metal; 4. cotton, fibre;
5. fibre, wool;
1. 65.5 x 128 cm; 2. 165.2 x 350.7 cm;
3. 125 x 125 cm; 4. 161 x 228 cm;
5. 180 x 150 cm*

Several of these women's shawls have a paisley pattern, a
generic nineteenth-century term for both the exotic patterns
and the shawls themselves. Paisley shawls got their name
from the Scottish town where they were mass produced by
weavers who adapted the designs from handmade, beauti-
fully patterned Kashmiri woollen shawls, imported from
India in the late eighteenth century.

A Jewish-Russian family at Quebec City, c. 1911, photographed by William Topley

SAMOVAR, APPROX. 1920 (ABOVE LEFT)

Russia
brass
56.5 x 35 x 30 cm

This fine brass samovar was the property of a White Russian cavalry officer forced to flee the Bolsheviks in 1917. Samovars of this high quality were used for brewing and serving tea in the finest Russian households in the late days of Tsarist rule.

SHOFAR, APPROX. 1900 (ABOVE RIGHT)

Minsk, Russia
horn (goat or sheep)
16 x 30 x 10 cm

A Jewish family fleeing Russian pogroms around 1900 brought this shofar, a natural trumpet used to welcome the Jewish New Year, to Winnipeg from Minsk.

A Doukhobor farmer ploughing near Bowell, Alberta, c. 1912

"KUBBESTOL" CHAIR, APPROX. 1900

Telemark area, Norway
wood
81.2 x 41.4 x 37.2 cm

This fine chair, carved from a single log, was one of several a Norwegian father carved for each of his sons. The son who immigrated to northern Alberta at the turn of the century brought his log chair with him.

Settlers detraining at Calgary, Alberta, as part of an incoming wave during the early twentieth century

CANADA.

DOMINION LANDS REGULATIONS.

31	32	33	34	35	36
30	School 29 Lands.	28	27	H. B. Co.'s 26 Lands.	25
19	20	21	22	23	24
18	17	16	15	14	13

TOWNSHIP AND SECTION TEMPLATE, PRODUCED BY THE DEPARTMENT OF THE INTERIOR, 1881

Canada
paper
33.5 x 21 cm

This diagram shows part of a township, the system used to divide up the empty prairie lands for settlement. Each township of 36 square miles (approx. 93 square kilometres or approx. 9,300 hectares) was divided into thirty-six sections, which in turn were further divided into quarter sections, the basic size for a farm. Two sections were set aside to pay for a school, and the Hudson's Bay Company, whose surrender of Rupert's Land to the new dominion in 1870 had opened the West, also received two sections in each township.

KITE, APPROX. 1901

Quebec
wood, canvas
71.1 x 165 cm

On December 12, 1901, the Italian inventor Guglielmo Marconi flew this kite from Signal Hill in St. John's, Newfoundland, trailing a long antenna. With it, he was able to intercept a faint telegraphed *S* tapped out on wireless equipment in Wales. Scarcely thirty-five years after the first transatlantic cable had been laid, wireless communication between the continents was now possible.

Raising the Marconi kite on Signal Hill

DIPPER, APPROX. 1912

Yukon
tin and wood
16 x 51 c

The Klondike Gold Rush was triggered by the discovery in August 1896 of placer gold on a tributary of the Klondike River. Despite advances in communications, however, news of the strike did not reach the outside world until the following summer. This water dipper made from an empty tin of lard probably belonged to one of the thousands of prospectors who journeyed to the Yukon – the journey took as long as two years – with the dream of finding instant wealth when they arrived. Most went home poorer than when they'd come, but they'd demonstrated how quickly news from far away could change lives and cause massive movements of people.

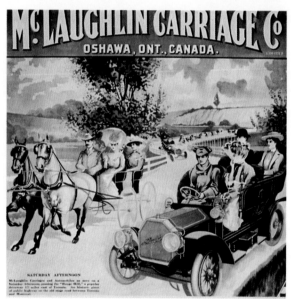

ADVERTISING POSTERS, APPROX. 1905 AND 1910, RESPECTIVELY

Oshawa, Ontario
paper
size unavailable

Two advertisements, from the same company, produced just five years and yet worlds apart. Automobile manufacturing began in Canada in 1904, when Ford began producing cars at Walkerville, but Oshawa's well-established McLaughlin Carriage Works didn't get into the game until 1908, when it began building cars featuring an engine produced by Buick. The company's 1910 advertisement shows a smart runabout, with "McLaughlin" proudly emblazoned on its grill.

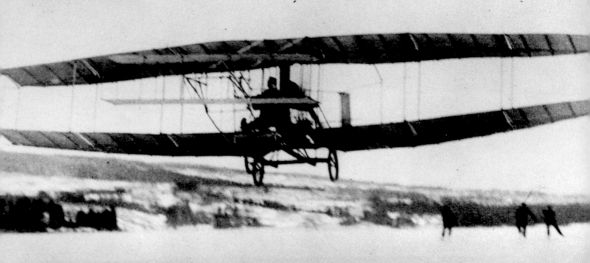

Alexander Graham Bell's Silver Dart *takes off near Baddeck, Nova Scotia, for Canada's first powered flight, on January 9, 1909*

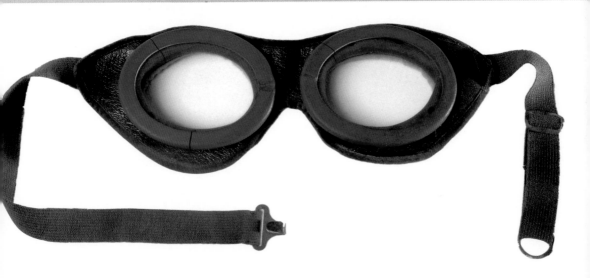

AVIATION GOGGLES, APPROX. 1917

Ontario
skin, leather, glass, fibre, felt
7.1 x 18.5 x 1.8 cm

Pioneer flyers adapted the types of goggles used by racing-car drivers as a protection against unidentified flying bugs and other airborne hazards. They also wore helmets similar to those used by football players and motorcyclists. The helmets came in handy when a pilot was pitched head first out of his flying machine, a fairly frequent mishap in the early days.

THE MAPLE LEAF LOUNGE

1830 to 1939

Above: *Marianne, the personification of France, holding the Red Ensign and draped in the colours of the Union Jack, an image of Allied unity from the First World War.* Opposite: *"Our Lady of the Snows: A Strictly Canadian Character,"* 1909

Originally, a *Canadien* meant someone from the St. Lawrence basin colony of New France. After New France became part of British North America, the English-speaking settlers of the new Province of Quebec began calling themselves Canadians. Soon they began appropriating traditional French-Canadian national symbols, notably the beaver and the maple leaf. Perhaps in unconscious response, French-Canadians increasingly identified with the fleur-de-lys of royalist France, which ultimately ended up on the Quebec flag. But symbols are one thing; knowing what they stand for is quite another. For both French-speaking and English-speaking British North Americans, the meaning of their citizenship evolved as the country grew.

ST. JEAN BAPTISTE SOCIETY EMBLEM, APPROX. 1830, FEATURED ON ST. JEAN BAPTISTE
SOCIETY PROGRAM, 1930

Montreal, Quebec
paper
size unavailable

The St. Jean Baptiste Society of Quebec, founded in 1834 to promote
French-Canadian language and heritage, claims one of the earliest docu-
mented uses of the sugar maple leaf as a Canadian symbol. In 1836 the soci-
ety adopted as its emblem a beaver wreathed with maple leaves, using the
motto "Nos institutions, notre langue et nos lois" (our institutions, our lan-
guage and our laws). But no copies of the original design seem to have sur-
vived. Over time the society's emblem varied, but, as in this example, always
included maple leaves.

THREEPENCE BEAVER STAMPS, POST-1851 PRINTING

Dominion of Canada paper approx. 19 x 25 cm

The beaver continued to be a popular symbol up to the time of Confederation, when it graced the Dominion of Canada's first postage stamp, the threepence, or threepenny, beaver (originally issued for use in the United Province of Canada). But its designer, Sandford Fleming (later the chief engineer of the Canadian Pacific Railway), had second thoughts about the beaver as a national icon. A couple of decades later he wrote: "There are other members of the same natural order (*Rodentia*), such as rats and mice, not less active and industrious than the beaver, and for this quality alone no one would dream of selecting one of these vermin for our national emblem."

TITLE PAGE OF *THE MAPLE LEAF OR CANADIAN ANNUAL*, HENRY ROWSELL, 1847

Toronto, Ontario
paper
27.7 x 21.1 cm

After the War of 1812, which helped give birth to an English-Canadian national consciousness, the maple leaf began to sprout symbolically all over Upper Canada. This literary annual from the 1840s provides a case in point. "When we formed the idea of offering to Canada a literary wreath," the editor writes in his preface, "we determined ... that no flowers, however lovely, should be twined with 'the maple leaf,' but those that had blossomed amidst her forests."

London, England
printed paper and green cloth
20.6 x 12.7 cm

It has been said that until you can name the things in the world you inhabit, you can't write about that world. In this sense, Susanna Moodie's best-known book, *Roughing It in the Bush*, is an early example of the Victorian mind attempting to grapple with the Canadian reality. Moodie's Ontario "bush," first near Cobourg, and later near Lakefield, was actually pretty tame by Canadian standards, but she does not romanticize her failed attempts at homesteading with her husband and children. Her account of pioneer life in this book and its sequel, *Life in the Clearings*, helped shape the nineteenth-century self-image of Canada.

DRAWING FROM *STUDIES OF PLANT LIFE IN CANADA, OR, GLEANINGS FROM FOREST, LAKE AND PLAIN*, BY CATHARINE PARR TRAILL, WITH ILLUSTRATIONS BY AGNES FITZGIBBON CHAMBERLIN, 1885

Ottawa, Ontario
chromolithograph from drawing
approx. 24.3 x 15.6 cm

Susanna Moodie's daughter Agnes FitzGibbon Chamberlin originally painted this illustration of a trillium, flanked by a wild lily of the valley and flowering wintergreen, for her aunt Catharine Parr Traill's book about eastern Canadian plants, *Wild Flowers of Canada* (1867). Traill then reused the illustrations in her *Studies of Plant Life in Canada*. Chamberlin's artistic style is Victorian, but her subject is undeniably and accurately Canadian.

Albert Edward, Prince of Wales (in centre), *known to his friends as "Bertie," poses with members of his entourage in front of the Montreal mansion "Rosemount" in 1860, soon after he began his official visit to the United Province of Canada*

1

1 ENGRAVING OF TROWEL USED BY THE PRINCE OF WALES IN THE COMPLETION OF VICTORIA BRIDGE, MONTREAL, 1860

made in England
ink on newsprint
27.3 x 40.2 cm

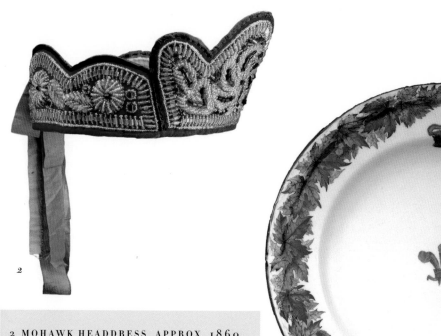

2

3

2 MOHAWK HEADDRESS, APPROX. 1860

Kahnawake, Quebec
cotton, silk, and glass beads
30 x 11 cm

3 DINNER PLATE, KERR AND BINNS, APPROX. 1860

Worcester, England
porcelain with transfer-printed and painted enamel decoration
25.5 cm

These three souvenirs of the Prince of Wales's visit to Canada in 1860 have one thing in common: they portray English Canada as a distinct society within the British Empire. The trowel and the dinner plate wear their Canadian symbolism quite brashly: maple leaves copiously decorate both objects, and the trowel's handle becomes a beaver. The Mohawk headdress was worn by one of the hundred paddlers who propelled a flotilla of nine Hudson's Bay Company canoes on a royal field trip from Dorval along the St. Lawrence River. Both the trowel and the plate include symbols of empire: on the trowel the maple leaves entwine with the British thistle, rose, and shamrock; the plate (made in Great Britain) features a crown and three feathers, traditional symbols of the heir apparent.

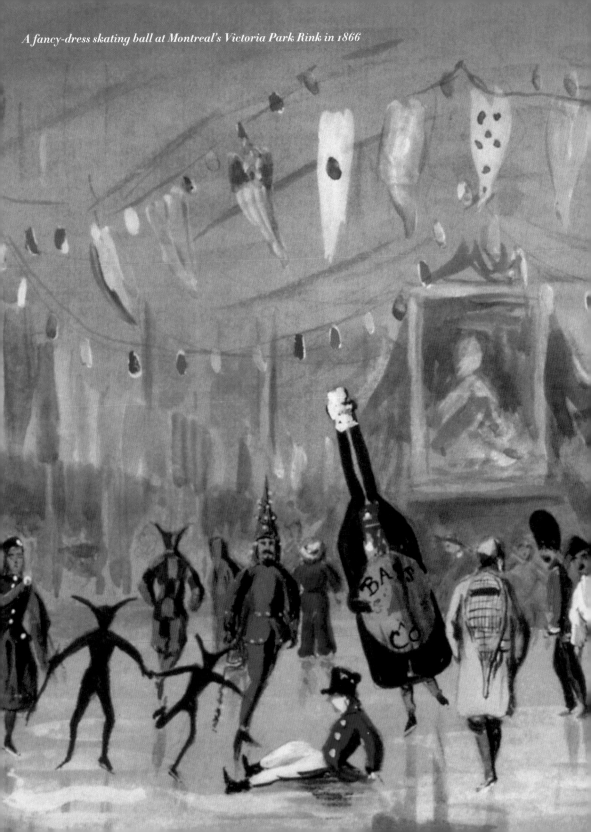

A fancy-dress skating ball at Montreal's Victoria Park Rink in 1866

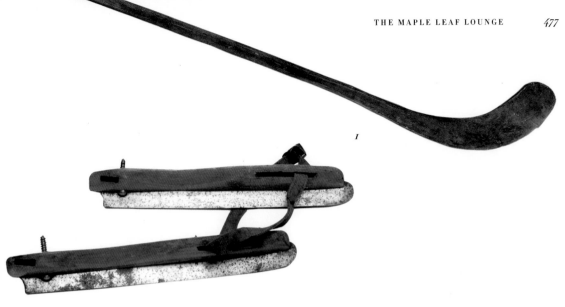

1 HOCKEY STICK, APPROX.
1879

Montreal, Quebec
wood with silver
109.5 cm

2 ICE SKATES, APPROX.
1900

Montreal region, Quebec
wood and metal
5.7 x 26.6 x 5.7 cm

3 CURLING STONE KNOWN
AS THE "CARMICHAEL
STONE," APPROX. 1850

Canada
wood and metal
size unavailable

Winter activities on ice grew in popularity after British officers introduced skating to Canada in the 1840s. It wasn't long before Canadian lakes and rivers were crowded with skaters of both sexes – skating was the rare sport deemed appropriate for women – who simply strapped contraptions like these early skates onto their boots and glided off. Turning skating into a team sport followed naturally. By the late 1870s a Canadian invention called ice hockey was growing so fast that the rules needed to be formalized. Lewis Skaife, a member of the McGill hockey team, used this stick, still closely resembling a field hockey stick, from 1878 to 1881. Unlike hockey, curling was an import from Scotland. This curling stone gets its name from William Carmichael, a famous curler in Lower Canada in the 1850s.

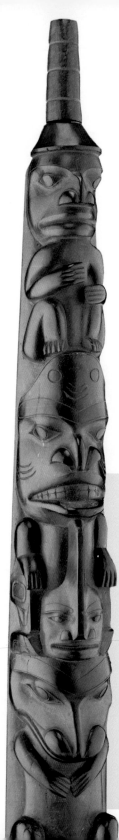

TOTEM POLE, ATTRIBUTED TO CHARLES EDENSHAW, 1879

Queen Charlotte Islands, BC
argillite
(fine-grained black silt stone)
57.7 x 6.2 x 5 cm

We would know that this finely carved stone totem pole came from Haida Gwaii, even if we did not know the name of its maker, because it is argillite – a fine-grained black shale found only in Slatechuck Creek on the Queen Charlotte Islands. Argillite carvings were so popular with European visitors that, after the fur trade declined, Haida carvers diversified their wares to cater to Victorian tastes. Totems like this one were especially popular, though it is doubtful that its heraldic figuers held much meaning for Israel W. Powell, who collected it in 1879. The figures represent (from top to bottom) a chief, a shark, and a grizzly. By the early twentieth century there was a distinct danger that the artistic traditions of the Northwest coast – and the ways of life they grew out of – would completely fade away, and with them the unique identities of whole peoples.

BAPTISMAL FONT, ATTRIBUTED TO FREDERICK ALEXCEE, 1886

Port Simpson, BC
wood, paint, and nails
82.5 x 62.5 x 60.6 cm

When cultures collide, each is changed. When one culture becomes subject to another, as did the Tsimshian and other native societies of the Northwest coast in the nineteenth century, it often subverts the outsider's symbolism, whether consciously or unconsciously. This baptismal font created for a Christian ritual by a Tsimshian artist is a synthesis of native and European styles. The face could have been carved only by someone from Northwest coast native culture, but the hands and body imitate European models. It is certainly no ordinary angel; apparently the font was removed from the church for which it was made because it frightened children.

FREEDOM BOX, 1884

London, England
silver
27.2 x 27.7 x 19.5 cm

Sir John A. Macdonald often loudly proclaimed his allegiance to the British Empire, but that loyalty didn't stop him from being a staunch Canadian nationalist as well. And nothing could have made a more appropriate gift from his "Political Friends of the District of Quebec" on the occasion of his seventieth birthday in 1885 than this commemorative box. The back, shown here, bears the coat of arms of Quebec. On the front a bilingual engraving, inside moosehead spandrels, honours Macdonald's birthday and his long career. Maple leaves decorate the borders of the lid and the box's base. And the crowning emblem is the beaver, busily gnawing on a stump.

THE OLD FLAG,
THE OLD POLICY,
THE OLD LEADER.

TORONTO LITH. C.

POSTER OF "THE OLD FLAG, THE OLD POLICY, THE OLD LEADER," 1891

Canada
paper
size unavailable

Sir John A. Macdonald fought and won his last campaign in 1891 with a wily blend of anti-Americanism, British Empire patriotism, and Canadian nationalism. In this famous campaign poster he is carried aloft by figures representing agriculture and industry, both threatened by the Liberal policy of reciprocity (free trade) with the United States. The Tories vehemently opposed this initiative and clung to their "old policy" of protection. Ironically, the flag Macdonald carries is not the "old flag," namely the Union Jack, but a Red Ensign, which by 1891 was already widely accepted as the de facto Canadian banner.

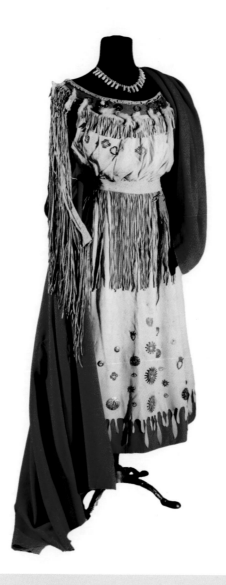

PERFORMANCE COSTUME WORN BY PAULINE JOHNSON, 1892

made in Winnipeg, Manitoba;
worn throughout Canada,
USA, and London, England
dress: buckskin, cotton, beads,
silver trade brooches;
blanket: wool;
necklace: bears' claws and
glass beads
dress: approx. 100 cm

Mohawk-Canadian poet Pauline Johnson's stage costume betrays her divided identity. While pretending to be authentic, it was actually cobbled together mostly from commercial sources. Authentic details include the silver trade brooches on the bodice (these came from her grandmother), the scalp hanging from the waistband, the ceremonial red blanket over the shoulder, and the rabbit pelt (hidden under the blanket). She wore the costume until 1909 in hundreds of performances throughout Canada and during two trips to London, England, in 1894 and 1906.

GOING NATIVE
The Two Lives of Pauline Johnson

"I am going to make a feature of costuming for recitals," the thirty-one-year-old poet E. Pauline Johnson wrote to a friend in 1892. Pauline had grown up on the Six Nations Reserve south of Brantford, Ontario. Her father was a Mohawk chief, and her mother a cultivated Englishwoman. Pauline wrote and recited, on stage, lyrical nature verse, passionate love poems, and stirring Indian ballads about bloodthirsty braves and true-hearted maidens. "For my Indian poems I am trying to get an Indian dress to recite in, and it is the most difficult thing in the world ... If you see anything in Montreal that would assist me in getting up a costume, be it beads, quills, sashes, shoes, brooches or indeed anything at all, I would be more than obliged to know of it."

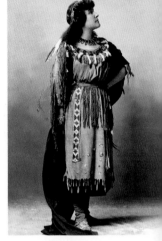

Pauline Johnson in a turn-of-the-century publicity photo

Pauline found her costume. And almost a hundred years after she last wore it, I was introduced to it by the curator at the Vancouver City Museum, where it now resides. She lifted the buckskin outfit, once soft but now brittle with age, out of the layers of tissue paper. A faint smell of dry autumn leaves clung to its folds, and I could almost feel the powerful aura of Canada's first coast-to-coast celebrity. Pauline wore the outfit for the recitals she gave between 1892 and 1909 throughout Canada and the United States, and during two trips to London, England, in 1894 and 1906.

I gently touched the fringed, calf-length skirt and saw where, a century ago, Pauline sewed an extra piece of fabric into the waistband when it needed enlarging. I examined the silver "trade brooches," bartered for furs by eighteenth-century British traders, that Pauline inherited from her grandmother and attached to the scoop-necked bodice. The stitches with which she attached a rabbit pelt to the garment's left shoulder were still visible. The famous neck-

lace of bears' claws interspersed with glass beads, presented to her by the poet Charles Mair (always a sucker for a pretty face), looked as exotic as ever. The wampum belt that she wore at her waist, its intricate bead pattern denoting important trade and land agreements, bespoke a long and honourable Iroquois tradition of treaties with other peoples. And the Huron scalp that once hung alongside the belt retained its gruesome fascination, although now just a shrivelled piece of gristle. When Pauline stuck a white eagle feather in her thick brown hair (as she often did, according to contemporary photographs), she looked every inch the Mohawk princess she claimed to be.

But the strongest impression I took away from my encounter with her performing costume was of how hard Pauline worked in those seventeen years on the road. There are patches on the skirt where the buckskin has been worn paper-thin and perspiration marks under the sleeves. Some of the silver trade brooches are missing, lost during one of the hundreds of one-night stands she gave in small towns served by the Canadian Pacific Railway. Sections of the skirt's fringe have disappeared, caught, perhaps, on a nail or splinter as she descended from a makeshift stage in the church hall of some rough prairie town.

In the poet's own day, her Indian get-up was daring and erotic. Her non-native audiences, many of whom had enjoyed Buffalo Bill Cody's wildly popular "Wild West Spectacle," starring the great Sioux Chief Sitting Bull, expected native performers to wear buckskin and feathers. But Pauline was an intriguing combination of highbrow literature and low-cut bodice, genteel demeanour and bare arms. When she opened a recital with one of her signature pieces – "A Cry from an Indian Wife" or "As Red Men Die" or "Ojistoh" – her soft, musical voice seemed to speak intimately to each individual present, yet it penetrated the farthest reaches of the hall. The effect was deliberate. Pauline's loose-fitting buckskin bodice allowed her to shed her corset, that mainstay of respectable Victorian womanhood, and project her voice more effectively. Tightly laced corsets reduced a woman's lung capacity by at least a third.

Buckskin, wampum, bare arms, a scalp, and a seductive voice: both the women and the men in her audiences found her performance thrilling. "Ooh! Isn't she savage?" she heard one man say during a performance in Medicine Hat. "I wouldn't want her for a wife." No one questioned her outfit's authenticity.

Yet if Pauline ever performed before a native audience – and there is no evidence she did – her listeners would have known the Indian costume for the sham it was. By the 1890s almost everybody on her own Six Nations Reserve had abandoned the traditional dress of tunics, leggings, and blankets. Iroquois women wore full-skirted European dresses, and Iroquois men appeared in buckskin breeches only on ceremonial occasions. At the time Pauline decided to adopt "Indian dress," she had never been outside her native Ontario, so had little idea of what Cree, Blackfoot, or Squamish peoples might wear.

Pauline Johnson's costume came from the commercial mecca of British North America, the Hudson's Bay Company in Winnipeg, which sold complete buckskin outfits (including moccasins, cuffs, and collars decorated with beads, moosehair, and porcupine quillwork) as souvenirs to European settlers and tourists. Pauline ordered her dress from the Bay, just as a prairie farmer's wife might have ordered a winter coat. Then she and her sister Evelyn altered it to more closely resemble the illustration of Minnehaha, wife of Hiawatha, in the copy of Longfellow's epic poem from which their mother had read to her daughters. In other words, Pauline chose the romantic European idea of what an Indian maiden should look like, rather than the genuine dress of a young First Nations woman in 1890s Canada.

Pauline was aware that the reality of Canada's native population was much darker than her sentimental verse and electrifying stage presence might imply. While outfitted in buckskin, she also recited poems that dealt with the harsher side of dominion policies towards native peoples: restrictions on travel outside reserves, residential schools, loss of language and tradition. But halfway through her program, she laced herself into her corset and reappeared on stage in one of the beautiful silk evening gowns she had purchased in

London, England. She filled her second act with poetry about canoes, Canadian patriotism, and the North-West Mounted Police. With her pale skin and regal bearing, she now looked every inch a daughter of Mayfair, Mount Royal, or Rosedale.

It was an erotic transformation, from earthy and passionate in the first act to ethereal and unattainable in the second. It reflected both her hybrid background and her conflicting emotions. But it was also reassuring in a dangerous way. It suggested that federal bureaucrats in Ottawa were correct in assuming that Indian peoples, decimated by disease and starvation, were heading for extinction and that the few native survivors would quietly adopt European customs.

The population decline was real: between 1881 and 1915, while the non-native population boomed, the native population shrank and Indians were pushed to the margins of public life. Pauline Johnson was one of the few native voices heard by non-natives during these years. Yet her nightly metamorphosis from romantic Mohawk to drawing-room belle confirmed the comfortable white assumption that Indians would be absorbed effortlessly into the dominant British culture. When the Indian population began to grow in the 1920s, Canadians, including the First Nations themselves, were completely unprepared. Pauline's dress told a seductive, but misleading, story.

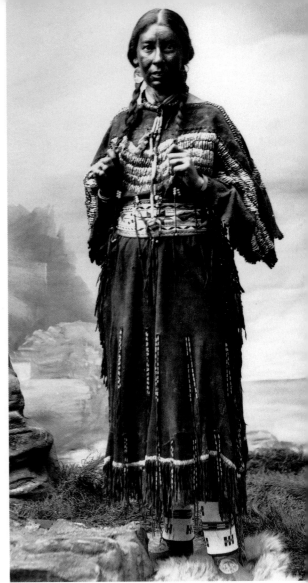

Miss Bloomfield at the 1896 Canadian history fancy-dress ball at Rideau Hall

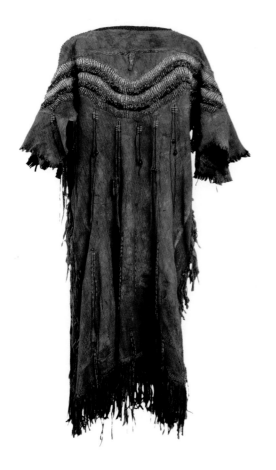

BLACKFOOT DRESS, APPROX. 1896

Alberta
hide coloured with ochre,
glass beads, metal, fibre,
and porcupine quills; hand stitched
128 x 60 cm

The farther Canadian society moved from its backwoods roots, the more romanticized its idea of the country's original inhabitants became. The Ottawa socialite who last owned this authentic Blackfoot dress wore it at the 1896 fancy-dress ball held at Rideau Hall by Lady Aberdeen, the wife of the governor general. Miss Bloomfield came with the "Indian group" to the ball, whose theme was Canadian history, as the imaginary Indian character "Akeka-Mak-Koye," or "Many Swans."

Laurier campaigning in the free-trade election of 1911 accompanied by, no doubt, the British Union Jack – at that time the only official flag of Canada

Late-Victorian Canada was a country in search of an identity, a former colony struggling out from under Great Britain's shadow but not yet sure what to do with itself in the world. With the election of 1896, Canadian politics took a definite step forward. The country's new prime minister was an elegant and eloquent French-Canadian who genuinely admired British democracy and referred often in English-speaking Canada to the Duke of Wellington's successful military campaigns. Laurier wisely avoided any mention of a Canadian flag, since the Red Ensign, with its very British Union Jack, was sure to inflame his French-speaking countrymen.

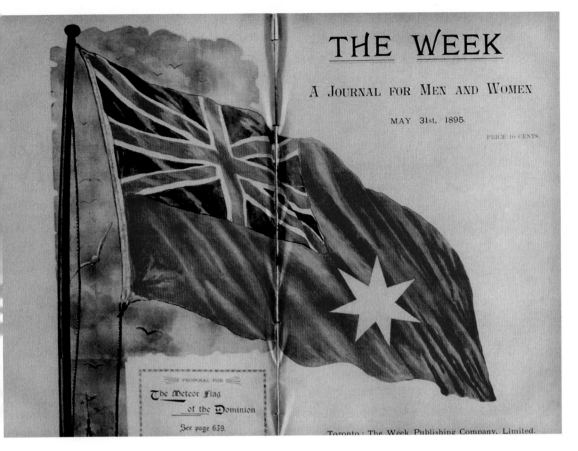

COVER FROM *THE WEEK* SHOWING "THE CANADIAN FLAG: A PROPOSAL FOR THE METEOR FLAG OF THE DOMINION," SANDFORD FLEMING, MAY 31, 1895

Toronto, Ontario paper 22 x 32.5 cm

At the turn of the nineteenth century, English-speaking Canadians were engaged in a lively debate about the meaning of their dual citizenship of both country and empire – and the appropriate symbols to express it. Quite a few tracts were published promoting various possibilities, most of them variants on the Red Ensign with different emblems in the fly. One of the more original proposals was Sir Sandford Fleming's, which rejected the Canadian coat of arms or any reference to the maple leaf or the beaver in favour of a seven-pointed North Star.

The main street of Simcoe, Ontario, festooned with Union Jacks and Red Ensigns to welcome Laurier's motorcade in 1911

GENERAL SERVICE BADGE OF THE ROYAL CANADIAN REGIMENT, 1899

Quebec
metal
3 x 2.5 x 1 cm

Canadian soldiers fought in the South African, or Boer, War under British commanders as part of a British Empire force, but they wore maple leaf badges on their hats or collars and maple leaf insignia on their battle helmets. Legend has it that one badly wounded Canadian soldier at the Battle of Paardeberg pointed to his maple leaf badge and said, "If I die, it may help *this* live."

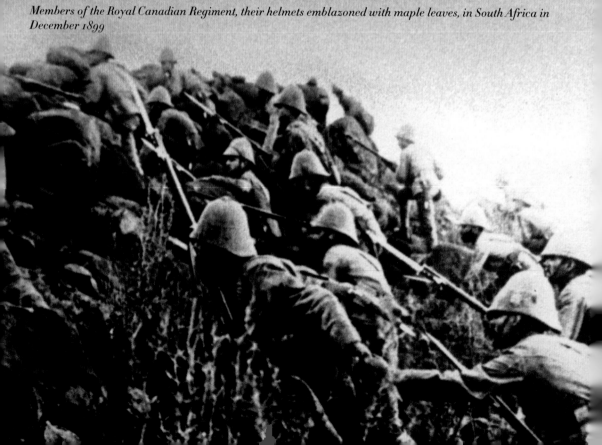

Members of the Royal Canadian Regiment, their helmets emblazoned with maple leaves, in South Africa in December 1899

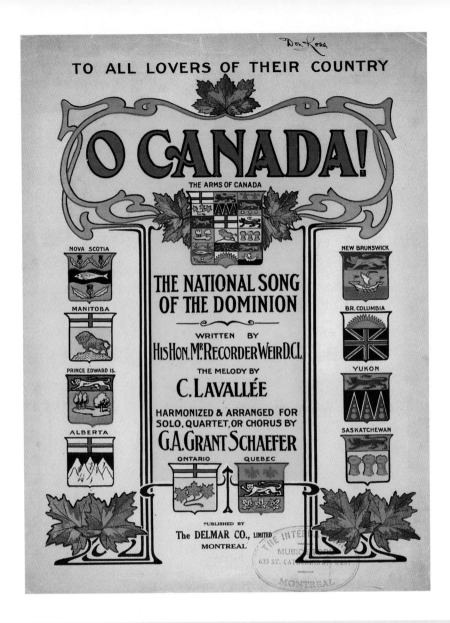

ENGLISH VERSION OF "O CANADA," ROBERT STANLEY WEIR, 1914

Montreal, Quebec
paper
34.5 x 26.5 cm

The original French version of "O Canada," composed by Calixa Lavallée with words by Adolphe-Basile Routhier, was first performed on St-Jean-Baptiste Day in 1880. But it took almost thirty years before Robert Stanley Weir provided an English version that gained popularity. The original English edition consisted of this cover, two interior pages, and a back page with an inspirational message from the lyricist. Parliament debated but failed to adopt "O Canada" as the country's official anthem in 1967. It finally became official in 1980, along with Routhier's original French lyrics, and with Weir's English lyrics only slightly altered from the original.

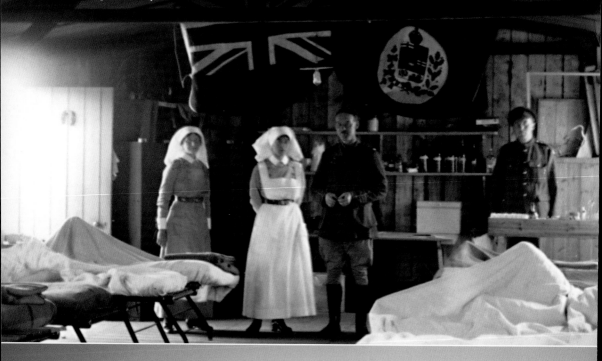

Despite the senseless carnage of the First World War, the crucial Canadian contribution to the eventual Allied victory marked a coming of age for the country. Canadians had fought with distinction, and they died out of all proportion to the size of their population. Canadian generals had led the way in modernizing Britain's approach to mass warfare. And, by the time the men who had served in the trenches came home, they had met fellow soldiers from every region of the country, French- and English-speaking, and had often exchanged maple-leaf-shaped regimental badges with them. The war marked the beginning of a national consciousness for all.

RCMP TUNIC, APPROX. 1920s

Regina, Saskatchewan red serge, gold braid, and metal buttons size 38

This scarlet tunic was worn by a member of Canada's first federal police force, which was created on February 1, 1920, by a merger of the Royal North-West Mounted Police and the Dominion Police. The cavalry tradition on which the original North-West Mounted Police had been founded survived in the ceremonial uniform, with its Stetson hat, and the much-rehearsed Musical Ride. This image of Canada's federal police (who also handle policing in all provinces save Ontario and Quebec) has become an international "brand," combining Canadian honesty and wholesomeness, which is very easy to lampoon.

EATON'S BEAUTY DOLL, THE T. EATON CO. LIMITED, 1923-24

Köppelsdorf, Germany
porcelain, silk
54 x 21 x 9 cm

The T. Eaton Company introduced its first "Eaton's Beauty Doll" in 1900, and it quickly became a fixture of the company's fall and winter catalogue (started in 1884), with hundreds of thousands of Canadian girls wanting nothing more for Christmas than this year's edition. The doll was always a European. The earliest, like this example from Germany, had bisque porcelain heads and shoulders and leather bodies.

An Eaton's window display from 1931.

Tom Thomson's painting Canoe Lake, *1913 or 1914, exhibits the landscape style that would make the Group of Seven into Canadian icons.*

**TOM THOMSON'S SHAVING MUG,
EARLY 20TH CENTURY**

Ontario
ceramic and oil paint
9 x 9 cm

**STUDIO PALETTE OF TOM THOMSON,
EARLY 20TH CENTURY**

Ontario
wood and oil paint
58 x 38 cm

Tom Thomson's mysterious death while canoeing in Algonquin Park sometime in July 1917 helped make him into a legendary figure and turned artifacts such as these into precious relics. (Both the palette and the mug show multicoloured paint splotches; no doubt the mug was used to mix paints or wash brushes.) But Thomson's real importance rests on his role in originating a style of landscape painting that captured the solemn beauty of the Canadian wilderness and caught the Canadian imagination. Three years after his death, a number of his artist peers formed the Group of Seven, whose work in this bold style made it famous.

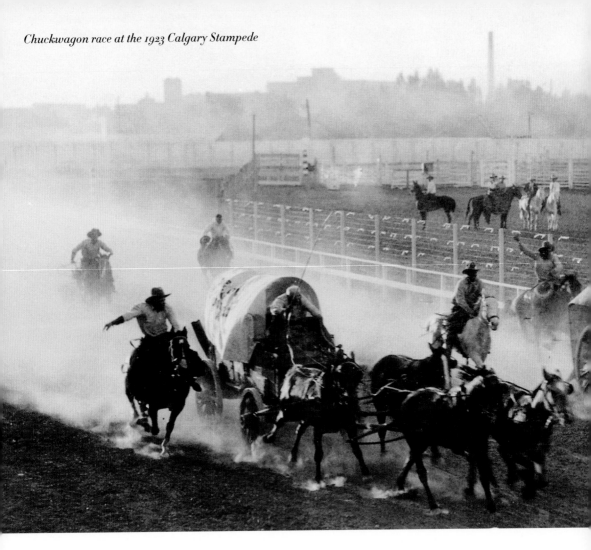

Chuckwagon race at the 1923 Calgary Stampede

SKIRT AND JACKET, ETTA PLATT, 1912

Calgary, Alberta
wool
jacket, 58 x 50 cm;
skirt, 83 x 80 cm

Etta Platt, the daughter of plainsman John "Kootenai" Brown, embroidered this woollen skirt and jacket for a friend, who wore it to the first Calgary Stampede rodeo in 1912. Etta's father wasn't competing in that rodeo, but he would have been well qualified. Since the 1860s he had lived an amazing variety of lives in the Canadian West: gold prospector, policeman, scout and guide, whisky trader, buffalo hunter, dispatch rider, and ardent conservationist. Thanks largely to his efforts, Waterton Lakes National Park was created in 1895.

OLYMPIC TEAM CREST, 1912

worn in Stockholm, Sweden
red cloth with stitching
24 x 24 cm (measured tip to tip)

Calvin Bricker wore this team crest when he won the silver medal in the "hop, step and jump" event at the 1912 Olympics in Stockholm, Sweden. Early Canadian athletes, amateur and professional, sported many variations of the Maple Leaf on their jerseys over the years. The shapes have generally been based on either the sugar maple or the silver maple leaf, they have appeared solo or embellished with the word Canada, and have sometimes been accompanied by other symbols, most often the beaver.

Canada's Percy Williams wins the 100-metre sprint at the 1928 Amsterdam Olympics

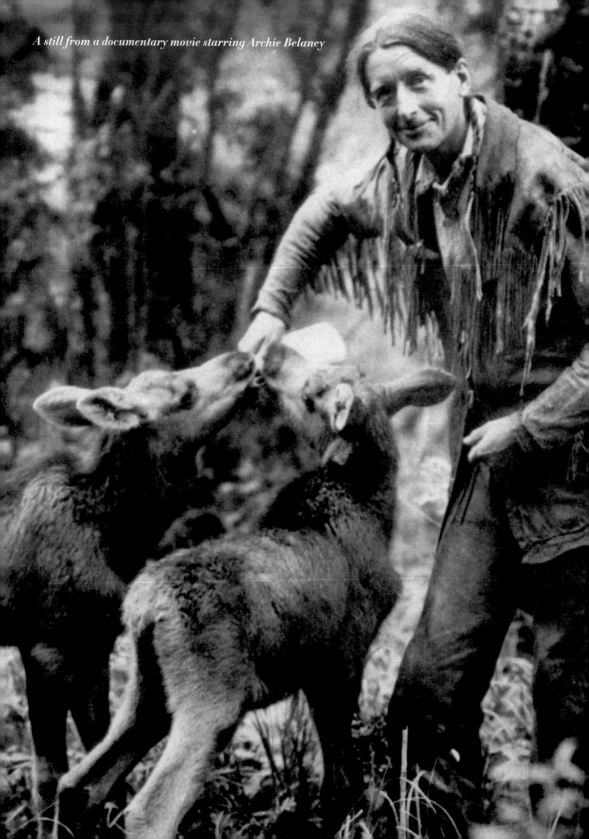

A still from a documentary movie starring Archie Belaney

GREY OWL (ARCHIBALD BELANEY), YOUSUF KARSH, 1936

Ottawa, Ontario
photograph
50.8 x 40.6 cm

The man Canadians knew in the 1930s as Grey Owl was, in fact, an Englishman named Archibald Belaney. He successfully masqueraded for many years as the son of a Scot and an Apache and, in the process, he made himself into one of the world's leading spokespeople for wildlife conservation (saving the threatened beaver was a particular passion). His books about the Canadian wilderness were extremely popular in Britain, where he gave sold-out lectures and even gave a command performance at Buckingham Palace in 1937. The famous Ottawa portrait photographer Karsh seems to have bought the disguise, for his portrait of Grey Owl carries no hint of subterfuge. Only after Belaney's death in 1938 was his true identity unmasked.

Dionne quintuplets, parents, nurses and guardian, 1939

MARIE

CECILE

YVONNE

ANNETTE

EMILIE

PALM PRINTS OF THE DIONNE QUINTUPLETS, 1935

Ontario
palm print (made with
face cream and finely
powdered and sifted
lampblack fixed on
kimeograph paper with
resin and 95% alcohol)
approx. 5.4–6.5 x 4.7–5.3 cm

This series of palm prints is the first complete set of the world's most famous babies, taken at the age of eighteen months. They appeared in *Collected Studies on the Dionne Quintuplets*, published by the University of Toronto Press in 1937, whose various articles were among the more scholarly of the millions of words written about these five girls, born to impoverished French-Canadian parents in northern Ontario on May 28, 1934. The story of the first set of quintuplets ever to survive birth provided a welcome diversion during the Great Depression. The Quints put Canada on the map in these years, but the five baby girls, who were removed from their parents' care at birth, grew up as lost souls.

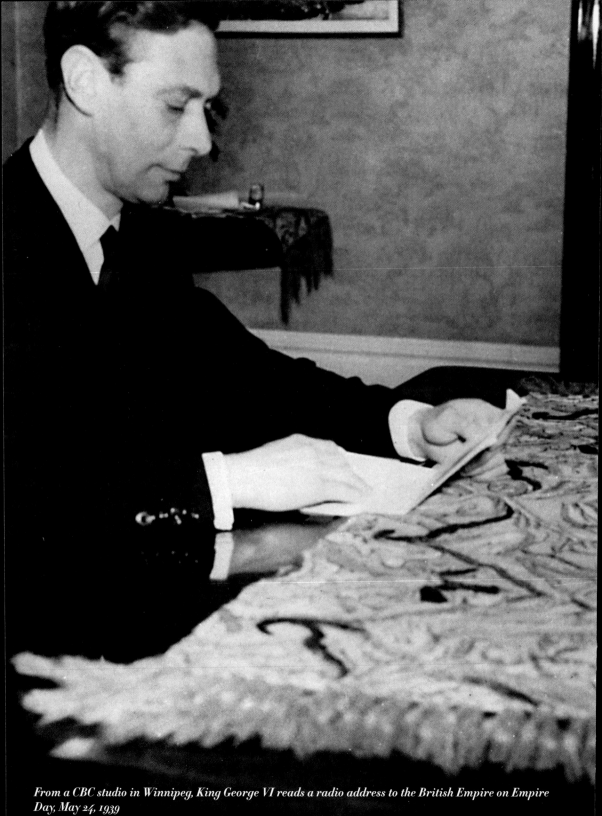

From a CBC studio in Winnipeg, King George VI reads a radio address to the British Empire on Empire Day, May 24, 1939

WESTERN ELECTRIC 633 MICROPHONE WITH CROWN, APPROX. 1939

Canada
spray-painted metal
with some brass parts;
insignia made of metal
and cloth
approx. 18.4 x 9.5 x
11.4 cm

CBC engineers came up with this outdoor microphone in 1939, just in time for the royal visit of King George VI and Queen Elizabeth to Canada. The microphone, which was weather-resistant and had an optional handle for outdoor reporting, successfully reduced the sound of the wind and made it possible for the network to cover the tour's many outdoor ceremonies. With royal fever sweeping the country, the radio audience skyrocketed. Canadians stayed tuned during the war that broke out a few months later, and the hand-held option allowed radio reporters to cover Canadian troops overseas. When the troops came home, they returned to a country much more confident in its place in the world.

WAR ROOM
1910 to 1948

A Second World War fighter pilot stands beside his Spitfire as a squadron of Spitfires flies past.
Opposite: *The First World War battlefield of Passchendaele, in western Belgium*

Global war proved to be the most pernicious invention of the twentieth century, during which two great conflicts involving vast armies and costing millions of human casualties were fought, as well as many smaller but equally bloody wars. Canada's population – just under 8 million people in 1914 and around 11 million in 1940 – was far smaller than that of the main European combatants in each of these world wars, but it shouldered more than its share of the fight and endured more than its portion of sacrifice. The experience of both the First World War and the Second World War in the field and on the home front did much to form the country Canada would become in the twenty-first century, a place whose people look outward as well as inward, a nation with a powerful sense of collective responsibility in global affairs. The last of those who fought in either of these two terrible conflicts first hand will soon be gone, but the wars themselves have become permanently embedded in the collective Canadian psyche.

A 1911 recruiting poster for the recently created Royal Canadian Navy

CAP TALLY, 1910–20

*United Kingdom or
Montreal, Quebec
silk with gold thread
approx. 3 x 94 cm*

This ribbon, with silver printing, was worn around the band of a seaman's cap to indicate the name of his ship, HCMS *Niobe*. After the passage of the Naval Service Act in 1910, *Niobe* and the cruiser *Rainbow* were transferred from Britain to Canada, making them the first two ships in Canada's navy.

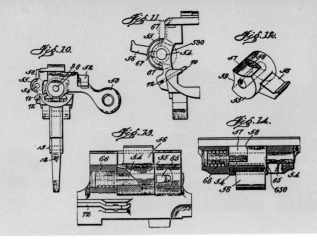

SKETCHES OF THE ROSS RIFLE MARK III, SIR CHARLES ROSS, 1913

Washington, DC
paper
size unavailable

The Ross rifle was unpopular with Canadian troops from the moment they found themselves at the front. They complained it was too heavy for modern trench warfare and that it had an alarming tendency to jam after a few minutes of rapid fire. Work began on the Mark III, the final version of the Ross rifle, in 1911. Even with the improvements, the soldiers still hated it. Not until the summer of 1916 was it finally replaced with Britain's Lee-Enfield rifle.

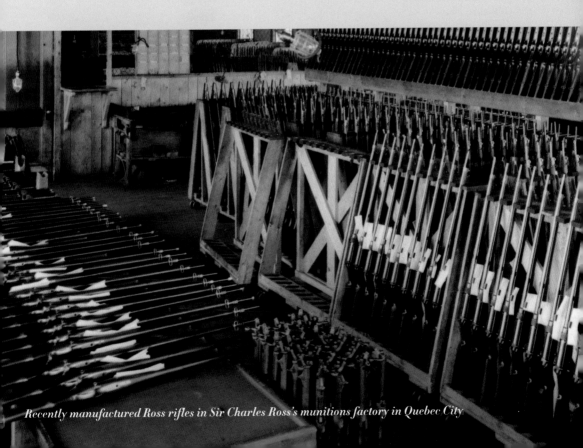

Recently manufactured Ross rifles in Sir Charles Ross's munitions factory in Quebec City

Canada's minister of militia, Sam Hughes (centre), promoted the Ross rifle despite evidence of its problems. Here he stands beside the British minister of munitions, Lloyd George.

COLLAR BADGES,
FIRST WORLD WAR, 1914–18

Canada
probably copper or brass
approx. 3.4 x 2.8 cm

These cap and collar badges belong to a variety of the overseas units raised for the Canadian Expeditionary Force (CEF), which, at its peak, numbered more than 600,000, but their designs are all based on familiar Canadian symbols. Canada's pre-war militia consisted of a hodge-podge of regiments, often styled as hussars, fusiliers, or highlanders in romantic imitation of British models. But when war broke out, Sam Hughes demanded the creation of numbered battalions rather than calling up existing units. By 1918, 258 infantry battalions and several mounted rifle battalions had been raised.

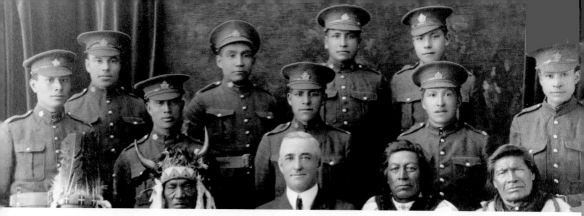

Members of the 68th Regina Regiment from the File Hills Indian Colony pose with their relatives before departing for England

NOTHING is to be written on this side except
the date and signature of the sender. Sentences
not required may be erased. If anything else is
added the post card will be destroyed.

[Postage must be prepaid on any letter or post card
addressed to the sender of this card.]

I am quite well.

~~I have been admitted into hospital~~

{ ~~sick~~ } ~~and am going on well,~~

{ ~~wounded~~ } ~~and hope to be discharged soon.~~

~~I am being sent down to the base.~~

(letter dated_____

~~I have received your~~ { telegram „ _____

(parcel „ _____

Letter follows at first opportunity.

~~I have received no letter from you~~

{ ~~lately~~

{ ~~for a long time.~~

Signature }
only } *Bert*

Date___ *Sept. 2nd 1917*

Wt. W34977293. 29246. 6000m. 9716. C. & Co., Grange Mills, S.W.

*Field Post Office 144,
probably situated in
northeastern France
or Belgium
paper
11.4 x 8.4 cm*

Bert Berry sent this "field service post card" to his family in Strathmore,
Alberta, in August 1917. Intended to allow a soldier at the front to communi-
cate with home without giving away any information that might aid the
enemy, the postcard permitted him to indicate little more than the fact he
was still alive. Later that year, Berry was killed at the Battle of Passchendaele.

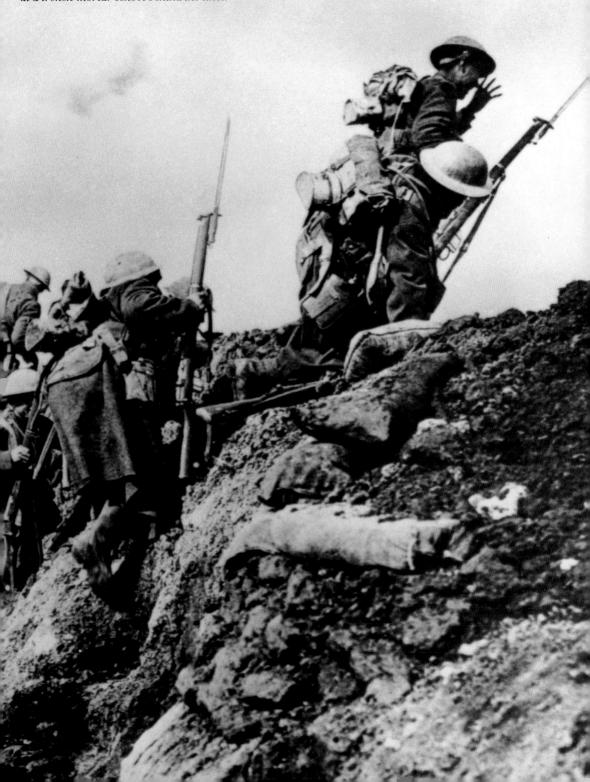

At Courcelette, France, Canadian infantrymen go "over the top" in a training exercise at a trench-mortar school behind the lines.

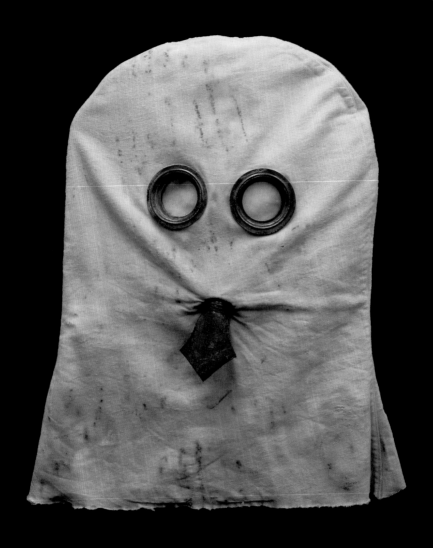

GAS MASK, APPROX. 1914

England
light cotton, rubber,
plastic
9.8 x 53.4 x 13.9 cm

This early and ineffective version of a First World War gas mask was designed and tested by Newfoundland physician Cluny Macpherson, chief medical officer of the Newfoundland Regiment. The Macpherson smoke helmet was replaced later in 1916 by the service-box respirator.

"Gas Has Few Friends"
The Invisible Weapon of the First World War

There is a kind of black comedy to this shapeless cotton hood with its two clownish eyeholes and a rubber tube hanging from the mouth. It looks like a prop for a *Saturday Night Live* sketch about aliens or hangmen. But in 1915 such headgear provoked no belly laughs. Known as a "P-helmet" (or "the google-eyed booger with the tit" among battle-weary troops), it is a respirator impregnated with chemicals to protect against the deadly poison gases that the Germans had unleashed against Allied troops. The P-helmet worked because, as Allied soldiers breathed through the fabric, the chemicals neutralized the gas. This hood was the difference between life and an agonizing, lung-searing death.

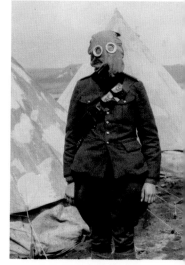

Soldier wearing an early First World War gas mask

Imagine pulling that smothering cloth bag over your head! I can understand why, nearly a century ago, British and Canadian Tommies hated the helmets, even though they knew they were their only hope of survival. The P-helmet effectively crippled all a soldier's senses. He would be blinded when the eyeholes steamed up. He would be deafened by the sound of his own breath rushing in and out, so he could not communicate with his comrades. The air inside smelt, according to one Canadian soldier, "like last year's birdseed." The valve that was clenched in his mouth, with a rubber tube hanging from it to prevent carbon dioxide build-up within the hood, often cut the soldier's lips and usually resulted in a continuous flow of drool. Moreover, when a soldier began to sweat inside the stifling head bag, the chemicals in the cloth burned his forehead and irritated his eyes.

There was more to surviving the gas war than simply being equipped with a respirator. The cloth helmets worked only if users were properly trained.

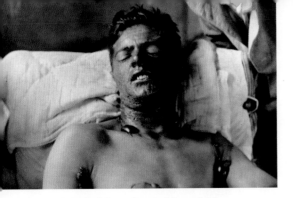
An unidentified Canadian soldier with burns caused by mustard gas

Soldiers often believed, in the chaos of battle, that they were being gassed, despite wearing masks, because of the combination of the helmet's own smell and some minor seepage of gas. Panicky men would rip off the helmets in fear and then fall victim to the deadly agents. Chemical warfare is about psychological as well as physical trauma.

Gas. Until the German generals ordered its use at Ypres on April 22, 1915, most people had regarded gas as a beneficial product of the industrial age. Coal gas illuminated streets in small towns across Canada, and gas-mantles, which gave a reassuring "pop" when lit, cast a soft glow within parlours and bedrooms. But that sunny April day, German gas units (known as *stinkpioneres* by their own infantry, who both disliked and feared them) released 160 tons of chlorine across the Ypres salient, a bitterly contested battlefield in Belgium. A green-yellow cloud of the deadly lung irritant, several kilometres wide and half a kilometre deep, blotted out the sun and rolled through French and Algerian troops; some gas drifted west to the place where Canadians were entrenched. Saskatchewan-born Major Andrew McNaughton (who would command the Canadian Army during the Second World War) watched the Algerians streaming past him, "their eyeballs showing white, and coughing their lungs out – they literally were coughing their lungs out; glue was coming out of their mouths. It was a very disturbing, very disturbing sight."

Two days later the Canadians were the primary targets of a gas attack. The only soldiers to survive were those who followed orders and held pieces of cloth they had soaked in their urine to their faces. The urine caused the chlorine to crystallize. Those too slow or too fastidious to bury their noses in their own piss died in gasping, retching agony.

British and Canadian civilians and soldiers were outraged by the use of these cruel and inhumane chemical weapons, which had been banned by the

Hague conventions of 1899 and 1907. This mass extermination treated men like insects. But with the war stalemated in the muddy trenches of the Western Front, the Allies knew that the enemy would use gas again. German factories produced 85 percent of the world's

Colonel Cluny Macpherson in Egypt in September 1915

chemicals, and gas was too effective a weapon to relinquish. The Allies' challenge was to protect soldiers against further chemical attacks – and to retaliate.

At Ypres a Canadian sergeant had noticed that the *stinkpioneres* wore what looked like flour bags over their heads. Captain Cluny Macpherson, a Newfoundland medical officer, experimented with the idea and produced the first prototype of a gas mask that covered the head. This Hypo or Smoke helmet was impregnated with chemicals to protect against chlorine and had a mica window at the front through which the soldier, in theory, could see what was happening. It worked, but the mica shattered too easily.

Various improvements, including plastic goggle eyes and a richer chemical mix, were made to Macpherson's prototype: the P-helmet, and then the PH-helmet (same design, but a different chemical mix), were developed just in time. On April 27, 1916, a squealing, whirling horde of rats rushed into Canadian trenches at Ypres, leaping into the faces and laps of the horrified soldiers as they fled from an invisible cloud of gas drifting on the wind from the German lines. The Germans were now using phosgene, which was eight times more deadly than chlorine, almost invisible, and without smell. Most of the Canucks survived, thanks to their P-helmets, but there were many casualties because troops were still ill-informed about how to identify gases, how to put on their gas masks, and when it was safe to remove them.

Both sides scrambled to develop deadlier poison clouds. In 1917 the Germans introduced mustard gas, which lurked in trenches and shell-holes for days, causing blisters and burns on any exposed skin. By war's end, poison

gases were being used on a weekly and sometimes a daily basis by both sides. Gas caused over a million casualties and immeasurable psychological stress: the British produced more than 55 million gas masks to combat its impact.

How little we know about the relentless use of poison gases by both sides on First World War battlefields. It has often been downplayed in official histories. As a British brigadier general remarked in 1919, "gas has few friends; people are only too ready to forget it." The inhumanity of gas warfare was too cruel to recall: the stigma attached to it ensured that it was never used on Second World War battlefields.

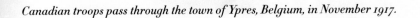

Canadian troops pass through the town of Ypres, Belgium, in November 1917.

First World War veterans making commemorative poppies

EARLY POPPY, APPROX. 1918

Canada
stiff woven textile,
possibly cotton, tin-foil-like
metal
approx. 5.2 cm

The poppy as a symbol of wartime sacrifice originates with Colonel John McCrae's poem "In Flanders Fields," which was written during the first Battle of Ypres in April/May 1915 and published in the British magazine *Punch* the same year. McCrae had enlisted as a medical officer in the Canadian Expeditionary Force and died in France only a few months before the end of the war. This is one of the earliest commemorative poppies. Its centre bears a small foil likeness of Arthur Currie, commander of the Canadian Corps on the Western Front from June 1917 until the end of the war.

Billy Bishop in the cockpit of a Nieuport aircraft of the Royal Flying Corps

First World War aerial operations

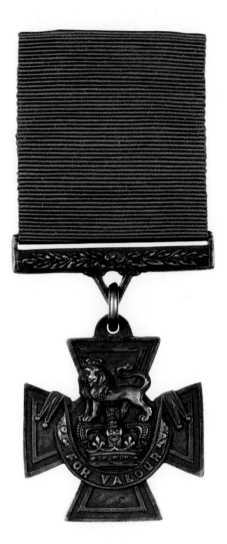

VICTORIA CROSS, APPROX. 1917

London, England
gunmetal and ribbon
cross, approx. 3.5 cm;
ribbon, approx. 3.8 cm

The Victoria Cross is the highest wartime honour in the British Commonwealth and is awarded only for exceptional bravery, almost always in the face of the enemy. The VC on display here was awarded to Private Harry W. Brown, Canadian Expeditionary Force, 10th Canadian Infantry Battalion, who, despite a shattered arm, delivered a crucial message to headquarters under heavy fire. "He was so spent that he fell down on the dug-out steps," reported the *London Gazette*, "but retained consciousness long enough to hand over his message ... He then became unconscious and died in the dressing station a few hours later. His devotion to duty was of the highest possible degree imaginable."

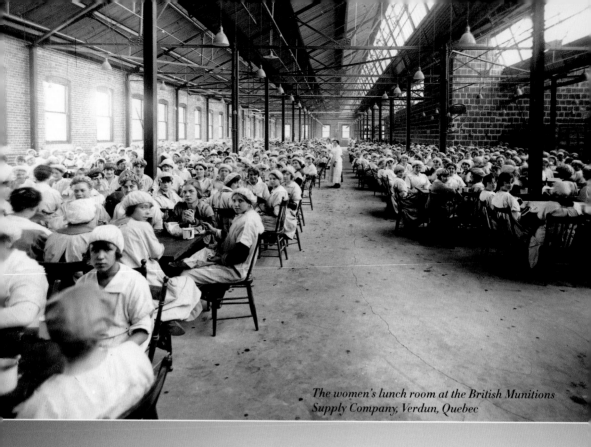

The women's lunch room at the British Munitions Supply Company, Verdun, Quebec

The First World War marked Canadians at home almost as deeply as those who served abroad. For every one of the hundreds of thousands of soldiers overseas, there were families and friends to worry about their safety and, all too often, grieve their loss. The war on the Home Front called for its own kinds of sacrifice and engineered a huge social shift – above all, in the status of women – that would change the country for good.

GOPHER DAY MEDAL, 1917

Saskatchewan
metal
size unavailable

Not all Canada's wartime enemies were fought overseas. This medal was presented to the children of Saskatchewan's Charlottenberg School District for their prize-winning efforts in shooting, trapping, and poisoning as many gophers as possible on "Gopher Day," May 1, 1917. Because these pesky rodents ate precious prairie grain, they were considered "enemies of production" and fair game for mass extermination. Some 980 Saskatchewan schools reported more than half a million gophers killed during the single day's effort.

CLOCK, EARLY 20TH CENTURY

Halifax, NS
metal and white enamel
5.5 cm

The hands of this clock stopped at a few minutes after 9 a.m. on December 6, 1917, the day of the Halifax Explosion, the most powerful human-made explosion until Hiroshima. In Halifax Harbour at 8:46 that morning, the Norwegian vessel *Imo* collided with the French ammunition ship *Mont Blanc*. Sparks from the collision ignited benzol stored on the French freighter's decks. Within moments, flames reached her main cargo of picric acid, TNT, and guncotton. At 9:06 she blew sky-high, sending a massive shock wave that blew out windows kilometres away, caused buildings to collapse, and left 2.5 square kilometres of the city of Halifax in ruins. More than 1,600 people died, some 9,000 were wounded, and over 6,000 Haligonians were left homeless.

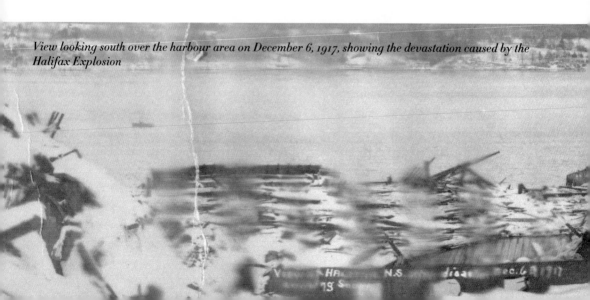

View looking south over the harbour area on December 6, 1917, showing the devastation caused by the Halifax Explosion

MORTUARY BAG CONTENTS, 1917

Halifax, NS
gold, unidentified stones
brooch, approx 3.8 cm,
heart centre, approx. 1.2 cm;
rings, approx. 2 cm

These two rings and a pin belonged to a young woman "about 24 years, dark brown hair, fair complexion," whose body was found in the wreckage at 14 Duffus Street in Halifax following the explosion. She wore patent leather no. 4 laced boots and long black stockings. Her identity was not determined, making hers one of the 250 and more bodies never identified.

Canadian military nurses, known as "Bluebirds," cast their ballots at a polling station set up in a field hospital in France in December 1917.

November 24, 1917 CANADA

DOMINION OF CANADA.

SOLDIERS' ELECTION.

A Selective Draft.

Not ALL liable to draft will be selected.

RELATIVES OF SOLDIERS will be sympathetically considered.

FOR

THE LEADER OF THE GOVERNMENT has given this PLEDGE:—

In enforcing this Act the Government will proceed upon the principle that the SERVICE and SACRIFICE of any FAMILY which has already SENT men to the Front <u>MUST</u> be taken into account in considering the exemption of other MEMBERS OF THE SAME FAMILY.

AS THERE ARE IN THE CLASS LIABLE TO SELECTION

MORE THAN FIVE TIMES THE NUMBER OF MEN REQUIRED

THIS MEANS THAT

SOLDIERS' RELATIVES WILL BE EXEMPTED FROM SERVICE.

WOMEN VOTERS IN CANADA.

Under the new Act the wife, widow, mother, sister or daughter of any person, male or female, living or dead, who is serving or has served Overseas in the Military Forces, HAS A VOTE IN CANADA.

WRITE AT ONCE to all your RELATIVES AND FRIENDS in Canada, telling them that

THE BOYS AT THE FRONT EXPECT <u>ALL</u> OF THEM TO VOTE FOR THE UNION GOVERNMENT.

SHOULDER TO SHOULDER SHOULD BE THEIR WATCHWORD AS WELL AS YOURS!

231

SELECTIVE DRAFT AND WOMEN VOTERS NOTICE, 1917

Canada
paper
size unavailable

This poster urges women voters to support the pro-conscription Union Government in the 1917 federal election, the first in which women were permitted to vote. But the franchise was extended only to women serving in the armed forces or with relatives who were serving or had served in the military. This restriction virtually guaranteed that they would vote overwhelmingly for the government. Prime Minister Borden won the election convincingly but, in the process, deepened the French-English divide.

GOLDEN BOY, GEORGES GAUDET, CAST IN 1918, MOUNTED ON THE MANITOBA LEGISLATIVE BUILDING IN 1919

*cast in Paris, France; mounted in
Winnipeg, Manitoba
originally cast in bronze; in the 1940s,* Golden
Boy *was painted and, in 1951, gilded with
24-karat gold
5.25 m*

French sculptor Georges Gaudet called the statue he designed to crown the Manitoba Legislative Building *Eternal Youth*. Like so many other contemporary youths, this one suffered many wartime travails. The factory in France where he was cast was bombed, but he survived unscathed. He was safely loaded aboard the *Empress of France* bound for New York, but the ship was commandeered as a troop transport and he was pressed into service as ballast. He finally reached New York at the end of the war and was shipped by train to Winnipeg. On November 21, 1919, the *Golden Boy* was finally hoisted into place atop the main dome of the new legislature, where he faces north, the symbolic direction of the province's future.

Royal North-West Mounted Police charge into a crowd of strikers in Winnipeg on Bloody Saturday, June 21, 1919

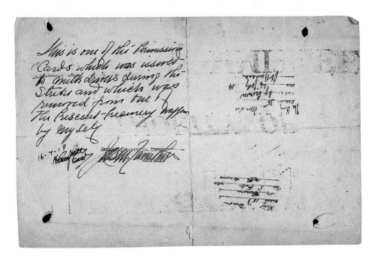

PERMISSION CARD FOR GENERAL STRIKE, 1919

Winnipeg, Manitoba
paper
20 x 32.5 cm

The 1919 Winnipeg strike so paralyzed the city that the Strike Committee took steps to make sure vital services would be maintained. This permission card, which authorized the bearer to deliver milk, was issued by the committee in cooperation with the Winnipeg City Council. The back bears the signature of J.M. Carruthers, manager of the Crescent Creamery Company. Several court stamps were added during its use as evidence in the subsequent trials of strike leaders Robert Boyd Russell and F.J. Dixon for seditious conspiracy. Also charged with seditious libel was a young Methodist minister named J. Woodsworth, who went on to become the first leader of the Cooperative Commonwealth Federation, the forerunner of the New Democratic Party.

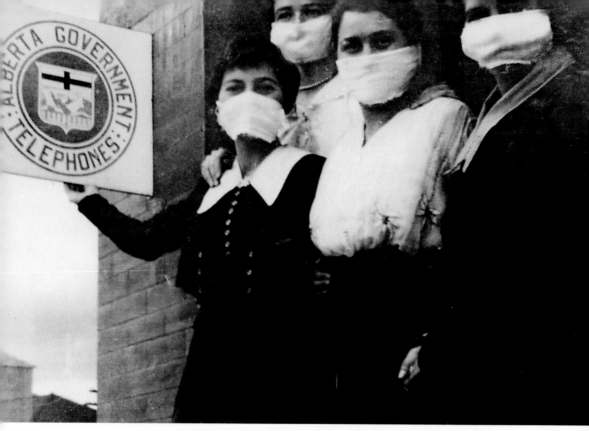

Telephone operators in High River, Alberta, wearing masks to protect them from the Spanish flu

INFLUENZA VACCINE AMPOULE AND MAILING TUBE, 1918

*Toronto, Ontario
ampoule: glass with
paper label;
mailing tube: wood, iron,
fabric
ampoule, 1.3 x 5.5 cm;
mailing tube, 2.4 x 16 cm*

This cylindrical mailing tube held a small glass container of influenza vaccine, something desperately needed during the 1918–19 Spanish influenza epidemic that ultimately killed 21 million people around the globe. Returning Canadian troops carried the virus home to even the most remote settlements. Before the epidemic had run its course, 50,000 Canadians had succumbed. Like the war in Europe, the flu hit the young and hearty the hardest, overwhelming public health measures and outpacing the production of vaccines.

EPIDEMIC INFLUENZA
(SPANISH)

This Disease is Highly Communicable.
It May Develop Into a Severe Pneumonia.

There is no medicine which will prevent it.

Keep away from public meetings, theatres and other places where crowds are assembled.

Keep the mouth and nose covered while coughing or sneezing.

When a member of the household becomes ill, place him in a room by himself.

The room should be warm, but well ventilated.

The attendant should put on a mask before entering the room of those ill of the disease.

TO MAKE A MASK

Take a piece of ordinary cheesecloth 8 x 16 inches, fold it to make it 8 x 8 inches. Next fold this to make it 8 x 4 inches. Tie cords about 10 inches long at each corner. Apply over mouth and nose as shown in the picture.

ISSUED BY THE PROVINCIAL BOARD OF HEALTH

Poster issued by Alberta's provincial board of health with information about the flu and instructions on how to make a mask

FOR WHAT?, FREDERICK HORSMAN VARLEY, 1918

France
oil on canvas
147.3 x 183 cm

F.H Varley's painting *For What?*, with its wagonload of anonymous dead, sig-
nals a sea change in the way artists depicted war. The carnage in Europe
made it impossible for an honest artist to paint pictures that glorified or
romanticized death in battle. True, some of the sixty and more artists
involved in Canada's war artist program (founded in 1916 by newspaper titan
Max Aitken, later Lord Beaverbrook, and under the aegis of the Canadian
War Records Office) produced kitschy propaganda. But many others created
paintings, drawings, and sculptures that did not shrink from the raw reality
of mass war in the age of technology. Varley returned home to become a
founding member of the Group of Seven and one of the finest portrait artists
of his generation.

Paintings from the Canadian War Memorials Fund collection went on display at the Canadian National Exhibition in Toronto, September 1919.

THE GOVERNMENT OF THE PROVINCE

PROSPERITY CERT

ONE

DATE OF ISSUE
AUGUST 5, 1936

THE PROVINCIAL TREASURER WILL
PAY TO THE BEARER THE SUM OF
ONE DOLLAR ON THE EXPIRATION
OF TWO YEARS FROM DATE OF
ISSUE HEREOF UPON PRESENTATION
HEREOF PROVIDED THERE ARE THEN
ATTACHED TO THE BACK HEREOF
ONE HUNDRED AND FOUR ONE
CENT CERTIFICATE STAMPS

ONE DOLLA

William Aberhart
PREMIER

C. Coc
PROV

WESTERN PRINTING & LITHOGRAPHING. CO. LTD. CALGARY

PROSPERITY CERTIFICATE, 1936

Alberta
paper
8 x 15.2 cm

If it hadn't been for a radio program hosted by Alberta evangelist William Aberhart, this piece of "funny money" would likely never have been issued. In the early 1930s Aberhart became converted to a fringe monetary theory propounded by an eccentric English engineer named Major C. H. Douglas. Douglas had concluded that the cause of capitalism's ills was that people simply didn't have enough money and that the answer was to print lots more and give it to them. On the coattails of this theory, "Bible Bill" Aberhart founded the Social Credit Party, which swept into office in 1935. But when he tried issuing Prosperity Certificates that could be spent as cash, Ottawa immediately declared them illegal.

Farmers's protests, like this one against war and fascism at Two Hills, Alberta, on August 5, 1934, often erupted during the Great Depression.

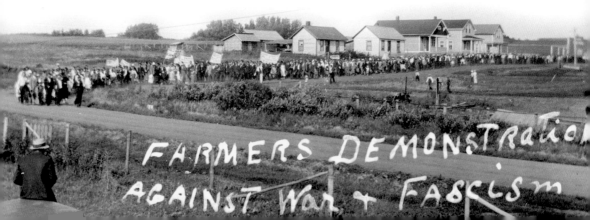

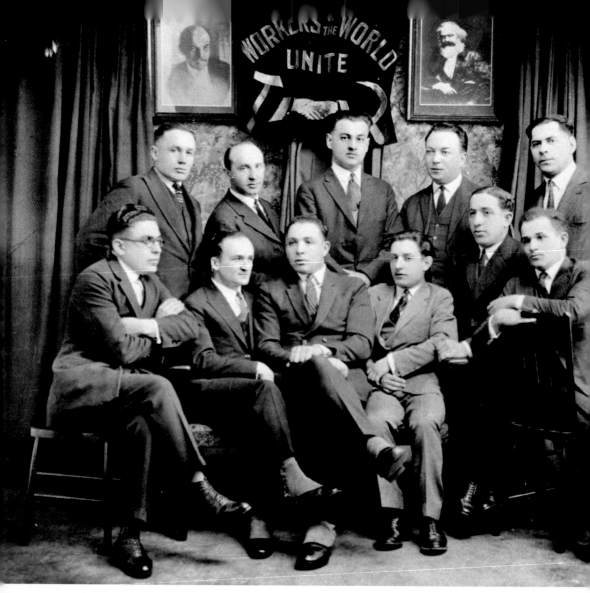

*A group of Winnipeg Communists and sympathizers poses beneath portraits of Lenin and Marx
in the late 1920s, a time when many on the left were drawn to the egalitarian ideology underlying the recent
Russian Revolution.*

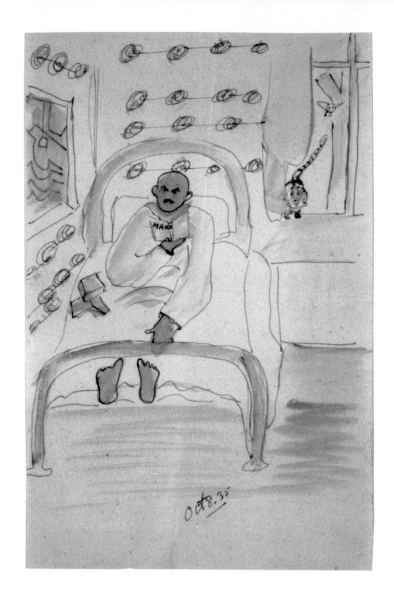

NORMAN BETHUNE SICK IN BED, NORMAN BETHUNE, 1935

Montreal, Quebec
watercolour
25.2 x 16.2 cm

Dr. Norman Bethune here portrays himself sick in bed and reading a volume entitled *Marx*, soon after the visit to the Soviet Union that convinced him to become a Communist. In 1936 Bethune travelled to Spain to assist the Communist-supported Republican forces fighting Franco's fascists in the Spanish Civil War. It was during his time in Spain that he pioneered a method of performing blood transfusions in the field, radically reducing the number of battlefield casualties that became fatalities. When Bethune wasn't off saving lives or fighting to save the world from capitalism and fascism, he indulged his interest in the visual arts, even running an art school for children out of his Montreal house.

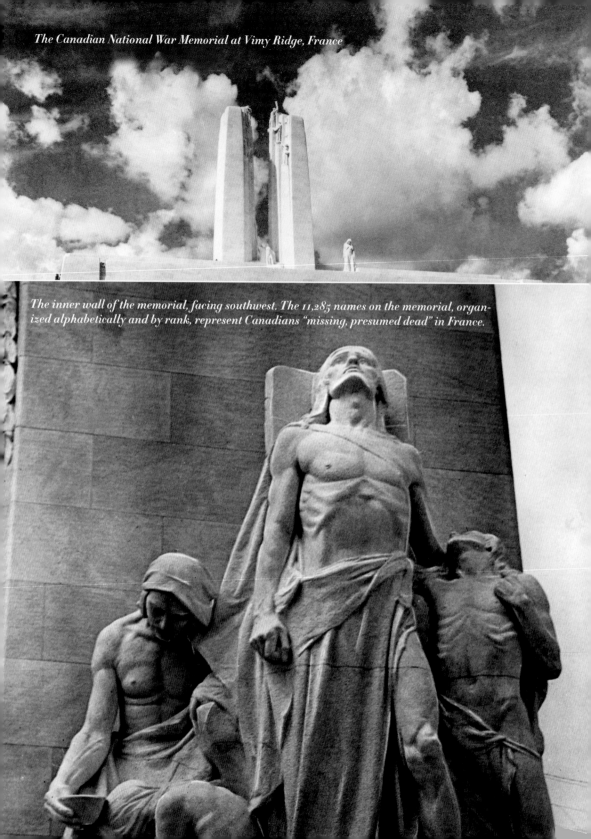

The Canadian National War Memorial at Vimy Ridge, France

The inner wall of the memorial, facing southwest. The 11,285 names on the memorial, organized alphabetically and by rank, represent Canadians "missing, presumed dead" in France.

CANADA MOURNING HER FALLEN SONS, WALTER SEYMOUR ALLWARD, 1925–36

Vimy, France
stone
approx. 5 m

One of twenty monumental statues carved by Walter Allward for his Vimy War Memorial, constructed between 1925 and 1936. The Toronto-born sculptor and architect worked on site on gigantic blocks of Croatian limestone and then directed their placement. King Edward VIII unveiled the Vimy Memorial on July 26, 1936, in one of his few appearances before his abdication.

During the 1930s Canada was in an isolationist mode, preoccupied with the social and economic disaster of the Great Depression. After Mackenzie King returned to power in October 1935 he steered a cautious course in world affairs and fully supported British prime minister Neville Chamberlain's policy of appeasement towards Hitler and a renascent Germany. When Britain finally declared war, King waited until he had Parliament's authorization before Canada followed suit – a real and symbolic act of independence. But his preoccupation for the next five years would be domestic unity, as once again the issue of conscription threatened to break the country apart.

Mackenzie King chats with a member of the Royal Canadian Horse Artillery near Surrey, England

1080

KINGSMERE,
Sunday, September 24, 1939

Slept well through the night though dreamed a good deal about the European situation. My mind is haunted with the thought of masses of men being slaughtered on the Western front.

Was up at 8.30 (Daylight saving changed at midnight). Out for a walk with Pat before breakfast. A beautiful morning.

Spent the forenoon writing Lady Minto, Lady Gladstone, and Gregory Clark, going over office papers particularly on organization of War Effort. Cleared up most material I had taken with me over the week-end.

Worked steadily till 1.30 when J. and G. arrived. J. and I walked with the little dogs across the open field. After lunch, we went for quite a long walk in the sun, first to the little cottages by the lake, then by Moorside across the Abbey Ruin to the far end of the field. Back across the fields and over the moor. Then went to bed for a good rest. Slept soundly from 4.30 till 6. We then went for another walk around by the side of the lake, and back by the road.

After dinner, spent the evening in the sitting room reading some war material. Also a few of the verses from the "Open Road".

Received today a despatch about British war plans, very serious outlook as it views possibilities of Italy and other countries entering against Britain. It is almost equivalent to Britain and France taking on most of the world except the U.S. which is out of things. Never has such an appalling situation faced mankind. I believe, however, that Britain and France will win. Two years has been the period that I have thought the war would take - those words having stood out underlined in my Bible on the morning that Britain entered the war.

After listening to the broadcast, read a little poetry before going to sleep.

DIARY, WILLIAM LYON MACKENZIE KING, ENTRY ON SUNDAY, SEPTEMBER 24, 1939

*Quebec
paper
21.5 x 18 cm*

A day seldom passed when Prime Minister Mackenzie King did not write in his diary. Here he mixes musing about the Allied prospects of winning the war with a mundane record of walks taken, visitors welcomed, and letters written. The Abbey Ruin he refers to stood in the grounds of his Gatineau retreat "Kingsmere," where he had created a series of false ruins in the English Romantic style, often using elements salvaged from torn-down Ottawa buildings. Pat is his Irish terrier; J and G are his close friends Joan Patteson and her husband, Godfroy. Gregory Clark was a beloved Canadian journalist and storyteller who served overseas as a war correspondent in the Second World War.

THE TORCH; BE YOURS TO HOLD IT HIGH!
IF YE BREAK FAITH WITH US WHO DIE
WE SHALL NOT SLEEP, THOUGH POPPIES GROW
IN FLANDERS FIELDS.
McCRAE.

GET YOUR TEETH
INTO THE
JOB

Issued by the DIRECTOR OF PUBLIC INFORMATION UNDER AUTHORITY OF HON. J. T. THORSON, MINISTER OF NATIONAL WAR SERVICES, OTTAWA. Printed in Canada, 10-41

Come on CANADA!

NEEDS
MEN LIKE YOU

ATTACK
ON ALL
FRONTS

IT'S OUR WAR

WAR POSTERS, 1939–45

paper
68.4–92 x 45.7–67 cm

"Do your part on the home front or the Western front," these posters exhort, using commercial advertising techniques from the 1920s and '30s to drive home their messages. Each poster relies on a powerful central image and a simple slogan aimed at a specific audience. They range in style from the cartoonish (a beaver gnawing down a tree Hitler has climbed) to Soviet-style social realism (the muscled arm holding a worker's hammer aloft). These images may now seem arch or obvious, but in their place and time they communicated with powerful immediacy.

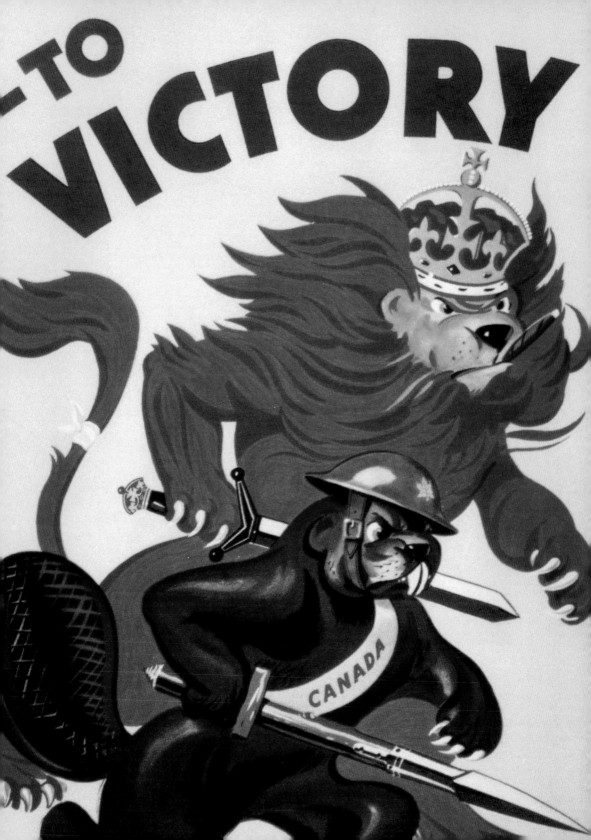

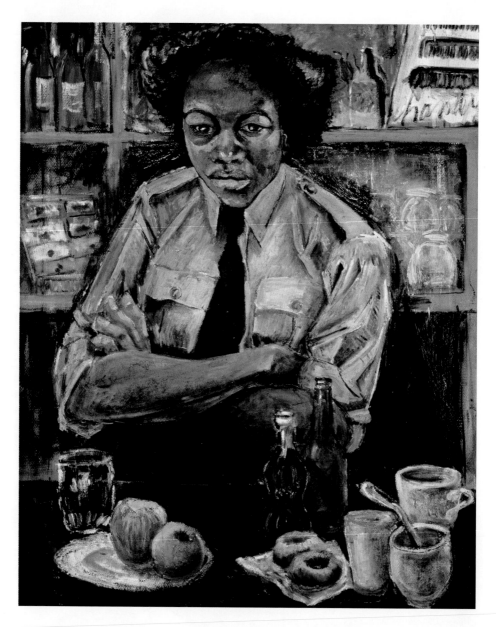

PRIVATE ROY, CANADIAN WOMEN'S ARMY CORPS, MOLLY JOAN BOBAK (NÉE LAMB), 1946

Toronto, Ontario
oil on masonite
76.4 x 60.8 cm

This uncompromising portrait, which shows the subject standing behind the counter of the Halifax canteen where she worked, is one of many executed by Molly Lamb after she joined the Canadian Women's Army Corps in 1942. It was not until the end of the war in 1945 that she was appointed an official Canadian war artist, the only woman to gain this distinction.

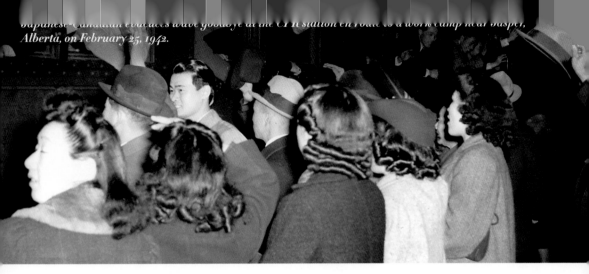

Japanese-Canadian evacuees wave goodbye at the CPR station en route to a work camp near Jasper, Alberta, on February 25, 1942.

DOLLS, APPROX. 1940

Japan
clay, wood,
fibre (possibly silk),
fur (possibly rabbit)
approx. 18 x 45 cm

The original owner of these four porcelain dolls was one of 21,000 or more Japanese-Canadians forced from their West Coast homes and evacuated to detention camps in the BC interior and in Alberta in the spring of 1942. The dolls were purchased at an auction of household items that spring by Charles Gowe, whose daughter remembered playing with them as a little girl. Unlike such portable personal possessions, Japanese-Canadian property – including land, houses, fishing boats – was confiscated by the federal government and later sold at knockdown prices. The dolls were donated to the Japanese Canadian National Museum in 1999.

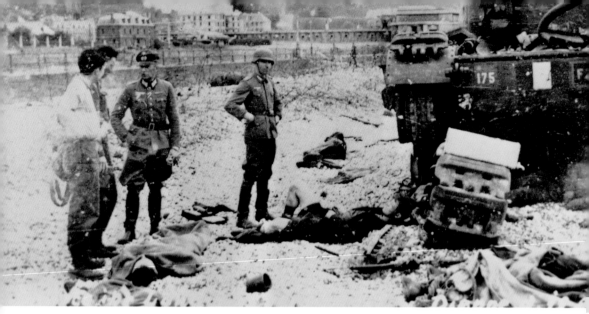

German officers on a Dieppe Beach littered with dead and wounded Canadians

NEW TESTAMENT, APPROX. 1940

used in Dieppe, France, and German prisoner-of-war camps leather cover and paper pages approx. 13 x 10 x 1.3 cm

Honorary Captain John Foote carried this copy of the New Testament when he landed at Dieppe with the Royal Hamilton Light Infantry on August 19, 1942. Under heavy German fire, the Protestant regimental chaplain gave first aid and spiritual comfort to the wounded and carried as many as he could to the regimental aid post. When the landing turned into a bloody retreat, he helped wounded men into landing craft but refused to leave those who remained on the beach. He spent the next three years in German prisoner-of-war camps. For his bravery, Foote was awarded the Victoria Cross, making him the only chaplain in the Canadian forces to be so honoured.

CHIESA DI SAN TOMASSO, CHARLES FRASER COMFORT, 1944

Ortona, Italy
watercolour
38.1 x 54.7 cm

As this painting of a bombed church by war artist Charles Comfort suggests, the Battle of Ortona was one of the bloodiest of the Allied advance through Italy. It was also one of the most pointless. The British commanding general, Bernard Montgomery, ordered the 1st Canadian Division to capture the virtually impregnable medieval seaport situated atop a rocky promontory. The Canadians took the town, which could easily have been bypassed, at the enormous cost of 1,372 dead.

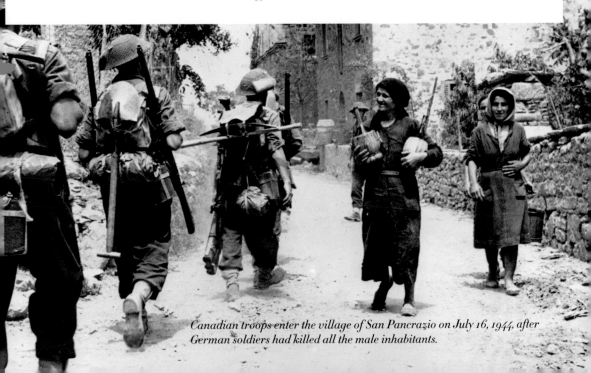

Canadian troops enter the village of San Pancrazio on July 16, 1944, after German soldiers had killed all the male inhabitants.

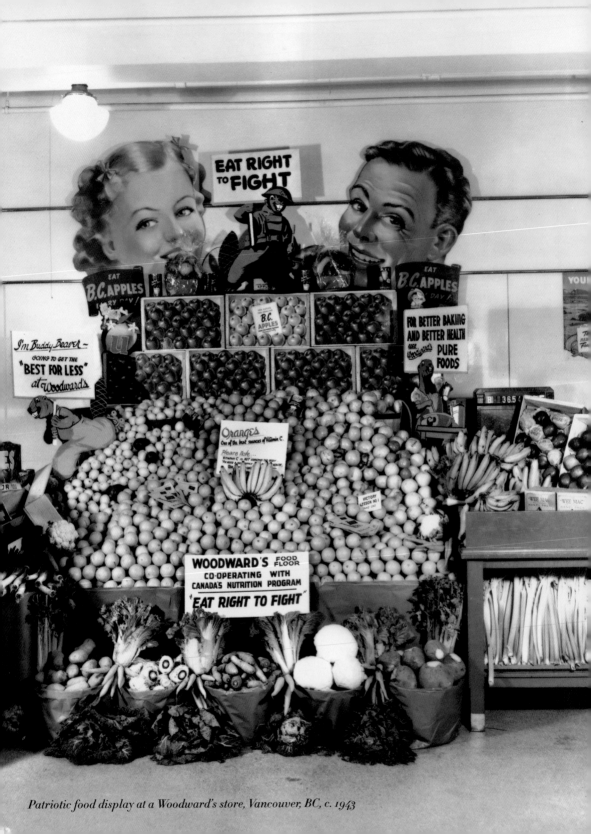

Patriotic food display at a Woodward's store, Vancouver, BC, c. 1943

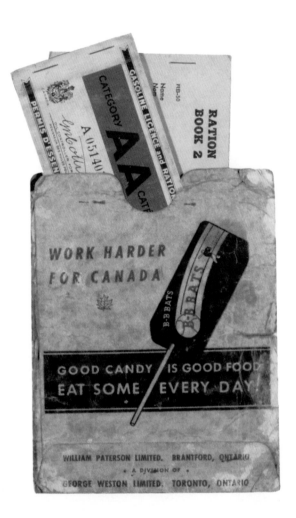

RATION BOOKLET HOLDER, 1939–1945

Brantford, Ontario
paper
size unavailable

This convenient cardboard folder, which helpfully reminds us that "Good Candy Is Good Food," holds both a gas-rationing booklet and a food-rationing booklet. To control wartime inflation and to allocate scarce resources fairly, the federal government established the Wartime Prices and Trade Board. Meat, butter, oil, and gas were all rationed. There was some black-market activity, but most people took rationing very seriously, and compliance was high.

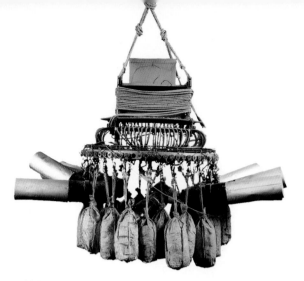

*made in Japan; found in
Minton, Saskatchewan
mulberry paper, inflated with hydrogen,
paper bags filled with sand, steel, wood,
rubber, fibre
80 x 120 cm*

*Opposite: D-Day view looking east along
"Nan White" Beach near Bernières-sur-Mer,
France, as personnel of the 9th Canadian
Infantry Brigade land from LCI(L) 299 of the
2nd Canadian (262nd RN) flotilla*

The Japanese launched thousands of balloons carrying bombs
like this one against the Pacific coast of North America in
1944–45, but no more than a hundred reached land. Packed
with incendiary explosives that were intended to trigger fires
in the forests of British Columbia, Oregon, and Washington
state, few did more than amuse the locals, and none managed
to set a fire. Like the Japanese balloon bombs, the threat
posed to Canada's west coast by the Japanese Empire was
more apparent than real. Apart from a single incident on June
20, 1942, when a submarine of the Imperial Japanese Navy
bombarded the coast of Vancouver Island to no measurable
effect, the closest the war in the Pacific came to Canadian soil
was the distant Aleutian Islands of Alaska.

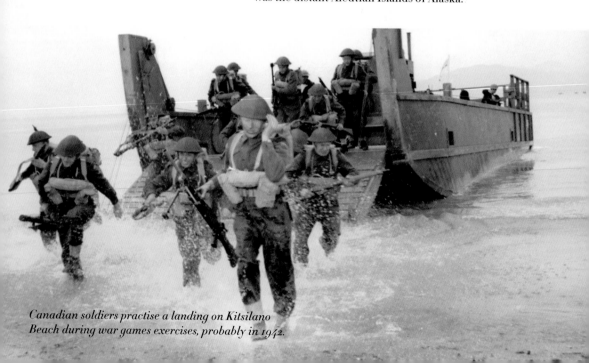

*Canadian soldiers practise a landing on Kitsilano
Beach during war games exercises, probably in 1942.*

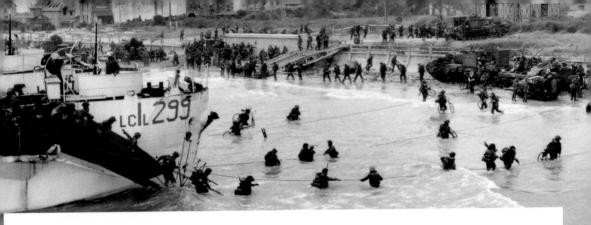

DUMMY PARATROOPER, APPROX. 1944

probably made in England
canvas filled with sand
approx. 90 cm

This dummy, popularly known as a Rupert, was one of hundreds that were dropped over Normandy in the early hours of June 6, 1944, just in advance of the first D-Day landings. Each Rupert was equipped with a gunfire simulator that went off with a bang as it hit the ground. The sight of hundreds of these figures floating down in the darkness, and the constant "bang, bang, bang" as they landed, must have been quite convincing. Thousands of real paratroopers also jumped that night, among them the several hundred members of the 1st Canadian Parachute Battalion as part of Britain's 6th Airborne Division.

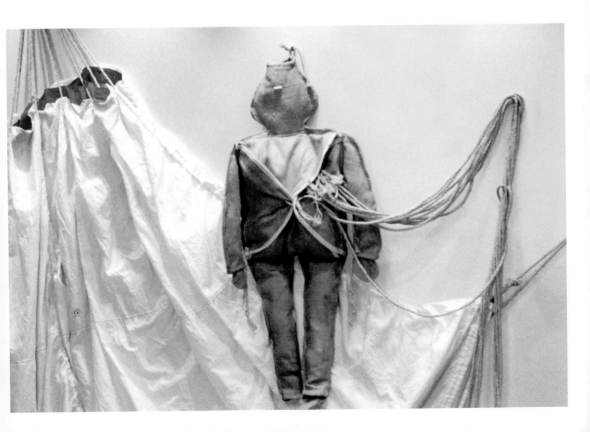

MUG SHOT OF KURT MEYER, 1945

*Dorchester, NB
photograph
size unavailable*

This is how SS Brigadeführer Kurt Meyer, a former commander in
the Waffen SS's 12th "Hitler Youth" Division, appeared at the time
of his admission to New Brunswick's Dorchester Penitentiary in
1945. After the D-Day landings in Normandy in June 1944, Meyer's
men murdered 156 Canadians captured in the fighting. At his trial
Meyer tried to blame a subordinate, but he was found guilty of
"denying quarter" to Allied soldiers and sentenced to be hanged.
While at Dorchester awaiting execution, his sentence was com-
muted to life imprisonment. He was later transferred to a prison in
West Germany, from which he was released in poor health in 1956.

DORCHESTER

ORPHAN TAG, 1948

Halifax, NS
paper
approx. 12.1 x 6 cm

This tag was issued to an orphaned Jewish child on his arrival at Halifax's Pier 21. Most of these child refugees were survivors of the concentration camps who had lost both parents and all their siblings. Few spoke any English, making an identity tag a practical necessity. They were among the earliest and most poignant members of a vast wave of displaced people, or DPs as they were sometimes unkindly called, who poured into Canada from the shattered countries of Europe.

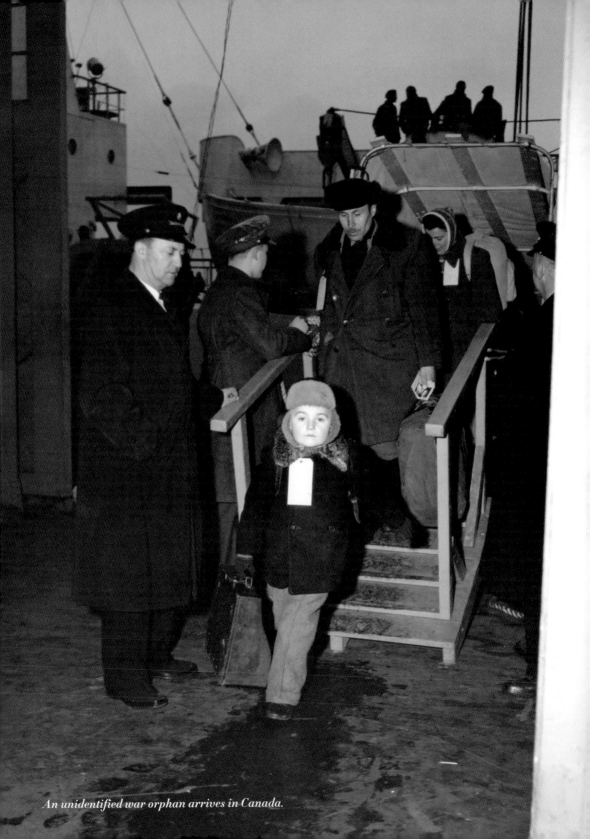

An unidentified war orphan arrives in Canada.

BETTER LIVING ROOM
1945 to 1959

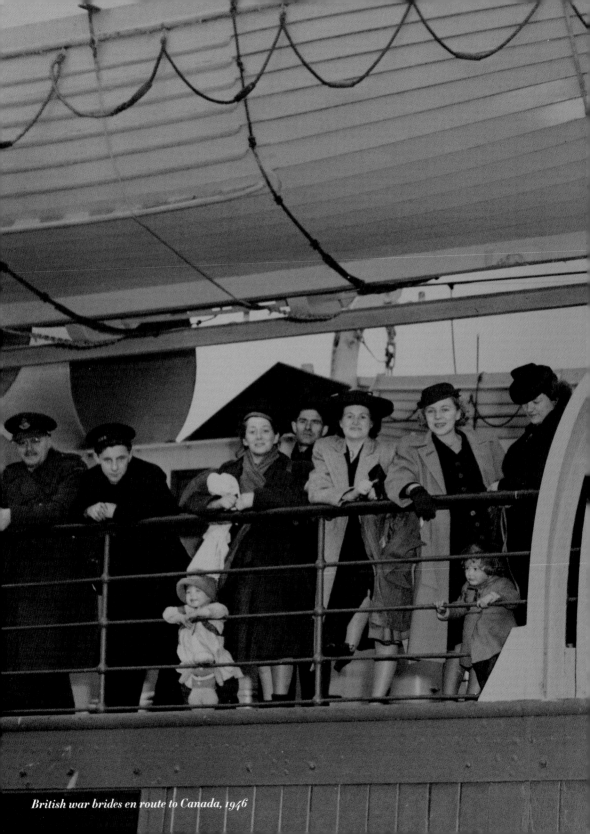

British war brides en route to Canada, 1946

The Second World War ended in triumph and uncertainty. The atomic bomb, the most powerful weapon ever created, cast a shadow over the ensuing peace; returning soldiers worried, as had their fathers and grandfathers at the close of the First World War, whether there would be any jobs for them when they got home. As it turned out, Canada was on the brink of an explosion in population and prosperity like none before in its history, a period of optimism that even the Cold War couldn't restrain. And society, starting with its basic unit, the family, was changing in ways only dimly understood. But there was money to spend – lots of it – and an exponentially increasing number of things to spend it on.

A BETTER CANADA

TO FIGHT FOR

TO WORK FOR

TO VOTE FOR

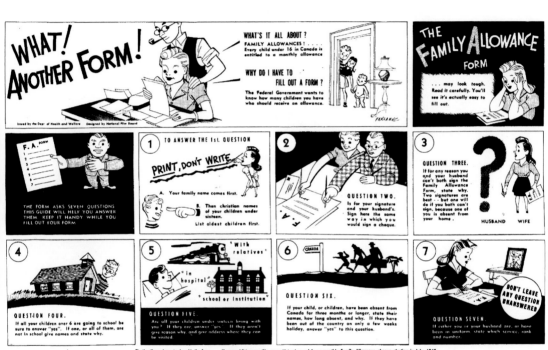

FAMILY ALLOWANCE ADVERTISEMENT, DESIGNED BY THE NATIONAL FILM BOARD, 1945

Ottawa,
Department of Health and Welfare
paper
size unavailable

The baby bonus – here explained with cartoon simplicity by artists from the National Film Board – was a state-sponsored post-war social program introduced to forestall a possible recession and to counter the growing strength of the political left. In a 1943 opinion poll, the socialist CCF had edged out the governing Liberals for first place, prompting Mackenzie King to appoint the Committee on Reconstruction, whose recommendations laid the groundwork for the Canadian welfare state. The recession didn't materialize, while the baby bonus – officially known as the Family Allowance – added impetus to the beginning of the post-war boom.

CARTOON, VIC HERMAN, SEPTEMBER 15, 1945

Toronto, Ontario
paper
11.5 x 14 cm

Despite economic expansion, most women gave up the jobs they'd held in wartime to return to domestic life. But an underlying social psychology had changed. This September 1945 *Maclean's* cartoon pokes fun at male anxiety about women taking on traditional male roles. In the short term, the guys needn't have worried. The iconic feminine image of the 1950s was of the perfect wife and mother living in the perfect suburban house with two perfect children. But the wishful image disguised a far more complicated reality.

1

2

1 CHAIR, DESIGNED BY JAMES DONAHUE
AND DOUGLAS SIMPSON, 1946

Ottawa, Ontario
moulded fiberglass
size unavailable

2 DINING CHAIR, DESIGNED BY WACLAW
CZERWINSKI AND HILARY STYKOLT, 1946

Stratford, Ontario
moulded plywood, bent laminated wood
84.7 x 41.2 x 83.2 cm

Even furniture started to look different after the war – and only partly because of the rapid technologi-
cal advances the war had wrought. Both these elegant, curvilinear chairs employed materials already
used in manufacturing military aircraft: new plastics and glues and new ways of working with moulded
plywood. The plywood veneer used to make this dining chair had earlier made possible the develop-
ment of the fast and nimble Mosquito bomber. New materials, combined with assembly-line tech-
niques, helped usher in the ultra-modern style we associate with the fifties.

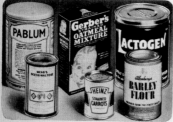

FOR YOUR BABY'S HEALTH AND COMFORT

FOR THE HAIR

(1) NESTLE'S BABY HAIR TREATMENT—"Curls for your baby" for those special occasions when photographs are taken,—memories you will cherish in years to come. A safe preparation, this treatment is harmless to baby's tender scalp. Simply dissolve in warm water and apply with a light, circular, upward motion.
112-390. 2-oz. bottle ... 1.25

(2) PLASTIC FINE COMBS.
112-308. Price.... 2 for 15c
112-395. Hard Rubber Fine Comb. 4-inch. Price... 29c
CUPREX (not shown). To remove head lice and nits.
12-322. Price, 2-oz....... 35c

(3) JOHNSON'S SEVEN-PIECE SET. A splendid combination set for the young arrival. Consists of two tins baby powder, 2 cakes baby soap, and one each oil, cream, and lotion.
112-391. Price, set, delivered... 2.95

(4) BABY'S OWN 3-Piece Set—Includes one cake of Baby's Own soap, talcum powder and small bottle of baby oil. A popular set at a reasonable price.
112-375. Three-piece set in box... 1.95

(5) BRUSH AND COMB SET, for baby. Comes in daintily decorated box. Brush has soft nylon bristles and sparkling plastic back. Complete with plastic comb to match.
112-387. Price, per set...... 1.00

(6) ELECTRIC BOTTLE WARMER—an improved bottle warmer made of Plastic. A great convenience for the mother of a young baby. Complete with cord.
112-319. Price, delivered... 4.25

(7) JOHNSON'S BABYLAND BOX. Contains 2 cakes baby soap and one each powder, oil, and cream. Attractively boxed for gift giving.
112-396. Price, complete..... 1.95

(8) BABY'S OWN 4-Piece Set—A bottle of baby oil, sifter tin of powder and two cakes of Baby's Own soap in attractive acetate-covered box. Would make a very acceptable gift.
112-376. Price....... 1.50

MENNEN ANTISEPTIC BABY OIL. To protect against irritation.
112-379. Per bottle, 5-oz.......... 59c

Z.B.T. A baby powder with olive oil.
12-380. 5½-oz. size........ 28c
112-381. 12-oz. size....... 55c

JOHNSON'S BABY POWDER.
112-384. 4-oz. tin. Price........ 28c
112-385. Large tin, 9¾ oz. Price 55c

JOHNSON'S BABY LOTION. For cleansing, lubricating and protecting baby's skin.
112-386. Price, 6-oz. bottle........ 60c

JOHNSON'S BABY CREAM.
112-382. Price....... 55c

JOHNSON'S BABY OIL.
112-383. Price, per 6-oz. bottle... 60c

TWIN TIPS—Cotton tipped Applicator Sticks for cleaning baby's ears, nose, etc.
12-293. Box of 102 tips. Price... 25c
12-294. Box of 216 tips. Price... 50c

"COTTON PICKER" Absorbent Cotton in a convenient container that mother will find very handy when attending to baby's needs.
12-295. Price................ 40c

BABY'S OWN SOAP. A very mild soap specially made for baby's tender skin.
112-377. Price.......... 2 cakes 25c

BABY'S OWN OIL. For the care of baby's tender skin.
112-378. 5-oz. bottle........ 59c

POPULAR AND RELIABLE BABY FOODS

MEAD'S DEXTRI-MALTOSE. A very nourishing baby food, highly regarded as a body builder. Note that Dextri-Maltose is prepared with and without salt added. About 1-lb. tin.
12-284. No. 1. Salt added. Price 65c
12-285. No. 2. No salt. Price... 65c

PABLUM—Pre-cooked and dried cereal for babies. Pablum has a good reputation as a baby food. Easily prepared.
12-290. Price, about 18-oz. pkg.... 45c

GERBER'S STRAINED OATMEAL Mixture. A nutritious food, completely cooked, dried and flaked. Just add milk to serve. A splendid food for many children.
12-291. Price, 8-oz. box 24c

GERBER'S CEREAL FOOD (not illustrated). Another nutritious food for baby. Strained and ready to serve.
12-292. Price, 8-oz. box........ 24c

HEINZ BABY FOODS—Selected meats and vegetables prepared and strained to make very nourishing meals for baby.
12-286. Beef and Liver Soup.
12-287. Vegetable Soup.
12-288. Carrots.
12-289. Vegetables and Lamb.
12-290. Chicken with Vegetables and Farina. Price......... 3 tins for 25c

ALLENBURY'S BARLEY FLOUR. For mixing baby's formula. This barley flour is prepared from fine barley and adds a nourishing, easily digestible element to baby's bottle.
12-283. Price, per 16-oz. package. 45c

LACTOGEN—modified cow's milk—Nestlé product highly recommended.
12-281. 1-lb. tin. Price........ 79c
12-282. 2½ lbs. Price........ 1.79

(9) A DE LUXE NURSING UNIT with new style large mouth bottle. Nipple can be inverted in bottle for easier carrying.
12-272. Nursing Unit, complete 35c
12-273. Nipple only. Price..... 15c
12-274. Cap and sealing disc. 15c
12-275. Bottle (8-oz.) only.... 15c

(10) OVAL FEEDER. Easy to clean.
12-305. Price........ 2 for 15c

(11) PYREX NURSER. Graduated.
12-306. Price 25c; 6 for 1.45

(12) GLASS FUNNEL.
12-307. Price.......... 25c

(13) NU-FORMULA NIPPLES. Two tabs to aid in putting nipple on bottle.
12-315. Price........... 3 for 25c

(14) TRANSPARENT NIPPLES.
12-317. Price........ 5 for 25c

BLACK BAND NIPPLES.
12-314. (Not shown).... 4 for 23c
REGO IMPROVED NIPPLES.
12-316. (Not shown).... 3 for 25c

(15) RUBBER BOTTLE CAP—fits securely on small necked bottle.
12-313. Price........ 3 for 25c

(16) GLASS BOTTLE CAP—Fits over nipple.
12-308. Each....... 10c; 3 for 25c

(17) CAMPHORATED OIL to help relieve congestion.
12-298. 4-oz. bottle. Price.... 24c

(18) CASTORIA—For constipation in infants and children.
12-297. About 2 ozs. Price.... 33c
12-309. Family size, 5 ozs..... 69c

(19) SUPPOSITORIES—Glycerin Suppositories to help relieve constipation. Infant size.
12-296. Price, 12 in bottle... 35c

(20) WHITE VASELINE.
12-392. 1¾-oz. tin. Price....... 20c
12-393. 4-oz. jar. Price....... 30c
12-394. Yellow Vaseline.
12-294. Price............. 20c

MILLER'S WORM POWDERS.
12-301. Price, 12 in box. 49c

(22) STEEDMAN'S SOOTHING POWDERS.
12-299. Price.......... 25c

(23) BABY'S OWN TABLETS.
12-300. About 35 in box. 23c

(24) BREAST PUMP—Shaped glass to fit the breast. Rubber bulb.
12-312. Price.......... 75c

(25) BABY MILK THERMOMETER to help get baby's milk at right temperature.
12-304. Price.......... 85c

(26) BABY HOT WATER BOTTLE.
12-320. Price, each...... 85c

(27) BOTTLE BRUSH, nylon bristle.
12-318. Price........... 35c
12-323. BOTTLE BRUSH. White bristles, tufted end. Price 2 for 29c

(28) "REGO" PRETTY LIP SOOTHER.
12-310. Price.......... 15c
BORACIC ACID (not shown).
12-302. 3¼ 0z. Price........ 10c
12-303. 16 ozs. Price........ 25c

PAGE FROM CATALOGUE, T. EATON COMPANY, FALL/WINTER 1948-49

Toronto, Ontario
paper
25.4 x 35 x 2.5 cm

By the year of this Eaton's ad, marketing mavens had already caught on to the demographic and cultural shift caused by the post-war baby boom and the accompanying economic upsurge. For the first time in history, child-rearing was to be treated as a scientific activity. Pablum and the impressive array of products on offer here, ranging from Q-tips to breast pumps, represented this new methodical approach.

The Bland Feeding the Bland
Pablum, Boomers, and the Consumer Society

New mothers in the 1950s faced a dazzling choice of baby foods. But the most popular product was that jar you can see on the lower left-hand side of this full page from the Eaton's catalogue and in close-up below: Pablum. Today's parent would give the package barely a second glance. It looks more like a jar of Metamucil than of baby food: it displays no smiling infants, no pretty pastel colours, no famous cartoon characters, and the language of its labelling is scientific rather than seductive. "Requires no cooking: Add milk or water, hot or cold. Serve with milk or cream." In the foodie world of the twenty-first century, new mothers expect something a little tastier – added bananas, for instance, or a dab of apricot purée. I recall my own children's expressions of disgust when first presented with spoonfuls of stone-cold mush tasting of soggy paper.

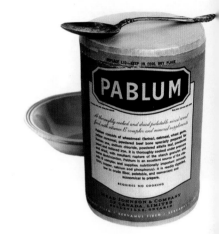

Can of Pablum, 1938

Yet Pablum stands for two important aspects of the years immediately following the Second World War: babies and blandness. When the boys came marching home, the birth rate soared and, partly thanks to Pablum, these boom babies thrived. And the name of the cereal quickly became synonymous with the way we look back at the fifties today: colourless, tasteless, or, in a word, "bland."

Pablum wasn't invented in the 1950s; it just came into its own in that much-maligned decade. It had been developed two decades earlier by Dr. Fred Tisdall and a team of researchers at Toronto's Hospital for Sick Children, scientists who knew that too many infants were dying, often as a result of malnutrition or intestinal-tract diseases due to inadequate diet (around one in six during the

A couple "relaxing" before the fire with their two children, Lethbridge, Alberta, 1945

1920s). Typically they were fed starchy, over-processed cereal from which all the bran and germ had been removed to prevent digestive problems. Tisdall and company found a way to produce the perfect infant cereal: something easily digested, containing all the calories required by growing babies, plus the necessary minerals such as iron, copper, and calcium, and Vitamins A, B_1, B_2, D, and E – and a product that would keep indefinitely. When Tisdall announced this nutritional breakthrough, he noted it was achieved from a process of grinding and thoroughly drying a mixture of grains at a high temperature for thirty minutes – one that "reduces the moisture and destroys the insect eggs which are present in all grains."

The invention – Tisdall named it Pablum from *pabulum*, Latin for "food" – was a flaky grey powder consisting of wheatmeal, oatmeal, cornmeal, wheat germ, bone meal, dried brewers' yeast, and alfalfa. The hospital took out a

patent, then granted the U.S. pharmaceutical company Mead Johnson the exclusive right to manufacture and market Pablum for twenty-five years. In return, Mead Johnson agreed to pay Sick Kids a royalty for every box sold. The pharmaceutical company made a killing, and the payoff for the hospital was twofold: not just a research-funding bonanza but also a gratifying drop in infant mortality figures. Not until the end of the Second World War, however, did this drop coincide with a dramatic jump in the birth rate to produce the baby boom. By 1959 three babies were being born for every two born twenty years earlier, and many more of them were surviving infancy.

The baby boom helped set in motion an enduring societal trend: the rise of consumerism. What Canadians thought they wanted, and what the media told them was desirable, was a new suburban tract house with a teeter-totter in the backyard and a brand-new station wagon in the driveway. Children were integral to this post-war fantasy of the nuclear family, which was centred on a wife whose main role in life was as a child bearer and nurturer busy spooning Pablum into her babies and ensuring that, by the time her husband stepped through the front door each evening, the house was spotless and dinner was on the table. The government in Ottawa encouraged the dream. Family allowance cheques gave mothers their "own" money: at $5 per infant, the baby bonus was the equivalent of an extra week's wages each month for a family of four or five.

Babies meant business in all kinds of ways. Women came under intense pressure from manufacturers to buy, say, gleaming chromium-trimmed washing machines for laundering all those diapers, at the same time saving themselves from the red hands, aching backs, and wet floors that their own mothers had known in the Dirty Thirties. By the end of the 1950s, the list of labour-saving innovations that homemakers took for granted was dizzying: drip-dry shirts, contoured bedsheets, aerosol cans, TV dinners, automatic washers and dryers, eye-level ovens, instant cake mixes – and a cornucopia of baby foods. Their apple-cheeked offspring proved eager consumers too. They begged for

Suburban tract houses, Richmond, BC

the toys advertised on the new medium of television: Meccano, Lincoln Logs, Princess Dolls, the list went on and on.

But the suburbs, it turned out, were no Eden – certainly not for women. In 1963 the American author Betty Friedan published *The Feminine Mystique*, in which she argued that the "comfortable concentration camp" that was suburban domestic life was turning women into "anonymous biological robots in a docile mass." In Friedan's view, suburban homemakers might look happy, but in private they were weeping over their angel cakes and gulping tranquilizers. Soon the Friedan polemic had become the new feminist orthodoxy, and the fifties lifestyle was derided as being as bland and dull as, of course, Pablum. Women were encouraged to develop their identities as career women, rather than as wives and mothers and homemakers. The Women's Movement was born.

The Feminine Mystique now seems curiously dated: nobody writes polemics deriding child-bearing any longer. Pablum, however, is timeless. The dazzling array of infant cereals on today's supermarket shelves, despite their glitzy packaging and nutritional boasts, are all still made of essentially the same mush that Dr. Tisdall first introduced in the 1930s and that helped make possible the baby explosion of the 1950s. As for the word Pablum, it is now a permanent part of our vocabulary.

Residents of Chicoutimi, Quebec in 1949. With the baby boom underway and a thriving economy, the fifties would bring both more leisure time, and the phenomenon of suburban sprawl.

I

1 *SUNRIDGE/GEESE IN FLIGHT* TEXTILE, DESIGNED BY THOR HANSEN, APPORX. 1950s

A.B. Caya, Kitchener; screen-printed by Montreal Fast Print, Montreal
viscose
108 cm, repeat 56 cm

2 *PERSONALITY*, MODEL 501, RADIO, 1948

Welland, Ontario
compression-moulded Plaskon, ureaformaldehyde
22.8 x 15.2 x 12.7 cm

3 DRIP COFFEE POT, DESIGNED BY JACK LUCK, 1949

Toronto, Ontario
spun aluminum, Bakelite
24 x 14 cm

More money and bigger living spaces meant a skyrocketing demand for domestic things, both useful and decorative. Radio had been around for years, but now radios came in decorator colours and, in the case of this Personality model from Westinghouse, ten different shades (its design also permits it to be laid on any of its surfaces except the front). Lightweight aluminum became the material of choice for cookware like this coffee pot, whose twin handles were made of durable Bakelite, an early wonder material soon to be superseded by plastic. Textiles also got a 1950s makeover, as in this very Canadian design by Danish émigré Thor Hansen.

Woman on an air-form lounge designed by the BC firm of Morrison-Bush, 1950

2

3

VIKING CONSOLE, ELECTROHOME 1952

Kitchener, Waterloo
wood and glass
91 x 60 x 56 cm;
screen, 43 cm

This handsome console television set is a forerunner of the early twentieth-century home entertainment system. As well as a 17-inch television, it includes an AM radio and a record player. The year this model reached the market, Canada's first two television stations hit the airwaves (in Toronto and Montreal). The first image broadcast was a test pattern (upside-down) and reached only a few hundred viewers. The first human to appear was Percy Saltzman, with a weather report. Pundits predicted the medium would never take hold. Yet by the end of 1952 there were 225,000 Canadian homes with a television and, a mere two years later, Canadians owned a million TV sets. The choreography of family life had irrevocably changed.

A fashion show being televised from CBC Toronto, 1952

MAURICE "ROCKET" RICHARD JERSEY, 1959

Montreal, Quebec
wool, fibre
86 x 88 x 40.5 cm

Rocket Richard, like television, was a fundamental component of Canadian popular identity in the fifties. From the time he broke in with the Montreal Canadiens in the early 1940s, the intense right-winger was a top scorer and crowd pleaser. From the moment the first hockey game was telecast in 1952 – the Canadiens playing the Detroit Red Wings at the Forum in Montreal – Richard's popularity skyrocketed. When he was banned for fighting near the end of the 1954–55 season, fans rioted at the Montreal Forum. He returned to help the Canadiens clinch five consecutive Stanley Cups before retiring in 1960. This sweater, bearing Richard's number 9, is less a valuable collector's item than the relic of a saint.

Montreal Canadiens stars Maurice "Rocket" Richard, Richard "Digger Dickie" Moore, and the Rocket's younger brother, Henri "Pocket Rocket" Richard

D.H. COPP HOUSE, DESIGNED BY RON THOM OF SHARP AND THOMPSON, BERWICK, PRATT, 1951

Vancouver, BC
wood, glass, brick and
other materials
size unavailable

Located on a hillside overlooking Vancouver's Spanish Banks, Ron Thom's design for the D.H. Copp house epitomizes what came to be called West Coast Style, a landscape-friendly architecture inspired in part by the work of Frank Lloyd Wright. Thom was just one of a number of young Vancouver architects, Arthur Erickson being another, who introduced the principles of Modernism to Canadian home design. Canada's post-war suburbs filled up with pallid split-level flagstone imitations of their ideas (a sort of debased Modernism lent itself well to mass production), but the original work these men did, particularly in Vancouver in the 1950s, still remains fresh.

CONVERSATIONS BETWEEN CLOWNS, HAROLD TOWN, 1953

Toronto, Ontario
oil on board
76.2 x 119.4 cm

This painting by Harold Town reminds us that the 1950s in Canada weren't all family values and bland subdivisions. Town was one of a group of Toronto artists known as Painters Eleven. Seven of them had met when their paintings were used in an exhibition at Toronto's downtown Simpsons department store. With the addition of four new members they began holding group shows of their own in early 1954. Showcasing what was then the last word in abstract expressionism, their exhibitions generated some curiosity, a little hostility, but no sales. That began to change as critics, particularly foreign critics such as Sir Herbert Read and Clement Greenberg, began to praise their work. In addition to Town, the group included such notable painters as William Ronald, Kazuo Nakamura, and Jack Bush.

ADVERTISEMENT IN *CHATELAINE* MAGAZINE FOR CLOTHES WASHER AND DRYER,
CANADIAN WESTINGHOUSE COMPANY LIMITED, JANUARY 1953

*published in Toronto,
Ontario;
Westinghouse Company
Limited situated in
Hamilton, Ontario
paper
30 x 23.5 cm*

Of all the labour-saving devices that lightened a woman's domestic load in
the 1950s, the washer/dryer was possibly the most liberating. A task that for-
merly occupied many hours of every week now took an hour or two. It
wasn't that the technology was new in the 1950s – automatic washers and
dryers had been around since well before the war – but that it achieved
unprecedented levels of efficiency, affordability, and stylishness. Ironically,
the automatic washer/spinner/dryer ghettoized laundry as women's work,
but it also saved time. And time saved was time gained for other activities –
which inevitably came to include more education and more possibilities
outside the home.

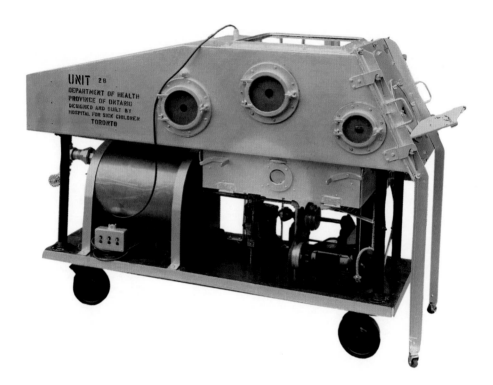

IRON LUNG, MADE 1937, USED UNTIL MID-1950s

Toronto, Ontario
steel and other materials
approx. 215 cm

This sinister-looking contraption was one of the iron lungs fabricated at Toronto's Hospital for Sick Children and used during the polio epidemic of 1953. Polio, a virus that attacks the nervous system and left some victims unable to breathe, had been a fact of life in Canada since the late 1920s. Children were especially vulnerable, and the iron lung was designed to do their breathing for them – forcing air in and out of their bodies until they were strong enough to breathe on their own again. Happily, while the 1953 epidemic ravaged Canada, scientists at Toronto's Connaught Laboratories helped develop a clinically viable version of the new "Salk vaccine," named for its American inventor, Jonas Salk. Soon millions were immunized with vaccine and it seemed that polio had been eradicated forever.

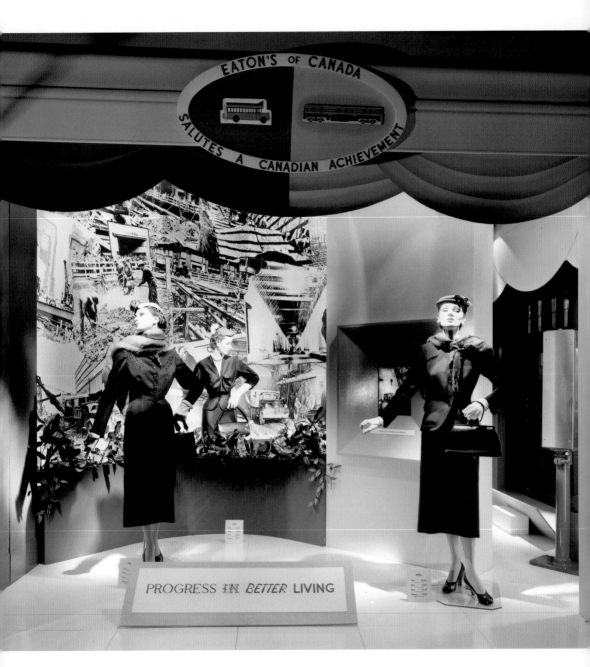

Eaton's celebrated the opening of the new subway with this window display chronicling the five years it took to build it.

IMPORTANT FACTS ABOUT CANADA'S FIRST SUBWAY

The Toronto Subway is 4.6 miles in length and has been constructed at a total cost of $50,500,000.00. The cost is better understood when one realizes the vast amounts of material which were required, and a summary of the more important items and quantities involved is set out below:—

Structural Steel	10,000 Tons
Reinforcing Steel	14,000 Tons
Rail Steel	4,200 Tons
Cast Iron Pipe	420 Tons
Cement	1,400,000 Bags
Sand (Concrete)	170,000 Tons
Gravel (Concrete)	240,000 Tons
Lumber	15,000,000 B. Ft.
Excavation	1,710,000 C. Yds.

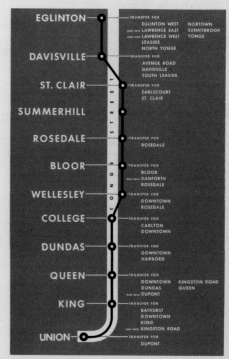

"IMPORTANT FACTS ABOUT CANADA'S FIRST SUBWAY" FROM *CANADA'S FIRST SUBWAY: A CAVALCADE OF PROGESS*, TORONTO TRANSIT COMMISSION, 1954

Toronto, Ontario
paper
15.2 x 8.8 cm

This map detailing the route of Toronto's new subway appeared in a helpful little guide put out by the Toronto Transit Commission. As post-war traffic grew on Yonge Street, the city's main artery, Toronto began working on plans for a subway that would carry people into the heart of downtown. Construction started in 1949, and Canada's first subway opened for business on March 30, 1954. The original adult fare was ten cents.

MV 8-5 PROVINCE OF NOVA SCOTIA

1955 OPERATORS LICENSE 1955
THIS LICENSE EXPIRES AT THE END OF THE REGISTRATION YEAR

The within named person is authorized to operate a Motor
Vehicle, otherwise than as a Chauffeur under the pro-
visions of the "Motor Vehicle Act."

Department of Highways and Public Works

IVAN COTTMAN SMITH JR.,
114 CAMBRIDGE ST. HALIFAX N.S.

NUMBER
32734

M.C.

8 308109

P.S.

THIS LICENSE NOT EFFECTIVE UNTIL THE ABOVE
NAMED PERSON HAS SIGNED ON THE REVERSE SIDE

MAY-19-55 2 0 7 5 8 F — 0PT 1.50

OPERATOR'S LICENCE, IVAN COTTMAN SMITH JR., 1955

Halifax, NS
paper
13.9 x 8.8 cm

By the mid-1950s a driver's licence was a badge of adulthood. For an adult it was a symbol of upward mobility and unprecedented freedom. As the suburbs flung farther from the city core, car ownership soared. Canada was home to about 2 million cars in 1950. In 1956 alone, Canadians bought 400,000 new automobiles, and by the end of the decade the country could boast more than 4 million in total. The cars of the 1950s embodied a romantic (and mostly unattainable) notion of the open road as well as the last word in futuristic modernity. In the 1950s your home was your refuge, but your car was your castle.

...udebaker Golden Hawk, *the Supercharged sports car that's a comfortable, 5-passenger family car, too.*

...built-in Supercharger, standard on Studebaker's Golden Hawk, is typical of Studebaker ...nces that bring you a better-performing, more economical car. The supercharger delivers ...fuel to the engine only when you need it, while in normal driving you enjoy all the ...omical benefits of a relatively light engine. It's another Studebaker "first" that makes ...e—like Twin-Traction Control, available on all V8's, Luxury-Level Ride, and the new ...ng—all part of the *Craftsmanship* that makes the big difference in '57!

...ew Commander 2-door sedan. *This bold, beautiful V8 inherits* ...udebaker's outstanding engineering that has won more Economy Run ...irsts" than any other car made!

 Studebaker-Packard
OF CANADA, LIMITED, HAMILTON, ONTARIO
Where pride of Workmanship comes first!

An advertisement for Studebaker-Packard

MODEL 250 *MAGNAJECTOR* MAGNIFYING PROJECTOR, DESIGNED BY SID BERSUDSKY, 1954

Toronto, Ontario
compression-moulded Bakelite
19.5 x 11 x 26 cm

The Magnajector was a mainstay of Canadian children's play boxes for three decades. Featuring a lamp and a mirror inside, you used it to project and magnify images from books, magazines, or other things onto a wall. The Magnajector was an adaptation of the more sombre and adult overhead projector. But in a world where kids seeme, literally to be all over and where you could sell them, or their parents, anything, a variation of this dull device for children was inevitable.

DALE OF THE MOUNTED

ATOMIC PLOT

JOE HOLLIDAY

DALE OF THE MOUNTED: ATOMIC PLOT, JOE HOLLIDAY, 1959

Toronto, Ontario
cardboard and paper
15.5 x 21 x 2 cm

In an era centred on kids, it made perfect sense that a publishing category called "young adult" would come into its own. Joe Holliday's *Atomic Plot* was one of series of Cold War adventure yarns starring Dale of the Mounted and aimed at Canadian teenagers. Other titles included *Manhunt at the UN, DEW Line Duty*, and *Pursuit on the St. Lawrence*.

GLOBAL VILLAGE SQUARE

1942 to 2001

At the Quebec City Conference in August 1943, Prime Minister Mackenzie King (seated left) *has a word for President Franklin Roosevelt while Winston Churchill ponders the world after war. Opposite: Canada's prophet of the global village, Marshall McLuhan, in conversation with American comedians Rowan and Martin*

At the end of the Second World War, a new image of Canada began to take shape in the minds of its citizens. Their country had played an important role in the defeat of fascism, continental Europe was in ruins, and victorious but weakened Britain was preoccupied with rebuilding. Might there be an enduring place for Canada on the world stage? So it seemed. If America were Jayne Mansfield or Mamie van Doren, then Canada could play the international equivalent of the nice girl in the class, the friendly joiner. And join it did: first the United Nations at the end of the war, then NATO in 1949, then NORAD in 1957. It also played an increasingly important role in the British Commonwealth. Canada now called itself a "middle power," and for a time the moniker seemed just about right.

JUSTITIA

Ernest Cormier stands beside a full-size maquette
for the door of the United Nations General Assembly
building, New York, 1951

DOOR PANELS, FEATURING JUSTITIA (JUSTICE), PAX (PEACE), AND FRATERNITAS
(FRATERNITY), FROM LEFT TO RIGHT, ON THE NORTH (PUBLIC) ENTRANCE TO THE
UNITED NATIONS GENERAL ASSEMBLY BUILDING, GIFT OF CANADA, 1953

New York, NY
nickel
approx. 40 cm high

Montreal architect Ernest Cormier designed these allegorical panels for the
public doors to the United Nations General Assembly building in New York.
Cormier, who would later gain renown for his design of the Université de
Montréal campus and Canada's Supreme Court building in Ottawa, was
appointed the Canadian member of the ten-person design committee (it
included the famed French architect Le Corbusier) that, in 1947, set to work
on the United Nations permanent headquarters.

Cabinet minister Paul Martin and Prime Minister Mackenzie King at the opening session of the United Nations General Assembly held at Flushing Meadow, New York, on October 23, 1946

NUMBER 19 RADIO SET, MADE APPROX. 1942, IN USE UNTIL MID-1950s

manufactured in Canada
steel case, plastic knobs, glass tubes
approx. 34.3 x 68.6 x 25.4 cm

This wireless radio set, designed in Great Britain but manufactured in Canada by Northern Electric, was used by Canadian troops who served as part of the UN-sanctioned multinational force in the Korean War. The enemy may well have used similar sets, since the design dated from the Second World War, when the Soviet Union (North Korea's main supplier) was our ally.

A young Radio-Canada journalist named René Lévesque interviews Canadian troops in Korea, 1950

Lester Pearson (seated between his wife Maryon and leadership rival Paul Martin) *awaits ballot results during the 1958 Liberal leadership convention that elected him leader.*

NOBEL PRIZE FOR PEACE, MEDAL, 1957

Kongsberg, Norway
gold
6.6 cm

In 1957, then Canadian External Affairs Minister Lester Pearson, was awarded this Nobel Prize for Peace. In 1956, angered by Egyptian President Nasser's nationalization of the Suez Canal, Great Britain and France used the pretext of an Israeli assault into the Sinai to seize the canal, in order, they claimed, to guarantee oil shipments. Tensions escalated. The Soviet Union threatened to wade in, and, it looked for a few frightening days in November 1956 as if the world were on the brink of war. Pearson's adroit handiwork at brokering a ceasefire at UN Headquarters in New York, and then inserting a United Nations peacekeeping force to keep Israel and Egypt apart, and to squeeze France and Britain out, saved the day. For Canadian diplomacy it was a height never achieved before – or since.

Theatregoers leaving the Festival's original tent theatre after an early performance

1 PROGRAM FOR THE CANADIAN NATIONAL
BALLET COMPANY, NOVEMBER 12–14, 1951

Toronto, Ontario
paper
22.7 x 15.7 cm

2 SOUVENIR, THE STRATFORD
SHAKESPEAREAN FESTIVAL FOUNDATION
OF CANADA, 1956

Stratford, Ontario
paper and canvas
9 x 23 cm

If anything symbolized the more sophisticated and outward-looking country Canada had become, it was the explosion of the performing arts in the 1950s and 1960s – and not just in big cities like Montreal, Toronto, and Vancouver. In those post-war years the feisty Royal Winnipeg Ballet became an international sensation, pianist Glenn Gould went to New York and Moscow, and Australian opera diva Joan Sutherland chose Vancouver as the spot to premiere a number of roles. Everywhere regional theatres were producing Canadian (and foreign) plays, which in turn meant more and more trained actors who fed the growing demands of television. Many of the pioneering enterprises of these years have grown into mature, established institutions that it's hard to imagine the country without. The National Ballet (founded in 1951) and the Stratford Festival (founded in 1953) are but two of many.

THE NATIONAL BALLET GUILD OF CANADA

presents . . .

THE CANADIAN NATIONAL Ballet COMPANY

EATON AUDITORIUM

Monday, Tuesday, Wednesday — November 12, 13, 14, 1951

8.30 p.m.

1

The Stratford Shakespearean Festival Foundation of Canada

takes pleasure in sending you, as a memento,
a portion of the canvas of the original Theatre-Tent

in appreciation of your past and continuing interest
in the Canadian Festival Theatre

Tent erected 1953 . . . Dismantled for
the last time 1956. To be replaced by
the Permanent Theatre summer 1957.

AVRO CF-105 ARROW, 1956-59

Malton, Ontario
airframe made of metal
approx. 26.1 x 6.5 m;
wingspan, 15.2 m

The Avro Arrow was born out of the early Cold War fear that long-range Soviet nuclear bombers would take the route over the North Pole to attack the United States and that Canada would find itself caught in the middle. But by the time the dartlike, delta-winged interceptor jet with a planned speed of 1,524 mph (2,453 km/h) had reached the test stage, the technology of intercontinental nuclear warfare had shifted from bombers and interceptors to remotely guided long-range ballistic missiles. The Arrow's test flights were successful, but the Diefenbaker government cancelled the project in 1959 and ordered the planes and the plans destroyed. Only models like this one survive to remind us that Canadians once designed and built what promised to be the fastest jet interceptor in the world.

Opposite: *A Maclean's cover from December 20, 1958, references plans for a line of Distant Early Warning (DEW) radar stations across the Canadian Arctic as part of Canada's recent decision to join NORAD (North American Air Defence Agreement). Or maybe the artist believes that Santa really does exist.*

an science
explain
he Star of
ethlehem?

Jacques Plante: the NHL's haunted goalkeeper

NEW TRENDS IN TOYS: AFTER HULA·HOOPS—WHAT?

MACLEAN'S

DECEMBER 20 1959 CANADA'S NATIONAL MAGAZINE 15 CENTS

PAUL ANKA ALBUM, FEATURING "DIANA," 1957

*printed in Paris, France
paper and vinyl
cover, 18 x 18 cm;
album, 17.4 cm*

Ottawa's Paul Anka was one of the first Canadians to record a rock 'n' roll hit. He was only fifteen when he penned "Diana," a song of puppy yearning for his beautiful babysitter, but it immediately catapulted the dark-haired dreamboat to international stardom. He followed "Diana," which would become an all-time classic, with a series of angst-ridden adolescent anthems, including "Lonely Boy," "You Are My Destiny," and the unforgettable "Put Your Head on My Shoulder."

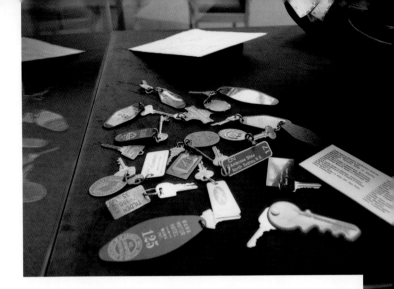

COLLECTION OF GLENN GOULD'S HOTEL ROOM KEYS, EARLY 1950s–1982

Canada and abroad These hotel keys provide evidence that Canada was making its cultural presence felt abroad in more than pop music. They were collected by the great Canadian concert pianist Glenn Gould while on tour. The Toronto-born Gould had made his professional debut in 1947 and released his first album, a revolutionary recording of Bach's "Goldberg Variations," in 1956, to international acclaim and commercial success. Gould gave up live performing in 1964 to concentrate on recording, arguing that only through an infinitely revisable electronic medium could he communicate his musical ideas the way he wanted.

Glenn Gould during a performance in May 1957

1 2

1 *THE STONE ANGEL*,
 MARGARET LAURENCE, 1964

 New York, NY
 green cloth, blocked in gold
 21.8 x 14.8 cm

3 *A CHOICE OF ENEMIES*,
 MORDECAI RICHLER, 1957

 London, England
 red cloth, spine blocked in gold
 19.7 x 12.5 cm

2 *DOUBLE PERSEPHONE*,
 MARGARET ATWOOD, 1961

 Toronto, Ontario
 paper
 17.2 x 13 cm

A Choice of Enemies and *The Stone Angel*, both published in the 1950s, were two early signs that a distinctly Canadian literature was moving beyond the nature tales of Ernest Thompson Seton and the pseudo-British stylings of Mazo De la Roche. However, both these writers had sought literary inspiration far from home, publishing their first books while living outside Canada. The younger Margaret Atwood, in contrast, was among the first generation of Canadian writers who didn't feel they had to leave Canada to make it. She wrote and published her 1961 poetry book, *Double Persephone*, at home in Toronto.

A CHOICE OF ENEMIES
Mordecai Richler

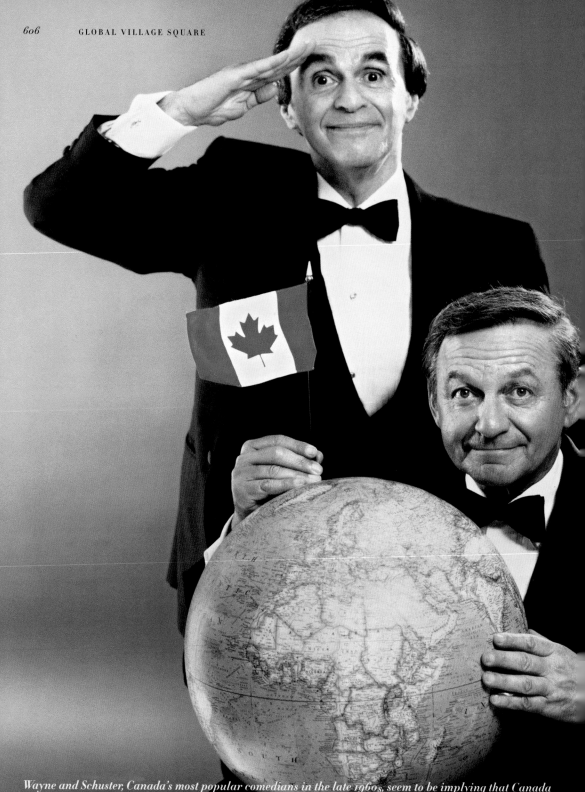

Wayne and Schuster, Canada's most popular comedians in the late 1960s, seem to be implying that Canada will soon rule the world.

Prime Minister Lester Pearson introduces the final design of the maple leaf flag at a press conference in December 1964.

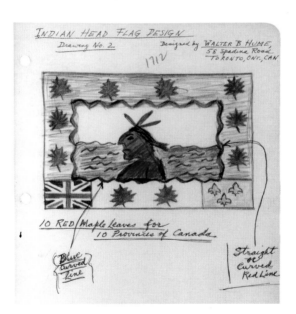

INDIAN HEAD FLAG SKETCH, APPROX. 1964

Toronto, Ontario
paper
approx. 28 x 21.5 cm

During its deliberations in the fall of 1964, the House of Commons Flag Committee considered thousands of possible designs, some proposed by professionals (including two from Group of Seven alumnus A.Y. Jackson), but the vast majority from ordinary Canadians. Toronto's Walter Hume sent in this very inclusive candidate, which manages to get in symbols representing all three founding peoples. But like the vast majority of the submissions, Hume's features the ubiquitous and by now quintessentially Canadian maple leaf.

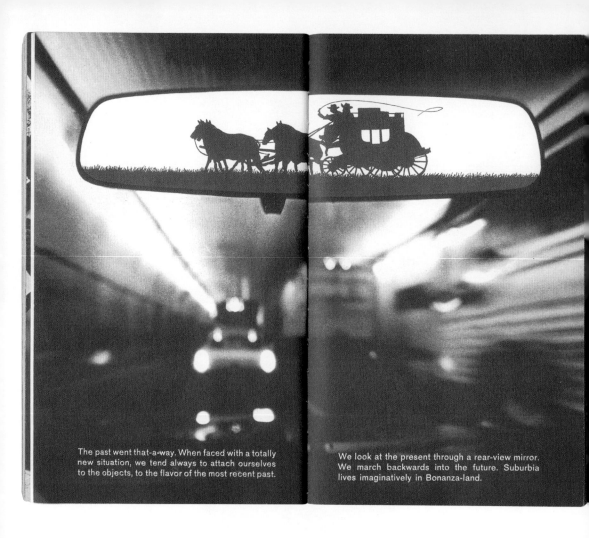

The past went that-a-way. When faced with a totally new situation, we tend always to attach ourselves to the objects, to the flavor of the most recent past.

We look at the present through a rear-view mirror. We march backwards into the future. Suburbia lives imaginatively in Bonanza-land.

PAGES FROM *THE MEDIUM IS THE MASSAGE,* BY MARSHALL MCLUHAN AND QUENTIN FIORE (DESIGNER), 1967

New York, USA
paper
17 x 10.5 cm

"You are changing. Your family is changing. Your job is changing. Your education, your neighbourhood, your government, your relation to 'the others' are changing. Dramatically!" So reads the jacket copy for Marshall McLuhan's seminal 1967 book, *The Medium Is the Massage* (not "Message," as is commonly assumed). Here McLuhan also famously predicted the imminent arrival of the electronic age, and how the advent of technology would turn the world into a "global village."

Pierre Elliott Trudeau

Today and Tomorrow

Pierre Elliott Trudeau: lawyer, economist, political scientist; social and political critic; educator; Member of Parliament, Attorney-General, Minister of Justice; Leader of the Liberal Party; Prime Minister. Born October 18, 1919 at Montreal; educated at University of Montreal, Harvard, University of Paris, London School of Economics; founder of Cité Libre, co-innovator of Quebec's quiet revolution; activist, Canadian.

LIBERAL FEDERATION OF CANADA
OTTAWA

CAMPAIGN PAMPHLET, 1968

Ottawa
paper
21.3 x 8.8 cm

The federal Liberals produced this pamphlet to introduce Canadians to the ideas of Pierre Elliott Trudeau, the party's new champion. Trudeau had learned how to massage his image from the master of media theory – Marshall McLuhan. Perhaps it was the post-Expo glow that still warmed the country, but when the Liberal Party gathered to choose a successor to Lester Pearson, the charismatic bilingual law professor stood out. Canadians also flocked to the man who seemed to embody the spirit of 1967, creating a frenzy known as "Trudeaumania."

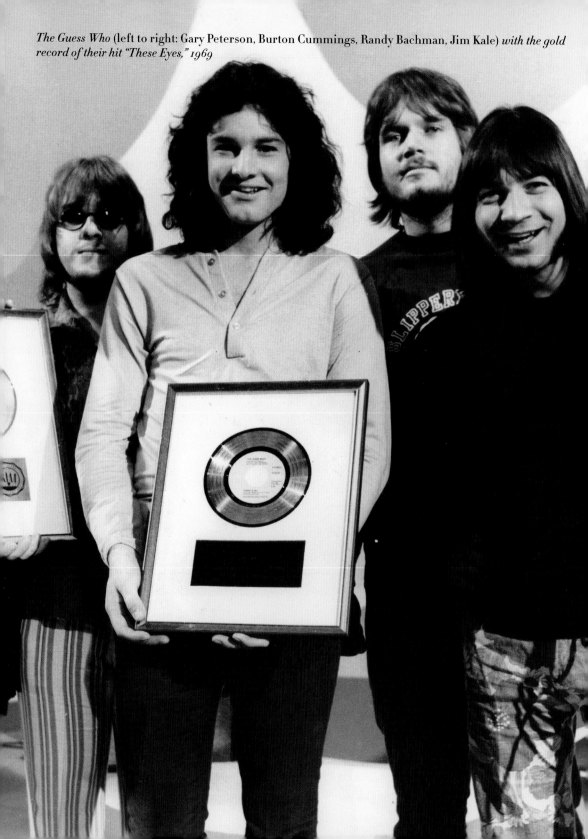

The Guess Who (left to right: Gary Peterson, Burton Cummings, Randy Bachman, Jim Kale) *with the gold record of their hit "These Eyes," 1969*

RANDY BACHMAN'S SUIT, 1974

Canada
jeans with striped material,
hand sewn
jacket, 77.4 x 48.5 cm;
pants, 113.2 x 48.5 cm

When guitarist Randy Bachman appeared on stage in this vividly embroidered denim outfit, his group, Bachman-Turner Overdrive, could definitely be said to be "taking care of business," which was also the title of one of their most popular songs, released in 1974. Bachman founded BTO with his brother Robbie Bachman after leaving the Guess Who in 1970. The other key members of the band were Blair Thornton and drummer Fred Turner. Randy and the boys became one of the biggest acts of the early 1970s, with international sales totalling more than 20 million records and hits that included "American Woman," which had a powerful anti-Vietnam War/anti-American theme.

"DRIVE U.S. IMPERIALISM OUT OF CANADA" POSTER, 1970

Toronto, Ontario
paper
size unavailable

As the sixties gave way to the seventies, Canadian nationalism blossomed in the English-speaking parts of the country. Foremost among the new nationalists was the Committee for an Independent Canada, founded by politician Walter Gordon, journalist Peter C. Newman, and economist Abraham Rotstein with the express purpose of promoting cultural and economic independence. The Canadian Liberation Movement, the organization behind this poster, was considerably to the left of the CIC. It demanded an end to American influence in Canada.

PHIL ESPOSITO HOCKEY CARD, APPROX. 1972

Canada
paper
approx. 9 x 6.5 cm

When the 1972 Canada-Russia hockey series moved to Russia, collectibles like this Phil Esposito card were losing future value fast. Team Canada was down two games to one (with one tie). The team's amazing comeback, capped by Paul Henderson's epic goal in the dying minutes of Game 8, has been replayed endlessly, not just because it was great hockey but because the team showed enormous heart – none more so than Esposito, the series' leading scorer, the team's spiritual leader, and the top point-getter in the tournament.

THE COMPLETE
HOSER'S
HANDBOOK

"A book for us, eh? Beauty!"

The official guide to identifying the complete Hoser (or Hosette) that you prob'ly are even if you think you know the score (Habs: 6; Leafs: 0) and you been down the States a few times...

If you have more than a couple cases of two-four waiting to go back to the In & Out Store...

If you think Coke is something you mix with a mickey of rye, not something you put up your nose...

If a hot turkey sandwich with chips 'n' gravy and a Half-Moon for dessert is a darn good supper...

Then you'd better get in goal cause this book's a centre shot on you!

"Inside every Canadian hides a Hoser waiting to get out and switch on the hockey game."

Borely Calabash, *That Summer in Paris, Ont.*

HUGH BREWSTER & JOHN FORBES

THE COMPLETE HOSER'S HANDBOOK, HUGH BREWSTER AND JOHN FORBES, APPROX. 1983

Scarborough, Ontario
paper
approx. 30 x 13.3 cm

The hoser phenomenon of the early 1980s was launched by the wildly popular series of skits performed by Rick Moranis and Dave Thomas on the *SCTV* comedy show, which also gave a boost to the careers of Eugene Levy, John Candy, Andrea Martin, Catherine O'Hara, and Martin Short. In the skits, Rick and Dave impersonated Bob and Doug Mackenzie, two dim-witted but affable Canadian "everygoofs" clad in toques, lumber jackets, and gumboots. The Mackenzie brothers touched a national nerve with their plodding, confused, and inane meditations on such quintessentially hoser topics as back bacon and beer, all punctuated with repetitions of the key tag "take off, eh?" And Canadian pop culture did take off in the late 1970s and early 1980s.

WAYNE GRETZKY #99, ANDY WARHOL, 1983

New York, NY
serigraph on paper
101.6 x 81.2 cm

Andy Warhol depicted hockey great Wayne Gretzky as a rather androgynous icon, an interpretation that no doubt puzzled (or offended) Canadian hockey fans. But the point about the print is that Americans had finally noticed the Canadian game and a Canadian hockey player. Gretzky was the first Canadian sports icon to become a North American superstar, especially after switching from the Edmonton Oilers to the Los Angeles Kings in 1988. He subsequently hosted *Saturday Night Live* and was given credit for much of hockey's growing popularity in the United States.

"BORDER" TELEVISION ADVERTISEMENT, APPROX. 1988

The "Border" television ad produced by the federal Liberal Party for the 1988 federal election was one of the most effective political messages ever aired. The campaign pivoted on Brian Mulroney's proposed free-trade agreement with the United States, which Liberal leader John Turner characterized as a sell-out of Canadian sovereignty. In the ad, a young U.S. trade negotiator says to his older Canadian counterpart, "There is one line I'd like to change," and the Canadian asks, "Which line is that?" Then the camera moves to this image of a hand grasping a pencil and erasing the border between Canada and the United States. The Liberals ended up losing the election, but the combined votes for the two parties opposing the trade deal outnumbered those cast for the winning Tories.

BOOK COVERS FOR FINNISH, FRENCH, AND TURKISH EDITIONS OF *THE ENGLISH PATIENT*, MICHAEL ONDAATJE, 1993, 1993, AND 1997, RESPECTIVELY

Helsinki, Finland;
Paris, France;
Istanbul, Turkey
Finnish: paper, cloth-covered boards;
French and Turkish: paper,
printed card covers
Finnish, 21.5 x 14 cm;
French, 22 x 15 cm;
Turkish, 19 x 12.5 cm

The international success of Michael Ondaatje's acclaimed novel *The English Patient*, which was translated into thirty languages, signalled the fact that Canadian writers now ranked with the world's best. In the eighties and nineties, authors such as Margaret Atwood, Robertson Davies, Alice Munro, and Mordecai Richler sold hundreds of thousands of books in scores of countries, garnered critical respect, and won international prizes. Canadians might fear the economic power of the United States or the homogenizing cultural effects of globalization, but the country's writers didn't seem to notice.

LESS-LETHAL SOLUTIONS
The 2001 Quebec City Summit of the Americas

The discarded tear gas canister looks as harmless as an empty cola can. It is roughly the same size, but with a release mechanism on one end and holes punctured through the metal sides. It is covered in military specs: "505C; Spede-Heat Grenade: Chemical Grenade." Much of the following text has burnt off, but the last paragraph reads, "Designed for outdoor use only. Personnel deploying this device should be trained in de-contamination and First Aid procedures." And in small print at the very end is the manufacturer's name: Defense Technology Federal Laboratories. This is an American subsidiary of Armor Holdings, Inc., a Florida-based corporation that is a "leading global provider" of law-enforcement products including body armour, batons, narcotic identification kits, and armoured vehicles. The company's website promises "Less-Lethal Solutions for every situation."

In April 2001 in Quebec City, 5,000 canisters of tear gas similar to this one were propelled from either 12-gauge shotguns or 37 mm launchers into crowds of demonstrators. In the preceding weeks a 4-kilometre-long, 3-metre-high chain-link fence, anchored in concrete, was erected around the city's historic centre to protect the thirty-four heads of state and their officials scheduled to meet there for the Summit of the Americas. Once the dignitaries arrived, more than 6,000 well-drilled police in black riot gear and gas masks and carrying perspex shields lined up both inside and outside the fence. Tear gas was only one of the less lethal solutions in their arsenal. They also had batons, water cannons, rubber bullets, and "flash-bangs": devices that explode noisily in the air, creating mass confusion.

Those outside the fence (estimates ranged from 30,000 to 50,000 people) included British Columbia's Raging Grannies, indigenous groups from the Andes Mountains, Mexican labour organizers, and landless Brazilians. Most of this ragtag assembly was entirely peaceful, but as the conference got under way

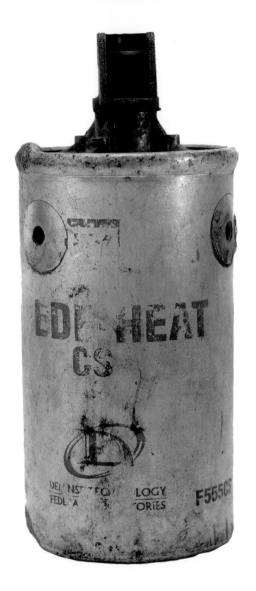

GAS CANISTER, APPROX. 2001

Quebec City, Quebec
metal
6.5 x 6.5 cm

This canister was just one of thousands fired by police during the April 2001 Summit of the Americas in Quebec City. While high-level delegations from thirty-four western hemisphere countries met behind barricades, thousands of protestors gathered outside. When a few in the crowd misbehaved, the 6,000 policemen present shot off repeated volleys of tear gas canisters, along with rubber bullets, water cannons, and other assorted "less lethal" weapons.

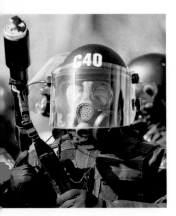

Policeman prepares to fire a tear gas canister.

a minority of demonstrators ("anarchist infiltrators," according to police) started to hurl rocks, sand-filled bottles, and parts of the fence at the police. The forces of law and order responded quickly. As protesters advanced, the black-clad, gas-masked lines briefly parted and specially trained colleagues popped canisters into launchers, then fired them above the crowd. As these projectiles spun through the air, they spewed out a cloud of gas. Soon hundreds of protesters were choking, their eyes smarting and streaming. Even those who had tied vinegar-soaked bandanas around their faces were left gasping for breath.

By all accounts, national leaders and their advisers attending the summit, though safe inside the fence, were shocked by the uproar. They had blithely convened to nudge towards fruition "hemispheric integration," in the form of a trade treaty that would encompass the 800 million people who live in North, Central, and South America. During the previous half-century, largely out of the limelight, trade negotiators had laboriously developed a set of rules governing international trade, steadily eliminating tariff barriers between trading nations. They had operated on the assumption that increased global commerce, and the wealth it would generate, was for the public good.

Now the trade guys found their most dearly held assumption contested by a bunch of flamboyant senior citizens, earnest labour organizers, and grungy kids who argued that freer trade between nations benefited only powerful institutions and big business. A free-trade bloc, insisted activists, would widen the gap between rich and poor countries and damage the environment. But the real battle was taking place on television screens. The millions who tuned in to their television news over the three days the summit lasted saw scene after scene of unprovoked attacks on crowds by black-clad police, their faces hidden by helmets. In one of the most peaceful cities of one of the most peaceful countries on earth, unarmed demonstrators were clubbed and gassed.

The spokespeople for the inside-the-fence crowd quickly moved into damage-control mode. They insisted that the negotiations were not simply about business. Education, the spread of democracy, battling drug traffickers, and easing poverty moved up the agenda. U.S. president George W. Bush started talking about forging "an age of prosperity in a hemisphere of liberty." But the dark-suited world leaders had already lost the PR battle. In Quebec City, "globalization" became a dirty word.

Yet the activists proved the power of a different kind of globalization: the Internet. Thanks to electronic communication, anybody concerned about trade deals could speak across national borders instantly and for free. In the previous months, plans for the protest and for ancillary paramedic and food services were posted almost daily on the protest group websites. In the weeks that followed, the outside-the-fence crowd exchanged horror stories about excessive use of force by police and vowed to continue agitating for human rights to be a priority in trade negotiations.

When I hold this gas canister, I am immediately back watching the television footage from Quebec City. So many kids I know, including my own son, are among the crowds who headed off to Quebec City with the intention of making a peaceful protest. I hear the chanting of activists ("So-so-solidarité!"), the roar of flash-bangs, and the whir of helicopters. I see the spreading fog of acrid gas and the hundreds of young and not-so-young people crying and retching. For this, Canadian taxpayers shelled out the $70 million it cost to build concrete walls and police barricades, and to pay security forces to protect the delegates.

This particular canister belongs to a friend of my son who took part in the protests. His souvenirs from Quebec City, spent canisters and rubber bullets, now decorate his bookshelves. My son's souvenirs included large purple bruises after being hit by rubber bullets. The bruises faded, but they and the bullets are talismans of a larger, more subversive global trend in the new century: a feeling, particularly among the anti-corporatist "No Logo" youth, that conventional political participation just doesn't work.

CENTENNIAL PAVILION
1967

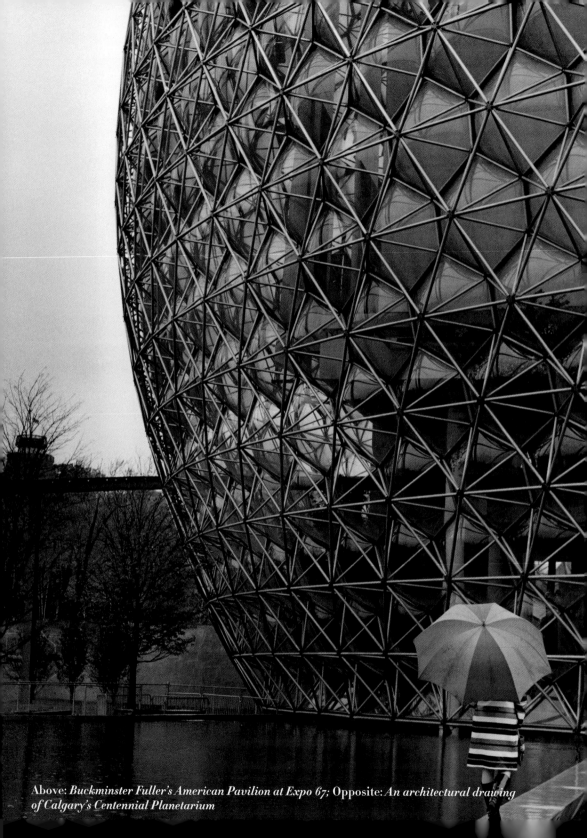

Above: *Buckminster Fuller's American Pavilion at Expo 67;* Opposite: *An architectural drawing of Calgary's Centennial Planetarium*

Perhaps it was the logical culmination of the preceding postwar decades, a sign of the country's growing confidence. Canada had taken a lead in the creation of the United Nations and seemed secure in its status as an increasingly prosperous middle power. Now, as the 100th anniversary of Confederation approached, there was a widespread feeling that this was a birthday worth celebrating. Serious preparations got underway in 1962 and 1963 while John Diefenbaker was still prime minister. These included the appointment of John Fisher, a popular broadcaster and patriot affectionately known as "Mr. Canada," to be chief Centennial commissioner and the creation of a Crown corporation dedicated to pulling together, in Montreal, North America's first-ever class one world exposition, namely a fair that celebrated every area of activity and achievement of contemporary "man." When Lester Pearson's Liberals came to power, they decided the celebration would become a twelve-month-long national birthday party. But would all the plans come together in time?

This group of top athletes gathered in Ottawa on July 31 for a Centennial sit-up competition dubbed the "test of champions."

The symbol for the Centennial of Canadian Confederation: eleven equilateral triangles representing the ten provinces and the Canadian North, arranged to form a stylized maple leaf.

L'emblème du centenaire de la Confédération canadienne: onze triangles équilatéraux symbolisant les dix provinces et le Nord du Canada et disposés de façon à représenter une feuille d'érable stylisée.

CARD HOLDING PIN OF THE SYMBOL FOR THE CANADIAN CENTENNIAL, 1967

Toronto, Ontario
metal pin on paper card
pin, 1.5 x 1.4 x 2.5 cm;
card, 11.1 x 5.4 cm

Ottawa created a variety of official objects to mark Canada's Centennial, many of which featured the Centennial logo designed by Stuart Ash of the renowned Canadian graphic design firm Gottschalk and Ash. Here the logo comes in the form of a nifty lapel pin. The front of the card explains the significance of Ash's design. The back reads: "Alert Auto Alarm Co / 342 Adelaide Street West / Toronto, Canada / Manufacturers of Metal and Wood Novelty Products."

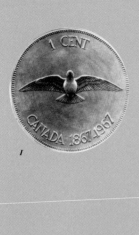
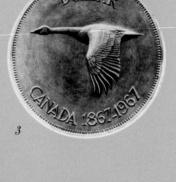

1

2

3

5

4

CENTENNIAL COINS, ALEX COLVILLE, 1967

Ottawa, Ontario

1 DOVE 1-CENT COIN

98% copper, 0.5% tin, 1.5% zinc
19.1 mm

2 RABBIT 5-CENT COIN

99.9% nickel
21.1 mm

3 CANADA GOOSE SILVER
DOLLAR

80% silver, 20% copper
36.1 mm

4 BOBCAT 25-CENT COIN

80% silver, 7.5% copper;
or 50% silver, 50% copper
23.9 mm

5 MACKEREL 10-CENT COIN

80% silver, 20% copper
18.3 mm

All Canadian coins minted in 1967 bore new animal images designed by artist Alex Colville. Most of his choices seem self-evident, except perhaps for the dime: "Being the smallest coin, this requires a simple and unambiguous image. I used the mackerel, one of the most beautiful and streamlined fish, common on both coasts. The fish has ancient religious implications; I think of it as a symbol of continuity."

A model shows off a handful of Centennial coins.

CENTENNIAL ASHTRAY, 1967

Toronto, Ontario
ceramic (glazed, baked,
and painted)
27.3 x 45 cm

Plenty of private companies, large and small, jumped on the Centennial bandwagon. Canadians wanted 100th-birthday mementos, and souvenir manufacturers were only too happy to oblige. They created a veritable confederation of kitsch – including this multihued ashtray in the shape of the Centennial logo.

Revered Montreal Canadiens player Maurice "Rocket" Richard at his investiture into the brand-new Order of Canada, November 24, 1967 – Richard is receiving his medal from Governor General Roland Michener.

made in London, England;
used in Ontario, Canada
metal, velvet, silk
3 x 15.7 x 11.4 cm

On July 1, 1967, Governor General Roland Michener presided over the first presentation of the Order of Canada. Among the recipients were historian Donald Creighton, Quebec actress Yvette Brind'Amour, and Group of Seven founder Arthur Lismer. The Order recognizes Canadians who have made noteworthy contributions to their country. Designed in the shape of a stylized snowflake, it bears the legend *"Desiderantes Meliorem Patriam,"* which translates as "they desire a better country."

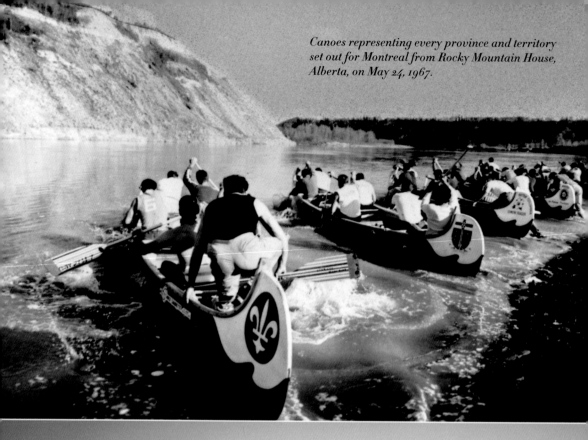

Canoes representing every province and territory set out for Montreal from Rocky Mountain House, Alberta, on May 24, 1967.

Centennial Year saw countless public works, great and small, from coast to coast to coast. Many of them were official "Centennial projects" that the Centennial Commission underwrote – some 2,860 in all. If you wanted money for a museum or a Centennial garden or a re-enactment of a great moment from Canadian history, you could probably get it. But the excitement ordinary Canadians felt about their country's 100th birthday didn't need much official encouragement. It was a true people's celebration.

LETTER WITH LEATHER POUCH CARRIED TO JUDY LAMARSH IN HONOUR OF THE CENTENNIAL, WRITTEN BY PAUL DROLET, 1967

written in St. Paul, Alberta;
transported to Montreal, Quebec
leather pouch, leather thong ties,
birch-bark letter, wax
pouch, 23.8 x 33.8 cm;
inner pouch, 15.8 x 22.7 cm;
letter, 14.7 x 20.3 cm

This leather pouch and letter addressed to the Cabinet minister responsible for Canada's Centennial celebrations was written by Paul Drolet, who carried it with him while he paddled with the crew of the Alberta canoe that retraced the steps of the voyageurs during the Centennial summer. Drolet's canoe, now lodged in Ottawa's Museum of Science and Technology, was one of twelve six-man freight canoes that covered the almost 5,500 kilometres from Rocky Mountain House to Montreal between late May and early September. The letter reads, "On the occasion of this Historic journey / of the Canoe Voyageurs to Mark Canada's / 100th Birthday of the Confederation, / The People of St. Paul, Alberta, send / Cordial Greetings through You to all / Their brothers in this Great Land."

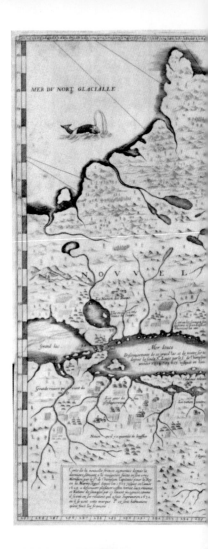

Below: *Crowds in Vancouver, British Columbia, wait in line for a chance to tour the Centennial train.*

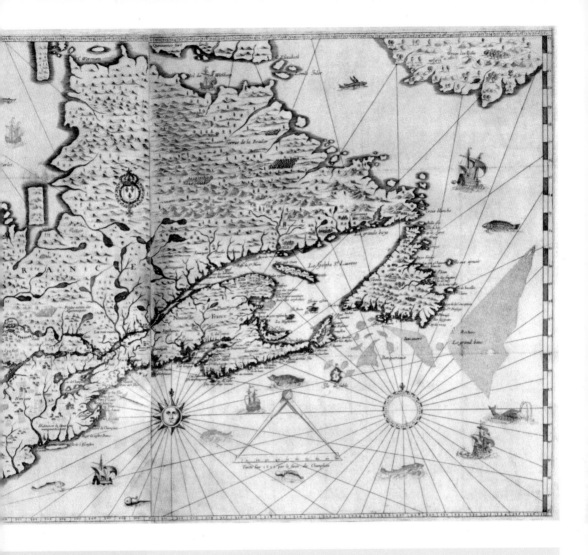

"CARTE DE LA NOUVELLE FRANCE: AUGMENTEE DEPUIS LA DERNIERE SERVANT A LA NAVIGATION FAICTE EN SON VRAY MERIDIEN" (CHAMPLAIN'S MAP), SAMUEL DE CHAMPLAIN, 1632

Paris, France
map printed from copperplate
52.7 x 86.4 cm

None of the artifacts transported on the Centennial train, a travelling museum of Canadian history, carried more meaning than Samuel de Champlain's map of the country he founded. Besides, he was first and always a map-maker, one of that special breed who seeks not just to visit new places but to make sense of them for those who follow.

Not Very Close Encounters
Alberta's UFO Landing Pad

It looks a little dated now. The cement is weather-stained, and the steps and railings have the 1960s Sputnicky design that characterized so many of the Expo pavilions. But the UFO landing pad in the middle of St. Paul, 200 kilometres northeast of Edmonton, still radiates the guileless optimism of the space-mad decade that saw both the first *Star Trek* episodes and the first moonwalk.

The motto of St. Paul, a farming community of 5,000 people, is "a people kind of place." The Chamber of Commerce has always boasted that the town gives everyone a warm welcome – so why, city officials wondered in the mid-1960s when Centennial projects were under discussion, shouldn't that include aliens? The pad cost $11,000, but, the Chamber notes gleefully, "no public funds [were] provided for its construction." The planning engineer donated his time. The concrete of the circular deck, which weighs 130 tonnes and is attached to the Chamber of Commerce, was provided free by a local cement company. Each province sent along a stone, from which a map of Canada was constructed in the centre of the backstop. A row of provincial flags flaps gaily from poles on the backstop, reflecting the exuberant spasm of national unity generated in the Centennial Year.

Next to the pad there is a sign: "Republic of St. Paul (Stargate Alpha). The area under the World's First UFO Landing Pad was designated international by the Town of St. Paul as a symbol of our faith that mankind will maintain the outer universe free from national wars and strife. That future travel in space

UFO LANDING PAD, 1967

St. Paul, Alberta
concrete reinforced with steel
platform, 12 m

The good citizens of St. Paul, Alberta, built this futuristic concrete structure to give visitors from outer space a convenient place to set down. Although to date no flying saucers are known to have landed, it doubles as a serviceable bandstand.

will be safe for all intergalactic beings, all visitors from earth or otherwise are welcome to this territory and to the Town of St. Paul."

The great success of this wacky Centennial project is that it fulfilled its sponsors' dream – the dream of "Build it and they will come." Well, not the intergalactic beings: no spaceships have put down on the pad to date. As far as the Chamber of Commerce knows, ET has not scrambled down those steps.

But as news of the pad spread through North America, UFO believers began to land on St. Paul. At first, local business people simply chuckled and catered to them in facilities like UFO Pizza, the Galaxy Motel, and Mama's Flying Saucer Pizza & Breakfast. Thirty years after the pad was installed, however, things got more serious. In 1998 a UFO conference in the town attracted 300 delegates; two years later more than 500 people turned up for "UFO 2000," at which alien abductions and mysterious cattle mutilations were discussed. Today about 30,000 tourists and UFO followers visit St. Paul each year. The town has been featured on the Space Channel, and it has its own toll-free UFO hotline (1-888-SEE-UFOS) for reports of paranormal activities.

Too many other Centennial projects had a short shelf life. Centennial gardens withered; Centennial statues cracked; Centennial libraries have seen their acquisition budgets slashed. But St. Paul's Centennial UFO Landing Pad has sparked a whole industry. Captain Kirk would be proud.

CENTENNIAL SYMBOL, 1967

Toronto, Ontario
cement
15 x 17 cm

Every square of sidewalk pavement laid in Toronto during Centennial Year was stamped with the Centennial logo, just one of countless ways in which Canadians officially and unofficially marked their country's birthday. As you travel Canada today, it's hard to find a town, or even village, untouched by this year-long national love-in: Centennial parks and parkettes and memorial flower gardens, Centennial hockey rinks and tennis courts and concert halls. For the first and perhaps the last time, the whole country seemed completely united.

The crowning event of Centennial Year was the Montreal World's Fair, or Expo 67. If the timing was fortuitous, Expo's arrival on schedule (if badly over budget) was something of a miracle. The site in the St. Lawrence River in Montreal required enlarging one island and creating a new one from river sediment and landfill. But after the exhibition corporation took possession, a panoply of strange and futuristic structures began to rise. In the end, 120 governments were represented in sixty pavilions, not to mention the many hundreds of other groups that filled the fifty-three private pavilions. Somehow, everything was more or less ready on opening day, April 28, 1967.

"HABITAT" HOUSING, DESIGNED BY MOSHE SAFDIE, 1967

Montreal, Quebec
concrete with steel cables
354 modules (or boxes)
that connect to create 158 apartments
with 1–4 bedrooms

Expo's mandate was to cover every aspect of contemporary life. The organizers chose as their theme the title of a book by Antoine de Saint-Exupéry, "Terres des Hommes / Man and His World." This grand idea was then subdivided into five categories: Man the Creator, Man the Explorer, Man the Producer, Man the Provider, Man and the Community. Under this last heading fell Moshe Safdie's futuristic apartment complex, "Habitat," although technically it was not part of Expo, having been built for the City of Montreal. Each apartment was created out of prefabricated concrete modules lifted into place by an enormous crane. Safdie's genius was to adapt industrial assembly-line techniques to home construction while never losing sight of the human factor. Amenities included private gardens and gorgeous views, but the whole structure, home to 158 families, fit into a compact space, making it ideal for urban living.

SPECIAL PREVIEW
expo67

THE CANADIAN UNIVERSAL and
INTERNATIONAL EXHIBITION
MONTREAL, CANADA, 1967

EXPO PROMOTIONAL MATERIALS, 1966–67

Montreal, Quebec
paper
22.5-74 x 10-51 cm

Expo 67 truly was a journey to the future, often brilliantly anticipating the world to come. These posters, created to promote the fair, are early examples of what we now call branding. They draw on styles of graphic design that were just becoming popular in the world of advertising: image-heavy, text-light, clean and unencumbered. In part they owe their uniform look, or brand, to the fair's trademark lowercase typeface and the distinctive Expo logo – a circle of interlocking Ys that represents the theme Man and His World.

Interior view of the Russian Pavilion

EXPO PAVILION PROMOTIONAL MATERIALS, 1967

Montreal, Quebec
paper
19·76 x 14·51 cm

These posters suggest the range of places you could visit at Expo 67. The national pavilions included Canada's inverted pyramid (named Katimavik, which means "meeting place" in the Inuit language); the United States' geodesic dome, designed by Buckminster Fuller; and West Germany's tent, constructed out of steel netting covered with a translucent plastic skin. Every Canadian province and territory, as well as many of the fifty U.S. states, had either stand-alone or shared pavilions.

Above left: *The Iranian Pavilion.* Above right: *Interior of the Canadian Pacific–Cominco Pavilion*
Below: *The Pulp and Paper Pavilion*

Expo 67

Le pavillon
des pâtes et papiers du Canada

Ann Miller

Carol Lynley

Pin-Ups
Les pin up

Some of the "pop-cult" displays in the United States Pavilion

WALKING WOMEN, MICHAEL SNOW, 1961–67

Montreal, Quebec
stainless steel and wood
approx. 230.5 x 91.5
x 2.7 cm

This eleven-piece sculpture, part of the famed "Walking Woman Works" series, was created by Canadian sculptor Michael Snow for display in and around the Ontario Pavilion at Expo 67. Under the subtheme of Man the Creator, Expo welcomed artists and art from around the world: experimental film, classical and popular music, dance, theatre, and opera, including Italy's La Scala opera company and Britain's National Theatre, under the direction of Sir Laurence Olivier. For an emerging artist like Snow, the fair also provided a chance to be seen alongside established greats, such as abstract sculptor Alexander Calder, and to reach an international audience.

Queen Elizabeth II takes in one of the pavilions on her visit to Expo on July 3, 1967.

THE GREAT RING OF CANADA, 1967

made in Steuben County, NY;
presented to Canada in Montreal, Quebec
crystal, rhodium-plated steel base and
arms, brass, and nickel
101.6 x 71.1 cm

This conversation piece was the official gift "for the
people of Canada on the Centenary of Canada's nation-
hood from the people of the United States of America."
President Lyndon Johnson presented it to Prime Minister
Lester Pearson during his visit to Expo on July 4, 1967.

Ontario
wood, silver, and ivory
16 x 38 x 26 cm

French president Charles de Gaulle would have gone home wit[h] this gift had he reached Ottawa in July 1967. His official visit to Canada began well enough. Quebec City greeted him with larg[e] and enthusiastic crowds, and a huge throng cheered him as he stood on the balcony of Montreal's city hall on July 24, preparin[g] to speak. But a few moments into his oration he uttered "*Vive l[e] Québec Libre!*" (a separatist slogan), suddenly reminding Centennial-drunk Canadians of the underlying tensions in thei[r] country that no big celebration could wish away. Prime Ministe[r] Pearson was predictably unamused, and de Gaulle decided to g[o] home and miss the state dinner planned for him at Rideau Hall[.] When Expo 67 closed its gates for the last time on October 27, 1967, 183 days after it began, de Gaulle's words had faded – but they were not forgotten.

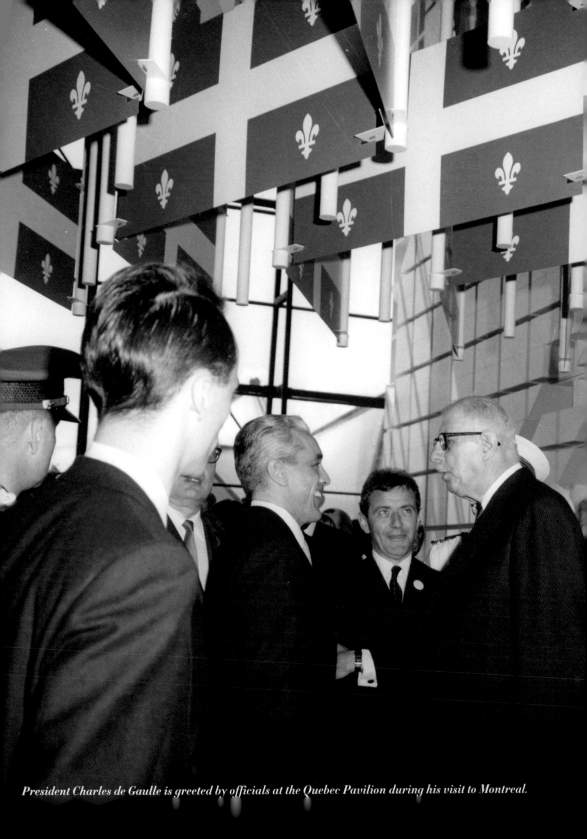

President Charles de Gaulle is greeted by officials at the Quebec Pavilion during his visit to Montreal.

Rights Auditorium
1960 to 1982

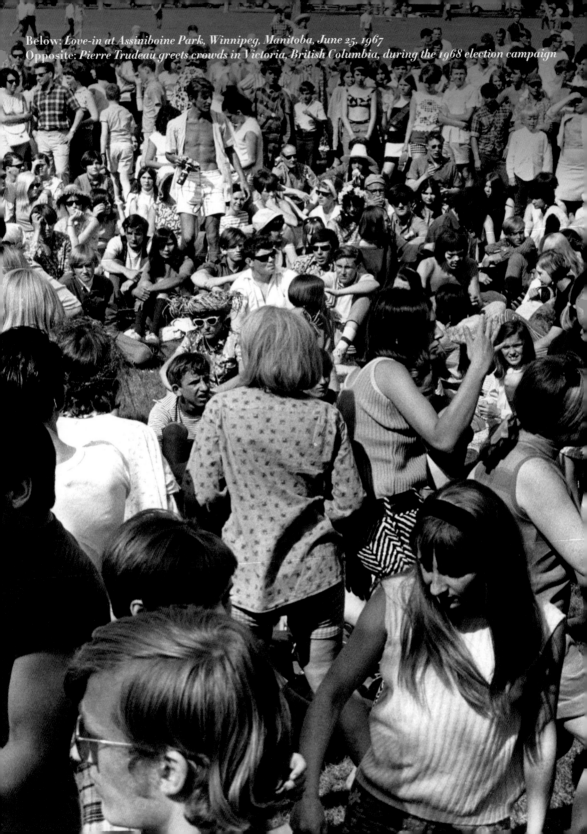

So immersed are Canadians today in the language of rights and freedoms, they sometimes forget how new this language is. Just ask the Doukhobors out west at the turn of the century, or the Japanese on the West Coast during the Second World War, or the Jews or blacks who remember a Canada where much of the country's social and economic life was "restricted." Canada's contemporary rights-based democracy, in which the legislative decisions of Parliament are constantly scrutinized and often challenged by an activist Supreme Court, has three unlikely godparents: the Co-operative Commonwealth Federation, the Jehovah's Witnesses and a fiery prairie populist named John Diefenbaker. In late-1940s Quebec the Witnesses began to demand a bill of rights that would explicitly protect them from harassment at the hands of the government of Maurice Duplessis by guaranteeing their right to assemble and their freedom of religion. The idea for a bill of rights was one that Diefenbaker, an ardent civil libertarian, chose to champion after he became prime minister in 1957. The result was the 1960 Bill of Rights, the beginning of Canada as a rights-based society.

THE CANADIAN BILL OF RIGHTS, 1960

Ottawa, Ontario
paper
60.6 x 45.3 cm

John Diefenbaker regarded the Bill of Rights as one of his greatest achievements. The bill guaranteed citizens personal security and equality before the law, and also provided for freedom of religion, speech, assembly, association, and the press. But because the consent of the provinces was not obtained beforehand, the bill applied only to federal laws; it was not entrenched in the Constitution, so Parliament could pass legislation that overrode it.

RIGHTS

...mental Freedoms.
...ᵗʰ August 1960.

...deprive a person of the right to a fair hearing in
...accordance with the principles of fundamental justice
...for the determination of his rights and obligations;
...deprive a person charged with a criminal offence
...of the right to be presumed innocent until proved
...guilty according to law in a fair & public hearing
...by an independent and impartial tribunal, or of
...the right to reasonable bail without just cause; or
...deprive a person of the right to the assistance of an
...interpreter in any proceedings in which he is involved
...or in which he is a party or a witness before a court,
...commission, board or other tribunal, if he does not
...understand or speak the language in which such
...proceedings are conducted.

...he Minister of Justice shall, in accordance with such
...ations as may be prescribed by the Governor in Council,
...ine every proposed regulation submitted in draft form
... Clerk of the Privy Council pursuant to the *Regulations*
...nd every Bill introduced in or presented to the House
...mmons, in order to ascertain whether any of the
...sions thereof are inconsistent with the purposes and
...sions of this Part and he shall report any such in-
...stency to the House of Commons at the first con-
...nt opportunity.

...he provisions of this Part shall be known as the
...dian *Bill of Rights*.

∿ ∿ ∿ ∿ ∿ ∿ ∿ ∿ ∿ ∿

...adian, a free Canadian, free to speak without fear, free to
... my own way, free to stand for what I think right, free to
...believe wrong, free to choose those who shall govern my
...heritage of freedom I pledge to uphold for myself and
...

...Honourable John G. Diefenbaker, Prime Minister of Canada,
House of Commons Debates, July 1, 1960.

Top right: *A young girl at an election rally
holds a portrait of her current hero, Prime
Minister John George Diefenbaker.* Right:
*Postmaster General William Hamilton present-
ing the Bill of Rights to some students*

JEAN LESAGE CAMPAIGN BANNER, 1960

Quebec
size unavailable

In the 1960 Quebec election, Liberal leader Jean Lesage campaigned on the slogan *C'est le temps que ça change* (It's Time for a Change). The change in question was from the inward-looking social conservatism of the Union Nationale, which had governed the province continuously for sixteen years. The previous year, long-time premier Maurice Duplessis had died and, with the social and economic changes taking place in the rest of Canada, Quebecers proved ready for Lesage's message. His victory launched what soon came to be known as *La Révolution tranquille* (the Quiet Revolution).

FLAG FOR THE UNION CATHOLIQUE DES CULTIVATEURS/QUEBEC (CATHOLIC UNION OF FARMERS/QUEBEC), 1924–72

Quebec, Canada
textile, paint
118 x 190 cm

The election banner evokes the Quebec of Maurice Duplessis: Catholic and rural, narrowly nationalistic, and suspicious of the outside world. This Quebec didn't vanish entirely with the coming of the Quiet Revolution. The Union Catholique des Cultivateurs and numerous other traditional institutions endured, but the province as a whole rapidly became more urban and more secular.

· XIV - LA VOIX DES FEMMES

(la contribution d)

Persuadée depuis longtemps que la femme peut apporter une
force dynamique ~~à~~ *dans* l'édification de la paix, je résolus de fonder, en
février 1961, la section québécoise de La Voix des femmes (Voice of Women).
A la suite de l'aggravation des relations entre les Américains et les Russes
en 1960, lors de l'incident U 2 à Paris, des Canadiennes de l'Ontario (1)
firent appel à toutes les femmes de notre pays pour qu'elles élèvent leurs
voix contre les tensions d'une guerre froide et la menace imminente d'un
conflit nucléaire. Leur but était d'~~établir~~ *assurer* la paix par la négociation *et par*
l'application de et leur devise: "Construction, not destruction." Apprenant ce qui s'était
passé au Maple Leaf Garden à Toronto, où Noël Baker, prix Nobel de la paix,
avait éloquemment parlé en faveur de la paix, je communiquai immédiatement
avec Mme Helen Tucker, présidente du nouveau mouvement, pour la prévenir
de mon intention d'en former une section québécoise. Plusieurs femmes
se réunirent chez moi dont le sénateur, l'honorable Marianna Jodoin, qui
m'avait autrefois aidée dans la lutte pour obtenir le suffrage féminin dans
la province. Je fus élue présidente de cette nouvelle association et le
sénateur Jodoin, présidente honoraire. Les Canadiennes françaises partageaient
avec leurs concitoyennes anglaises l'amour des enfants et de la famille, base
même de la société. Sachant que les hommes seuls ne pouvaient accomplir un
travail ~~adéquat~~ *vraiment efficace*, les femmes décidèrent de se joindre à eux pour combattre
la menace des guerres nucléaires ou biologiques et de créer dans le public
un climat de sympathie et de compréhension. Dès le début, Mme Lester
Pearson (2) accorda son appui à La Voix des femmes et, dans le premier
numéro de notre bulletin, elle écrivit: "... if we, the women of the West
could succeed in reaching women of the other side of the curtain with no

(1) Lotta Demsey; colomnist au Toronto Daily Star, Mme J. Davis, Helen
Tucker, Gaby Roblins, June Callwood et les sénateurs Hodges, Inman, Irving
and Quart.

(2) Mrs Lester Pearson démissionna en 1962, dès que La Voix des femmes
fut qualifiée de communiste par la presse et considérée comme ayant une
orientation politique.

*Marie-Thérèse Casgrain before
television cameras in 1960*

"LA VOIX DES FEMMES," FROM *A WOMAN IN A MAN'S WORLD*, THÉRÈSE CASGRAIN, 1966

*Quebec
typed and annotated
size unavailable*

This manuscript page is the opening of chapter 14 of the autobiography of
French-Canadian activist Marie-Thérèse Casgrain. A veteran battler for
women's suffrage in Quebec, where women gained the right to vote in
provincial elections only in 1940, Casgrain played a key role in mobilizing
support against the Union Nationale in 1960, and subsequently became one
of the representative figures of the Quiet Revolution. She was also active in a
movement that by the late 1960s was known as Women's Liberation. She
founded the Fédération des Femmes du Québec and the Quebec branch of
the Voice of Women.

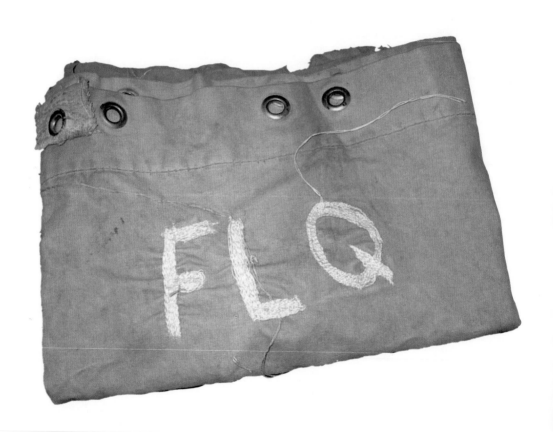

FRONT DE LIBÉRATION DU QUEBEC (FLQ) MAILBAG, 1970

Kingston, Ontario
heavy canvas with metal
eyelets
74 x 102 cm

In November 1970 this bag was sent for repair to the Kingston Penitentiary, where an anonymous convict stitched the letters *FLQ* onto it. Whether it was a prank or an act of rebellion, no one knows. Today the mailbag is part of the collection of Kingston's Penitentiary Museum.

Sewing Separatism
The FLQ Mailbag and the Kingston Pen

Since 1858, inmates of Kingston's federal penitentiary have been manufacturing and repairing mailbags. Each sack is the same size as a laundry bag, but it's made out of the heavy-duty grey canvas, tightly woven and difficult to sew, used for straitjackets. The rhythm of the mailbag shop has always been monotonous. And so it was in November 1970. For five days a week, six hours a day (3.5 hours in the morning, 2.5 hours in the afternoon), the sixty inmates who were repairing mailbags worked steadily. They

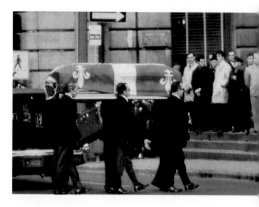

Justice Minister Pierre Laporte's coffin being carried into Montreal's Notre Dame Church, October 21, 1970

fixed about 800 bags per day, 4,000 per week. By the end of the month they had declared close to 16,000 mailbags fit to return to postal service.

But in 1970 the job of letter carrier carried a lot more weight than just the daily mail. In May 1963 bombs had been dropped into fifteen mailboxes in Westmount, the wealthy Anglo enclave in Montreal: five exploded. The perpetrators belonged to a group of revolutionaries that called itself the Front de Libération du Québec, or FLQ, and was bent on securing Quebec independence. During a second wave of sabotage in 1969, bombs were placed in several Ottawa mailboxes (none exploded), and in downtown Montreal a package blew up a postal truck. By 1970 seven people had been killed and scores injured, and over two hundred bombs had detonated at post offices, army barracks, and even the Montreal Stock Exchange.

That November of 1970 the situation in Quebec was even scarier. Early the previous month the British trade commissioner in Montreal, James Cross, had been snatched from his home by a handful of long-haired young men. The FLQ

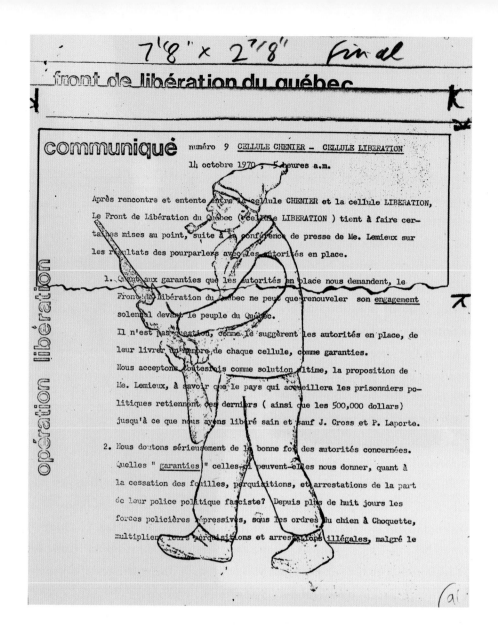

7'8" x 2'8" final

front de libération du québec

communiqué numéro 9 CELLULE CHENIER — CELLULE LIBERATION

14 octobre 1970 ; 5 heures a.m.

Après rencontre et entente entre la cellule CHENIER et la cellule LIBERATION,
Le Front de Libération du Québec (cellule LIBERATION) tient à faire cer-
taines mises au point, suite à la conférence de presse de Me. Lemieux sur
les résultats des pourparlers avec les autorités en place.

1. Quant aux garanties que les autorités en place nous demandent, le
 Front de Libération du Québec ne peut que renouveler son engagement
 solennel devant le peuple du Québec.
 Il n'est pas question, comme le suggèrent les autorités en place, de
 leur livrer un membre de chaque cellule, comme garanties.
 Nous acceptons toutefois comme solution ultime, la proposition de
 Me. Lemieux, à savoir que le pays qui accueillera les prisonniers po-
 litiques retiennent ces derniers (ainsi que les 500,000 dollars)
 jusqu'à ce que nous ayons libéré sain et sauf J. Cross et P. Laporte.

2. Nous doutons sérieusement de la bonne foi des autorités concernées.
 Quelles " garanties " celles-ci peuvent-elles nous donner, quant à
 la cessation des fouilles, perquisitions, et arrestations de la part
 de leur police politique fasciste? Depuis plus de huit jours les
 forces policières répressives, sous les ordres du chien à Choquette,
 multiplient leurs perquisitions et arrestations illégales, malgré le

opération libération

PART OF THE FRONT DE LIBÉRATION DU QUEBEC (FLQ) COMMUNIQUÉ 9, 1970

Montreal, Quebec
paper
approx. 28 x 21.5 cm

This copy of an FLQ communiqué includes a drawing of an 1837 Patriote
rebel, based on a painting by Henri Julien, albeit equipped with a modern
rifle. Founded in the early 1960s, the Front de Libération du Québec was
inspired in part by the success of Algeria's Front de libération nationale
(FLN) in driving the French from their homeland. The FLQ took French-
Canadian nationalism in a new and disturbing direction, beginning with a
series of bombings and climaxing with the kidnapping of James Cross and
Pierre Laporte in October 1970.

had then issued a communiqué saying Cross would be released only if seven demands were met, including the broadcast of the FLQ manifesto and the release of twenty-three "political prisoners" – FLQ members who were serving sentences for robberies and bombings.

The Quebec minister of justice offered safe passage abroad to the kidnappers in return for Cross's liberation. But before this could happen, another group of FLQ members kidnapped Quebec cabinet minister Pierre Laporte. On October 18 Laporte's body was found in the trunk of a car. In Ottawa a shocked Prime Minister Pierre Trudeau denounced the murder as "a cowardly assassination by a band of murderers," and the Liberal federal government proclaimed the existence of an "apprehended insurrection." It declared a state of emergency and

Prime Minister Pierre Trudeau and Premier Robert Bourassa (right) *at Pierre Laporte's funeral*

imposed the War Measures Act; armed guards appeared on Parliament Hill and in the streets of Quebec; and hundreds of people were arrested and detained without charge. When Trudeau was asked by a reporter how far he would take the suspension of civil liberties, he replied grimly, "Just watch me!"

In Kingston Pen, despite limited access to newspapers and radio, the 700 inmates were aware of the dramatic events unfolding outside the prison's walls. Some of those who came from Quebec might even have met a few of the "political prisoners" while they were in detention in their home province, although at this point none of the October Crisis detainees had been sent to Kingston. One of the Kingston inmates decided to use the mailbag to send a message. The words "Parcel Post: Crown/1955/Canada P.O." were stencilled on the bag's front. The big, jagged gash at the bottom meant its repairer had to run the thick needle of his industrial-strength sewing machine backwards and for-

wards over the damage at least twenty times. And somehow, while sewing machines whirred, locks clicked, and steel-toed boots clattered on metal staircases, he gave the bag an additional, subversive designation. Using the same backwards and forwards stitch that had closed the rip, he embroidered the letters *FLQ* below the metal grommets and drawstrings at the mailbag's mouth. He must have worked fast in the harsh glare of the metal-shaded overhead lights: he didn't pause to cut the thread as his needle finished the *F* and moved on first to the *L*, and then the *Q*.

Who was the prisoner who stitched the initials onto the mailbag and what was his motive? Was he a Quebec separatist who approved of the FLQ's terrorist tactics, designed to galvanize French-Canadian opinion and persuade English Canada to give independence to Quebec? Or was he simply a prankster who took this subversive initiative to break the tedium of incarceration and bug the authorities? Was dismay at the bloodshed and the restrictions on civil liberties diluted among the Kingston convicts, with an underworld sympathy for law-breakers who challenged the status quo?

Throughout that November there was a massive manhunt for the murderers of Pierre Laporte and for the FLQ hideaway where James Cross was being held. The terror within Quebec spilled out into fear and shock across Canada. Law-abiding citizens were appalled by the threats and bloody violence from a handful of extremists. Was Canada becoming another Northern Ireland? Would political protesters surge through the streets of Montreal, creating the same mayhem that American protesters against the war in Vietnam were triggering in cities like Washington and Chicago? Trudeau hammered away in his speeches at the "handful of self-selected dictators ... kidnappers and revolutionaries and assassins" who were challenging the democratically elected government.

At the same time, an articulate minority of civil libertarians expressed outrage that a prime minister elected as the embodiment of liberation had moved so quickly to suspend civil liberties. And there was an unhappy recognition that the FLQ was a delinquent offshoot of a larger, legitimate movement:

Quebec's determination to be *maîtres chez-nous* (masters in our own house).

As it turned out, the events of October 1970 marked not the start of a decade of revolution but the end of civil unrest in Quebec. In early December James Cross was discovered alive, Pierre Laporte's murderers were captured, and the crisis began to subside. There were no more terrorist incidents, and the War Measures Act was replaced by less draconian regulations. The much-feared FLQ proved to be a far smaller and more disorganized grouping than the authorities had assumed: after 1971 its activities ceased. Quebecers turned their attention to the legitimate political process, and in 1976 the province elected a Parti Québécois government, with political independence as its goal.

With soldiers and military vehicles in the background, children play in an Ottawa park during the October Crisis.

But Canada had changed. The October Crisis shook English Canada out of its complacency. The comfortable assumption that a country founded on the promise of "peace, order and good government" would never see bloodshed in its streets had gone. In Ottawa, Trudeau moved quickly to deal with Quebec's legitimate grievances. Elsewhere, some Canadians reacted by embracing the "French fact" and enrolling their children in the new bilingualism programs, while others grew increasingly resentful of the growing power of Quebecers in government.

Back at the Kingston Penitentiary, the mailbag repair program continued its relentless path: 800 bags per day, 4,000 per week, 200,000 per year. As for the FLQ bag, quality control caught it before it left the thick limestone walls of Canada's oldest jail. But the prison screws never discovered who embroidered the initials onto its heavy grey canvas.

Student protestors, c. 1965

The Quiet Revolution. Women's Lib. Flower Power. Gay Liberation. Red Power. Black Is Beautiful. At the beginning of the 1970s Canada's rights revolution was only just getting started. Maybe it was the wave of post-colonialism that had swept through Asia and Africa in the years following the Second World War. Maybe it had something to do with the rising education levels that came with an increasing standard of living. Whatever the cause, new voices were being heard, and not just in Quebec. In English Canada the speakers were still mostly white and male, but increasingly they came in many colours and spoke in a multitude of accents.

the **body politic**

gay liberation newspaper

25¢

CHARTER C

GAY RALLY OTTAWA

9-09B
ONTARIO

no. 1 november–december 1971 toronto

THE BODY POLITIC, NOVEMBER/DECEMBER 1971

Toronto, Ontario
paper
43.5 x 29 cm

Canada's *The Body Politic* was among the first and for many years one of the most influential publications that sprang to life following the famous Stonewall Riot at a gay bar in Greenwich Village in 1969, an event that historians consider the official birth of North America's Gay Liberation movement. The monthly tabloid's content could be extreme, but it was its mere existence (and survival) that made it revolutionary. By the time it ceased publication in 1985, no one needed to write an article like "The Power of Zapping," which appeared in this first issue. Zapping was a gay lib tactic in which a homosexual couple entered a straight bar and "liberated" the dance floor.

HOOKED RUG FOR INTERNATIONAL WOMEN'S YEAR, FLORA HIGGINS, 1975

Canada
(probably London, Ontario)
burlap, cotton
89.5 x 58.5 cm

This hooked rug by artist Flora Higgins was created to commemorate International Woman's Year in 1975. Feminists in the 1970s were working not just to change the way society treated women but to change the way women thought and felt about themselves. One path was through reinventing women's handicrafts. Visual artists such as Higgins and Joyce Wieland worked in the conventional male-dominated forms, such as painting, even as they experimented with hooked rugs, quilts, and other traditionally female media.

The National Film Board of Canada

presents

NOT A LOVE STORY

a film about

PORNOGRAPHY

Produced by the National Film Board of Canada

National Film Board of Canada Office national du film du Canada

POSTER FOR *NOT A LOVE STORY: A FILM ABOUT PORNOGRAPHY*, 1981

Montreal, Quebec
paper
48.3 x 31.8 cm

One issue that consumed, and sometimes divided, feminists throughout the 1970s and early 1980s was pornography, which many viewed as a form of hate literature. The film this poster promotes was an attack on pornography made by Montreal's Bonnie Sherr Klein. She worked out of the National Film Board's Studio D, founded in 1974 to produce films by and about women. One reviewer described it as "a feature-length documentary about the nature of pornography, from the point of view of women who view it as one of the most vile expressions of human life."

Poster for the Guess Who's anti–Vietnam War hit "American Woman," 1972

AMEX: THE AMERICAN EXPATRIATE IN CANADA MAGAZINE, OCTOBER/NOVEMBER 1970

Toronto, Ontario
paper
28 x 20.5 cm

Amex was the magazine of one of Canada's more unusual, and now largely forgotten, immigrant groups – American draft dodgers. Altogether, about 50,000 mostly young men chose to move to Canada rather than participate in a war they viewed as unjust (or simply wanted to avoid). *Amex* began publication in 1966 and finally closed up shop in 1977, the year American president Jimmy Carter announced an amnesty for draft dodgers.

APPEAL TO ALL ASIANS

The titanic battle of the Canadian ballot box is in full swing. Politicians and political parties plunged into a relentless struggle for loaves and es of office, power and patronage.

The Asians living in Canada since 1967, (whe they belong to India, Pakistan or other countrie the Commonwealth) have a right to vote and right must be exercised in the elections set for O ber 30, 1972.

The Liberal Government of Mr. Pierre Trudeau done much for us, and we have reasons to be gr ful. We must now rally round and ensure that returned to power. Every vote given to the Libe is a nail in the coffin of opportunists, freebooters time-servers who have nothing to offer you.

ٹرودو کو ووٹ دیجئے

ضمنی وٹ لبرل پارٹی کو دیجئے ٹرودو جیسا لیڈر کینیڈا میں اس وقت وکوئی نہیں آپکی ترقی انکے ہاتھ کی ہے
چلتی کانام گاڑی ہے دھوکہ مت کھائیے

ट्रूडो को वोट दीजिये!

अपना कीमती वोट लिब्रल पार्टी को दीजिये। ट्रूडो जैसा
लीडर केनेडा में इस समय कोई नहीं है। आपने उन्नति उनके
हाथ की है। चलती का नाम गाड़ी है ····धोका मत खवाइये

A STUD IN HAND IS WORTH TWO UNDER THE BED

Released by Capt. Anant Singh, 240 Wellesley Street East Suite 1512, Toronto 5. Telephone (416) 924-1811

Opposite: *Privately published poster urging Asian-born Canadians to vote for Pierre Trudeau's Liberals in the 1972 federal election*

RIGHTS AUDITORIUM *673*

PHAM THE TRUNG'S REFUGEE BAG, 1980

Toronto, Ontario
leather
approx. 23 x 30 x 9 cm

This leather bag was all that Pham The Trung, a Vietnamese refugee who arrived in Canada in 1980, was able to bring out with him. On it he printed in white letters his refugee identification number from the Songkhla refugee camp in Thailand. The welcoming of 70,000 Vietnamese boat people like Pham, who fled South Vietnam after it fell to the Communists, was hard evidence that Canadian immigration laws had discarded the last of their not-so-subtle pro-white, pro-European biases. The year 1971 had been the first in which immigrants of non-European origin outnumbered Europeans. (They have done so every year since.) Canada was in the process of becoming a truly multiracial society.

1

2

3

1 UKRAINIAN-STYLE
 EASTER EGG, NADINE
 ZELEM, 1975

 Ottawa, Ontario
 eggshell and dye
 5.5 x 4 cm

2 UKRAINIAN-STYLE
 EASTER EGG, ODARKA
 SIRSKYJ, 1972

 Waterloo, Ontario
 eggshell and dye
 5.5 x 4 cm

3 BOWL, 1980

 Ottawa, Ontario
 cherrywood
 17 x 72.5 x 25 cm

These two charming eggs, or *pysanky*, were both decorated in Canada, using an ancient Ukrainian folk-art technique involving beeswax and dyes. The bowl, though Russian in craft, represents a thoroughly Canadian subject. By the time the earliest of these artifacts was made, it could be seen in the context of the new Canadian concept of "multiculturalism," a term coined in the late 1960s as a counter to "biculturalism." The word was soon picked up internationally.

THE INDIAN IN TRANSITION, DAPHNE ODJIG, 1975

*Anglemont, BC
acrylic on canvas
2.43 x 8.22 m*

Odjig's epic painting portrays native history as having four stages: the ideal pre-Columbian stage (the Indian drummer symbolizes ancient traditions; the serene earth mother represents the unity of humanity with nature); the arrival of the first Europeans (the giant boats); the collapse of Indian societies (faceless people, an empty bottle, a broken drum); and, finally and

Inuvialuit children at Tuktoyaktuk in 1969

optimistically, the native renaissance and reconnection to the natural world (the Thunderbird). At the time the artist completed this major work, the outlook for most of Canada's aboriginal communities appeared anything but rosy. They had gained the right to vote in federal elections in 1960 and by 1969 had gained the franchise in all provinces. But, on and off the reserves, they remained the poorest, most short-lived, and least-educated segment of the population.

BANQUE DE LÉVESQUE

PQ1979 PQ1979

UN **1** FRANC

QUÉBEC

THIS NOTE IS PENDING TENDER

VIVE LE QUE LIBRE

J. Parizeau
MINISTRE DES FINANCE

Ting
BANK NOTE CO.

"UN 1 FRANC QUÉBEC," 1979

Quebec
paper
approx. 6 x 13 cm

This fake banknote, proudly featuring Premier René Lévesque, satirizes his Parti Québécois's goal of an independent Quebec. By the spring of 1980, however, the prospect of Quebec's separation was no laughing matter. The rumpled, chain-smoking Lévesque had called a provincial referendum that, if passed, would authorize Quebec "to negotiate a new agreement with the rest of Canada, based on the equality of nations." With skill honed from years as a TV personality, the premier projected a folksy persona that made his goal of "sovereignty association" seem less threatening. The large-scale exodus of anglophones from Quebec after the PQ's election in 1976 and the subsequent passage of Bill 101, which guaranteed the dominant position of the French language in Quebec, made a *Oui* vote a distinct possibility. But a spirited *Non* campaign brought out the fighter in Pierre Trudeau and turned the tide. In the end, only 40.6 percent of Quebecers voted *Oui* and 59.4 percent *Non*. Commenting on the defeat of the referendum, Lévesque vowed *À la prochaine!* (Until the next time!)

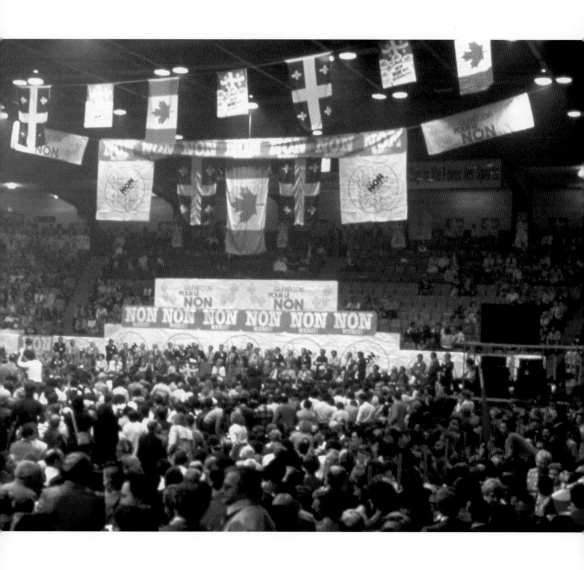

A crowd of over 10,000 gathered at Montreal's Paul Sauvé Arena on May 14, 1980, to hear Pierre Trudeau deliver his most important speech of the referendum campaign.

Queen Elizabeth and Prime Minister Trudeau walk through the crowds on Parliament Hill after their historic signing of the Canadian Constitution on April 17, 1982.

Whereas Canada is founded upon principles that recognize supremacy of God and the rule of law:

Guarantee of Rights and Freedoms

1. The *Canadian Charter of Rights and Freedoms* guarantees the righ freedoms set out in it subject only to such reasonable limits prescri law as can be demonstrably justified in a free and democratic socie

Fundamental Freedoms

2. Everyone has the following fundamental freedoms: (*a*) free conscience and religion; (*b*) freedom of thought, belief, opinion an expression, including freedom of the press and other media of communication; (*c*) freedom of peaceful assembly; and (*d*) freedom association.

Democratic Rights

3. Every citizen of Canada has the right to vote in an election members of the House of Commons or of a legislative assembly an qualified for membership therein. 4.(1) No House of Commons and legislative assembly shall continue for longer than five years from th fixed for the return of the writs at a general election of its member (2) In time of real of apprehended war, invasion or insurrection, a h Commons may be continued by Parliament and a legislative assembl be continued by the legislature beyond five years if such continuati opposed by the votes of more than one-third of the members of th Commons or the legislative assembly, as the case may be. 5. There a sitting of Parliament and of each legislature at least once every twel

Mobility Rights

6. (1) Every citizen of Canada has the right to enter, remain i leave Canada. (2) Every citizen of Canada and every person who ha status of a permanent resident of Canada has the right (*a*) to move take up residence in any province; and (*b*) to pursue the gaining of livelihood in any province. (3) The rights specified in subsection (2) subject to (*a*) any laws or practices of general application in force in province other than those that discriminate among persons primar the basis of province of present or previous residence; and (*b*) any la providing for reasonable residency requirements as a qualification receipt of publicly provided social services. (4) Subsections (2) and (preclude any law, program or activity that has as its object the ame in a province of conditions of individuals in that province who are e or economically disadvantaged if the rate of employment in that pr below the rate of employment in Canada.

Legal Rights

7. Everyone has the right to life, liberty and security of the p and the right not to be deprived thereof except in accordance with principles of fundamental justice. 8. Everyone has the right to be se against unreasonable search or seizure. 9. Everyone has the right no arbitrarily detained or imprisoned. 10. Everyone has the right on ar detention (*a*) to be informed promptly of the reasons therefor; (*b*) t and instruct counsel without delay and to be informed of that righ (*c*) to have the validity of the detention determined by way of *habea* to be released if the detention is not lawful. 11. Any persons charge offence has the right (*a*) to be informed without unreasonable dela specific offence; (*b*) to be tried within a reasonable time; (*c*) not to b compelled to be a witness in proceedings against that person in res the offence; (*d*) to be presumed innocent until proven guilty accord law in a fair and public hearing by an independent and impartial tr (*e*) not to be denied reasonable bail without just cause; (*f*) except in of an offence under military law tried before a military tribunal, to benefit of trial by jury where the maximum punishment for the of imprisonment for five years or a more severe punishment; (*g*) not found guilty on account of any act or omission unless, at the time

CANADIAN CHARTER OF RIGHTS AND FREEDOMS

...constituted an offence under Canadian or international law ...al according to the general principles of law recognized by the ...f nations; (h) if finally acquitted of the offence, not to be tried ...d, if finally found guilty and punished for the offence, not to ...nished for it again; and (i) if found guilty of the offence ...nishment for the offence has been varied between the time ...an and the time of sentencing, to the benefit of the lesser. 12. Everyone has the right not to be subjected to any cruel and ...ment or punishment. 13. A witness who testifies in any ... has the right not to have any incriminating evidence so given ...minate that witness in any other proceedings, except in a ...or perjury or for the giving of contradictory evidence. ...witness in any proceedings who does not understand or ...guage in which the proceedings are conducted or who is deaf ...o the assistance of an interpreter.

Equality Rights

Every individual is equal before and under the law and has ...ne equal protection and equal benefit of the law without ...n and, in particular, without discrimination based on race, ...hnic origin, colour, religion, sex, age or mental or physical ...Subsection (1) does not preclude any law, program or activity that ...ct the amelioration of conditions of disadvantaged individuals or ...ding those that are disadvantaged because of race, national or ...colour, religion, sex, age or mental or physical disability.

Official Languages ...Canada

...English and French are the official languages of Canada and ...y of status and equal rights and privileges as to their use in all ...f the Parliament and government of Canada. (2) English and ...he official languages of New Brunswick and have equality of ...qual rights and privileges as to their use in all institutions of the ...nd government of New Brunswick. (3) Nothing in this Charter ...hority of Parliament or a legislature to advance the equality of ...of English and French. 16.1 (1) The English linguistic community ...ch linguistic community in New Brunswick have equality of ...ual rights and privileges, including the right to distinct ...nstitutions and such distinct cultural institutions as are ...e preservation and promotion of those communities. (2) The ...gislature and government of New Brunswick to preserve and ...status, rights and privileges referred to in subsection (1) is ...) Everyone has the ...nglish or French in any ...other proceedings of ...2) Everyone has the ...nglish or French in any ...other proceedings of ...e of New Brunswick. 18. ...es, records and journals

of Parliament shall be printed and published in English and French and both language versions are equally authoritative. (2) The statutes, records and journals of the legislature of New Brunswick shall be printed and published in English and French and both language versions are equally authoritative. 19. (1) Either English or French may be used by any person in, or in any pleading in or process issuing from, any court established by Parliament. (2) Either English or French may be used by any person in, or in any pleading in or process issuing from, any court of New Brunswick. 20. (1) Any member of the public in Canada has the right to communicate with, and to receive available services from, any head or central office of an institution of the Parliament or government of Canada in English or French, and has the same right with respect to any other office of any such institution where (a) there is a significant demand for communications with and services from that office in such language; or (b) due to the nature of the office, it is reasonable that communications with and services from that office be available in both English and French. (2) Any member of the public in New Brunswick has the right to communicate with, and to receive available services from, any office of an institution of the legislature or government of New Brunswick in English or French. 21. Nothing in sections 16 to 20 abrogates or derogates from any right, privilege or obligation with respect to the English and French languages, or either of them, that exists or is continued by virtue of any other provision of the Constitution of Canada. 22. Nothing in sections 16 to 20 abrogates or derogates from any legal or customary right or privilege acquired or enjoyed either before or after the coming into force of this Charter with respect to any language that is not English or French.

Minority Language Educational Rights

23. (1) Citizens of Canada (a) whose first language learned and still understood is that of the English or French linguistic minority population of the province in which they reside, or (b) who have received their primary school instruction in Canada in English or French and reside in a province where the language in which they received that instruction is the language of the English or French linguistic minority population of the province, have the right to have their children receive primary and secondary school instruction in that language in that province. (2) Citizens of Canada of whom any child has received or is receiving primary or secondary school instruction in English or French in Canada, have the right to have all their children receive primary and secondary school instruction in the same language. (3) The right of citizens of Canada under subsections (1) and (2) to have their children receive primary and secondary school instruction in the language of the English or French linguistic minority population of a province (a) applies wherever in the province the number of children of citizens who have such a right is sufficient to warrant the provision to them out of public funds of minority language instruction; and (b) includes, where the number of those children so warrants, the right to have them receive that instruction in minority language educational facilities provided out of public funds.

Enforcement

24. (1) Anyone whose rights or freedoms, as guaranteed by this Charter, have been infringed or denied may apply to a court of competent jurisdiction to obtain such remedy as the court considers appropriate and just in the circumstances. (2) Where, in proceedings under subsection (1), a court concludes that evidence was obtained in a manner that infringed or denied any rights or freedoms guaranteed by this Charter, the evidence shall be excluded if it is established that, having regard to all the circumstances, the admission of it in the proceedings would bring the administration of justice into disrepute.

General

25. The guarantee in this Charter of certain rights and freedoms shall not be construed so as to abrogate or derogate from any aboriginal, treaty or other rights or freedoms that pertain to the aboriginal peoples of Canada including (a) any rights or freedoms that have been recognized by the Royal Proclamation of October 7, 1763; and (b) any rights or freedoms that now exist by way of land claims agreements or may be so acquired. 26. The guarantee in this Charter of certain rights and freedoms shall not be construed as denying the existence of any other rights or freedoms that exist in Canada. 27. This Charter shall be interpreted in a manner consistent with the preservation and enhancement of the multicultural heritage of Canadians. 28. Notwithstanding anything in this Charter, the rights and freedoms referred to in it are guaranteed equally to male and female persons. 29. Nothing in this Charter abrogates or derogates from any rights or privileges guaranteed by or under the Constitution of Canada in respect of denominational, separate or dissentient schools. 30. A reference in this Charter to a province or to the legislative assembly or legislature of a province shall be deemed to include a reference to the Yukon Territory and the Northwest Territories, or to the appropriate legislative authority thereof, as the case may be. 31. Nothing in this Charter extends the legislative powers of any body or authority.

Application of Charter

32. (1) This Charter applies (a) to the Parliament and government of Canada in respect of all matters within the authority of Parliament including all matters relating to the Yukon Territory and Northwest Territories; and (b) to the legislature and government of each province in respect of all matters within the authority of the legislature of each province. (2) Notwithstanding subsection (1), section 15 shall not have effect until three years after this section comes into force. 33. (1) Parliament or the legislature of a province may expressly declare in an Act of Parliament or of the legislature, as the case may be, that the Act or a provision thereof shall operate notwithstanding a provision included in section 2 or sections 7 to 15 of this Charter. (2) An Act or a provision of an Act in respect of which a declaration made under this section is in effect shall have such operation as it would have but for the provision of this Charter referred to in the declaration. (3) A declaration made under subsection (1) shall cease to have effect five years after it comes into force or on such earlier date as may be specified in the declaration. (4) Parliament or a legislature of a province may re-enact a declaration made under subsection (1). (5) Subsection (3) applies in respect of a re-enactment made under subsection (4).

Citation

34. This Part may be cited as the *Canadian Charter of Rights and Freedoms*.

"We must now establish the basic principles, the basic values and beliefs which hold us together as Canadians so that beyond our regional loyalties there is a way of life and a system of values which make us proud of the country that has given us such freedom and such immeasurable joy."

P.E. Trudeau 1981

CANADIAN CHARTER OF RIGHTS AND FREEDOMS, 1982

Ottawa, Ontario
paper
27.9 x 34.3 cm

Pierre Trudeau patriated the Canadian Constitution – which, until 1982, was an act of the British Parliament – over the objections of Quebec, but one aspect of the package soon earned widespread public support both inside and outside *la belle province*: the Canadian Charter of Rights and Freedoms. Unlike Diefenbaker's Bill of Rights, the Charter was "entrenched" in the Constitution and had become the law of the whole land.

EARTH & SKY ATRIUM

1970 to 1997

Below: *The Rocky Mountains photographed from an* Apollo *spacecraft*
Opposite: *A view of the Earth with a solar starburst pattern to the right, June 1, 1996*

As the sixties gave way to the seventies, Canada began to seem like a much smaller place. During the *Apollo* moon missions, human beings had, for the first time, taken in their whole planet in one glance. Back down on the surface, the rise of satellite communications meant that messages that a century earlier would have needed a week to cross the country, from coast to coast, now took milliseconds. In the collective imagination, the world had shrunk and looked unexpectedly fragile. Canada's vast territory, which had seemed inexhaustible to its earliest inhabitants, began to reveal its limits: lakes killed by acid rain; air and water pollution; species gone or sharply diminished. Outer space might have been the final frontier, but, to an increasing number of Canadians, the real challenge was protecting our Earthbound home.

RIGHT WHALE SKELETON (*EUBALEENA GLACIALIS*), APPROX. 1970–92

Saint John, NB
bone
approx. 13.7 m

The rapid decline in whale populations gave impetus to the environmental movement. Whale watching became a popular pastime, and one of the oddest albums of the era, *Songs of the Humpback Whale*, emerged as a fixture on "underground" FM radio stations. In 1970 the Don't Make a Wave Committee, the predecessor to the formidable environmental group Greenpeace, was founded in Vancouver in response to the Americans' explosion of a nuclear bomb on a tiny island off Alaska in October 1969. The group soon changed its name and expanded its mandate to encompass a radical environmentalism. This skeleton belonged to a right whale known as Delilah, who was first spotted off Grand Manan Island in the Bay of Fundy in the early 1980s, but was probably born around the same time Greenpeace came into being. Scientists followed her until 1992, when she died in a collision with a ship.

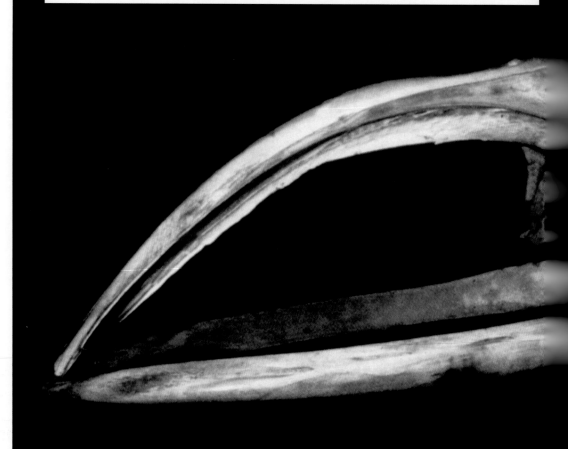

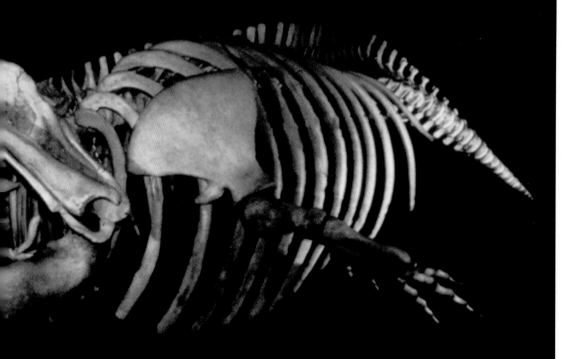

PAINTING OF THE *ANIK A* SATELLITES, PAINTED 1978–80

*material and size
unavailable*

This artist's view shows Canada's three *Anik A* communication satellites
(launched in 1972, 1973, and 1975) orbiting scarcely 30 metres from each
other. The *Anik* satellites were a technologically savvy answer to the
perennial Canadian problem: How, given our country's great size and
harsh climate, do we all talk with one another? Once the satellites were
positioned in geostationary orbit, maintaining a fixed point above the
Earth as it rotates, their enormous antennae opened, enabling them to
relay phone calls, TV signals, and other data from almost anywhere to
almost anywhere in the country. Canada was the first nation to employ
satellites for non-military communication and the first to achieve such
complete satellite coverage.

PEREGRINE FALCON (*FALCO PEREGRINUS ANATUM*), COLLECTED 1925, ENTERED ON THE ENDANGERED SPECIES LIST, C. 1979

Red Deer River region,
Alberta
approx. 40 cm

The Canadian government began formally listing the many plants, mammals, birds, and fish that were in environmental danger in 1979. Each was categorized according to the threat it faced, which ranged from "special concern" to "extinct." One of the species most at risk was the peregrine falcon, a crow-sized predator that strikes its prey in the air at speeds of up to 300 kilometres an hour. Like the bald eagle, which was virtually wiped out in Canada east of the Rockies in the 1960s, the peregrine suffered from the effects of pesticides. The widely used insecticide DDT was not banned in Canada until 1969.

Within the image, handwritten and printed specimen label text reads:

No. 87634
Herb. Geological Survey of Canada.
PLANTS OF VANCOUVER ISLAND
Castilleja levisecta, Greenman
Hab. and Loc. Oak Bay, Victoria
Collector, John Macoun, May 21st 1908.

G.W. Douglas,
B.C. C.D.C.

GOLDEN PAINTBRUSH (*CASTILLEJA LEVISECTA*), COLLECTED 1908, ENTERED ON THE
ENDANGERED SPECIES LIST, C. 1979

Oak Bay, Victoria
size unavailable

This humble herb, known as golden paintbrush, once flourished in natural
meadows throughout British Columbia. As the meadows disappeared – due,
largely, to human development – the golden paintbrush began to disappear
as well. It is now restricted to three small areas on Vancouver Island and the
Gulf Islands.

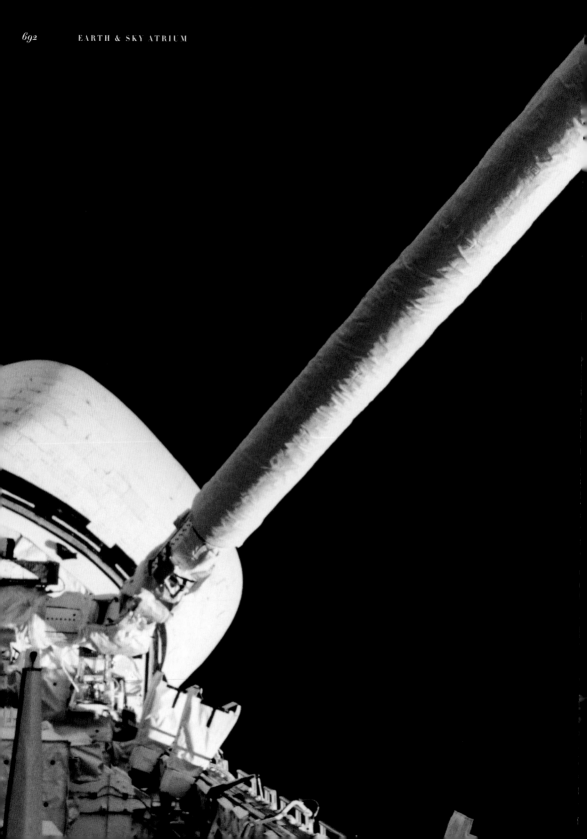

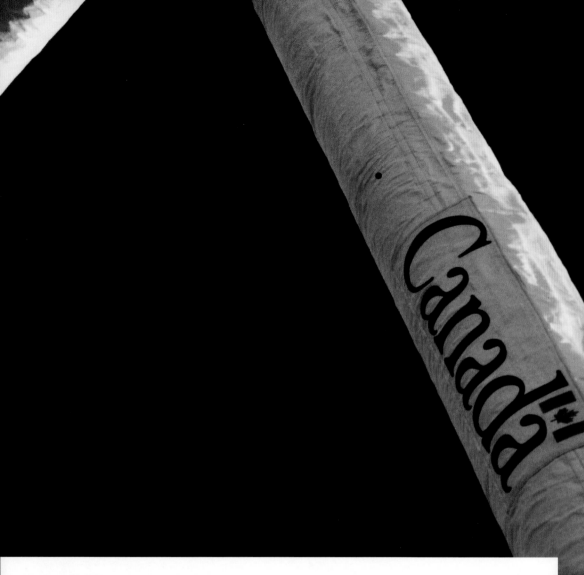

SPACE SHUTTLE REMOTE MANIPULATOR SYSTEM (CANADARM), PLANNING BEGAN 1974, SIGNED OVER TO NASA IN 1981

Toronto, Ontario
carbon composite material,
electrical cabling, 2
closed circuit televisions,
general purpose computer
approx. 1520 x 38 cm

The Canadarm first sailed into space on November 13, 1981, aboard the *Columbia* on the second shuttle flight. Properly called a shuttle remote manipulator system, it was Canada's first direct involvement with human space flight, although Canada's own space program dated back to 1962 and the launch of the first *Alouette* satellite. The spindly Canadarm, which cannot support itself under Earth's gravity, was designed by Spar Aerospace under the direction of the National Research Council. When the NRC donated the first one to NASA, the space agency promptly ordered four more. Now a fixture of shuttle missions, the nimble Canadarm manoeuvres objects in and out of the ship's cargo bay in minimal gravity with the help of five separate on-board computers. A newer version, Canadarm 2, has been created for use on the International Space Station.

Space shuttle Challenger *lifting off from the Kennedy Space Center, Merritt Island, Florida, October 5, 1984*

COVERALL WORN BY MARC GARNEAU, 1984

space shuttle Challenger
fibre, cotton, metal,
and leather
158 x 158 cm

Marc Garneau wore this jumpsuit when he lifted off aboard the
space shuttle *Challenger* in October 1984 to become the first
Canadian in space. Designed for work in zero-gravity conditions
inside the shuttle, the suit was equipped with smart-closing
pockets to prevent their contents from floating away. NASA
created the crest on the right-hand side of the suit specifically
for Garneau, who was a trained engineer as well as a career
naval officer. It is based on Leonardo da Vinci's famed drawing
The Proportions of the Human Figure, which shows three fig-
ures, two of them free-floating. The three are meant to repre-
sent the three areas that concerned Garneau on his mission:
space technology, space science, and the life sciences.

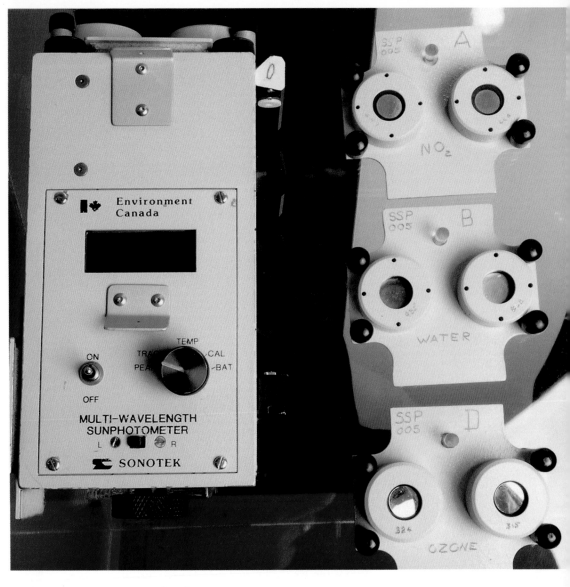

SUN PHOTOMETER, 1980–84

space shuttle Challenger
metal, glass
11.8 x 20 x 11 cm

This sun photometer, with its six lenses for measuring light, is an example of how our reach into space can coincide with our fears for our planetary home. Created by the Atmospheric Environmental Service of Canada, the photometer was designed to measure local matter in the atmosphere and to detect acidic haze, an indicator of acid rain. These substances had first been noted in Great Britain during the early days of the Industrial Revolution, but they came to prominence as an environmental issue only in the 1960s. One of Marc Garneau's missions aboard the *Challenger* was to calibrate the photometer away from the effects of the atmosphere, to ensure that it would work accurately on Earth. The instrument was also useful in determining the presence in the atmosphere of chemicals that affect the ozone layer.

50
40
30
20
10
0
-10
-20
-30
-40
-50
-70

OZONE MEAN DEVIATION MAP OF THE NORTHERN HEMISPHERE, MARCH 1–10, 1997

computer-generated image This diagram compares the state of the ozone layer in the northern hemi-
sphere in March 1997 with what was known about it before 1980. As can be
seen on the scale to the right of the map, the darker blue and violet areas
show where depletion has been the most severe, with marked losses over
the North Pole, including the north of Greenland and Ellesmere Island.
There is also a small area of very severe depletion off the west coast of
North America. These darker blue and violet areas are frequently, and
erroneously, characterized as a "hole" in the layer. There is no hole, just a
dangerous thinning caused by increasing amounts of CFCs (chlorofluoro-
carbons) in the atmosphere. This thinning, first confirmed in 1985, means
that increased levels of ultraviolet radiation reach Earth, a phenomenon
linked to skin cancer and to damage in plants and other animals.

Section of clear-cut forest near Port Alberni, Vancouver Island, British Columbia, 1970s

BULLHORN, APPROX. 1993

Clayoquot Sound, BC
cardboard
104 x 45.7 cm

This bullhorn is a veteran of many actions in an effort to save British Columbia's Clayoquot Sound. In 1979 a group of environmentalists founded the Friends of Clayoquot Sound to fight clear-cutting on the west coast of Vancouver Island, an area that held one of Canada's last untouched stands of old-growth Pacific rain forest. (Clear-cutting, which means that every tree is cut and removed, is the most economical way of harvesting old-growth forest.) An epic battle followed, pitting environmentalists against lumber companies and a provincial government that earned royalties from timber leases. The conflict culminated in 1993 with the arrest of hundreds of demonstrators. Much of the Crown land at Clayoquot was ultimately logged, but rising international pressure caused UNESCO to designate the area a Biosphere Reserve in January 2000. Nonetheless, the last of this virgin forest is still threatened.

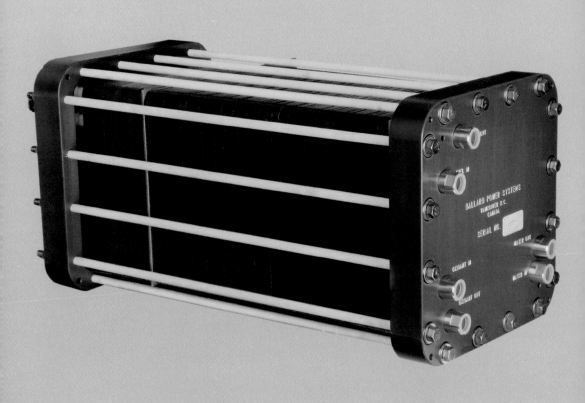

BALLARD FUEL CELL, APPROX. 1995

Burnaby, BC
metal, steel, carbon, aluminum,
and wood
26 x 51 x 25 cm

This simple-looking contraption was the creation of Canadian-born engineer Geoffrey Ballard. It's a refinement of ideas that were used to create fuel cells for spacecraft. The Ballard Fuel Cell is a renewable, non-polluting source of energy that uses hydrogen and oxygen to produce electricity, with only water as a by-product.

INVENTIVE ENERGY
Geoffrey Ballard's Hydrogen Solution

You may or may not be looking at the answer to our energy prayers. What you are definitely looking at is one man's obsession. That man is engineer and geo-physicist Geoffrey Ballard, a brilliant, difficult, and intense Canadian who was prepared to stake his career on a neglected technology that he became con-vinced would change the world. This illustration shows his Ballard Fuel Cell, early 1990s edition. It sits in the Innovators' Hall of Ottawa's Museum of Science and Technology, but its successors are anything but museum pieces.

The prototype on display here looks like a black microwave oven encased in sixteen horizontal bars that are screwed tightly through steel endplates, but it is actually made up of twenty individual fuel cells, stacked up like slices in a loaf. Each of these cells consists of a plastic membrane sandwiched between two black flow-field plates. The crust, or aluminum endplate, on the right-hand side of the stack has six carefully labelled openings into which tubes could be inserted. They read "Fuel in," "Fuel out," "Oxidant in," "Oxidant out," "Water in," "Water out." The whole loaf could produce 5 kilowatts – enough to power the microwave oven it resembles.

But how does it work? I've watched the Museum of Science and Technology's video and here's what I've learned about the electrochemical reaction inside a Ballard Fuel Cell. The basic idea is to convert the chemical energy of hydrogen into electrical energy by combining it with oxygen from the surrounding air. The hole in the aluminum endplate marked "Fuel in" is where the hydrogen fuel enters. The hole marked "Oxidant in" lets in the air. Inside each slice of the loaf, the hydrogen and air pass between the two flow-field plates, which are each coated on one side with a layer of platinum and separated by the membrane. The platinum acts as a catalyst, causing the hydro-gen to separate into its component parts: one electron and one proton. The freed-up protons immediately pass through the membrane to bond with the

Thirty Mercedes-Benz Citaro buses like this one, powered with Ballard fuel-cell engines, are slated to be operating in Europe by 2006.

oxygen, which leaves the orphaned electrons as a usable electric current. The current travels through an external circuit, then reunites on the other side of the membrane with the oxygen from the air and the protons to form H_2O. Voilà! Safe, clean electricity whose only by-product is good old water.

The idea that hydrogen can be used to produce electricity has been around since 1839, when a British lawyer and amateur scientist named William Grove, a friend of the pioneering physicist Michael Faraday, started messing about with electrodes. The idea got its next boost from the U.S. space program in the 1960s, when General Electric developed hydrogen fuel cells to provide electric power for the *Gemini* space flights. But these cells were astronomically expensive to produce and too large to be used to power a family car. Besides, pure compressed hydrogen is bulky and also has a bad reputation. "What about the *Hindenburg* disaster?" non-scientists ask, recalling the ghastly conflagration of the hydrogen-filled airship in 1937 and wondering whether vehicles propelled by hydrogen-powered fuel cells risk the same fate. (Interestingly, a 1997 study showed that the cause of the *Hindenburg* disaster was atmospheric electricity and the flammable fabric covering the diesel-powered airship, not the hydrogen that kept it aloft.)

The obstacles to commercial production of fuel cells, including cost, durability, and fuel storage, had deterred both independent inventors and large corporations like General Electric from pursuing their development for everyday use. Besides, there was little demand: the supply of hydrocarbon fuels appeared infinite. Then the OPEC crisis of 1973–74 struck, and, for the first time in their lives, Americans were forced to line up at gas stations. In the wake of the crisis, the U.S.

government established a new office of energy conservation. Ontario-born Ballard, who had worked for both Shell and Mobil in oil exploration and was then employed as a civilian scientist in the U.S. Army, found himself seconded from the army to Washington, to be the new organization's director of research. His task was to find ways to make the United States self-sufficient in energy.

Under Ballard's supervision, teams of scientists studied such alternative energy sources as solar, tidal, geothermal, and wind power. But as red tape, pork-barrelling, and political roadblocks stymied all his efforts, disillusionment quickly set in. Finally he had had it up to here with government and industry indifference. More fundamentally, he concluded that conservation of fossil fuels would not solve future energy supply problems. The world needed a new source of energy. In 1975 the forty-three-year-old Ballard walked away from his well-paid job and set up his own outfit to develop alternative energy sources.

His first laboratory was located a half-kilometre from the Mexican border in a fleabag motel previously owned by a religious cult. His first financial backer was a neighbouring rancher with whom he played fierce tennis matches. As he strove to achieve his first goal – a lightweight, rechargeable battery with which to power a small car – Ballard drove himself so hard that his two partners began calling him "the bulldozer."

In 1977 Ballard relocated to Vancouver, where he had an investor, and founded Ballard Research Inc., appointing himself both president and CEO. After four years he still hadn't made much progress towards his goal, but he managed to persuade a couple of oil companies to help fund further research on a rechargeable hydrogen battery. And he gave everyone who stuck with him through the lean times a stake in the company, making the Ballard organization a tight-knit family. Then, in 1983, one of Ballard's colleagues read that the Department of National Defence in Ottawa was interested in developing fuel-cell technology. Ballard Research Inc. was on the case in a flash, putting in bids for funding. Ballard himself did not travel to Ottawa: he knew he was too abrasive, too impatient. Instead, David McLeod, his gung-ho young marketing manager,

pitched the proposal to DND officials. The strategy paid off: Ballard Research Inc. got a contract. It was for only half a million dollars spread over twenty-eight months of work, but it was enough to keep going. Twenty years earlier, General Electric had allocated a million dollars over the same number of months in its failed attempt to develop a fuel cell.

Thanks to the occasional government contract and the backing of private investors, the Ballard team developed its fuel cell on a shoestring budget in a small industrial bay across an alleyway from a filthy, noisy body shop in downtown Vancouver. Day after day the team laboured to develop a low-cost version of this clean, quiet technology. Many of the components came from the local Canadian Tire outlet rather than scientific suppliers. But these guys were obsessed, pulling all-nighters and brainstorming over pizza. They had the scientific smarts, but they also had the creativity and curiosity to challenge conventional wisdom. They took their cue from Ballard and his motto: "Dare to be in a hurry to change things for the better."

By the early 1990s the Vancouver team had successfully reduced the cost and bulk of their patented fuel-cell prototype. Cars and buses powered by clean fuel cells, instead of dirty internal combustion engines, were now a real possibility. By 2000, Vancouver city buses and several small prototype Daimler-Chrysler and Ford cars, whose only fuel was electricity produced by Ballard's fuel cells, were purring along city streets, with water as their only emission.

However, mass commercial use remains an elusive goal: there are still issues of cost to solve, and of creating a distribution infrastructure for hydrogen, before we are all rolling along on fuel cells. As for Ballard, success came at a price. Development of his fuel cell, from the research phase to production (let alone marketing), required massive infusions of cash – money Ballard didn't have and couldn't raise on his own. Moreover, if the fuel cell was going to bust into the world's mega-markets for cars and electricity and challenge the global oil and gas industry, Ballard's boys needed some heavy-hitting partners. Finally, companies were willing to buy in.

As the enterprise grew, these corporate investors insisted on a more conventional management structure, instead of an eccentric scientist running the show. In 1989 a McGill University MBA named Firoz Rasul was hired as president and CEO. Soon there was tension between the ambitious younger man and the firm's founder. After a particularly sharp boardroom row in the early 1990s, Ballard took himself out of the day-to-day operations of the company. In subsequent years a series of public offerings enlisted more investors but steadily diluted Ballard's control.

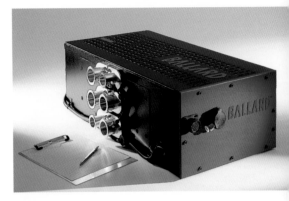

Ballard Mark 902 fuel-cell power module, which can be configured for vehicles or power stations

Today Geoff Ballard is a rich man living in semi-retirement in Vancouver. He may no longer have his hands on the levers of the company he founded, but he is constantly on his feet at academic and industry conferences, arguing the case for hydrogen-powered fuel cells. Today's model, which is roughly the same size as the prototype, can generate ten times the amount of power. Maybe he is close to his avowed mission "to change the way the world thinks about power." One decade ago his prototype fuel cell was regarded as an innovation ahead of its time. Now it is not only a museum piece but global corporations like Daimler-Benz and Ford are pouring money into its successors.

A high, oblique view of Canada's North Atlantic coast, taken from the Skylab space station in Earth's orbit

From Earth's orbit, the east coast of Canada looks much the way it did after the last ice age. It doesn't look like a piece of a planet on life support, a place hungry for the kind of clean, cheap energy promised by Geoffrey Ballard's hydrogen fuel cell. From this altitude you get the big picture. You can see why the wide, welcoming mouth of the St. Lawrence River became the gateway to the heart of the continent; you can see the outline of the Bay of Fundy, along whose shores the Acadians planted and thrived before being uprooted and expelled. But you can't see the details. History is in the details. As you've explored this virtual museum, as in all museums, the primary details you encountered have been things: fragments of bone or metal or stone, giant geologic features or miniscule traces of prehistoric life, sophisticated works of art or simple household objects. Each thing has told its own story. The story of a journey, perhaps.

Before you leave our museum, think back over the journey you've taken through its twenty-five rooms that began in the prehistoric past and have brought you into the twenty-first century. You've come a long way. And so has Canada.

ACKNOWLEDGEMENTS

It has been a joy to work on this book, not least because I have had the help of so many talented and generous experts. I would particularly like to thank for their contributions on individual essays the following: Alex Anderson, Morgan Baillargeon, Dr. Nicholas Beck, Jim Burant, Dr. Christina Cameron, Dr. Sandra Campbell, Tim Cook, Jean Dougherty, Dr. David Fisher, Le'Anne Frieday, Dr. Richard Fry, Dr. Norman Hillmer, Dr. Roy Koerner, Dr. Richard Landon, Dr. Alan MacEachern, Monica MacDonald, Dr. Duncan McDowell, Dr. Robert McGhee, Dave Meslin, Dr. Jacques Monet, Marco Oved, Faye Pearson, Don Reid, David St. Onge, Harry Thurston, Dr. Susan Till.

Rick Archbold has been a wonderful editor, and I have been consistently impressed by the good-humoured professionalism of the Otherwise researchers: Sharon Conway, Ian Coutts, Dominic Farrell, Amy Hick, Amber Austin, Bao Nghi-Nhan, Karen Press. Rosemary Shipton did a great job on copy-editing, and, at Random House, Stephanie Gowan has been a wonderful publicist.

Most of all, I would like to thank Sara Angel for having a great idea for a book, and for including me in a project that is both exciting and valuable.
– *Charlotte Gray*

The style, beauty, and form of *The Museum Called Canada* is the result of the vision of Jonathan Howells and Luke Despatie at Dinnick & Howells. Jonathan and his studio devoted their extraordinary energy, generosity of spirit, and amazing talent to build a book that would be more exciting than a museum. For the collective efforts of Dinnick & Howells there can not be enough thanks.

Nor can there be enough thanks for Charlotte Gray, whose collaboration on this project can only be described as an enormous pleasure. Her understanding and interest in *The Museum Called Canada* from the outset gave this book its unique voice and point of view.

The Museum Called Canada has also depended upon the remarkable collaboration of countless museums and cultural institutions across Canada. In particular, Norah Farrell at the Art Gallery of Ontario; Frédéric Paradis, Martin Villeneuve, Annie Laflamme, Stacey Girling, and the staff and curators of the Canadian Museum of Civilization; Jennifer-Lee Scott and the Canadian Museum of Nature; the Canadian Museum of Science and Technology; Maggie Arbour-Doucette, Et Van Lingen, and the staff and the curators of the Canadian War Museum; Martin Legault and the Earth Sciences Information Centre; the Hudson's Bay Company; Liette Robert and the staff and curators of the Manitoba Museum; Stéphanie Poisson and the McCord Museum; the Metro Toronto Reference Library; Bernard LeBlanc and the Musée acadien; Sean Lancaster and the National Archives of Canada; Kevin Joynt and the National Library of Canada; the offices of Parks Canada; the Provincial Museum of Alberta; Mr. Len Headde and the Royal Canadian Legion in Gibson's, BC; Nicola Woods and the Royal Ontario Museum; Marty Eberth and the Royal Tyrrell Museum; the Thomas Fisher Rare Book Library; the Tom Thomson Gallery; Patricia Ormerod and the University of British Columbia Museum of Anthropology and the Laboratory of Archaeology; the Archives of the Ursulines of Quebec.

Special thanks to the following individuals who so generously offered their expert opinions: Dr. Stephen Cumbaa, Rachel Gottlieb, Dr. J.R. Miller, Dr. Robert McGhee, Dr. Desmond Morton. And thanks to those who kindly offered special permission to reproduce their amazing artifacts: Murray Alcosser, Jacques Cinq-Mars, John Einarson, Randy Fillipone, Norman Hallendy, John Harrington, Janet Inkester, Jean-Pierre Lapointe, Dave Meslin, Michael Ondaatje, Dr. James Tuck, and Jake Wright. At Toronto's Moveable Type, James Li took particular care in making sure that every museum image would be as expertly reproduced as possible. Dave Willcock at Profile Water Jet created the amazing letters that grace the book's cover. And finally, thanks to those who helped out so graciously throughout the process of making this book: Rick Feldman, Amir Gavriely, and Pat Wingate.

This book would not have been possible without the following people who believed in *The Museum Called Canada* from its inception: Michael Angel, who didn't let a day pass without conveying his love and good cheer. Jackie Kaiser, who was the first to know about *Museum* and lent it her great support. Michael Levine, who never tired of hearing about *Museum* over its three-year creation and acted as a constant source of insight and reassurance. At Random House Canada Louise Dennys, Stephanie Gowan, Janine Laporte, Brad Martin, Pamela Murray, Linda Scott, Craig Pyette, Susan Renouf, and Tracey Turriff offered their incredible publishing expertise to *Museum*. Final and great thanks must go to Anne Collins, publisher at Random House. Anne embraced *Museum* from the start and offered it her undivided attention, considerable editorial acumen, and incomparable unwavering enthusiasm.
– *Sara Angel*

IMAGE SOURCES

All chapter opener and guide text images – locations courtesy of the Art Gallery of Ontario, photography by Nancy Tong.

FOSSIL FOYER, ROOM 2

p.18 Collection of the Glenbow Museum, Calgary, Canada NA-3250-14; p.19 Smithsonian USNM58311; p.20 Murray Alcosser; p.21 Thematic Fossil Centre CTF.199.26; p.22 Smithsonian; p.23 Smithsonian; p.24 The Manitoba Museum; p.25 The Denver Museum of Nature and Science 2242, PJ4.8. Photo by Rick Weber, 1995; p.26 Parc de Miguasha; p.27 All items Royal Tyrrell Museum/Alberta Community Development; p.28 Nova Scotia Museum of Natural History, Halifax, a part of the Nova Scotia Museum GS-J-00366; p.30 Nova Scotia Museum of Natural History, Halifax, a part of the Nova Scotia Museum; p.32 Nova Scotia Museum of Natural History, Halifax, a part of the Nova Scotia Museum; p.33 Nova Scotia Museum of Natural History, Halifax, a part of the Nova Scotia Museum RF-13-427; p.34 The Linda Hall Library of Science, Engineering & Technology, Kansas City; p.35 Royal Tyrrell Museum/Alberta Community Development; p.36-37 The Manitoba Museum; p.38 Glenbow Archives NA-1497-57; p.39 Royal Tyrrell Museum/Alberta Community Development; p.40 American Museum of Natural History Library; p.41 American Museum of Natural History Library; Royal Tyrrell Museum/Alberta Community Development; p.42 Royal Tyrrell Museum/Alberta Community Development; p.44 Burke Museum of Natural History and Culture, Seattle; p.45 Royal Tyrrell Museum/Alberta Community Development

HALL OF ICE, ROOM 3

p.48 Reproduced with the permission of the Minister of Public Works and Government Services Canada, 2004 and Courtesy of Natural Resources Canada, Geological Survey of Canada A94S0021; p.49 Metro Toronto Reference library; p.51 Reproduced with the permission of the Minister of Public Works and Government Services Canada, 2004 and Courtesy of Natural Resources Canada, Geological Survey of Canada F92S0110; p.52 Reproduced with the permission of the Minister of Public Works and Government Services Canada, 2004 and Courtesy of Natural Resources Canada, Geological Survey of Canada A94S0051; p.53 Reproduced with the permission of the Minister of Public Works and Government Services Canada, 2004 and Courtesy of Natural Resources Canada, Geological Survey of Canada F92S0073; p.54 Reproduced with the permission of the Minister of Public Works and Government Services Canada, 2004 and Courtesy of Natural Resources Canada, Geological Survey of Canada 2001-356; p.55 All items Reproduced with the permission of the Minister of Public Works and Government Services Canada, 2004 and Courtesy of Natural Resources Canada, Geological Survey of Canada 14783l; 89651; p.56 Reproduced with the permission of the Minister of Public Works and Government Services Canada, 2004 and Courtesy of Natural Resources Canada, Geological Survey of Canada A89S0054; p.57 Reproduced with the permission of the Minister of Public Works and Government Services Canada, 2004 and Courtesy of Natural Resources Canada, Geological Survey of Canada A94S0065; p.58 NAC PA-182827; p.59 Nova Scotia Museum of Natural History, Halifax, a part of the Nova Scotia Museum; p.60 Reproduced with permission of the Canadian Museum of Nature, Ottawa, Canada; p.61 Reproduced with permission of the Canadian Museum of Nature, Ottawa, Canada; photographer R. Martin; p.62 All items photographer Jacques Cinq-Mars; p.63 photographer Jacques Cinq-Mars; p.65 All items MCC-CMC S89-1830; K89-847. Photographer Harry Foster

FIRST PEOPLES ROOM, ROOM 4

p.68-69 Courtesy of the Provincial Museum of Alberta, Edmonton, Alberta, DgOv 2 Panel 17; p.70 British Columbia Archives I-11735; p.71 MCC-CMC VII-C-329, photographer Harry Foster; p.72 MCC-CMC GbTo-33-C-588, photographer Ross Taylor; British Columbia Archives I-11650; p.73 Copyright Cambridge University, Museum of Archaeology and Anthropology, 1922.949; p.74 Courtesy of the Royal British Columbia Museum, Victoria,B.C., EbRj22:1, PN 18699; p.75 Courtesy of the UBC Museum of Anthropology, Vancouver, Canada DgRr 6:2687; p.77 American Museum of Natural History Library 32318; p.79 American Museum of Natural History Library 104481; p.81 American Museum of Natural History Library 104479; p.82 Reproduced with the permission of the Minister of Public Works and Government Services Canada, 2004 and Courtesy of Natural Resources Canada, Geological Survey of Canada KGS-889; p.83 All items MCC-CMC: JjVi-7:217 a, photographer Richard Garner; MjVg-1:410, photographer Harry Foster; MjVg-1:3309, photographer Harry Foster; jtVg-1L5-5a, photographer Richard Garner; p.84 Glenbow Archives NA-3466-16; MCC-CMC MjVl-1:66; p.85 McCord Museum of Canadian History, Montreal M5846; MCC-CMC KjNb-7:44; p.86 Courtesy of Head-Smashed-In Buffalo Jump Interpretive Centre; p.87 Saskatchewan Archives Board R-PS-94-0473-06; Courtesy of the Provincial Museum of Alberta, Edmonton, Alberta; p.88 Saskatchewan Museum of Natural History; p.89 Courtesy of the Provincial Museum of Alberta, Edmonton, Alberta; p.90 NAC PA-126861; p.91 photographer Jacques Cinq-Mars; p.92 Ontario Archives 10001642; MCC-CMC; p.93 All items MCC-CMC: BdHi-1:1965, photographer Harry Foster, VIII-E:8496; p.94 Reproduced with the permission of the Minister of Public Works and Government Services Canada, 2004 and Courtesy of Natural Resources Canada, Geological Survey of Canada 377570; MCC-CMC CcCp-7:513 photographer David Keenlyside; p.95 All items MCC-CMC BIDq-1:50; BaGg-2:1; p.96 Reproduced with the permission of the Minister of Public Works and Government Services Canada, 2004 and Courtesy of Natural Resources Canada, Geological Survey of Canada KGS-987; p.97 All items MCC-CMC: KbFk-7:308, photographer Ross Taylor; Courtesy of the Department of Archaeology; p.98 Levi Iluitok and Eskimo Museum, Churchill, Manitoba, C58.1-1; p.99 photographer Norman Hallendy

FIRST CONTACT COLLECTION, ROOM 5

p.102 cliché Bibliothèque Nationale de France; p.103 University of Oslo; p.104 Parks Canada, 2391003:1; p.105 Photograph by Helge Ingstad; p.106 MCC-CMC Photograph courtesy of Robert McGhee; p.107 Den Arnamagnaenanke; p.109 All items Parks Canada; 23910026, 23910028, 4A68E2-8; p.110 Parks Canada; p.111 Parks Canada; p.112 The Newberry Library; p.113 University of Oslo; MCC-CMC S89-1828; p.114 All items MCC-CMC: PgHb-1:14765, photographer Harry Foster; SfFk-4:3502, photographer Merle Toole; p.115 All items MCC-CMC: PgHb-1:15859, photographer Pat Sutherland; TaJa-1:2, photographer Ross Taylor; QiLd-1:35, photographer Harry Foster 3; p.116 Wichmann 1995/National Museum of Denmark; p.117 MCC-CMC keDq-7:325, photographer Harry Foster

WATER ROOM, ROOM 6

p.120 By permission of the British Library G.6633(6); p.121 Reproduced with the permission of the Minister of Public Works and Government Services Canada, 2004 and Courtesy of Natural Resources Canada, Geological Survey of Canada 63480; p.122 NAC ; p.123 Stewart Museum 1980-53-1; p.124 McCord Museum of Canadian History, Montreal ACC141; p.125 Provincial Museum of Newfoundland and Labrador, Provincial Museum of Newfoundland and Labrador EkBc-1:679; NAC NMC 4046l; Stewart Museum; p.126 Provincial Museum of Newfoundland and Labrador; p.127 Provincial Museum of Newfoundland and Labrador; p.128 NAC C-003686; p.129 British Library Add. MS 5414.30; p.130 Bibliothèque nationale, Paris; p.131 NAC C-11334; p.132 NAC NMC-1908; p.133 Reproduced with permission of the Canadian Museum of Nature, Ottawa, Canada; McCord Museum of Canadian History, Montreal M192; p.134 NAC e-002282726; p.135 NAC; p.136 Photographer Robert McGhee; p.137 Copyright the Bodelian Library; p.138 MCC-CMC, from Stefansson and McCaskill 1938. Photographer Harry Foster; p.139 Ghent University Library ms2466, f._124r; p.140 MCC-CMC Photograph courtesy of Robert McGhee; p.141 Courtesy of the Department of Culture, Language, Elders and Youth, Government of Nunavut, photograph by Steven Darby; p.142 Courtesy of the Department of Culture, Language, Elders and Youth, Government of Nunavut; Photographer Steven Darby; p.143 MCC-CMC; p.145 MCC-CMC Courtesy of Donald D. Hogarth, photographer Steven Darby

SALON DE LA NOUVELLE FRANCE, ROOM 7

p.148 NLC; p.149 Courtesy of a Collection du Vieux-Monastère des Ursulines de Québec; p.150 Rideau Hall; NLC NL 8759; p.151 Archives Nationales de Quebec; p.152 NLC NL 6643; Centre d'Interpretation de Place-Royale; p.153 Bibliothèque Sainte-Geneviève Inv 1943, no. 128, Boinet sup 128; NLC NL15309; p.154 NAC B-84668; p.155 MCC-CMC 989.56.1, photographer Harry Foster; p.156 City of Montreal. Records Management and Archives; p.157 All items Reproduction autorisée par Les Publications du Québec: CeEt-009 (151QU) – IG8-37; CeEt-009 (151QU) – 8A5-843; CeEt-009 (151QU) – 694-333; CeEt-009 (151QU) – IJ6-18; p.158 Copyright Her Majesty the Queen in Right of Canada, Department of Energy, Mines and Resources A12649-276; Archives Nationales de France FR CAOM DPPC G1 vol 461; p.59 NAC C-147536; Reproduction autorisée par Les Publications du Québec CeEt-061 (1QU2154b) –IL-27 Reproduction autorisée par Les Publications du Québec Ce-Et-187 (1QU2148)-D-33; p.160 Le Monastère et Archives des Ursulines de Québec; p.161 Musée de la Civilisation; p.162 Marguerite Bourgeoys Museum; p.163 Marguerite Bourgeoys Museum; p.164 Library of Congress, Prints and Photographs Division, LC-USZC4-2032; p.165 cliché Bibliothèque Nationale de France; p.166 Marguerite Bourgeoys Museum; p.167 Marguerite Bourgeoys Museum; p.168 Reproduction autorisée par Les Publications du Québec CeEt-061 (1QU2154b)-IL3-292; National Currency Museum; Reproduction autorisée par Les Publications du Québec CeEt-188 (1QU2149) L-178; p.169 NAC C-17059; p.170-171 Archives Nationales de France C11A 19, folios 41 - 44

ATLANTIC PROMENADE, ROOM 8

p.174 Collection of the Art Gallery of Nova Scotia; p.175 Parks Canada; p.176 Nova Scotia Museum; p.177 Musée acadien de l'Université de Moncton; NAC PA-20117; p.178 From Justin Winsor, ed., *Narrative and Critical History of America: English Explorations and Settlements in North America 1497-1689*. Vol. III Boston: Houghton, Mifflin & Company 1884, 518; p.179 Copyright Trustees of the National Museums of Scotland UC288; NLC NL 22261; p.180 All items Colony of Avalon Fld-077; Colony of Avalon; Fld-177; p.181 All items Colony of Avalon; Fld-427; Colony of Avalon; p.182 Photograph courtesy of the Colony of Avalon; Copyright The College of Arms, London, England; p.183 Colony of Avalon Fld-464; p.184 NAC NMC; p.185 Musée acadien de l'Université de Moncton; NAC PA-16833 p.186 Archives Nationales de France FR CAOM Colonies C11B 39 no. 110; Parks Canada/Fortress of Louisbourg/National Historic Site of Canada/Ambrose MacNeil/4x5-G-69-868; p.187 Archives Naitonales de France; Parks Canada/Fortress of Louisbourg/National Historic Site of Canada/RAL-6213-T; p.188 NAC C-004293; Fort Beausejour 141-21; p.189 NLC; p.190 NAC PA-126494; p.191 Parks Canada; p.192 Parks Canada; p.193 NAC MG 18, K 5; p.194 NAC C-024549; p.195 All items Musée acadien de l'Université de Moncton; p.197 NAC C-105286; p.199 NAC C-87698; p.201 NAC C-28544; p.203 NAC NMC 27

TRAP ROOM, ROOM 9

p.206 NAC C-4188l; p.207 Musée de la Civilisation; p.208 Le Monastère et Archives des Ursulines de Québec; Musée de la Civilisation; p.209 Ministere de la culture et des communications du Quebec, archaeology department; MCC-CMC S75-357; Minnesota Historic Society 74.66.2; p.210 NAC NMC 026825-1; NMC 026825-2; p.211 Musée Conde; p.212 McCord Museum of Canadian History, Montreal M9535; p.213 Glenbow Archives NA-1532-4; p.214 Muséum de La Rochelle H 3774; p.215 Thomas Gilcrease Museum 4726.7. p. 17; p.216 MCC-CMC 983.12.16, photographer Merle Toole; p.217 Stewart Museum; p.218 NAC NMC 16349; p.219 Courtesy of Hudson's Bay Company. Trade-mark reproduced with the permission of Hudson's Bay Company', HBC Archives 1987/363-C-25/6; p.220 NAC C-41292; p.221 Parks Canada; p.222 NAC C-145920; p.223 NAC C-014943; Glenbow Archives NA-1194-12; Glenbow Archives NA-1194-11; NAC C-62710. Canadian Portrait Gallery 244; Glenbow Archives NA-1194-10; p.224 Archives of Manitoba MG1 D/3; p.226 The Manitoba Museum, HBC Archives , 93 p.229 Glenbow Archives,; p.230 NAC C-2771; p.231 Provincial Archives of Alberta B.992